Compelling Visuality

Compelling Visuality

The Work of Art in and out of History

Claire Farago and Robert Zwijnenberg, Editors

University of Minnesota Press
Minneapolis • London

The University of Minnesota Press gratefully acknowledges financial assistance
provided by the Netherlands Organisation for Scientific Research (NWO) for the
publication of this book.

All photographs in chapter 9 were taken by the author.

Portions of chapter 9 originally appeared in *Brain of the Earth's Body: Art,
Museums, and the Phantasms of Modernity,* by Donald Preziosi (Minneapolis:
University of Minnesota Press, 2003).

Published by the University of Minnesota Press
111 Third Avenue South, Suite 290
Minneapolis, MN 55401-2520
http://www.upress.umn.edu

Library of Congress Cataloging-in-Publication Data

Compelling visuality : the work of art in and out of history / Claire
Farago and Robert Zwijnenberg, editors.
 p. cm.
 Includes bibliographical references.
 ISBN 0-8166-4115-3 (HC : alk. paper) — ISBN 0-8166-4116-1 (PB : alk.
paper)
 1. Art criticism. 2. Art and history. 3. Visual perception.
 I. Farago, Claire J. II. Zwijnenberg, Robert, 1954–
N7475.C59 2003
701'.18—dc21 2003008902

Printed in the United States of America on acid-free paper

The University of Minnesota is an equal-opportunity educator and employer.

12 11 10 09 08 07 06 05 04 03 10 9 8 7 6 5 4 3 2 1

Contents

Art History after Aesthetics:
A Provocative Introduction

Robert Zwijnenberg and Claire Farago

The discipline of art history has always aimed to do justice to the complexity of works of art in their compelling visuality, taking the relationship between particular works of art and their individual beholders as the field's primary object of investigation. In this respect, this book is no different from any traditional art historical inquiry. The following essays, however, articulate questions that contemporary art historians generally dismiss as ahistorical or anachronistic or—worse yet—philosophical, implying that "anything goes" when a work of art is approached "philosophically." In her contribution to this volume, Michael Ann Holly cogently articulates the conundrum at the core of our enterprise: "The very materiality of objects with which we deal presents historians of art with an interpretive paradox absent in other historical inquiries, for works of art are both lost and found, both present and past, at the same time." According to Holly, the typical art historical enterprise is characterized by "a compulsion to recover a *certain something* long since forgotten or lost," that is, things such as provenance, individual intentions, physical settings, and so on. More pointedly, she asks: "Are these the only kind of questions that art historians should be asking: Whodunnit? Or whatisit?"

These essays address some of the "other" questions. We invited our contributors to write about what they actually see, touch, and experience when confronted with a "historical" work of art—that is, to focus on their particular experience of one of those peculiar objects of historical inquiry that, in seeming defiance of time itself, is still with us today. An

intrinsic part of every work of art is that it can still be seen and touched. We conventionally understand works of art as objects whose significance transcends the historical circumstances of their making partly for this reason. Precisely and paradoxically, it is the materiality of the object— its "compelling visuality," to cite Holly once again—that is at once affected and (miraculously) unaffected by time. To this compelling presence, visual and otherwise, the discipline of art history has offered no answer— and certainly no sustained critique—other than to retreat to conventional forms of historical inquiry: art historians value the same things as historians concerned with past events. We investigate what is no longer here and no longer seen, such as provenance, the artists' and the patrons' intentions, and the physical setting in which a given work was formerly displayed. In this anthology, documentation of historical production and historical reception are not the primary objectives. Instead, philosophers with interests in art and art historians with an interest in philosophical problems explore the implications of their own firsthand experiences as beholders. The variety of perspectives is enhanced by the fact that the contributors to this volume come from different disciplines (art history, philosophy, comparative literature, and history) and from various countries with different intellectual traditions (the United States, Switzerland, France, and the Netherlands).

Our insistence on these facts of difference points to an acute problem that we faced in the process of articulating certain ideas in an interdisciplinary framework. Ideas are, of course, expressed in words, which are concrete entities with histories of their own: to cite a significant example of a problematic word, does the English "reality" refer to the field of social relations, to the external world of appearances, or to the existent or actual in a strictly conceptual sense? The word "reality" used without further explanation ignores epistemological slippages that occur between the seams of various disciplinary formations and across languages.

For example: in his contribution to this volume, native Dutch-speaking philosopher Frank Ankersmit uses the English word "reality," which for him is intellectually rooted in a Dutch word, in circulation since the fourteenth century, that has a German cognate but does not exist in the English language. That word is *werkelijkheid,* equivalent to the German word *die Wirklichkeit.* The Dutch word *realiteit,* on the other hand, was borrowed from the French *realité* (derived from the Latin *realitas,* the root of which is *res,* meaning "thing") only at the end of the seven-

teenth century. In modern garden-variety Dutch, *realiteit* and *werkelijkheid* are synonymous, although the conceptual differences between them are audible in philosophical texts such as Kant's *Critique of Pure Reason* (1781), where Kant describes *Wirklichkeit* as "Was mit den materialen Bedingungen der Erfahrung (der Empfindung) zusammenhängt" [What is related to the material conditions of experience (sensation)]. *Realität*, according to Kant, is "das, was einer Empfindung überhaupt korrespondiert" [that which corresponds to a perception in any way.][1] Without doubt, these nuances inform Eric Auerbach's choice of *Wirklichkeit* in the subtitle to his internationally influential work *Mimesis, dargestellte Wirklichkeit in der abendländischen Literatur* (1946; translated as *The Representation of Reality in Western Literature*, 1947). For Auerbach, as for Ankersmit, there is no *Wirklichkeit* outside literary or artistic representations, and no representation is transparent or comprehensive. For this reason, infinite representations of reality are possible. But the distinction between *Wirklichkeit* and *Realität* is problematic in English because the word "reality" is the only translation for both the Germanic equivalents and the Latinate cognates. Need we mention that the original Dutch connotation of *werkelijkheid,* meaning to take an active interest in worldly values as opposed to a theological interest in spiritual values, is completely lost in translation?

Epistemological slippages owing to the history of various languages, and to customary usage recognized within but not across various disciplines, are only the beginning of the problem. Certain ideas, couched in words such as "reality," as a variety of twentieth-century thinkers have noticed, are epistemologically complex and in need of unpacking for other reasons—such as being philosophically unclear, or inextricable from certain historically specific worldviews. The initial Dutch connotations of *werkelijkheid* are a case in point.

The notion that *die Wirklichkeit* does not exist outside representation is modern—as Heidegger most famously proposed in his essay about modernity ushering in the age of the world *as* picture, that is, of "reality" as a human construct that renders the world accessible, transparent, and controllable.[2] In some quarters today, such as the ever widening circles of Lacanian studies, the philosophical ambiguities implied today in the Enlightenment concept of reality that Heidegger critiqued are the site of a complex theoretical discussion—as the Lacanian distinction between "the real" and "reality," meaning the field of social relations,

immediately signals. Of course, there is no consensus even among Laca-
nians, let alone among a more general intellectual audience, on the ex-
act nature of either the real or reality—in fact, their respective natures
are the main subject of investigation in a variety of intellectual arenas
inside and outside the field of psychoanalysis.

The contributors to the present volume are by no means all Lacani-
ans, though some are to some degree. None of us could, however, make
do with a Lacanian notion of "reality" as the represented world of social
relations for one basic, indisputable reason: our subject of investigation
is not the direct representation of social or political reality (some would
add, were such a thing possible) but rather the role of artistic repre-
sentation—and the mediated relationship between the two "symbolic
orders" of artistic and political or social representation, to use the Lacan-
ian term for representation, is *our* object of investigation. In other words,
we cannot import psychoanalytic theory wholesale—Lacan's semiotic
explanation of the formation of the self developed on the basis of Freud,
or any other theory about social reality—into the study of material cul-
ture. How such theory is applicable or adaptable to the study of works
of art is the intellectual labor to be undertaken *if* we choose to use social
theory at all.

As difficult as the conscientious translation of words and terms can
quickly become, the problems raised in the process of editing this volume
of essays also provided us with an intellectual breath of fresh air, so to
speak, that we hope to share with our readers. The dialogue that emerged
between the coeditors and with our contributors heightened everyone's
awareness of some egregious disciplinary blind spots—by which we mean
arbitrary assumptions rooted in disciplinary conventions (such as the
use of the word "reality") that merit attention and careful consideration,
especially when ideas are developed in an inter-, intra-, or, better, post-
disciplinary context.

To return to the core argument of this introduction—the theme of
this volume: what happens when the presence of a given work of art in
a given contemporary viewer's experience is theorized as part of a his-
torical interpretation? That is, what happens if instead of denying or
discounting the materiality of the work, we take our experience of it ex-
plicitly into account? Our response to a given painting, for example, is
directed by who and what we are, what we know, and where we situate
ourselves in society. In this volume, nine scholars make their personal

experience and involvement an active element of interpretation. A sculpture or painting is defined or demarcated not only by knowledge of who made it, when and why, and for what purpose, external or internal, or even within which historical, intellectual, and economic context, but also—and not least—by its significance or value to us, contemporary beholders. The meaning of the work of art can only be known in a confrontation with a beholder who is "enthusiastic" in the ancient Greek sense of the word: in a moment of enthusiasm, we lower our defenses, allowing the work of art to touch or even overwhelm us. As conscientious historians, how can this initial moment of enthusiasm function as an impetus to, and guideline for, interpreting the possible meaning of the work of art?

Of course, art historians are well aware that a work of art is more than its reconstructed history. We would not want this volume to suggest otherwise—and several contributions testify to the self-reflexive capacity of art historical inquiry. Everybody "knows" that what we call a work of art is a work of art because it provokes a special subjective experience that we usually call an aesthetic experience. A number of art historians have testified eloquently to the ways in which they have been moved by the presence of an object in the midst of their historical labors. It is not at all common practice, however, to acknowledge the formative role of this personal experience in art historical methodology and the analysis of works of art. We treat descriptions of an aesthetic experience as an excursus that informs us about the author and adds color to his or her text. Unlike essayists of earlier generations such as Walter Pater, or connoisseurs past and present working in the tradition of Bernard Berenson (whose expertise serves the explicit purpose of assigning value to the object), most scholars today deny or refuse to recognize that their engaged, embodied responses constitute an intrinsic and necessary part of scholarly investigation. In this anthology, we question this attitude by treating the personal response of the beholding scholar as intrinsic to the sequence of analysis that results in an interpretation.

So what do we gain from making our personal, subjective responses part of the argument? The nine essays included here address this question in widely different ways. However, before reading them, it might be useful to ponder the concept of "personal response" a bit further. In our view, to regard personal response as a constitutive element of interpretation does not necessarily lead to unrestrained or undocumentable

interpretation. The act of representation creates its own conditions of reception that deserve to be acknowledged and respected in the interpretative act. This entails recognizing that no subject position exists outside the historical continuum: the work of art and the successive generations of interpreters exist in the same dynamic flow of time. Therefore, the form of the interpretation—its method and style of presentation—must be suited to these circumstances. It follows that a deductive method, a *mathesis universalis,* is not appropriate. The most important consequence of acknowledging our contingent position as viewing subjects (and it is the central thesis of this volume) is that the interpretation of a work of art, which is by definition a concrete, individual object, requires a *mathesis particularis.* This means that the choice of theoretical instruments and the vocabulary of interpretation are more or less (or as far as possible) motivated by the work of art.

The interpreter should also make clear why the given work of art necessitates the method of interpretation chosen. Mutatis mutandis, if an interpreter deploys her or his personal response as an element of the argument, this response also needs to be justified in and by the interpretation. As Panofsky articulated his hermeneutic method (in an essay that has in turn been criticized for privileging texts as the ground of interpretation), an initial personal response to a painting or other work of art can prove incorrect for any number of reasons, and thus response is directed (and corrected) by historical knowledge.[3] However, if we want to talk *sensibly* about a work of art of the Renaissance or Baroque period, for example, then—in addition to researching the historical data—we must also understand our personal perceptual and affective response in a way that allows for scholarly refutation. For example, Renée van de Vall, in her essay on Rembrandt's self-portraits included here, demonstrates that the known fact that Rembrandt painted his own face inevitably affects our response. But we may also wonder, with her, if our response can ever be adequate when the sitter's identity is in doubt. Thus van de Vall runs up against a difficulty that Panofsky clearly saw but could not solve in a satisfactory way: what is the value of our personal response, if we must admit that our response can always be refuted by historical data as yet unknown to us? Van de Vall tries to resolve this difficulty by analyzing her initial response to the faces that Rembrandt painted. Her ensuing investigation transforms the historical and textual

evidence that Rembrandt's paintings are self-portraits from a premise into an open question.

As van de Vall's essay suggests, the interpretative role played by the historian's personal experience with the work of art, situated in his or her own cultural milieu, is our common theme. Georges Didi-Huberman discusses the inevitability of anachronism in art historical research by showing that his own description of Fra Angelico's frescoes at San Marco is grounded in his knowledge of Jackson Pollock's paintings. In a similar vein, Mieke Bal demonstrates that contemporary understandings of Bernini's sculpture of Saint Theresa depend on an understanding of modern sculpture. Both Didi-Huberman and Bal produce interpretations that are anachronistic *in essence* (thus challenging art historians' fears of anachronism) without placing themselves outside the historical continuum. Their innovative methods also permit historically grounded refutations to be made. In other words, their subjective experience does not produce a purely subjective interpretation.

The same can be said of the other authors, who in most cases turn to contemporary philosophical theories and ideas to verbalize their response to concrete works of art—whether pleasurable or unsettling. Claire Farago, who describes her approach to Leonardo's *Virgin of the Rocks* as the converse of Bal's, considers the contemporary historian's subjective experience to better understand how the object framed historical beholders' experience of it, and thereby to address the larger question of how objects constitute their subjects. She maintains that the second-order objective, exponentially more complex but part of the same continuum, is to understand the socially constructed nature of the contemporary investigator's experience as it is expressed in and by the study.

How the historian establishes distance (or difference of any kind) from his or her object of study is one of the leading threads running through this volume. We encourage our readers to ask how this distance or difference then operates in the text, and how the difference established by the text constitutes subjects who see and act in the world. Mieke Bal makes use of Benjamin's notions of translation; Renée van de Vall refers to Levinas's philosophical discussion of the Other; Robert Zwijnenberg relies on Herder to explain his unease with the bodily presence of Leonardo's *Saint John;* Michael Ann Holly remembers Heidegger's essay

on van Gogh's shoes and Derrida's response to elucidate her fascination with the underdrawing of a Van Eyck painting. Frank Ankersmit, on the other hand, inverts the relationship between personal experience and philosophy by making his childhood experience of boredom into a powerful heuristic instrument in his discussion of rococo ornament. But because all the authors conceptualize their initial, felt responses, they are able to integrate their personal aesthetic experience into the sequence of argument that results in a historically grounded interpretation. By "performing" their roles as beholders, the authors construct the context of the work in relation to their own subject positions. The voice of the interpreter is explicitly located, rather than hovering nebulously outside the framework of interpretation.[4]

In all nine essays, personal response is both object and subject of an interpretation that communicates something about the interpreter and about the work of art. The authors demonstrate that scholarly interpretation is necessarily entangled with personal involvement with the work of art. Every interpretation is, by extension, a self-reflexive act in which the beholder is not neutral but actively involved bodily and intellectually. All the essays are therefore also theoretical meditations on issues such as the relationship between a work of art and its beholders, the subjectivity of the interpreter at the center of interpretation, the inevitable use of anachronism in all historical interpretation, the relationship between material presence and historical absence in a work of art, the coexistence of multiple valid interpretations, and the difference between description and interpretation. In the penultimate essay, by Oskar Bätschmann, these themes are taken up in the guise of describing the process of interpreting a painting by Poussin. We can read Bätschmann's essay as a critical evaluation of theoretical themes important to our experiment as a whole.

The final essay, by Donald Preziosi, serves as an epilogue to the volume. Preziosi treats Soane's early-nineteenth-century house museum as the work of art Soane saw it as, which was, in accord with the aims of many earlier humanists and collectors from the fifteenth through the eighteenth century, an instrument of contemplation and reflection. But Soane's project was framed by the larger enterprise of Freemasonry and its concern with shaping spatial experience as an agent for shaping character in the modern world. Preziosi understands Soane's Museum as a

transitional institution between older humanist practices of the self and the interests of modern museology and art history as instruments of modernizing nation-states.

All the essays in this book are experiments that suggest possible ways of reshaping art history. We urge readers to use this anthology not merely as a collection of independent chapters but as texts dialogically engaged with one another in an ongoing discussion about the value and importance of personal response as an element of interpretation. Our expectation is that, taken as a whole, these essays demonstrate the importance (and, even more fundamentally, the possibility) of making the material presence of works created at other moments in time an intrinsic feature of historical writing. We hope the volume will provoke further critiques of the unique challenges and opportunities that works of art and other forms of material culture offer to the problematic of historical inquiry.

The aim of this anthology is more ambitious than demonstrating that art history is no longer a unified field of study or even the sole parent discipline for analyzing visual images, or that the theoretical inspiration of art historical practitioners is both diverse and eclectic. Our starting point is the class of historical objects that we have, since the eighteenth century but not earlier, called works of fine art, and that comprise a great diversity of material objects. As art historians, we recognize styles and periods in the history of art, but our labels and classificatory schemes are not intrinsic characteristics of particular objects—rather, they are extrinsically imposed in and through the act of interpretation. It is our contention that, to do justice to the differences between individual works of art, we need to consider our present-day personal responses to them rigorously.

We offer, therefore, not a cross section of modern strategies of interpretation but rather an experiment (or series of experiments) in interdisciplinary practice, focused on European art of the early modern period that shaped the category "fine art" and the activity of aesthetic contemplation. Objects and activities that are conventionally identified with Renaissance and Baroque styles, therefore, become the basis for an anthropological study turned inward, on the history of our own society, for the purpose of locating "art" as both a historical category and a dynamic ritual that today maintains collective memory in diverse cultural settings around the globe.

Notes

1. Immanuel Kant, *Kritik der reiner Vernunft* (Hamburg: Felix Meiner Verlag, 1976). The quoted description of *Wirklichkeit* is from Kant's 2d edition (1787), p. 266; the description of *Realität* is from the 1st edition (1781), p. 143, and the 2d edition (1787), p. 182.

2. Martin Heidegger, "Die Zeit des Weltbildes," in *Holzwege* (Frankfurt am Main: Vittorio Klostermann, 1976). "Der Grundvorgang der Neuzeit ist der Eroberung der Welt als Bild. Das Wort Bild bedeutet jetzt: das Gebild der vorstellenden Herstellens" (87).

3. See, for example, Irving Lavin, ed., *Meaning in the Visual Arts: Views from the Outside: A Centennial Commemoration of Erwin Panofsky (1892–1968)* (Princeton, N.J.: Institute for Advanced Study, 1995); Keith Moxey, *The Practice of Theory: Poststructuralism, Cultural Politics, and Art History* (Ithaca: Cornell University Press, 1994); Michael Ann Holly, *Panofsky and the Foundations of Art History* (Ithaca: Cornell University Press, 1984).

4. Mieke Bal and Norman Bryson, in "Semiotics and Art History," *Art Bulletin* 73 (1991): 174–208, esp. 174–81, offer an incisive critique of the manner in which interpretation generates "context," rather than the other way around.

CHAPTER ONE

Ecstatic Aesthetics: Metaphoring Bernini

Mieke Bal

> While content and language form a certain unity in the original, like a fruit and its skin, the language of the translation envelops its content like a royal robe with ample folds.
> —Walter Benjamin, "The Task of the Translator"

The image of a royal robe with ample folds cannot today but evoke that historical aesthetic and its contemporary counterpart that we associate with Gilles Deleuze (1993), with the idea of the fold. The image is thoroughly baroque. Walter Benjamin, whose work on German baroque drama has inspired extensive philosophical commentary on the baroqueness of his thought as exemplary of modernity in general, is here speaking not about art but about language.[1] Comparing the task of the translator with that of the poet, Benjamin creates a powerful image of the translator's product as both rich (royal) and encompassing (ample), expansive yet enveloping.[2]

His essay on translation, in line with his more straightforwardly philosophical musings on language, takes an explicit position against the idea of translation as derivative.[3] Instead it proposes a philosophy of language in which the translation serves not the original but the liberation and release of its potential, which he calls "translatability" and which is located in that which resists translation. Although his essay—somewhat embarrassingly to our postmodern taste—abounds in organic metaphors, essentialism, and a terminology of purity, the gist of his philosophy of language through translation can be seen, retrospectively, as a critique

of logocentrism. The "pure language" that translation is called upon to release in the original is—far from the core of truth of the hermeneutic tradition—located nowhere more precisely and definitively than in the folds that envelop it. Elsewhere, when describing the task of the critic, Benjamin uses equally baroque imagery to upgrade the function of the critic compared with that of the commentator (the philologist).[4] In this case, the image is fire. Fold and fire: two images that refer language to the domain of visuality, and philosophy to the—baroque—aesthetic. Images, moreover, that are central to the work of two philosophers of our time, John Austin and Gilles Deleuze, who doubtlessly are among the most influential in the cultural disciplines to which art history belongs.

John Austin, whose philosophy of language liberated language from the stronghold of meaning in a way that resonates with Benjamin's, introduced the concept of performativity—today widely used, and abused—into the discourse on art. For him, fire is the image of the fleeting nature of speech acts: not a semantic core, but rather something that, although it can do great damage (Butler 1997), is not a thing but a temporally circumscribed event; something that, like fire, hovers between thing and event. Deleuze, explicating and updating Leibniz's baroque philosophy, demonstrated that the aesthetic motif of the fold is far more than an element of decoration; indeed, as a figure, it also defines a specific type of thought. A thought, it is now well known, that Benjamin exemplifies, and that connects from within, so to speak, the baroque of the seventeenth century, permeated with religion and authoritarianism, with the baroque of our time, which tries hard to be liberated from both.[5] In this chapter, I will confront Benjamin's essay on translation, as a sample of philosophical discourse, with an art historical issue, in order to explore a few elements of the key question of the latter: how to *do* art history?[6]

Two works of art—one from the seventeenth century, the other from our present time, both considered baroque—represent, as a dual case, my view of the relationship between philosophy and art history. I propose that relationship as an *ec-static form of translation*. Moreover, I will later argue that this form of translation is not only ethically responsive but also, in the strict sense where philosophy and art history blend, *aesthetic*. On the one hand, I will put forward Giambattista Bernini's famous *Ecstasy of Saint Teresa*, from 1647, located in the Cornaro Chapel of the Santa Maria della Vittoria Church in Rome (Figure 1.1). This is a major object of interest for the "typical" art historian (Lavin 1980) and

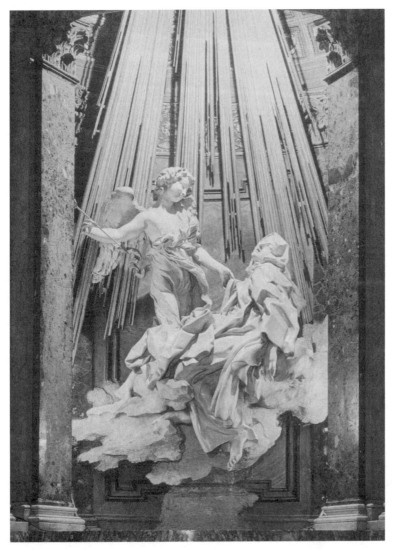

Figure 1.1. Giambattista Bernini, *Ecstasy of Saint Teresa*, 1647. Photograph from Kunsthistorisch Instituut, Universiteit van Amsterdam.

the less typical but more influential philosopher (Lacan in his *Seminar 20*).[7] It is in this double status that it will here serve as my historical object. On the other hand, I will propose Louise Bourgeois's sculpture *Femme Maison*, from 1983, not studied in any detail by art historians or engaged by philosophers, as my theoretical object (Figure 1.2). I hasten to add that these works will exchange functions as my argument develops.

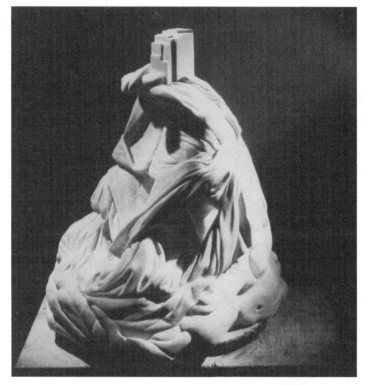

Figure 1.2. Louise Bourgeois, *Femme Maison*, 1983. Marble, 63.5 x 49.5 x 58.4 cm. Courtesy Cheim and Read New York. Photograph by Allan Finkelman.

This exchange, in fact, embodies my argument. In an anti-instrumentalist conception of theory, I contend that the relationship between philosophy and art history is best reframed as the relationship between history and theory—two aspects of both philosophy and art history— which in turn stands for the relationship between object and analysis. But theory here is not an instrument of analysis to be "applied" to the art object, supposedly serving it but in fact subjecting it. Instead it is a discourse that can be brought to bear on the object, while at the same time the discourse can be brought to bear on it, for this relationship is reversible in both temporal and functional terms. The historical interpretation of objects of visual art requires a fluctuating, mobile, and irreducible tension, between past and present on the one hand and between theory and history on the other. In what I have elsewhere dubbed a "pre-posterous" history, historical interpretation is by definition an activity of a philosophical nature.[8]

The status of my sculptural objects as visual art is equally subject to doubt. While it would be pedantic to argue about Bernini's relevance to the (art) historical concept of the baroque, it would not be so to scrutinize his work for its implications for that concept. Louise Bourgeois, in addition to calling herself a baroque artist, created a sculpture titled *Baroque* (1970), as well as one called *Homage to Bernini* (1967). Because Bourgeois and Bernini can be considered exemplary of what art history calls "baroque," it is through the two works *Ecstasy* and *Femme Maison* that this concept will be defined as both historical and philosophical. In defiance of art historical practice, I will treat these two works together, as if they had no separate existence, and as much theoretically and philosophically as in terms of their visual existence or "nature." The relationship between these works and between these works and the concept of baroque will be construed in terms of translation according to the metaphor in the epigraph from Walter Benjamin's philosophy of language. Needless to say, the figure of the fold will be deployed as baroqueness's synecdoche.

Theses on the Philosophy of Art History

> The past can be seized only as an image which flashes up at the instant when it can be recognized and is never to be seen again.
> For every image of the past that is not recognized by the present as one of its own concerns threatens to disappear irretrievably.
> —Walter Benjamin, "Theses on the Philosophy of History"

Image, recognition, disappearance: history depends for its conditions of possibility on the self-centered anachronism of the present. In spite of Benjamin's current popularity, these words of his are not heeded in the academic environment, where "the call for history," to use Jonathan Culler's critical term (1988), has been resounding loud and clear for decades. And especially not in art history, whose objects are images, whose primary tool—iconography—is predicated on recognition, whose greatest magic consists of "disappearing" the object under the dust of words.[9]

But philosophy is a discourse in the present that—unlike historical thinking—engages past thought in the present but does not "reconstruct" or causally explain it. If there is a relationship between philosophy and art history, then it is a philosophy *of* art history. Such a philosophy can only be involved in recognizing for the present, "as one of its own concerns," the objects of its inquiries that flare up for only brief instants,

like scenes that snapshots are unable to grasp and of which they can only inscribe a trace. The philosophical attitude I would like to propose in this chapter is not to make the best of a sad situation but rather to endorse this image of history as truly important for the present, which is our only lived temporality—a matter of life and death. Not stoic resignation but ecstatic enthusiasm is involved in heeding the warning that was Benjamin's last, given to us to honor, on the eve of his—and Enlightenment culture's—suicide.

To make this proposal more concrete, I will bring Benjamin's "Theses" to bear, "pre-posterously," on a much earlier, much more practical, and much less ominous text: his introduction to his own practical piece of work "The Task of the Translator." I would like to translate his position on the philosophy of history ("every image of the past that is not recognized by the present as one of its own concerns threatens to disappear irretrievably") into the practice it solicits. Thus it is more suitable to recognize, as one of our own concerns, his ideas as a practicing philosopher in the routine present of 1923 than his apocalyptic vision on the threshold of his death. According to Benjamin, history, including the history of art, is neither a reconstruction of, nor an identification with, the past; it is a form of translation.

Translation: *tra-ducere.* To conduct through, pass beyond, to the other side of a division or difference. If this etymology of translation is acceptable, it can be recognized in Benjamin's celebration of translation as liberation (80), transformation, and renewal (73), as a supplementation that produces the original rather than being subservient to it: "Translation is so far removed from being the sterile equation of two dead languages that of all literary forms it is the one charged with the special mission of watching over the maturing process of the original language and the birth pangs of its own" (73). It is the consequences of this philosophy of translation as a philosophy of language that I contend to be extendable to the historical interpretation of visual objects that defines the relationship between philosophy and art history as I see it.

Moving

One of the first consequences is the principle of *dissipation.* As soon as one undertakes translation, the object translated does not stay within the "duct," the conduit. It attaches itself left and right, not only engages a single "destiny" but attempts many encountered on its way. It also leaves

elements behind, irretrievably lost; thus the sense that translation is always reductive. But this dissipation is also enriching. And in anticipation of what follows, it is also *ec-static*. The translator endorses a loss of (linguistic) self to dissipate language.

A second consequence derives from the notion that translation traverses a *gap*, an irreducible difference between the "original" and its destiny in the new environment. The preposition "trans-" is as deceptive as the verb "to carry" *(ducere)*. Even if the translation effectuates the passage, it can never really build the bridge. The gap remains and even in the best of translations—the result of the act of translating—manifests its scars. Dissipation plus gap equals infinite process, without origin or end. Translation is an ongoing activity (after a translation has been printed, its reader continues the task), and because it emphatically has neither origin nor end, the process through the dissipated field, crossing (out) gaps, and hauling along history's remnants, a verb—"translating"—not a noun, is needed here.[10]

There is an illuminating parasynonym of this Latinate word, namely, its Greek version: metaphor.[11] Nuances differ; literally, "metaphor" means to carry beyond, not through; transference rather than translation, if we confine the former to its psychoanalytical meaning.[12] Benjamin's insistence that a translation changes the original beyond its initial state, revealing or rather producing the *translatability* that is its "essence" (71), justifies the metaphor of translation as metaphor. Translating as metaphoring, in Benjamin's conception of it, can be considered distorted representation; as Sigrid Weigel formulates it in her study of Benjamin, metaphor is "translation without an original" (1996, 95). I will risk decomposing these words to substantiate this claim.

Two meanings of translation will be left behind, lest their obviousness get in the way of the complexity of the argument. The first is the usual sense of passage or transference from one language into another. For Benjamin, this sense recedes before the supplementation of each in the service of the emergence of "pure language" (74), but as mise-en-scène of some key problematics of art history, it cannot be overestimated. Linguistic translation successively stages the problems of the subject (Who speaks, in a translation?), of context (Where is the translated text, or to speak with the title of Niranjana's 1992 volume, how can we "site" translation?), and of moment (What is the historical position of a translated text?).

But once those consequences become clear, translation can no longer be considered just an exchange between languages. All these questions pertain to *any* work of historical interpretation. This is one reason why both history and philosophy are considered activities of translation here, and why they must be not only realigned but even enmeshed. Sighting, citing, and siting translation require an account of the literal, or concrete, result of each of these verbs: spectacularization, recycling, and location. This leaves straightforward translation from language to language far behind.

The second sense of translation to be discarded concerns intermediality. Here, my reason for bracketing this issue is strictly political. Reflection on the complex and problematic relations between words and images tends to solicit defensiveness. The emphatic indivisibility of film notwithstanding, art historians often allege the visuality of images so that they can bar literary scholars from access under the banner of disciplinary purification (e.g., Elkins 1999). Others, nonbelievers in purity, abuse images as illustrations in terms of the fidelity that for Benjamin marks bad translations (78–79). They invoke images, point to them, but their discourse does not engage with them qua image.[13]

I will bracket these two meanings of translation in order to foreground those three aspects of translation that allow it to become a suitable model for historical work: it is multiple (dissipating), metaphorical (transforming), and active (a verb rather than a noun rendering its "essence," in Benjamin's sense). In Greece, the word "metaphor" identifies moving vans. Moving, then, in all its possible meanings, may be our best bet yet.[14]

This pun would please the artist whose face is best known through the photograph made of her by Mapplethorpe, in which she carries a work—*Fillette*—which resembles both a French bread stick, a baguette, and a hyperbolic penis. In the photo, her aging, wrinkled face smiles like that of a naughty girl. Bourgeois works so much with metaphor—so many of her works can be understood only if one takes the puns of their titles into account—that "literalizing," translating metaphors might well be the underlying principle of coherence in her widely variegated work.

Early modern Bernini, on the other hand, is much more earnest, at least if we believe art history. But there is room for doubt here. His clearly erotic representations of swooning saints make art historians feel obliged to blushingly insist on his deeply devout walk of life and on

the mystical, not erotic, nature of the scenes he depicted. But on the face of it, Bernini does not poke fun at language and the body the way postmodern Bourgeois does.[15] Yet once we deploy Bourgeois's punning as a searchlight to look back "pre-posterously," Bernini's thresholds between registers of representation—his transitions from painting to sculpture to architecture—so keenly analyzed by Giovanni Careri, come to help us *site* the activity of translating in his *Ecstasy.*[16]

Art historians have tended to see this activity through the systematic principle of analogy that Benjamin would call "bad translation" (72), based on "resembling the meaning of the original" (78).[17] This form of translation is based on the principle of logocentrism, where meaning is the end point of interpretation, centripetal, transhistorically stable, and transmedial. It ignores what Benjamin defines as the "mode" in translation, its *translatability* (70–71), and limits itself to the "inaccurate transmission of an unessential content" (70)—unessential because (only) content. Note that Benjamin's remarks on translation build on his resistance to *two,* not one, conceptions of language, which *together* flesh out what logocentrism is. He opposes the idea that the word coincides with the thing—a vision in turn relevant for his engagement with Hebrew, where word and thing are indicated by the same noun, *dabar.* And he opposes the idea that words convey meaning, a notion implying that meaning is "whole" and stable enough to be the object of conveyance.

The two conceptions Benjamin resists have referentiality in common. The first considers reference absolute; the second sees it as mediated by semantics yet primary. But if meaning is unitary, whole, and stable, nothing really happens in the transition from semantics to reference. And although a sculpture or image is not a set of words, iconographic analysis in fact treats it as if it were just that. Careri opposes to that habit a more Benjaminian mode of translation that, as the latter has it, "lovingly and in detail incorporates the original's mode of signification" (78). In line with this injunction, Careri analyzes not so much the singular meaning of singular elements as the "multiple syntactic and semantic *modalities*" that produce that meaning but also determine its effectivity (Careri 1995, 85; italics mine).

For my own analysis, I will take my cue from Careri's brilliant interpretation, and his clear and convincing articulation of his method, a particular brand of reception theory. Through what I would call a "pre-posterous" translation of Sergei Eisenstein's theory of montage in

cinema, Careri, carefully avoiding the term "baroque" in order to estrange his readers from its traditionally banal and confusing usages, qualifies Bernini's Albertoni Chapel as a *pathetic* work, "in which the uniting of sensorial elements with intellectual and cognitive ones is achieved through a violent shock—by a paroxystic mounting of tension and by a series of conceptual, dimensional and chromatic leaps from each element to its opposite" (83). He thus grounds the effectivity of what I would like to call the "ecstatic aesthetic," not in the content or the textual sources, thus firmly rejecting iconography as a method of translation, but in the "tension of representation to 'go outside itself'" (83). In other words, he translates what he sees, the "original," into something that comes to terms, as Benjamin has it, with "the foreignness of languages" (75), defined a bit later as "the element that does not lend itself to translation" (75). This aspect of Bernini's work, the untranslatability that defines its effect, can properly be called "pathetic," or, for my purpose here, *moving*.

Moving House

Over a period of many years, from the 1940s onward, Louise Bourgeois has produced a great number of works under the generic title *Femme Maison*. Generic, not serial. These works form not a series but a genre. Through a great diversity of media and styles, they explore the ambivalent relationship between women and (their) houses. Sometimes the woman has lost her head, imprisoned as she is in her life as *femme sans/cent tête(s),* to speak surrealistically. Or she falls from a roof. Or she escapes the house and manages to communicate through it, using it, headless herself, as a prosthesis. How can we know if the house is an asset or liability, a possession or prison? Sometimes she manages to climb onto the roof and shout out her freedom, albeit dangerously.

Are these works metaphors, say, in the dualistic sense, translating the melancholia of the trapped woman from the realm of feeling, a sense of a lifestyle, to the realm of the senses, of visibility? It is difficult to ignore the extent to which the comic absurdity of this situation coincides with the tragic absurdity in which many women were trapped at the time. But to interpret the *Femme Maison* works in this way, in other words to translate them in the sense of transmitting this as their singular information content, is, as Benjamin would insist, impossible.

There are at least two translations, simultaneously necessary yet in-compatible. The one moves from feeling, melancholia or frustration, to visibility through concretization, the figuration of the trapped falling into a trap, a visible, deforming prison; but also in the language of the title: *maîtresse de maison* becomes *femme-maison,* a literal translation of the English "housewife." The other retranslates what we see into language: the woman whose head gets lost in the house, because in a moment of Bovaresque stupidity she has lost her head, is a woman without a head. This visual pun is a linguistic pun, but also a metaphoring, a transfer-ring from the domain of words and images to the domain of historicist linearity.

We cannot ignore the visual allusion to Max Ernst's visual pun of his generic *femme cent tête.* Providing another version of Ernst's work, Bour-geois can also be alleged to translate it in order to appropriate it, thus staking out her claim to a place in surrealism. Can these two transla-tions—into a women's issue and a surrealist pun—work together as a critique of the sexism of the surrealists?[18] But then the metaphor of the lives of women imprisoned in their houses contradicts the act of the woman artist debating with her colleagues. Nor can we deduce from the style or content of these women's lives, their figuration or their humor, a conclusion that would make them translatable in terms of their his-torical moment, school, or style, just by applying a label such as "surre-alist" to them. Such labels are as confining as the houses of which, they say, women are the "mistresses" *(maîtresses de maison).*

In fact, Bourgeois escapes academic categories because she fights the one translation with the other. Actively metaphoring from one side of our categorizations to the other, her *Femme Maison* genre offers a per-spective on the constructive possibilities of translation as generated by the impossibility of translating "badly," in the semantic singular, infor-mationally. In the first place, the internal anachronism of the postsurre-alist and postmelancholic sculpture alleged here, *Femme Maison* from 1983, deconstructs from within—a spatial term to be taken literally—the attempt inherent in art historical methodology to translate in such a manner. Instead, and in spite of the impossibility of "psychoanalyz-ing" Bourgeois's work, she "masters" her own discourse on her past too well to avoid a collapse of unconscious and rhetorical material; her work lends itself singularly well to a mode of translation that is, in Jean

Laplanche's terms, antihermeneutic (1996). That mode, dissipating and crossing gaps that it leaves in place, is ana-lytical: unbinding.

Indeed, the reason that no singular meaning—either women's melancholia, or surrealist jokes—can "fit" the works in the way that an iconographic interpretation would require is the absence of a key or code with which to do the translating. Instead, Benjaminian translation comes closer to Freudian free association, which is "only the means employed for the *dissociation* of all proposed meaning" (Laplanche 1996, 7; italics mine). This sculpture associates its namesakes with itself, only to propose conceiving of the objects titled *Femme Maison* not as a series but as a genre that traverses the differences between media. Therefore the 1983 *Femme Maison,* I contend, proposes the genre not as surrealist or feminist but, *through* the preoccupations of Bourgeois's time, as baroque. This term is not a translation of the sculpture, or a code to translate it with, but an enfolding that embraces past (Bernini) and present (Bourgeois) into a fold that, as Deleuze would have it, embodies baroqueness.

Here the term "baroque," in its most visual content, point of view, does not characterize the two works independently but rather marks the relationship between a contemporary and a historical baroque work:

> Moving from a branching of inflection, we distinguish a point that is no longer what runs along inflection, nor is it the point of inflection itself; it is the one in which the lines perpendicular to tangents meet in a state of variation. It is not exactly a point but a place, a position, a site, a "linear focus," a line emanating from lines. To the degree it represents variation or inflection, it can be called *point of view.* (19)

No; I am not proposing to classify this sculpture as baroque rather than surrealist or feminist. I am invoking baroque as a theoretical notion that *implies*—literally, that is, visually, in its folds—a mode of translation, an activity of metaphoring that resists the singular translation of one sign to another with the same meaning. The baroqueness of Bourgeois's work is more like the royal folds of Benjamin's translation, including the fold of thought upon which Deleuze insists, than like the decorative prettiness too often associated with that historical style. Let's say that Bourgeois addresses, dialectically, polemically, and respectfully, the way Bernini attempted to represent Teresa's ecstasy ec-statically. Without in the least imitating Bernini, she, like him, supplements his work ec-statically. More precisely, she examines through this sculpture the way the seventeenth-century artist attempted to translate the transfigura-

tion—itself a form of translation, in the sense of metamorphosis à la de Certeau—of the mystic. *Femme Maison* as theoretical object houses this inquiry into the modalities of the historical object. The issue of philosophy-and-art history, then, has moved house.

Flaming

This retrospective examination requires metaphoring, if not moving, vans. Bourgeois's work metaphorizes baroque sculpture, in particular Bernini's *Teresa*, through two elements that characterize both works. The first is the integration of interior and exterior of the represented body. The second is the integration of interior and exterior of the space where the viewer stands in relation to that body.

According to common art historical lore, Bernini aimed to translate a text—say, the description of her own ecstasy by the Spanish mystic—into sculpture. In Michel de Certeau's conception of mysticism, Bernini would thereby demonstrate a deep understanding of mysticism. As Hent de Vries writes in a commentary on de Certeau's text, such an understanding involves "[formalizing] the different aspects of its writing, of its 'style' or 'tracing'" (1992, 449), thus producing the "fabulous" event/ experience that the mystic herself could not, precisely, "render." Mystical experience cannot, by definition, be "expressed," because in this view, it is always already an aftereffect. It comes after the shattering of language, and it is situated in a void, which requires a new mode of "speaking" such as the one Bernini attempts. That mode of speaking is a formal espousing, a tracing, and it is performative: it is a form of acting, both theatrically and socially. Thus the subject is, or attempts to be, "larger than"—not "prior to"—discourse. The performative speech act has an illocutionary force—according to de Vries, a promise without the social conditions on which promises can be effective speech acts. This is why it is also, by definition, a failed or failing speech act. One is tempted to add that the necessary failure of the speech act is a function of the aporia of subjectivity that results from the mystic attitude. The subject is "larger" than discourse, but far from transcending it, she cannot be prior to it and therefore can only "do" mystical experience by way of abandonment. This is an unavoidable abandonment of subjectivity—necessary for the transfiguration—through the abandonment of discourse. Bernini's work, then, is the indispensable prosthesis through which Teresa's ecstasy can come to be, pre-posterously, as an aftereffect.[19]

This is clearly not simply a translation of words into images. The text itself is already an attempt at translating: the writer sought to render a bodily experience in language. Moreover, the experience itself was a translation—a transfer—of divine love into the ecstasy of this human being, as well as of the spiritual into the corporeal. This transforming translation as such is not at all new in Western culture.

Ovid's *Metamorphoses,* a much-used model for the arts in early modernity and invoked by de Certeau, is one of Bernini's "sources," if not here, at least, explicitly, in an earlier work. The very concept of transformation implies a program of study of the possibilities of inter- and multimedia translation. Take his famous *Daphne and Apollo* in the Galleria Borghese: clearly, the job was difficult. At first, it looks like a great success of triple translation: within the myth, from myth to plastic form, from sculpted human flesh to vegetation. The young woman's hair flowing in the wind because of the speed of her flight is transformed into rather rigid branches at the moment her flight is stopped by the man who is pursuing her. The narrative movement rigidifies into an image that will stay forever, never aging.

But it is at the threshold, namely, the surface, that Bernini is confronted with untranslatability. In this early work, he is stopped in his tracks; in the later *Teresa,* he challenges that limit by means of "royal folds." At the site where Daphne's soft skin begins to change—translated from one materiality into another—the laurel's bark is both fine and coarse, differentiating and detaching itself from the soft skin at the very moment when the transformation ought to produce a perfect blend. One can speculate on the meaning of the precise site on the female body where this untranslatability manifests itself, which, at least in the common, albeit extremely infantile, conception of femininity, is her genitals.[20]

But Daphne's transformation was not her own. It was in fact a violation and destruction of her agency. In contrast, Teresa willed, according to the *volo* of the mystical postulate, her transformation. Bernini's task therefore became much more challenging. In *Teresa,* the transformation is much more radical, more successful, as metaphoring, to the extent that material layers can no longer be distinguished. There is a narrative reason for that difference. In contrast to Daphne's transformation, this one is willed—the mystical *volo*—by the subject who is at the same time subjected to it, even if she lacks the subjectivity to carry out her will. But through the retrospective "criticism" embodied in Bourgeois's

work, the difference also acquires art historical and philosophical meaning. Elsewhere, I have argued for this retroversive historical relationship as pre-posterous (1999); in other words, "post-" precedes "pre-."

In a Benjaminian allegorical manner, the difference is articulated at the precise site where folds and flames coincide. Bernini has created a sculpture that captures a moment between thing and event. As a result of her extreme pious passion, Teresa the mystic, on her own account and in line with clichéd metaphors of passionate love, is both beyond herself and burning. Her state is called ecstasy. That word expresses extreme intensity, but also, etymologically at least, decentering. This last aspect tends to be ignored. But Bernini didn't ignore it, and Bourgeois reminds us of it. She does so by placing more figurative emphasis on the ambiguity of inside and outside, which is just as important in Bernini's sculpture but can more easily be overlooked there because the arrow as well as the doxic interpretations of ecstasy get in the way of the work's aesthetic. Bourgeois's critical work is important, for the eccentricity of ecstasy is, in turn, a defining feature of baroque aesthetics and thought.

The site of *Teresa*'s baroqueness is, not surprisingly, the folds. Ecstasy knows no center: neither on the picture plane, nor in the fiction, in the guise of linear perspective's vanishing point. The transformation of Teresa, set on fire by the divine love that pierces her heart, emanates from the interior toward the outside, where her body's envelope, the lusciously folded drapery that iconographically marks the sculpture as baroque, equally transforms into flames. Her whole body becomes a flame: each part of it, of its cover, its surface beneath which nothing else remains, becomes a flame; fire comes to overrule previous shapes. More than ever, the folds exemplify their function of baroque device par excellence, suspending the distinction between interior and exterior as they take the shape of flames.[21] From the point of view of iconography, this is undeniable. But there is more to this metaphoring. The saint's body, although in paradoxical willing abandon, figures a will-less body, neither standing nor lying. In the shape of the letter *S*, it unwillingly "imitates" the shape of the flames sketched by the folds of her habit.

To measure the importance of this feature—of the wavering, not only between thing and event but also between inside and outside—it is useful to consider, by contrast, another commentary of our time. In his *Seminar 20*, in a desire to translate "badly" and in contrast to what Bernini appears to be doing, Jacques Lacan reverses this totalization of the

interior's exteriorization, thus canceling the decentering of ecstasy. When the psychoanalyst-philosopher sees in it the desire to be penetrated, he relegates the mystic's heart to its false function of center in favor of a phallic interpretation that the sculpture had so superbly avoided. He demonstrates the blindness that comes with obsession when he claims that Teresa's *jouissance* is a matter of her desire to be penetrated again and again *(encore)* by God, the transcendental phallus.[22]

As well as finding this a rather implausible way of eliminating the narrative dimension of the sculpture—by turning its event into a reiteration—I submit that this is indeed a translation of Benjamin's "bad" kind, an "inaccurate transmission of an unessential content" (70).[23] In contrast, and through narrativity, visual representation stipulates that she has already been penetrated, by the flaming arrow. Here/now what matters is that the fire spreads throughout her entire body, *including its surface.* The ecstasy is a literalized ec-stasis, according to a conception of metaphor that is neither monist nor dualist but rather pluralist, a conception of metaphor as activity and as dissipation. The surface, the skin, participates in the fire, and in the process loses its status as limit (of the body). Hence the participation of the clothing. The transformation— here, transfiguration—is total.

It is the figure of the flame that translates baroque language, including its modality. There fire "metaphors" passion. You just have to read Racine's *Phèdre* to realize to what extent this metaphor emerges from its own death when it is literalized and made active again after having been abused into meaninglessness in an overextended baroque poetry. As I mentioned earlier, for John Austin (the initiator of the analytical philosophy of speech acts), fire, the flame, is precisely the paradigmatic example of speech act as performative: hovering between thing and event.[24] Indeed, in Bernini's work, the momentary arrest, the resolution, or the hesitation between narrative movement and arrested visuality could not be more adequately metaphored than by these generalized, incorporated flames. How does one translate a flame? Given the metonymic logic of narrativity, any attempt to do so consumes it. As soon as one attempts to trace its shape, one falls back onto cold marble, and the flame disappears.

Is it a coincidence, then, that the flame is also the image Benjamin used to characterize the work of the critic as distinct from that of the philologist? In a beautiful passage quoted by Hannah Arendt in her in-

troduction to *Illuminations*, set in a characteristically melancholic tone, Benjamin supplements Austin's emphasis on the occurrence in time of the performance of speech acts by insisting on the present ("being alive") of the critic's activity. The image of the flame represents both the importance and the presentness of that work: "While the former [the commentator] is left with wood and ashes as the sole objects of his analysis, the latter [the critic] is concerned only with the enigma of the flame itself: the enigma of being alive. Thus the critic inquires about the truth whose living flame goes on burning over the heavy logs of the past and the light ashes of life gone by" (5).

This ongoing and, in Benjamin's language, lifesaving relevance ("goes on") of critical work demonstrates what preposterous history can be. But thus criticism is synonymous with translation. It is one form translation can take. Especially when juxtaposed to the passage quoted earlier from the "Theses" ("every image of the past that is not recognized by the present as one of its own concerns threatens to disappear irretrievably"), criticism is here embodied by the modern artwork "reworking" Bernini's prosthetic supplementation of Teresa's failing subjectivity. This is Bourgeois's critical intervention against Lacan's subordination of the sculpture to a doxic and, perhaps not coincidentally, phallogocentric commonplace.

But if mysticism, for most of us, can safely be relegated to the baroque age, the ecstasy that is its paroxysm cannot. The question here is how it can regain meaning from its confrontation with our time. Transfiguration, including its collusion with death, is not unrelated to what Georges Bataille called *alteration*.[25] According to Krauss's account of it (1999, 8), this concept simultaneously grasps two totally different logics that can help to further clarify the paradox of Benjamin's philosophy of translation. The first logic is that of decomposition, the blurring of boundaries through matter's tendency to dissipate. The second is what we would today call "othering," the logic of radical distinction. The two meet where death decomposes the body and transforms the former subject into a soul, ghost, or spirit. The two meet, that is, in the transfiguration, which both "melts" the body and elevates it to something else—here, sanctity. This is why flames can so aptly replace decomposition. But flames themselves are in movement. The resolution of the hesitation between narrative movement and still visuality could therefore not be better shaped than in this all-consuming fire.

Unlike Daphne's metamorphosis, Teresa's transformation into a voluptuous fire consumed her entirely. Daphne was still subject to a division between inner body and outer layer, so that her transformation confined her to the fragmentation to which a subject remains condemned when exteriority and interiority are divided. Teresa, by contrast, escapes fragmentation, division, but at the cost of her total absorption into the otherness of her desire. She relinquished subjectivity.

The integration of Teresa's inside and outside fires can also be seen as programmatic of a sculpture that integrates within the architecture that houses it. The sculpture is integrated within a chapel in which the viewer must stand to see it. This integration is precisely part of the challenge posed by Bernini's representation of a holy woman in the unified composition of a chapel. He pushes the inquiry into narrative sculpture as far as he possibly can within a discussion of the unification of sculpture and architecture.

Virtuality

Bourgeois intervenes on this dual level. The integration of interior fire with exterior flames that were meant to affect the faithful viewers turns the play with fire into a metaphorization of the second degree. Bourgeois responds to Bernini at the point where the latter's sculpture is integrated within the architecture the woman inhabits. More radically than Bernini, Bourgeois insists that woman and habitat are neither one nor separable. The metaphoric act—the multiple translation that supplements the untranslatability of the "original"—happens at the threshold of these two orders of scale. The chapel invites the viewer into its interior. It is from this interior position that the latter is invited to *see* from the outside, but, metaphorically, to enter inside, the experience that consumes also limits. The chapel thus creates a *fiction of presence*. This is how it activates what is today called virtuality (Morse 1998).

Bourgeois's 1983 *Femme Maison* quotes Bernini insistently, in ways that the earlier works in this "genre" did not. This citational practice is not limited to a simple recycling of the figure of the fold. *Femme Maison* also quotes the attempt to integrate scale and space, the entanglement of body and its dissipation, the *volo* of the subject doing the abandoning. But as a form of translation and criticism, quotation—Benjamin's ideal of writing—is a response. In a project of integration pushed even farther, Bourgeois translates the one level of integration, of body, skin,

and dress, into the other, of sculpture and architecture. Where Bernini pursued a double integration, Bourgeois translates Bernini's project to release from it what matters most: not meaning, not information, not a unification of diverse media and dimensions, but the tensions, thresholds, and modes of signification that both separate and integrate them. For Benjamin, this would be the "purity" of language, *reine Sprache*. In the post-purity age that is our present, I propose to preposterously give Benjamin credit for having at least implied that this purity could be an originless, endless multiplicity.[26] Instead of "badly" translating this notion of the *reine Sprache* to be released by translation, I propose to translate it as "language as such."

Let me be more explicit. On the condition that we interpret "language" as semiosis and "pure" as unconfined to a particular medium, Benjamin's formulation of the translator's task can help us to understand the full impact of this response and the pre-posterous history it facilitates. For such a formulation articulates how Bourgeois "explains," supplements, and further pursues Bernini's work, by transforming, seeking to "release in [her] own language that language [as such] which is under the spell of another, to liberate the language imprisoned in a work in [her] re-creation of that work."

To achieve this, Bourgeois speaks the language of the baroque fold and all it implies for us since Deleuze's work on Leibniz. She "metaphors" that language by literalizing it. According to Deleuze's Leibniz, the fold represents infinitude by engaging the viewer's eye in a movement that has no vanishing point. As I mentioned previously, the fold theorizes and embodies relationship without center. In an important but enigmatic sentence, Deleuze describes the baroque response to the truth claim of Renaissance perspective:

> Leibniz's idea about point of view as the secret of things, as focus, cryptography, or even as the determination of the indeterminate by means of ambiguous signs: *what* I am telling to you, *what* you are also thinking about, do you agree to tell *him* about *it*, provided that we know what to expect of *it*, about *her*, and that we also agree about who *he* is and who *she* is? As in a Baroque anamorphosis, only point of view provides us with answers and cases. (22)

Baroque point of view establishes a relationship between subject and object and then goes back to the subject again, a subject that is changed by that movement and goes back in its new guise to the object, only to

return to its ever-changing "self." Scale is one important element in this transformation.

Subjectivity and the object become codependent, folded into each other, and this puts the subject at risk. The object whose surface is grazed by the subject of point of view may require a visual engagement that can only be called microscopic and in relation to which the subject loses his or her mastery over it. The mystic subject about to abandon her subjectivity is easier to understand in such a thought-fold. This co-dependency is the baroque alternative for a historical attitude derived from the romantic response to classicism, which is based on a mastery and reconstruction of the historical object combined with reflection on how the subject grasps it. A baroque historical view of the baroque, on the other hand, abandons the firm distinction between subject and object.[27]

It is within this double context of the subject-object relation in art as well as history that I would like to place Bourgeois's work on Bernini's folds, as the principal work of Bernini on Teresa's mystical aporia. In *Femme Maison* (1983), the fold envelops the eye and the architecture in a single movement. Unlike Bernini's folds, Bourgeois's refuse any regularity. On one side, toward the bottom, the folds own up to their deception, transforming the infinitude of the surface when the base of the sculpture turns out to be simple matter. Elsewhere the folds come forward, detaching themselves from the interior mass, betraying their banal secret of Teresa's transfiguration through reference to Daphne's detached bark.

Here and there the folds form knots, citing that other baroque figure (Allen 1983). By the same token, they transform the infinitude of the texture into inextricable confusion, and liberation into imprisonment. The cone-shaped, sagging body refuses to be elevated in the flames of transcendence. Firmly fixed on its disk-shaped base, the body remains heavy and does not believe in miracles. But still, its sagging pose is as abandoning as Teresa's S-shape.

Bourgeois is not deeply devout. Nor would her historical position encourage her to be so in the way Bernini's did him. In a post-Catholic culture, she is therefore able to point out that Bernini's devotion does not exclude the sensuality the nineteenth century has taught us to unlearn. The translation of one form into another and the simultaneous translation of the senses are all the more powerful, multiple, and active

because this house-woman is not transcendental. On top of the body, like a secular chapel, stands a skyscraper, the angular emblem of twentieth-century architecture. The gigantic body of folds and the folds of flesh simultaneously render the mutual dependency and threat that this inextricable integration signifies. The sculpture absorbs architecture in a disillusioned but also joyful, if not ecstatic, endorsement of the materiality of the body, the house, and sculpture.

Sculpture, the site of translation, functions as Benjamin's "pure language" or language as such, which it is the translator's task to release. The house confines women but also offers them the mastery that imprisons and protects the body it weighs down so heavily. But to prevent us from kneeling down before tragedy in a transcendental escapism, the folds, knotted around the neck of the building, are also, literally, just that: folds. Fabulations or fabulous fictions of presence that flaunt their fictionality.

Between figuration and conceptualism—yet another route for her metaphoring activity—Bourgeois winks at us when, from a specific viewpoint, the surface full of secrets is no more than a dress, a habit unlike Teresa's habit-turned-flames. Fabric that lovingly envelops, warms, the house with its royal folds. Care, humor, comradeship, and the maternal excess that suffocates surround the architecture. The level at which this work absorbs and releases Bernini's search is this: the level of the most paradoxical integration, the fullest one—of the arts into the one art-as-such, pure, ideal, nonexistent—that Benjamin induces the translator to pursue.

Here translation can no longer be traced as a one-directional passage from source to destination. It mediates in both directions, between architecture and sculpture, building and body, body and spirit, body and clothing, clothing and habitat . . .

Ecstatic Aesthetic

So where does this leave the relationship between philosophy and art history? The history part of the relationship, as I have argued many times, can only be pre-posterous. Bourgeois translates Bernini by transforming his work, so that after her, in the present that is ours, the baroque sculpture can no longer ever be what it was before her intervention. The art part is best conceived as—translated into—translation according to Benjamin. But on one condition. The philosophy part must heed

Richard Rorty's injunction to rigorously turn away from the representational obsession to be a mirror of nature (1979). It is that obsession that underlies the idea of history as reconstruction, just as it underlies the logocentric conception of translation, and of art. Such an obsession can only remain locked up in either illusionary projection or tautological conflation.

An example is provided by Michael Baxandall's superb tautology: "The specific interest of the visual arts is visual" (1991, 67). This line demonstrates what his paper argues: that the language of artspeak can only be indirect, a crudely inadequate approximation. The critic characterizes the art historian's discourse as ostensive, oblique, and linear. This is as good as any formulation of the kind of translation that Benjamin sought to ban. Since the advent of poststructuralist critique, we know that the language that constitutes the matter of all texts cannot be described according to the Saussurian axiom that suggested a one signifier–one signified equation. Language may unfold in linear fashion, but that unfolding in no way accounts for the multiple significations construed along the way, sometimes falling into dust before the end of the sentence. Meaning cannot be atomized, nor is it simply accumulative. Hence putting one word after another may have the semblance of linearity, but producing meaning does not.

To bring Baxandall's analysis of art discourse to bear on my own analysis of the triple relationship between Benjamin, Bourgeois, and Bernini, I will happily admit that I have not succeeded in adequately evoking the visual nature of the objects under discussion. Nor did I try. But nor did I succeed in writing ostentatiously, as Baxandall claims art history must. The photographs that "illustrate" this argument—it is unnecessary to insist on the inadequacy of the notion of illustration!—do not provide enough visuality to enable my readers to see what I saw when, some months back, I took notes for my description, my translation. My language was indirect, as is the nature of language. It was also linear, but at the same time it circled around, avoiding an imaginary center. Perhaps surprisingly, perhaps not, Bourgeois's work itself presents the inadequacy, not only of descriptive language but of the very idea of a "literal" translation between images and words. It does this not so much because language is linear but rather because, in the "purity" released by the translation, its dissipation, visuality "as such" is temporal. The time it takes to see Bourgeois's sculpture, and to see Bernini's

through it, prevents any unification of the objects. It cannot be unified in either one of the specific "languages"—the Catholic baroque or the postmodern baroque—for being construed in the mind of the person (here, me) who would subsequently wish to describe it. If words fail images, then it is not because images are beyond meaning (Elkins 1999) but because meaning is always already dissipated by the translation that attempts to grasp it; because, that is, meaning is itself ec-centric.

Teresa's flaming soul moves outward, not inward. Bourgeois's body that envelops the house, that secular chapel, insists on it, against Lacan. We know since Freud that man—neither man nor woman—is not master in his own house, no more than the *maîtresse de maison*, with a hundred heads or none, is. The theoretical metaphoring that this work performs is to show—perform, not state—that the image is not master in its own house either: its meanings cannot be confined; they ceaselessly escape attempts to grasp them. Even in his own textbook of translation, *The Interpretation of Dreams*, Freud explicitly cautions his readers against "reading off the page," in other words, against translating symbols and figures. Even if he too sometimes falls for the allure of content. But this happened only later, after he had been pressured to adapt his work a bit more to the intellectual styles of the day. Up to the first edition of 1900, *The Interpretation of Dreams* contained no reading code, no reductive, summarizing hermeneutic, as Laplanche rightly remarked. The commentary on Irma's dream, so centrally important for the theory as a whole, is what he calls a de-translation (1996, 7).

But don't misunderstand this reference to an antihermeneutic as a plea for refusing to interpret, a yielding to a vague metaphysical belief in the uniqueness of art. Semantic indetermination is not the same as infinitude. Even endlessness is not the same. Even though each interpretive step takes place at a crossroads and therefore must leave behind other possibilities, each such step is nevertheless concretely derived from a material aspect or element of the image. My reference to Freud's caution concerns something altogether different.

British psychoanalyst Christopher Bollas speaks of the *unthought known* (1987). This concept seems suitable enough to deploy simultaneously, in the face of works such as *Teresa* and *Femme Maison*, interpretation and the refusal of a form of interpretation that is like "bad" translation: a precise equation that admits to no more than the stingy exchange of one signifier for another. The concept of the "unthought

known" refers to what the senses sense, of which one has a sense, but which rational thought can only encircle, not translate into a singular meaning. Such translation would be its death, for the work would cease to operate on the multiplicity of levels—rational and affective, theoretical and visual—required for it to continue to be recognized by the present "as one of its own concerns" lest it "threaten to disappear irretrievably."

The house-chapel offers the kind of metaphoring that preserves the unthought known between rational interpretation and strong, sitable, sightable, and citable affectivity, with content but without fixed content; a house where, indeed, the ego is not master. In the end, after the preceding remarks on translation, I submit that Freud's enigmatic penultimate sentence of the third of his *New Introductory Lectures,* "Wo Es war soll Ich werden," is best left untranslated (Freud [1933] 1965, 80). Even Lacan, who was notoriously hostile to reductive translation and could not resist trying, came up with a number of "good" alternatives to the "bad" French translation, which reduces it to a one-sided moral imperative: "le Moi doit déloger le Ça."[28] Lacan tried his hand and failed; his translations, one by one, were "bad." Laplanche's insistence that psychoanalysis, qua ana-lysis or unbinding, opposes translation is in line with Benjamin's view of the latter. Neither of them—but perhaps Bourgeois does imply it—mentions that there is a philosophical reason for this lack of mastery.

Beyond the philosophy of language, this reason reaches into the realm of ethics, for a question remains if Bourgeois's *Femme Maison* is to be brought to bear meaningfully on Bernini's *Teresa:* what does it mean that the central meaning of Teresa's mystical experience has been set aside by the later artist? In other words, that ec-stasy has been made ecstatic. My phrasing announces the answer, but let me spell it out anyway. Translation has a philosophical force to it, even more so since it is an event suitable for a particular occasion. In his essay on the problem of translation in philosophy, philosopher Lawrence Venuti (1996, 30) insists, like Benjamin, that "faithful" translation, in the smooth sense of catering to the target audience, is "bad." It is an appropriation that obscures the "remainder," the Benjaminian "untranslatable."[29] A translation, for Venuti, "should not be seen as good, unless it signifies the linguistic and cultural difference of that text for domestic constituencies." A translation must not be invisible. He argues that the ethical value of this difference resides in alerting the reader to a process of domestication

that has taken place in the translating, on its behalf but also at the source text's expense. Hence the ethics of translation consist in preventing that process from "slipping into a wholesale assimilation to dominant domestic values." This is how his overt subject matter—specifically, philosophical translation—shifts. He continues: "The best philosophical translating is itself philosophical, in forming a concept of the foreign text based on an assessment of the domestic scene. But the concept ought to be defamiliarizing, not based on a ratification of that scene" (1996, 30).[30] This view would not wish Teresa's ecstasy—the key element in the source text—to become invisible in the new work. But the point that no such ecstasy would be acceptable—aesthetically as well as socially, or perhaps even ethically—in the target world, for today, that is, must also remain visible. Nor should it become so idiosyncratic that an unwarranted "othering" of a religiosity from the past would result. The "conceptually dense text"—Venuti's term for philosophical texts under translation—must be made intelligible yet must remain, in its foreignness, both informative and provocative. Clearly, Benjamin would agree with this injunction to both dissipate and release the text's otherness but not to remain an outsider to the target culture. The latter must be able to estrange itself from its own assumptions, so that the automatic othering of what comes at it from its outside can be replaced by a negotiation.

Instead of either erasing or othering ec-stasy, Bourgeois's sculpture updates it. The desire of the subject in abandonment of subjectivity to experience decentering may have been sacrificed in the negotiation. But instead of the ongoing quest to understand ecstasy in terms of the mystical postulate around *volo* (I desire), the decentering that results, which Bernini has so lovingly supplemented with his own narratorial subjectivity, is very much present in the modern work. Teresa's first-person text, after thematizing her loss of self, needed a prosthetic "third person" to be visually told. In this version, her dissipation may appear less desirable. But then, who said mystic ecstasy, desired as it may have been by its historical practitioners, is in itself desirable? Perhaps giving up the self, as housewives did under the influence of romantic love and surrealists did under the influence of psychoanalysis, drugs, and philosophy, provides a great experience of ec-stasy. The loss of self, as has been argued in different contexts, has great benefits.[31]

At the end of the day—and at the end of this inquiry—the point of the aesthetic issue is aesthetic again. But the aesthetic is not most char-

acteristically embodied by a lone man in black by the sea.[32] Rather, we have here a woman abandoning her subjectivity and discourse, for better or for worse, but *housing* whoever wishes to be "touched," not in the hastily translated mode that Lacan fantasized but in the untranslatable, multiple senses this word harbors, for whose remainder we can read the sculptures. Unlike Kant's—or Friedrich's—monk, this subject refrains from overcoming the awe. The aesthetic thrill is not one of a barely sustained threat to one's subjectivity. The subject, if it survives the flames, remains ec-static. From that sideways position, sited on the edge, perhaps more is in store. Perhaps not. Bourgeois doesn't say. Bernini can't know. Teresa can't tell. We'll see.

Notes

1. Benjamin 1977; Buci-Glucksmann 1994.

2. Benjamin's 1968 essay "The Task of the Translator," central to my argument as my primary "philosophical object," will henceforth be referred to by page numbers only.

3. On Benjamin's philosophy of language, see de Certeau 1982, 1986; and Derrida 1982, 1987. These texts were discussed by de Vries (1992) in terms more focused on (Jewish) mysticism and the "mystical postulate" than those I will use here, although, as I will hint later, mysticism is not to be neglected as the bottom line of Benjamin's vision of translation. Moreover, Bernini's *Saint Teresa* foregrounds the link between mysticism and translation on an additional allegorical level.

4. In the essay on Goethe's *Elective Affinities*, quoted by Hannah Arendt (Benjamin 1968, 5).

5. But that liberation is harder than we thought. See de Vries 1999 for the tenacious presence of religion in the kind of philosophy today that, in Deleuze's terms, would most definitely be qualified as "baroque." Needless to say, in spite of his caution in endorsing Benjamin's thoughts on language, Derrida is also a baroque thinker.

6. As my friend Hent de Vries pointed out, the status of this essay by Benjamin as "philosophical" is subject to debate. However, disciplinary "purity" is the last thing I am worried about here. Given, on the one hand, Benjamin's status as a hot item within philosophy, and, on the other, the philosophical issues his views on language broach, I feel justified in using this text here. I use it as a sample, if not of philosophy *stricto sensu*, then at least of the kind of thought dear to philosophers, which, I contend, is embodied in visual art when it is attended to as "meaningful" without being a "conveyer" of meaning; without being "translatable." "Philosophy," then, takes place *between* the two essays by Benjamin and the two sculptures of baroque aesthetic.

7. Mitchell and Rose 1982.

8. See the introduction to *Quoting Caravaggio: Contemporary Art, Preposterous History* (Bal 1999). The reverse might also be true, although that may be a profoundly a-philosophical response to philosophy. If I may for a moment challenge

these disciplining conventions, I would suggest that Derrida's postmodern—and post-Holocaust—response to Benjamin suffers from a lack of historicizing within philosophy, in spite of its insistence on dating (Derrida 1982, 71; 1990, 1040).

9. The uneasiness in art history about the need for language to "do" the discipline is a long-standing commonplace. It keeps recurring and was recently most emphatically reiterated by Elkins (1999). More words to say that words fail. This outdated romanticism today serves to keep "others" out of a field whose boundaries the words are busy policing. My uneasiness concerns not the use of words to talk about images but the extent to which those words point to images, point out their specifics, or fail to do so. The standard art historical discourse, which uses images as illustrations of its own arguments that concern the images, emphatically, only tangentially, is the one I mean with this verb "to disappear." In line with Maaike Bleeker's comment on the Cartesian split between mind and body in terms of discursive performances, following Drew (1990), the relationship between artworks and art historical discourse could be characterized as dys-appearing, provided the word is taken as the active progressive verb form (Bleeker 1999).

10. Benjamin's commentary on Genesis suggests as much. See his essay "Ueber Sprache ueberhaupt und ueber die Sprache des Menschen" (in Benjamin 1980). In his time and context, the endgame could not help but lead to "God." Today I would suggest multimedia and transnational practice as a good alternative. For the implications of the activity of translating within the latter, see Spivak 1999.

11. De Certeau (1982, 238) equates translation with metamorphosis. This is certainly justified in his context (mysticism). Strictly speaking, however, this choice is predicated on a formalist bias (*morph* means form), as well as on an unwarranted emphasis on the outcome, not the process.

12. Transference is at the heart of Shoshana Felman's psychoanalytic theory of literature or, more precisely, of reading-literature (1987). There, the site of transference is, indeed, "beyond" the text rather than "through" it.

13. I have written extensively on this problematic elsewhere, an argument I am reluctant to rehearse (Bal 1991, 1997).

14. To emphasize metaphor's active nature, but avoid confusion with the slippery activity implied in the more usual verb "to metaphorize," I will use, neologistically, the verb *to metaphor*.

15. In his masterful study of Bernini's multimedia chapels, without which the present essay could not have been written, Giovanni Careri wryly responds to that prudish distortion by reminding us that "in the seventeenth century the boundaries between the spirit and the senses were not drawn according to the Victorian criteria that we have inherited from the nineteenth century" (1995, 59).

16. The fact that ecstasy is the trade of the mystic, and that mysticism, in turn, is the main focus of de Vries's article on Benjamin's philosophy of language, albeit only indirectly important in that philosophy, makes the case I am building here even more tight (1992, 443).

17. Lavin (1980) interprets all levels of signification as different ways of conveying the same meaning. In the same vein, Perlove (1990) translates that meaning into theological "originals."

18. On Ernst and surrealists' attitudes toward gender, see Krauss 1993, 1999.

19. For the text in which Teresa attempted to render her mystical experience, see Bilinkoff 1989.

20. Needless to say, Freud's narratives of little boys seeing "in a flash" the absence of the mother's penis—seeing, that is, the unseeable, absent, synecdoche of his self—set the tone for an ongoing identification of male and female identity with the genitals, a naive mythical theory. See Bal 1994. Laplanche says of such theories that they are "a code... founded on anatomy and function[ing] as a binary myth, plus/minus," which becomes a semantic theory with universalist claims (1996, 9).

21. Lavin (1980, 122) translates. For him, the flamelike pattern of the folds is a "visual counterpart of her own metaphor" so that the folds/flames seem "not only to cover but to consume" her body.

22. See, for the relevant fragments, Mitchell and Rose 1982, 137–61; the French original is *Le Séminaire de Jacques Lacan, Livre XX, Encore* (Paris: Editions du Seuil, 1975).

23. Given Benjamin's opposition to a simplistic semiotic conception of language, any transmission would have to be inaccurate, any content inessential.

24. Speech act theory, with its insistence on the meaning-producing effect of utterance, remains a compelling framework within which to rethink contemporary art. Austin's theory ([1962] 1975) has been subject to—failed—attempts to "normalize" it, as Shoshana Felman (1983) argues. For Felman, incidentally, seduction is the paradigmatic speech act.

25. Rosalind Krauss uses Bataille's term to elaborate a concept for the analysis of surrealism beyond the formalist argument that considered surrealism not formally innovative. See Krauss 1999, 7–8.

26. Here I would venture to take issue with Derrida as de Vries renders his thought (1992, 463).

27. Part of this paragraph is taken from my book on this subject (Bal 1999). On the similarity and difference between baroque and romanticism in this respect, see the suggestive remarks by Octavio Paz (1988, 53–54).

28. For an excellent critical commentary, including Lacan's alternative translations, see Bowie 1987, 122–23.

29. Venuti speaks of "domestic" where I prefer the term "target" for the audience of the translation. The term "remainder," which refers to all that gets lost in translation, is taken by Venuti from Lecercle (1990).

30. For more elaboration of this point, see also Venuti 1994, 1995.

31. Precisely in terms of overcoming cultural prejudice. See Bersani 1989 and van Alphen 1992.

32. As the Kantian example of the sublime, of David Kaspar Friedrich's painting, Spivak (1999, chap. 1) offers an unsettling account of the restrictions pertaining to Kantian sublimity. Reasoning from art to morality, she thus gives a welcome counterpart to the more usual argument (Crowther 1989).

References

Allen, Suzanne. 1983. "Petit traité du noeud." In *Figures du baroque*, ed. Jean-Marie Benoist. Paris: PUF.

Alphen, Ernst van. 1992. *Francis Bacon and the Loss of Self.* Cambridge: Harvard University Press.

Austin, J. L. [1962] 1975. *How to Do Things with Words.* Cambridge: Harvard University Press.

Bal, Mieke. 1991. *Reading "Rembrandt": Beyond the Word-Image Opposition*. New York: Cambridge University Press.

———. 1994. "Telling Objects: A Narrative Perspective on Collecting." In *The Cultures of Collecting*, ed. John Elsner and Roger Cardinal, 97–115. London: Reaktion Books.

———. 1997. *The Mottled Screen: Reading Proust Visually*. Trans. Anna-Louise Milne. Stanford: Stanford University Press.

———. 1999. *Quoting Caravaggio: Contemporary Art, Preposterous History*. Chicago: University of Chicago Press.

Baxandall, Michael. 1991. "The Language of Art Criticism." In *The Language of Art History*, Cambridge Studies in Philosophy and the Arts, ed. Salim Kemal and Ivan Gaskell, 67–75. Cambridge: Cambridge University Press.

Benjamin, Walter. 1968. *Illuminations*. Edited and with an introduction by Hannah Arendt. Trans. Harry Zohn. New York: Schocken.

———. 1977. *The Origin of German Tragic Drama*. Trans. John Osborne. London: New Left Books.

———. 1980. *Gesammelte Schriften: Werkausgabe*. Vol. 2. Frankfurt am Main: Suhrkamp.

Bersani, Leo. 1989. "Is the Rectum a Grave?" *October* 43 (winter): 197–223.

Bilinkoff, Jodi. 1989. *The Avila of Saint Teresa: Religious Reform in a Sixteenth-Century City*. Ithaca: Cornell University Press.

Bleeker, Maaike. 1999. "Death, Digitalization, and Dys-appearance: Staging the Body of Science." *Performance Research* 4 (2): 1–8.

Bollas, Christopher. 1987. *The Shadow of the Object: Psychoanalysis and the Unthought Known*. New York: Columbia University Press.

Bowie, Malcolm. 1987. *Freud, Proust, and Lacan: Theory as Fiction*. Cambridge: Cambridge University Press.

Buci-Glucksmann, Christine. 1994. *Baroque Reason: The Aesthetics of Modernity*. Trans. Patrick Camiller, with an introduction by Bryan S. Turner. Thousand Oaks, Calif.: Sage Publications.

Butler, Judith. 1997. *Excitable Speech: A Politics of the Performative*. New York: Routledge.

Careri, Giovanni. 1995. *Bernini: Flights of Love, the Art of Devotion*. Trans. Linda Lappin. Chicago: University of Chicago Press.

Crowther, Paul. 1989. *The Kantian Sublime: From Morality to Art*. Oxford: Clarendon Press.

Culler, Jonathan. 1988. *Framing the Sign: Criticism and Its Institutions*. Norman: University of Oklahoma Press.

de Certeau, Michel. 1982. *La fable mystique, I, XVIe–XVII siècle*. Paris: Gallimard.

———. 1986. *Heterologies: Discourse on the Other*. Trans. Brian Massumi. Minneapolis: University of Minnesota Press.

Deleuze, Gilles. 1993. *The Fold: Leibniz and the Baroque*. Translated and with a foreword by Tom Conley. Minneapolis: University of Minnesota Press.

Derrida, Jacques. 1982. *D'un ton apocalyptique adopté naguère en philosophie*. Paris: Galilée.

———. 1985. *The Ear of the Other: Otobiography, Transference, Translation*. Ed. C. McDonald. Lincoln: University of Nebraska Press.

———. 1987. *Psyché: Inventions de l'autre*. Paris: Galilée.

———. 1990. "Force of Law: The 'Mystical Foundation of Authority.'" *Cardozo Law Review* 11 (919): 921–1045.

Drew, Leder. 1990. *The Absent Body*. Chicago: University of Chicago Press.

Elkins, James. 1999. *On Pictures and the Words That Fail Them*. New York: Cambridge University Press.

Felman, Shoshana. 1983. *The Literary Speech Act: Don Juan with J. L. Austin, or Seduction in Two Languages*. Ithaca: Cornell University Press.

———. 1987. *Jacques Lacan and the Adventure of Insight: Psychoanalysis in Contemporary Culture*. Cambridge: Harvard University Press.

Freud, Sigmund. 1900. *The Interpretation of Dreams*. In vol. 5 of *Standard Edition of the Complete Works of Sigmund Freud*, ed. James Strachey, 533–621. London: Hogarth Press.

———. [1933] 1965. *New Introductory Lectures on Psychoanalysis*. Ed. and trans. James Strachey. New York: Norton.

Krauss, Rosalind. 1993. *The Optical Unconscious*. Cambridge: MIT Press.

———. 1999. *Bachelors*. Cambridge: MIT Press.

Lacan, Jacques. 1975. *Le Séminaire, Livre XX, Encore*. Paris: Editions du Seuil.

Laplanche, Jean. 1996. "Psychoanalysis as Anti-Hermeneutics." Trans. Luke Thurston. *Radical Philosophy* 79 (September–October): 7–12.

Lavin, Irving. 1980. *Bernini and the Unity of the Visual Arts*. New York: Pierpont Morgan Library/Oxford University Press.

Lecercle, Jean-Jacques. 1990. *The Violence of Language*. London: Routledge.

Mitchell, Juliet, and Jacqueline Rose, eds. 1982. *Feminine Sexuality: Jacques Lacan and the École Freudienne*. Trans. Jacqueline Rose. London: Macmillan.

Morse, Margaret. 1998. *Virtualities: Television, Media Art, and Cyberculture*. Bloomington: Indiana University Press.

Niranjana, Tejaswini. 1992. *Siting Translating: History, Post-structuralism, and the Colonial Context*. Berkeley: University of California Press.

Paz, Octavio. 1988. *Sor Juana, or The Traps of Faith*. Trans. Margaret Sayers Peden. Cambridge: Harvard University Press.

Perlove, Shelley Karen. 1990. *Bernini and the Idealization of Death: The Blessed Ludovica Albertoni and the Altieri Chapel*. University Park: Pennsylvania State University Press.

Rorty, Richard. 1979. *Philosophy and the Mirror of Nature*. Princeton: Princeton University Press.

Spivak, Gayatri Chakravorti. 1999. *A Critique of Postcolonial Reason: Toward a History of the Vanishing Present*. Cambridge: Harvard University Press.

Venuti, Lawrence. 1994. "Translation and the Formation of Cultural Identities." *Current Issues in Language and Society* 1: 214–15.

———. 1995. *The Translator's Invisibility: A History of Translation*. London: Routledge.

———. 1996. "Translation, Philosophy, Materialism." *Radical Philosophy* 79: 24–34.

Vries, Hent de. 1992. "Anti-Babel: The 'Mystical Postulate' in Benjamin, de Certeau, and Derrida." *MLN* 107: 441–77.

———. 1999. *Philosophy and the Turn to Religion*. Baltimore: Johns Hopkins University Press.

Weigel, Sigrid. 1996. *Body- and Image-Space: Re-reading Walter Benjamin*. Trans. Georgina Paul, with Rachel McNicholl and Jeremy Gaines. New York: Routledge.

CHAPTER TWO

Before the Image, Before Time: The Sovereignty of Anachronism

Georges Didi-Huberman

Translated by Peter Mason

Whenever we are before the image, we are before time. Like the poor illiterate in Kafka's story, we are before the image as *before the law:* as before an open doorway. It hides nothing from us, all we need to do is enter, its light almost blinds us, holds us in submission. Its very opening—and I am not talking about the doorkeeper—holds us back: to look at it is to desire, to wait, to be before time. But what kind of time? What plasticities and fractures, what rhythms and jolts of time, can be at stake in this opening of the image?

Let us consider for a moment this piece of Renaissance painting (Figure 2.1). It is a fresco from the convent of San Marco in Florence. It was probably painted in the 1440s by a local Dominican friar who later became known as Beato Angelico. It is situated at eye level in the eastern corridor of the *clausura,* just below a *sacra conversazione.* The rest of the corridor, like the cells themselves, is whitewashed with chalk. In this double difference—from the figurative scene above, and from the white background surrounding it—the section of red fresco, dotted with its erratic spots, produces an effect like a deflagration: a blaze of color that still bears the trace of its original spurt (the pigment was projected from a distance like rain in the fraction of a second) and, since then, has assumed permanence as a constellation of fixed stars.

Before this image, all of a sudden, our present may see itself stopped in its tracks and simultaneously born in the experience of the gaze. Although in my case more than fifteen years have passed since I underwent this unique experience, my "reminiscent present" has not failed, it

Figure 2.1. Fra Angelico, lower part of *Madonna of the Shadows*, c. 1440–1450 (detail). Fresco. San Marco convent, northern corridor, Florence. Height: 1.50 m. Photograph by the author.

seems to me, to draw all manner of lessons from it.[1] Before an image, however old it may be, the present never ceases to reshape, provided that the dispossession of the gaze has not entirely given way to the vain complacency of the "specialist." Before an image, however recent, however contemporary it may be, the past never ceases to reshape, since this image only becomes thinkable in a construction of the memory, if not of the obsession. Before an image, finally, we have to humbly recognize this fact: that it will probably outlive us, that before it we are the fragile element, the transient element, and that before us it is the element of the future, the element of permanence. The image often has more memory and more future than the being who contemplates it.

But how are we to be equal to all the temporalities that this image, before us, conjugates on so many levels? And first of all, how are we to account for the present of this experience, for the memory it evoked, and for the future it promised? To stop before the painted surface by Fra Angelico, to surrender to its figural mystery, already means to enter, modestly and paradoxically, into the discipline known as art history. Modestly, because the grand painting of Renaissance Florence was bounded by its borders: its *parerga,* its marginal zones, the registers rightly—or wrongly—called "subordinate" to the cycles of frescoes, the registers of "decor," the simple "imitation marble." Paradoxically (and decisively in my case), because it was a question of understanding the intrinsic necessity, the figurative—or rather *figural*—necessity of a zone of painting that could easily be characterized as "abstract" art.[2]

At the same instant (and in the same bewilderment) it was a question of understanding why all this painting activity by Fra Angelico (but also by Giotto, Simone Martini, Pietro Lorenzetti, Lorenzo Monaco, Piero della Francesca, Andrea del Castagno, Mantegna, and so many others), intimately bound up with religious iconography—why this whole world of perfectly visible images had never yet been considered or interpreted, or even glimpsed, in the vast scientific literature on Renaissance painting.[3] It is here that the epistemological question fatally arises: it is here that the case study—a unique painted surface that, one day, stopped me in my tracks in the corridor of San Marco—imposes a more general demand on the "archaeology," as Michel Foucault would have called it, of the study of art and its images.

In positive terms, this demand could be formulated as follows: under what conditions can a new historical object—or questioning—emerge

so late in a context as well known and "documented," as one says, as the Florentine Renaissance? It would be justifiable to formulate it more negatively: what, in the discipline or "order of discourse" of art history, has been able to maintain such a condition of blindness, such a "willingness not to see" and not to know? What are the epistemological reasons for such a denial—the denial that consists of knowing how to identify the slightest iconographic attribute in a *Holy Conversation* while at the same time not paying the slightest attention to the astounding three-meter by one-and-one-half-meter blaze of color situated just below it?

These simple questions arising from a singular case (though one, I hope, with some value as an example) touch the history of art and its method at its very status—its "scientific" status, as it likes to be called—and its history. To stop before the painted surface by Fra Angelico is first to try to confer a historical dignity, an intellectual and aesthetic subtlety, on visual objects that had until then been regarded as nonexistent or at least as meaningless. It soon becomes clear that even to approximate it, other paths are called for than those magisterially and canonically laid down by Erwin Panofsky under the name of "iconology."[4] In this case it is difficult to infer a "conventional meaning" from a "natural subject," to discover a "motif" or an "allegory" in the conventional sense of these terms, to identify a clearly defined "subject" or a distinctive "theme," to produce a written "source" by which to verify the interpretation. For the iconological conjuror who is so good at pulling the "symbolic" key of figurative images from his hat, there is no "key" to be produced from the archives or the *Kunstliteratur*.

So things were displaced and became more complex. It became necessary to ask again what "subject," "signification," "allegory," and "source" basically mean to an art historian. It became necessary to plunge again into the *noniconological*—in the humanist sense, that of Cesare Ripa—semiology that formed, on the walls of the convent of San Marco, the theological, exegetical, and liturgical universe of the Dominicans.[5] And, in consequence, to raise the demand for a noniconological—in the current "scientific sense" going back to Panofsky—semiology, a semiology that would be neither positivist (the representation as mirror) nor structuralist (the representation as system). It was the representation itself that really had to be called into question before the painted surface, with the result of entering into an epistemological debate on the means and ends of art history as a discipline.

To attempt, in short, a critical archaeology of art history capable of toppling the Panofskian postulate of "the history of art as a humanistic discipline."[6] To that end, it was necessary to critique a whole body of assumptions regarding the object "art"—the very object of our historical discipline—assumptions whose roots lay in a long tradition running, notably, from Vasari to Kant and beyond (including Panofsky himself).[7] But to stop before the painted surface is not only to question the object of our gaze. It is also to stop before time. It is therefore to question, in art history, the object "history," historicity itself. That is what is at stake in the present preliminary introduction: to tackle a critical archaeology of the models of time, of the use values of time in the historical discipline that has set out to make images its objects of study.[8] It is an urgent, specific, and everyday question—does not every act, every decision of the historian, from the humblest ordering of index cards to the most lofty synthetic ambitions, spring every time from a choice of time, from an act of temporalization? That is difficult to clarify. It soon appears that nothing here remains for long in the serene light of what is evident.

Let us start with precisely what seems the most evident to a historian: the rejection of anachronism. It is the golden rule: above all not to "project," as they say, our own realities—our concepts, our tastes, our values—on the realities of the past, the objects of our historical inquiry. Is it not evident that the "key" to understanding an object from the past is situated in the past itself, and what is more, *in the same past* as the past of the object? A commonsense rule: to understand Fra Angelico's colored surfaces, it will be necessary to look for a *source of the period* capable of giving us access to the "mental tool kit"—with its technical, aesthetic, religious, and other tools—that made possible this type of pictorial choice. Let us give a name to this canonical attitude of the historian: it is nothing but the quest for a concordance of times, a quest for *euchronistic consonance.*

In the case of Fra Angelico, we have a euchronistic interpretation of the first order: the verdict passed on the painter by the humanist Cristoforo Landino in 1481. Michael Baxandall has presented this verdict as the very type of a source of the period capable of enabling us to understand a pictorial activity as closely as possible to its intrinsic reality, according to the "visual categories" of its day—that is, the "historically pertinent" ones.[9] That is euchronistic evidence: a specific source (Landino's verdict, after all, is not general but bears a name) is produced, and thanks

to that, it becomes possible to interpret the past using the categories of the past. Is that not the historian's ideal?

But what is the ideal if not the result of a process of idealization? What is the ideal if not purification, simplification, abstract synthesis, denial of the flesh of things? Landino's text is no doubt historically pertinent in the sense that, like Fra Angelico's fresco, it belongs to the civilization of the Italian Renaissance: in this respect, it bears witness to the humanist reception of a painting produced under the patronage of Cosimo de' Medici. But does that make it historically pertinent in the sense of enabling us to understand not only the pictorial necessity but also the intellectual and religious necessity, of the colored painted surfaces of San Marco? By no means. Compared with the production itself of Fra Angelico, Landino's verdict suggests that he had never set foot within the *clausura* of the Florentine convent—which is highly likely—or that he saw this painting without looking at it. Each of these "categories"—natural facility, congeniality, naive devotion—is the diametric opposite of the complexity, gravity, and subtlety displayed in the highly exegetical painting of the Dominican friar.[10]

Thus before the painted surface we find ourselves before a new question to put to the historian: if the ideal—specific, euchronistic—source is not capable of telling us anything about the object of inquiry, offering us only a source on its reception, but not on its structure, to which saints or interpreters should we turn? It should first be noted concerning the authority wrongly granted to Landino's text that it is considered pertinent because it is "contemporary" (I speak of euchronism here only to underline the value of ideal coherence, of Zeitgeist, attributed to such contemporaneity). But is it really contemporary? Or rather, by what standard, by what scale, can it be considered to be such? Landino was writing some thirty years after the painter's death, a sufficient length of time for many things to have changed, here and there, in the aesthetic, religious, and humanist spheres. Landino was versed in classical Latin (with its categories, its own rhetoric), but he was also an ardent defender of the vulgate.[11] As for Fra Angelico, he was only versed in the medieval Latin of his readings as a novice, with their scholastic distinctions and endless hierarchies: that alone could be reason enough to suspect the existence of a veritable anachronism separating the painter from the humanist.

Let us go further: not only was Landino anachronistic with regard to Fra Angelico because of the distance in time and culture that clearly separated them, but Fra Angelico himself seems to have been anachronistic with regard to his most immediate contemporaries, if one wishes to consider Leon Battista Alberti as one of them, for example, who was theorizing on painting at the very moment and only a few hundred meters from the corridor where the red surfaces were being covered with white spots sprayed from a distance. Nor can the *De pictura,* in spite of being "euchronistic," adequately account for the pictorial necessity at work in the frescoes of San Marco.[12] All that leaves the impression that contemporaries often fail to understand one another any better than individuals who are separated in time: all of the contemporaneities are marked by anachronism. There is no temporal concordance.

Fatality of anachronism? That is what can separate even two perfect contemporaries such as Alberti and Fra Angelico, because they did not at all think "at the same time." Now, this situation can only be qualified as "fatal"—negative, destructive—from the point of view of an ideal, and therefore impoverished, conception of history itself. It is better to recognize the necessity of anachronism as something positive: it seems to be internal to the objects themselves—the images—whose history we are trying to reconstruct. In a first approximation, then, anachronism would be the temporal way of expressing the exuberance, complexity, and overdetermination of images.

In the single example of Fra Angelico's mottled painted surface, at least three temporalities—three heterogeneous times, anachronistic to one another—are intertwined in a remarkable fashion. The trompe l'oeil frame stems, evidently, from a "modern" mimetism and a notion of *prospectiva* that can be roughly characterized as Albertian, and therefore euchronistic in this Florentine fifteenth century of the first Renaissance. But the mnemonic function of the color itself implies a notion of the *figura* that the painter found expressed in Dominican writings of the thirteenth and fourteenth centuries: arts of memory, "sums of similitudes" or biblical exegeses (in this sense, Fra Angelico could be qualified as an "old-fashioned" painter, an adjective that, in current usage, is used as an equivalent to "anachronistic"). Finally, the *dissimilitudo,* the dissemblance at work in this painted surface, goes back even further: it constitutes the specific interpretation of a whole textual tradition carefully

collected in the library of San Marco (the commentaries on Dionysius the Areopagite by Albertus Magnus and Saint Thomas Aquinas), as well as of an ancient figural tradition that reached Italy from Byzantium (the liturgical use of semiprecious multicolored stones) via Gothic art and Giotto himself (imitation marble in the Scrovegni chapel). All of that served a different temporal paradox: the liturgical repetition—temporal propagation and diffraction—of the constitutive and capital moment of this entire economy, the mythical moment of the incarnation.[13]

We thus find ourselves before the painted surface as an object of complex, impure temporality: an *extraordinary montage of heterogeneous times forming anachronisms.* In the dynamic and complexity of this montage, historical notions as fundamental as those of "style" or "epoch" suddenly take on a dangerous plasticity (dangerous only for those who would like everything to be in its place once and for all in the same epoch: the fairly common figure of what I shall call the "historian with time phobia"). So to raise the question of anachronism is to question this fundamental plasticity, and with it the combination—so difficult to analyze—of the temporal differentiation at work in each image.

The social history of art, which has dominated the whole discipline for several years, often abuses the static—semiotically and temporally rigid—notion of a "mental tool kit," which Baxandall, with reference to Fra Angelico and Landino, has called cultural or cognitive equipment.[14] As if it were enough for each of them to extract words, representations, or preformed and ready-to-use concepts from a tool kit. It is to forget that from the tool kit to the hand that uses them, the tools themselves are being formed, that is to say, they appear less as entities than as *plastic forms* in perpetual transformation. Let us think rather of malleable tools, tools of wax that take on a different form, signification, and use value in each hand and on each material to be worked. As Baxandall usefully reminds us, Fra Angelico may have drawn the contemporary distinction between four types of religious styles of speech—*subtilis, facilis, curiosus, devotus*—from his mental tool kit, but to say that is only to go part of the way.[15]

The art historian should understand above all in what and how the pictorial work of Fra Angelico will have consisted precisely of subverting such a distinction and thus of transforming and reinventing such a mental tool kit; how a religious painting will have been able to present itself in the *facilis* mode, easy to view from the iconographic point of

view, but at the same time in the *subtilis* mode, which implements the more complex point of view of biblical exegesis and incarnational theology.[16] The *facilis* mode, before our painted surface, would consist of seeing in it nothing but a decorative register without any "symbolic" meaning: a simple ornamental frame, a panel of imitation trompe l'oeil marble serving as the base for a *Holy Conversation*. The *subtilis* mode emerges on several possible levels, depending on whether one concentrates on the liturgical reference proposed here by the painter (the surface of imitation marble is exactly to the *Holy Conversation* what an altar is to a retable); its devotional associations (the white spots stud the wall of the corridor as the drops of milk of the Virgin were said to stud the wall of the grotto of the Nativity); the allegorical allusion that turns the multicolored marble into a *figura Christi;* the performative implications of the projection of a pigment from a distance (a technical act that can be defined, strictly speaking, as an unction); or the numerous mystical references associating the act of contemplation with the "abstract" frontality of multicolored surfaces (the mottled marble as *materialis manuductio* of the *visio Dei,* according to Johannes Scotus Erigena, the Abbé Suger, or the Dominican Giovanni di San Gimignano).[17]

The image is extremely overdetermined: it plays, one could say, on several levels at the same time. The range of symbolic possibilities that I have just sketched with regard to this single painted surface of Italian fresco only takes on a meaning—and can only begin to receive verification—from consideration of the open range of meaning in general, whose practical and theoretical conditions of possibilities had been forged by medieval exegesis.[18] It is within such a field of possibilities, no doubt, that the aspect of montage of differences characterizing this simple but paradoxical image is to be understood. Now, with this montage, it is the whole range of time that is also thrown wide open. The temporal dynamic of this montage should therefore logically stem from a theoretical paradigm and a technique of its own—precisely what the "arts of memory" offer in the *longue durée* of the Middle Ages.[19]

The image is therefore highly overdetermined with regard to time. That implies the recognition of the functional principle of this overdetermination in a certain dynamic of memory. Well before art had a history—which began, or began again, it is said, with Vasari—images had, bore, produced memory. Now, memory too plays on all the levels of time. It is to memory and to its medieval "art" that is owed the montage

of heterogeneous times by which, on our painted surface, a mystical notion of the fifth century—that of pseudo-Dionysius the Areopagite with regard to mottled marble—can be found there, ten centuries later, surviving and transformed, inserted into the context of a thoroughly "modern" and Albertian perspective.

Sovereignty of anachronism: in some moments of his present, a Renaissance artist, who had just projected white pigment onto a red fresco ground surrounded by a trompe l'oeil frame, will have rendered permanent for the future this veritable constellation—made image—of heterogeneous times. Sovereignty of anachronism: the historian who today would confine himself to the euchronistic past—to the Zeitgeist of Fra Angelico alone—would completely miss the point of his pictorial act. Anachronism is necessary; it is fertile when the past proves to be insufficient, that is, forms an obstacle to the understanding of the past. What Alberti and Landino do not allow us to understand in Fra Angelico's painted surface we are fully allowed to understand thanks to the multiple combinations of ideas separated in time—Albertus Magnus with pseudo-Dionysius, Thomas Aquinas with Gregory the Great, Jacobus de Voragine with Saint Augustin. Let us imagine that the Dominican artist had them permanently at his disposal in that preeminently anachronistic place, the library of the convent of San Marco.[20]

In a case like this, therefore, it is not enough to practice art history from the perspective of euchronism, that is to say, from the conventional perspective of "the artist and his time." What such a visuality demands is that it be envisaged from the perspective of its memory, that is, its manipulations of time. It is in tracing them that we discover an anachronistic artist, an "artist against his time." We should therefore consider Fra Angelico as an artist of the historical past (an artist of his time, the Quattrocento), but also as an artist of the *more-than-past* of memory (an artist manipulating times that were not his own). This situation gives rise to an additional paradox: if the euchronistic past (Landino) screens or blocks the anachronistic more-than-past (Dionysius the Areopagite), how is one to smash the screen in order to remove the obstacle?

What is needed, I shall venture to say, is one more strange feature that confirms the paradoxical fecundity of anachronism. To gain access to the stratified multiple times, to the survivals, to the *longues durées* of the more-than-past of memory, we need the *more-than-present* of an

act of reminiscence: a shock, a tearing of the veil, an irruption or appearance of time, what Proust and Benjamin have described so eloquently under the category of "involuntary memory." What Landino and all the art historians were incapable of seeing and showing before the mottled painted surface of the fifteenth century—and here comes the anachronism—Jackson Pollock proved himself to be quite capable of seeing and showing. If I try today to recall what stopped me in my tracks in the corridor in San Marco, I think I am not mistaken in saying that it was a kind of displaced resemblance between what I discovered there, in a Renaissance convent, and the drippings of the American artist that I had discovered and admired many years before.[21]

It is certain that such a resemblance belongs to the domain of what is called a pseudomorphosis: the relations of analogy between Fra Angelico's mottled surface and a Jackson Pollock painting do not stand up to analysis for long (from the question of horizontality to that of the symbolic meanings). Fra Angelico is in no way the ancestor of action painting, and it would have been simply stupid to look in the projections of pigment in our corridor for any abstract expressionist "libidinal economy." Pollock's art, of course, cannot be used for an adequate interpretation of Fra Angelico's spots. But the historian does not get out of it that easily, for the paradox remains, the malaise in the method: it is that the emergence of the historical object as such will have been the result not of a standard—factual, contextual, or euchronistic—historical approach but of an almost aberrant anachronistic moment, something like a symptom in historical knowledge. It is the very violence and incongruity, the very difference and unverifiability, that will actually have brought about a lifting of censorship, the emergence of a new object to see, and, beyond that, the constitution of a new problem for art history.

Heuristic of anachronism: how can an approach that on this point is contrary to the axioms of the historical method lead to the discovery of new historical objects? The question, with its paradoxical reply—it is Pollock and not Alberti, it is Jean Clay and not André Chastel, who have enabled the "recovery" of a large surface of fresco painted by Fra Angelico, visible for all but kept invisible by art history itself—touches on the difficult problem of the "right distance" that the historian dreams of maintaining vis-à-vis his or her object. If it is too close, the object runs the risk of being no more than a peg to hang phantasms on; if it is too distant, it is in danger of being no more than a positive,

posthumous residue, put to death in its very "objectivity" (another phantasm). What is required is neither to fix nor to try to eliminate this distance, but to make it work within the differential tempo of the moments of empathic, unexpected, and unverifiable juxtapositions, with the reverse moments of scrupulous critique and verification. Every question of method perhaps boils down to question of tempo.[22]

From this position, the anachronism could not be reduced to this horrible sin that every qualified historian sees in it. It could be thought of as a moment, as a rhythmic pulse of the method, even though it is its moment of syncope, paradoxical and dangerous, as every risk is. From here it is a question of extending to the question of time a hypothesis that has already been advanced and argued on the question of meaning: if the history of images is a history of overdetermined objects, then it is necessary to accept (But how far? How? The whole question lies there.) that an overinterpretive science corresponds to these overdetermined objects.[23] The temporal version of this hypothesis could be formulated as follows: The history of images is a history of objects that are temporally impure, complex, overdetermined. It is therefore a history of polychronistic, heterochronistic, or anachronistic objects. Is it not to say, already, that the history of art is itself an anachronistic discipline, for better and for worse?

Notes

1. Didi-Huberman 1986.
2. Didi-Huberman 1990b.
3. In the monograph that was considered authoritative at the time when this research was undertaken, only half of the actual surface of Fra Angelico's *Holy Conversation* was interpreted, photographed, and even measured, as though the surprising register of the multicolored "painted surfaces" was simply nonexistent. See Pope-Hennessy 1952, 206.
4. Panofsky 1962, 3–31.
5. Ripa [1611] 1976.
6. Panofsky 1970, 23–25.
7. Didi-Huberman 1990a.
8. This text is the introduction to a work in progress entitled *Devant le temps: Histoire de l'art et anachronisme des images*.
9. Baxandall 1985, 224–31. Landino's text runs: "Fra Giovanni Angelico et vezoso et divoto et ornato molto con grandissima facilita" [Fra Angelico was congenial, devout, and endowed with the greatest facility].
10. Didi-Huberman 1990b, 25–29.

11. Santoro 1954.
12. Didi-Huberman 1990b, 49–51.
13. See Didi-Huberman 1990b, 113–241, on the Annunciation analyzed as a figural paradox of time.
14. Baxandall 1985, 168.
15. Baxandall 1985, 227–31.
16. Didi-Huberman 1990b, 17–42.
17. Didi-Huberman 1990b, 51–111.
18. De Lubac 1959–1964.
19. Yates 1966.
20. Ullman and Stadter 1972.
21. To this reminiscence should be added an important element of "taking into consideration the figurability": it is the friendship and intellectual companionship with Jean Clay (author in particular of an illuminating article entitled "Pollock, Mondrian, Seurat: La profondeur plate" [1977], *L'Atelier de Jackson Pollock* [Paris: Macula, 1982], 15–28) under the motto . . . the stain *(macula)*. This theoretical motto, engaged in the *contemporary* debate concerning artists such as Robert Ryman, Martin Barré, or Christian Bonnefoi, suddenly seemed to come to life, in Florence, in the most unexpected *historical* dimension, that of the Middle Ages and the Renaissance. Note that Jean-Claude Lebensztejn, who made important contributions to the review *Macula* between 1976 and 1979, has subsequently elaborated another evocation of the stain on the basis of the experiences of Cozens in the eighteenth century. See Lebensztejn 1990.
22. Patrice Loraux (1993) has even admirably shown that every question of thought is a question of tempo.
23. See Didi-Huberman 1990a, 192–93, where the answer was sought in Freudian formulations.

References

Baxandall, Michael. 1985. *L'Œil du Quattrocento: L'usage de la peinture dans l'Italie de la Renaissance.* Trans. Y. Delsaut. Paris: Gallimard.
De Lubac, H. 1959–1964. *Exégèse médiévale: Les quatre sens de l'Écriture.* Paris: Aubier.
Didi-Huberman, Georges. 1986. "La dissemblance des figures selon Fra Angelico." *Mélanges de l'École française de Rome, Moyen-Âge-Temps modernes* 98, no. 2: 709–802.
———. 1990a. *Devant l'image: Question posée aux fins d'une histoire de l'art.* Paris: Minuit.
———. 1990b. *Fra Angelico: Dissemblance et figuration.* Paris: Flammarion.
Lebensztejn, J.-C. 1990. *L'Art de la tache: Introduction à la "Nouvelle méthode" d'Alexander Cozens.* N.p.: Éditions du Limon.
Loraux, P. 1993. *Le Tempo de la pensée.* Paris: Le Seuil.
Panofsky, Erwin. 1962. *Studies in Iconology: Humanistic Themes in the Art of the Renaissance.* New York: Harper and Row.
———. 1970. "The History of Art as a Humanistic Discipline." In *Meaning in the Visual Arts,* by Erwin Panofsky, 1–25. Harmondsworth: Peregrine Books.

Pope-Hennessy, J. 1952. *Fra Angelico*. London: Phaidon.

Ripa, C. [1611] 1976. *Iconologia overo Descrittione dell' Imagini universali cavate dall' Antichità e da altri luoghi ... per rappresentare le virtù, vitii, affetti, e passioni humane.* 2d ed., illustrated. Padua: Tozzi; New York: Garland.

Santoro, M. 1954. "Cristoforo Landino e il volgare." *Giornale storico della letteratura italiana* 131: 501–47.

Ullman, B. L., and P. A. Stadter. 1972. *The Public Library of Renaissance Florence: Niccolò Niccoli, Cosimo de' Medici, and the Library of San Marco.* Padua: Antenore.

Yates, F. A. 1966. *The Art of Memory*. London: Routledge and Kegan Paul.

CHAPTER THREE

Aesthetics before Art:
Leonardo through the Looking Glass

Claire Farago

"I think I'll go and meet her," said Alice, for, though the flowers were interesting enough, she felt that it would be far grander to have a talk with a real Queen.

"You can't possibly do that," said the Rose: "I should advise you to walk the other way."

This sounded nonsense to Alice, so she said nothing, but set off at once towards the Red Queen. To her surprise, she lost sight of her in a moment, and found herself walking in at the front-door again.

A little provoked, she drew back, and after looking everywhere for the Queen (whom she spied out at last, a long way off), she thought she would try the plan, this time, of walking in the opposite direction.

It succeeded beautifully. She had not been walking a minute before she found herself face to face with the Red Queen, and full in sight of the hill she had been so long aiming at.

—Lewis Carroll, *Through the Looking-Glass*

As anyone who has ever attempted to act on a mirror image's spatial cues knows, the logic of the looking glass is counterintuitive. Walking through time's looking glass, as it were, in the opposite direction from contemporary understandings of science, religion, and art as three distinct domains, toward their fluid intersection in the early modern period, the following essay attempts to recapture a decidedly unmodern aspect of our artistic heritage. The aspects of Leonardo's paintings that will be of concern here pertain to that elusive and troubling designation known as "style." Meyer Schapiro associated "style," in an article published

in 1953 that quickly became a classic, with a system of forms with a quality and a meaningful expression through which the personality of the artist and the broad outlook of a group are visible.[1]

The concept of style is crucial to the concept and legitimacy of art history itself, but an intellectual revolution has occurred since Schapiro offered his classic definition. The discipline of art history has become a more pluralistic practice that identifies closely with cultural history. Our inherited notions of style, long identified with the visible properties of material artifacts through which the maker expresses his interpretive vision of the world, have become questionable assumptions. Indeed, style is arguably better understood as a *historical* category, as much a subject for investigation as the art to which the term is applied. That is to say, viewers—historical as much as contemporary viewers—project meanings onto the stylistic features of objects, but style itself is mediated by many social and cultural factors.

Ultimately the leading question posed by a reconsideration of style in a historical frame of reference is how the formal visual properties of paintings signified to their original viewers. By way of articulating the problematic between philosophy and art, this essay asks where the notion that works of art elicit a subjective response comes from—not in order to search for the origins of the idea, or to reconstruct its past, but to locate, with the aid of the future conditional tense, the theoretical implications of a certain pictorial structure for contemporary accounts of subjectivity. The following (trans)location is situated at the intersection of art, religion, and science in the sixteenth and seventeenth centuries. The discussion proposes that the modern scientific understanding of paintings is indebted to Byzantine (Greek) literary texts that artists may not have known directly—in all likelihood, did not know directly— and to visual sources that they probably did not recognize as originating in Byzantine theological formulas that had pervaded the Latin West for hundreds of years.[2]

Then why is it important now to acknowledge the sources of these themes and arguments as specifically Byzantine? The modern(ist) convention of subjective response to works of art that relies on language to articulate emotion, feeling, and other experiential states deserves to be reintegrated into the historical framework out of which it emerged. Why? Museums provide the staging of such languages so as to rectify the "absence" located on or projected into the nonabsent, physically palpable

object—what might be called its virtual being. This links up to a language discourse on "art" as the de-absencing of absence, rooted in Christian theories of images as suited to human modes of cognition, that is, suited to accessing the sacred immanent within the world through sense experience. But the presence or virtual being felt by modern subjects is experienced as threatening because it appears to mirror a (preexisting) absence in oneself, which (in Lacanian terms) needs to be "cured" or papered over or rendered in masquerade. The art museum is the ideal stage on which such "language" of absence/de-absencing is deployed in modernity. The social function of art to structure subjectivity in certain ways and not others—that is, to constitute the subject—ties in directly and deeply not only with Christian theories of images developed in Byzantium a millennium ago but also with Lacan's contemporary dynamic notion of the subject, to which the present discussion will turn at its conclusion.

A great deal has been published in the last fifteen years on the conventions of art historical prose.[3] Although the discipline's genre practices are consequently not viewed as transparently as they once were, we are still caught in a double b(l)ind. First, the investigator's own subjective experience of the works of art under study usually remains outside the framework of evaluation. Second, the discipline lacks the means (methodology, expectation, or routine) for evaluating how the investigator's own "subjective experience" is socially constituted. At the moment of this writing, few authors acknowledge their own subject positions with respect to their objects of study, let alone justify them. Currently the decision to include such a self-reflexive component appears to be a matter of individual discretion, rather than a matter of ethical necessity or professional intellectual expectation. Yet, as historians, observes Joan Wallach Scott, it is important to recognize the socially constructed nature of our own experience, as well as that of our subjects, otherwise:

> When experience is taken as the origin of knowledge, the vision of the individual subject (the person who had the experience or the historian who recounts it) becomes the bedrock of evidence on which explanation is built. Questions about the constructed nature of experience, about how subjects are constituted as different in the first place, about how one's vision is structured—about language (or discourse) and history—are left aside. The evidence of experience then becomes evidence for the

fact of difference, rather than a way of exploring how difference is established, how it operates, how and in what ways it constitutes subjects who see and act in the world.[4]

Transposing Scott's recommendations to the case of art, the primary analytical objective becomes to understand how the object frames historical beholders' experience of it, and thereby to address the larger question of how the object constitutes its subjects. The second-order objective, exponentially more complex but part of the same continuum, is to understand the socially constructed nature of the investigator's experience, as it is expressed in and by the study. How does the historian establish difference from her object of study? How does this difference then operate in the text, and how does the difference established by the text constitute subjects who see and act in the world? Scott's argument deserves to be translated (in the same sense that Bal, following Benjamin, discusses translation in her contribution to this volume) to considerations of other forms of evidence besides texts.

In his 1977 essay "Signature Event Context," Derrida is concerned with a metacritical problematic similar to Scott's, relevant to the present context of discussion: "If we now ask ourselves what, in this analysis [of communication and signification], is the essential predicate of this *specific difference* [between writing and everything else], we rediscover *absence*."[5] Writing preserves communication for those who are absent; but "absence," Derrida continues, with reference to Condillac's *Essay on the Origin of Human Knowledge,* is presupposed to be a modification of presence. Absence, per se, is not examined by Condillac.[6] Absence is absent from Condillac's writing on what writing is vis-à-vis communication—a defining moment in the history of theorizing writing, Derrida argues, in which writing's distinguishing characteristics and purposes were articulated.

Isn't the work of art in a similarly compromised situation whenever it survives, making "history" directly available to present-day experience? First and foremost, the presence of the object calls into question the entire historical project—for how can an object simultaneously be in the past and in the present? But second, and more disturbing, what is absent appears not to be absent. The historian's direct experience of the object produces invaluable data, the status of which is deeply problem-

atic. For how does the historian link, as well as distinguish between, the two orders of experience, one's own in the present and the absent historical subject's in the past?

In the case of material culture, generally speaking, the same object appears to occupy both present and past "worlds." Elsewhere in this volume, Mieke Bal distinguishes historical thinking from philosophy on the following grounds: "philosophy is a discourse in the present that— unlike historical thinking—engages the past through the present but does not 'reconstruct' or causally explain it."[7] This distinction between history and philosophy configures time as a linear progression in which individual units have equal exchange value. Yet these supposedly neutral, value-free categories of past, present, and future are, in reality, products of a complex cultural heritage.

Granting the privilege of universality to one's own culture does not really provide a solid epistemological foundation for an argument—it is only a rhetorical strategy that masks the point of real inquiry.[8] Wouldn't a "real" historical argument take the conventionality of the definition of "history" as the causal past into account and embrace all the convolutions that Bal addresses? My only quarrel with Bal is that I want, like Benjamin, to grant "history" the same intellectual rigor that she reserves for "philosophy."

I also wish to avoid polemical disputes over disciplinary formations. Whatever their relationship, what counts is that the historian's experience and that of historical viewers cannot be the same. Yet art historians seldom acknowledge any difference at all. A typical case of denial is Kenneth Clark's classic 1939 monograph on Leonardo da Vinci, which emphasizes the artist's formal treatment of movement. For example, Clark describes Leonardo's first major independent commission, the unfinished *Adoration of the Magi* (Figure 3.1), as a series of curves on the left side of the painting, an arc of shadowy figures that "stabilize the restless" rhythm of the four main vertical elements. This "most revolutionary and anti-classical picture of the fifteenth century" is, for Clark, to be experienced as emotive responses to depicted motion.[9] Clark integrates his considerations of Leonardo's interest in motion across a wide range of applications—the artist's studies of waves, plaited hair, light and shade—as aspects of his psychic makeup: "[Leonardo's] love of twisting

Figure 3.1. Leonardo da Vinci, *Adoration of the Magi* (unfinished), 1481. Uffizi Gallery, Florence. Copyright Alinari/Art Resource, N.Y.

movement was an instinct, visible, as we have seen, in his earliest work; and becoming more pronounced as his sense of form becomes more liberated. His innumerable studies of waves, knots, and plaited hair were not done in pursuit of a theory, but in satisfaction of an appetite."[10] However intuitive and insightful they are, such observations never lead Clark to consider the original viewer's response to the image.

The paired categories of visual form and artistic character that are consistent features of Clark's study of Leonardo recur frequently in the art historical scholarship. Monographs on Leonardo are not unique in

this respect. Art historians routinely link analyses of artistic composition directly to inquiries about the artistic identity of the individual maker. Consequently, questions of artistic *production* establish the intellectual horizons of our investigations, at the expense of other issues that are just as much a part of the history of aesthetics. Such is the heritage of connoisseurship, an interpretative method that is fundamentally concerned with the affective aspects of viewer response but treats works of art as if viewers were an ever-present, homogeneous entity, transcending all historical considerations save the artist's self-expression.

Studies that emphasize iconography rebalance the same formula of form and artistic invention (the art and/as the artist), but they do not depart from it in principle.[11] Iconographic studies have also avoided considerations of historical reception. Leo Steinberg's study of Leonardo's *Last Supper*, with its extended analysis of the relationship of form and religious content, would appear to be a notable exception to the ingrained pattern of scholarly exegesis. Yet Steinberg, too, treats the initial reception of the painting only cursorily, with respect to the shape of the space in which the mural is displayed. He substitutes the historian's erudition for the mental horizons of the period viewer.[12] In Steinberg's words, "it is assumed that intelligent reactions to the *Last Supper* constitute a source of insight into the work itself."[13]

I do not wish to suggest that there is anything *wrong* with investigations of artistic production, but I want to know how Steinberg's assumption is justified by evidence. Past scholars have tried to elucidate Leonardo's paintings on the basis of their own emotional response to the artist's psyche, as they consider it manifested directly in his visual forms. Contemporary categories of subjective experience, however—those we routinely encounter in writings on connoisseurship and iconography—have long histories of their own. Identifying that history, specifically connections between "motion" and "emotion" in the cultural formations that produced and encompass Western philosophical aesthetics and theories of representation, as seen through the focusing lens of Leonardo's *Virgin of the Rocks,* is the subject of the next section of this chapter. The historical reception of Leonardo's religious paintings—amazingly—has not been the subject of study. Perhaps Leonardo's powers of invention, and his unparalleled ability to render nature's effects, have relegated these conventional aspects of his paintings to the margins. The present essay focuses on a single painting that, without doubt,

served as an instrument of religious devotion at a time when most of Leonardo's paintings—and there were always only a few in number—had already made their way into private art collections. Collectors, though they may have continued to regard his paintings as instruments of religious devotion, also valued them as works of art from the hands of a great artist.[14] In this sense, collectors were (and still are) metaviewers. What the present essay explores is the devotional purpose that Leonardo's "style" served, *aside* from being venerated by an elite audience of collectors and connoisseurs.

The *Virgin* at San Francesco Grande

In 1483 the Milanese Confraternity of the Immaculate Conception, a lay organization of the Franciscan Minors newly founded in 1475, commissioned the *Virgin of the Rocks* for the altar of its parent chapel in the church of San Francesco Grande. There are two extant versions of the altarpiece (Figures 3.2 and 3.3). This unusual circumstance has so intrigued art historians that most of the scholarship to date has been devoted to sorting out the circumstances that resulted in two altarpieces nearly identical in size and very similar in design, both considered to be autograph works in whole or in part. Although there is no scholarly consensus, the most convincing explanation is that the two versions were made in succession for the same chapel, no longer extant but once located to the left of the west (main) entrance to the church (Figure 3.4).[15]

Whether the earlier version ended up in northern Europe through a gift exchange or by other means, the second version, now in the National Gallery in London, concerns us more because it apparently occupied the chapel in San Francesco Grande throughout the sixteenth century (Figure 3.3). However, for the purposes of the following argument, it is unnecessary to put too fine a point on which painting was displayed in Milan, since the similarities of subject and design that will be of concern far outweigh the differences. Notwithstanding nuanced revisions in the later version, the Confraternity of the Immaculate Conception received an image of a vision of Mary adoring the Christ Child accompanied by the infant Saint John the Baptist and an angel. The four luminous, sculpturally conceived figures are set into a jewel-like woodland setting with running water, a bright and cloudless sky visible between the rocky crags.[16]

Figure 3.2. Leonardo da Vinci, *Virgin of the Rocks*, 1483. Louvre, Paris. Copyright Alinari/Art Resource, N.Y.

Figure 3.3. Leonardo da Vinci, *Madonna of the Rocks,* 1508–. National Gallery, London. Copyright Alinari/Art Resource, N.Y.

Surprisingly—or perhaps not, given the dominating role played by genre conventions in the field—ways in which sixteenth-century behold-ers responded to Leonardo's altar painting in situ have not been stud-ied. Leonardo recorded his interest in Roger Bacon's writings on the multiplication of species and other texts on formal optics during ap-proximately the same period that the altarpiece commission was ful-filled.[17] But the complex, scientifically correct optical effects and other

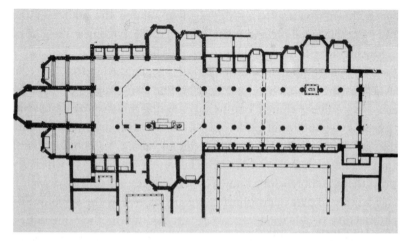

Figure 3.4. Floor plan of San Francesco Grande. Reconstruction, after Aristide Calderini.

naturalistic details that the artist sought were not merely, or perhaps even primarily, regarded as manifestations of his inventive powers by a lay audience. The painting played an intercessory religious role in keeping with the original commission awarded by a lay organization for its main chapel. In 1576 a group of Milanese citizens dedicated a special devotion to the image to intercede during a plague, according to the testimony of the notary Giacomo Filippo Besta recorded at the height of the Catholic Reform movement.[18] Besta's testimony has been widely cited in the scholarship on the *Virgin of the Rocks,* but only because it is the earliest identifiable reference to the image in situ.[19] Although additional documents may be awaiting discovery in the archives, the published excerpts are sufficient to testify that, well into the sixteenth century, the *Virgin of the Rocks* functioned as an intercessory image for a secular (in the period sense of worldly) audience.

In this connection, it is important to bear in mind that San Francesco Grande was one of the greatest depositories of saints' relics in Milan, located in one of the city's most ancient and illustrious districts. The history of the building and its location were, moreover, important sources of civic pride in the sixteenth century. Bonaventura Castiglione's *Lives of Eleven Archbishops of Milan before St. Ambrosio,* which remains an unpublished chapter of his ancient history of Gaul published in 1541, expressed the opinion that the Franciscan Minors had constructed the choir of San Francesco Grande directly over an ancient basilica dedicated

to all the martyr saints, a building that housed the bodies of the
Milanese saints Nabore and Felice, who were martyred near the gate of
Codi Vecchio, circa 290, and buried in the church that bore their name
for many years.[20] Besta's guidebook to the city, finished in 1598, gives the
details of the saints' lives just cited, and he also understood that the
site—not only the church, but the surrounding garden and forest—was
consecrated in honor of Christ and all the saints for 1,500 years.[21] Besta
cites another historical account, the life of Milanese archbishop Saint
Castriciano written by Cardinal Guglielmo Sirleto (d. 1585), which re-
ports that the church, long known as San Francesco Cimiterio de' Santi,
was a place of great devotion for the city as well as the surrounding
countryside: people went there to ask for health from their infirmities,
"as written on a marble tablet to the left of the entrance to the choir."
 In other words, the testimony that the site was a miraculous one was
located next to the chapel in which the *Virgin of the Rocks* was displayed
(Figure 3.3). With its extensive landscape setting, the altarpiece in context
was also a testimonial to the healing powers of the sacred setting of the
church. Noting that the building was consigned to the Franciscan Frati
Minori in 1233, Besta describes the "sumptuous and great tabernacle" for
housing the Sacrament, adding that many indulgences were granted there
on account of the numerous bodies of saints deposited in the taberna-
cle itself, which faced the Confraternity's chapel containing Leonardo's
altarpiece (Figure 3.3). The tabernacle includes the ashes of Saint Bar-
nabas that were translated there from the chapel dedicated to the saint
by Milanese archbishop Carlo Borromeo himself (leading figure of the
Catholic Reformation during and after the Council of Trent's decree on
sacred images). The relics housed in San Francesco Grande included
the body of one of the massacred innocents, the body of Saint Desiderio,
the heads of Saint Matthew Apostle, Saint Odelia, Saint Ursula, and one
of the Maccabees; wood from the true cross and from the room where
Christ ate supper (unclear which one); some relics of Saint Francis, a
tooth of San Lorenzo; bones of the Magdalene, Santa Romana, Saint
Silvester, Pope Sixtus, and many others.[22]
 Whether these claims are justified or not, it is certain that in the six-
teenth and seventeenth centuries, San Francesco Grande was considered
one of the most sacred centers of Latin Christianity since early Chris-
tian times. Unlike many popular shrines that were the subject of eccle-
siastical criticism and reform, this sanctuary carried the blessing of church

leaders themselves, starting with one of the most major figures of all, Archbishop Carlo Borromeo. And throughout this period, Leonardo's innovative iconography was in a prominent place in the building—whatever theological doctrines the symbolism proclaimed, the painting was evidently not transgressive.

Besta also testifies—although Calderini notes that his source is false—that the chapel dedicated to the Conception of the Virgin was originally a devotion of Azzo Visconti, lord of Milan—whose lineage Ludovico Sforza had usurped.[23] Visconti had arranged for the Frati Minori to celebrate the Virgin with Divine Offices, and every year the (entire) "community of Milan" observed her feast day at the chapel where "se vede una pittura di detta Vergine molto rara" [one sees an exceptional painting of the said Virgin].[24] This is the context in which the famous earliest reference to the *Virgin of the Rocks* appears.

As an instrument of religious devotion, the formal qualities of this sacred painting—Leonardo's scientific treatment of light, dark, and color, his attention to ephemeral aspects such as the subtle gradations of light and shadow on flesh and water—had both symbolic value and a perceptual function that together defined the cognitive field of the viewer's experience. Optical phenomena guided worshipers on an inner journey, exciting the imagination through external stimuli, moving the soul through contemplation of the external image to internal "imaginative vision" and toward salvation.[25] To supplement Joan Scott's terminology with Derrida's, the picture organizes the subject and constitutes the subject's world, but the viewer's "constructed" experience is never saturated, because new visual discoveries and associations are always possible. The openness of the signifying process keeps the beholder engaged.[26]

The visual imagery, though it was specifically suited to the patrons' desires, was also accessible to a wide audience. Joanne Snow Smith has referred the symbolism to contemporaneous controversy between the Franciscan Immaculists and the Dominican Maculists, concluding that the iconography was perceived as a visual argument for the Franciscan position that the Virgin was conceived without the stain *(macula)* of Original Sin.[27] A segment of the audience, for a period of time, would perhaps have been attuned to this context. However, it is important to emphasize that the individual visual motifs were commonplace and therefore widely accessible, although some viewers might not have interpreted the Confraternity's ideology "correctly." Leonardo's interweaving

of conventional imagery such as a grotto, sacred spring, mirror brooch, crescent moon, and—as the following discussion elaborates at greatest length—the play of color, light, and shadow, spoke volumes to a broad audience.

In effect, the painting as an icon played the same role for the faithful as a relic did. Relics are traces, indexical in the Peircean sense, a point that the following argument will elaborate. Relics demonstrate the basic Christian doctrine of salvation by offering a concrete manifestation of the real presence of the divine. What is attributed to the corporeal remains of saints and other sacred persons, or to articles, such as clothing, on the basis of tactile contact, is attributed to paintings on the basis of visual contact. The idea that "art" is the product of human contact with the divine is not new (in the neo-Aristotelian Scholastic literature, the exemplum is given to the artist by God), but Leonardo's interpretation of that contact in terms of his privileged scientific understanding is.[28]

More significant historically than any particular interpretation for understanding the initial historical horizon of viewer expectations is the procedure of looking for symbolic meanings—that is, the meditational practices described by Augustine in De doctrine christiana (3.5.9), Gregory in In Canticum, Bonaventure, and numerous other sources.[29] Viewers need not have chosen among a painting's many symbolic associations; rather, meditation on the icon, like the contemplation of sacred text by a literate person, inspired a continual chain of associations with sacred Scripture. For worshipers, rich possibilities for semiosis brought the image to life. But whereas rumination was a practice of meditative reading limited to the educated elite, visual symbols without text were potentially universally accessible to anyone seeking salvation.

To take a specific example of the various connections that religious beholders of the time could have made while contemplating Leonardo's painting, the most salient symbol in the Virgin of the Rocks (aside from the holy figures themselves) is the grotto, an age-old locus throughout Magna Graecia for access to the divine.[30]

Over time, many variants of the sacred grotto emerged. No matter what specific symbolism Leonardo's patrons or the artist himself intended, therefore, the "meaning" of the grotto in the context of the painting was ultimately determined by the audience. Grottoes are places where life is both generated and comes to an end—a cosmos created in minia-

ture. In its specifically Christian guise, the grotto can serve as a reference to the mystery of the Annunciation that took place in a grotto in Nazareth; the Nativity in Bethlehem; and the Entombment, Resurrection, and the Ascension of Christ in Gethsemane. Perhaps some viewers were also reminded of apocryphal stories of the Milk Grotto, where the Holy Family sought shelter on its flight into Egypt; or of the sepulcher of the Virgin, believed to be fed by a magic holy well in the Garden of Gethsemane; or John the Baptist in the wilderness, given the innovation of including him in the scene.[31] Because San Francesco Grande was a cemetery church, a grotto's allusion to the Anastasis (the Harrowing of Hell) might have featured prominently in some beholders' imaginations. For the Franciscan tertiaries who commissioned the subject, the visual reference no doubt reminded them that Saint Francis received the stigmata in a similar setting at Mount Alverna, near this very church.[32] And no matter where or by whom the painting was viewed, the Latin word meaning stone *(petra)* could be read out of the image as a visual sign of Christ and of Peter's founding of the terrestrial church as a safe haven.

In short, the grotto is a site and a symbol of passage, healing, and revelation. The image encoded its audience in a variety of ways. Leonardo's painting, simultaneously erudite and broadly accessible, served a number of purposes. Connotations of a marriage blessed with male heirs no doubt appealed to the dynastic concerns of state rulers. According to Snow Smith's research, this specific pairing of John the Baptist with the Virgin presents a scene of consummation with deeper theological significance: with the incarnate God present as the infant Christ, the pairing refers to their analogous roles as instruments of the "revealed" Trinity. These associations would have been more apparent when the altar painting was displayed in its original gilded frame with three inserted panels of God the Father, cherubim, and seraphim (as well as flanking panels of prophets by Ambrogio de' Predis).[33]

For a lay audience, it was the image of the Virgin specifically that functioned as a mediator between human and divine realms, depicted by Leonardo in the mystic form of a vision seen in the fourteenth century by Saint Bridget of Sweden, whose visions, incidentally, were shaped by her experience of painting.[34] The style of representation, by contrast, was thoroughly contemporary: the most accomplished mode of scientific naturalism combined with classicizing sculptural figures. Iconographic studies leave the purpose of stylistic differences between the

two altarpieces unexplained. Why, for example, is the lighting in the London version (Figure 3.3) so much harsher? The jarring highlights are usually attributed by Leonardo scholars to the artist's associate Ambrogio de' Predis, responsible for completing the London version to the Confraternity's satisfaction.[35] What could account for both the iconographic consistencies and these subtle visual differences between the two versions?

There are additional interpretative possibilities, not necessarily exclusive of one another. The presence of John and the emphasis on water make a reference to baptism unavoidable. In this connection, a Greek parallel to the harsh but naturalistically rendered light in the London version offers significant clues about its possible symbolic value. The painting, displayed in a setting where the reference to the Christian doctrine of salvation was omnipresent in its treasury of relics and cemetery of saints, conjoins themes of (re)birth and baptism: the imagery of light is used to describe the initiating rite of baptism (the original Greek name of which, *photisma,* means illumination). In a passage of striking beauty from a late-third-century commentary on Revelations 12:1, Methodius of Olympus describes how the initiate reenacts the role of the mysterious woman described in the scripture as clothed with the sun. She/the initiate becomes an image of moonlight emanating from darkness, much like the Virgin herself in Leonardo's rendering (notably, the unusual saffron lining of the Virgin's dark blue robe, as it folds, falls into the shape of the crescent moon, associated with both the mysterious woman of the Apocalypse and the Virgin of the Immaculate Conception conceived by Saint Bridget):

> For moonlight seems to bathe us like lukewarm water, and all humidity derives from the moon. The Church must preside over the baptised as a mother: it is thus that her function is called moon *[selene],* since those who are renewed shine with a new glow *[selus],* that is, with a new brightness, which is why they are also called "newly illuminated": the Church shines in their eyes, through the phases of the Passion, the full moon of the Spirit . . . until the radiant and perfect light of the full day.[36]

Baptisms by moonlight have a long history in Christian ceremony, and although any connection between the *Virgin of the Rocks* and nocturnal baptisms is only conjectural, it is significant that baptisms held just before dawn were popular in north Italy at the time of this commission.[37]

Viewing Leonardo's painting from the perspective of lay devotion establishes yet another historical horizon, a performative context that has not previously been connected with the painting, although its relation to Marian devotion has been mentioned.[38] Throughout the western Mediterranean basin, popular shrines in churches and community chapels are frequently dedicated to the Nativity in a grotto, usually represented in the three-dimensional form of a miniature creche scene and often in the same manner as Leonardo's painting, that is, according to the mystic vision of Saint Bridget of Sweden. One of the most monumental Nativity grottoes that survives is an eighteenth-century mixed-media tableau located in the monastery church of Santa Magdalena in Palma, Mallorca (Figure 3.5). On the island of Mallorca, the large number of such scenes still in situ at popular shrines and church chapels may be related to the extensive presence of natural springs. It is difficult to avoid seeing at least *some* connection between the widespread existence of these springs and caves in Mallorca and the widespread presence on the same island of creche scenes depicting the epiphany of Christ, that is, the theme that the Leonardo literature describes as the Virgin in a grotto. The connection is likely to be found in the broader cultural significance that grottoes held in the popular imagination since ancient times, when they were already places associated with birth and death, and female divinity.[39]

In point of fact, however, it is difficult to say whether Leonardo really depicted a grotto in his painting. The background looks more like an architectural facade employing stock motifs—a strange configuration of craggy rocks and running water imitating a grotto, rather than an actual cave or rustic nymphaeum. Possibly Leonardo intended his audience to register a faux grotto (i.e., a faux faux cave). As far-fetched as this conjecture might seem initially, in the same years that the commission was fulfilled, life-size tableaux with sculpted figures dressed in costumes, situated in theatrical settings made real by the inclusion of props and scenery depicting the main scenes of the Passion in the Holy Land, were installed just outside Milan at Varallo by the Franciscan Oratory, executed by artists in Leonardo's immediate circle.[40]

There is, moreover, specific precedent for grottoes in theatrical architecture. Vitruvius (*De architectura* 5.6.9) prescribed grottoes for the scenery of satyr plays, and monumental theatrical structures with grottoes

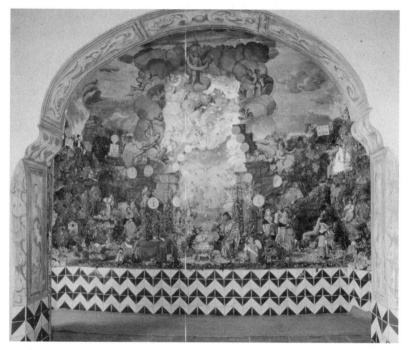

Figure 3.5. Creche, Monastery of Santa Magdalena, Palma, Mallorca, eighteenth century.

survive from the early Roman empire, at Sabratha as the background scene *(frons scaenae);* at Ephesus as the facade of the Library of Celsus, and elsewhere. Naomi Miller thinks it probable that the *frons scaenae* formed by monumental nymphaea in certain theaters became an architectural formula that was often used for other purposes, as in the Library at Ephesus just mentioned, or in the sacro-idyllic conventions of Pompeian wall painting and Campanian maritime villas.[41] Leonardo himself had sketched a variant of the architectural topos of the grotto among his ingenious theatrical designs, notably a movable mountainous setting depicting a subterranean world, preserved in the Codex Arundel, probably dating from 1496.[42]

Would Leonardo's original audience have associated the background of the *Virgin of the Rocks* with the stage set of a mystery play or a diorama like the scenes constructed at Varallo? The difference between the depiction of a grotto and the depiction of a false grotto involves questions about the nonexistence or existence of a second-order reality in the painting (that is, is the painting the representation of a representation?).

Remaining (for now) with the context of lay devotion—without having to decide whether the background depicts a "real" grotto or a theatrical facade—we can observe that actual sculptural assemblages lit by artificial light in church interiors had established the viewers' expectations in this direction.[43]

Viewing "high art" through the lens of participatory material culture is historically justified by just these kinds of "crossovers."[44] Visual demonstration is the key, shared element in conveying the idea that the divine is immanent in the created world. And the older root of the same idea is the promise of salvation and everlasting life that every presentation of the sacred offers to the faithful—although the primary condition that a relic must fulfill is actual physical contact with the holy (relics are indexical signs) rather than a close artistic copy of a holy person (figurative representations, regardless of their style or pictorial conventions, are iconic signs in the Peircean sense). The evident theatricality both calls attention to and masks the presence of the real that Christian doctrine postulates.

The culturally assigned meaning of color, light, and other optical phenomena in Byzantine art, as documented in the ekphrastic literature, also suggests numerous parallels with Leonardo's paintings, despite the great visual differences between Byzantine and Italian Renaissance pictorial style. If the lifelikeness of the image, as described by Byzantine ecclesiastical writers, conveyed theological truths at the experiential level, then the possibility also exists that Leonardo's painted descriptions of nature were meant to do the same thing—that is, provide material signs of the presence of the spiritual world. Is it possible to demonstrate that Leonardo was indebted specifically to theological metaphors and not just to classical literary formulas on which both the conventionalized Byzantine descriptions of art and Leonardo's are ultimately based?

Unconventional interpretive strategies are needed to address the question of Leonardo's possible indebtedness to theological metaphors. Leonardo rarely alluded to the devotional context in which many of his paintings functioned. It is up to us to remember that the original audience for the two *Adorations* (had they been completed), the *Last Supper*, the *Virgin of the Rocks*, and even the smaller devotional panels eagerly sought by discriminating collectors contemplated Leonardo's images of nature through a cultural lens very different from our own secular

framework. Optical effects such as the shimmer, luster, and glow of light and color defined, in Leonardo's view, the capabilities of the painting medium at its most praiseworthy level of artifice. The same is true for Byzantine mosaics, as the extensive ekphrastic literature to which we now turn attests.

Leonardo's descriptions of nature, and his claims for painting generally, are usually contextualized as objective renderings of external appearances. Seldom, if ever, do we study them in terms of the emotional response he intended his images to elicit from viewers. Yet as the producer of these effects, Leonardo saw himself from the standpoint of reception, claiming that the painter so faithfully imitates the created world that he "transmutes himself into the actual mind of nature." This act of transformation enables the painter to render truthfully nature's most ephemeral and subtle details by his art:

> The painter will demonstrate various distances by the variation of color of the air interposed between objects and the eye. He will demonstrate how the species of objects penetrate mists with difficulty. He will demonstrate how mountains and valleys are seen through clouds in the rain. He will demonstrate dust itself, and how the combatants raise a commotion in it. He will demonstrate how fish play under the surface of the water and in its depths. He will demonstrate the varied colors of polished pebbles lying on the washed sand in river beds, surrounded by verdant grasses beneath the surface of the water. He will demonstrate the different heights of the stars above us and, similarly, innumerable other effects.[45]

Movement of the senses expressed through optical effects is a fundamental trope that the Latin West inherited from medieval Greek literature. The movement of the senses is also widely recognized to be one of Leonardo's central preoccupations. Moreover, similar claims for sensate judgment are at stake in both Greek Orthodox justifications of religious images and Leonardo's polemical defense of painting as a form of scientific truth that appeals to the sense of sight. At the eighth Ecumenical Council held in Constantinople in 869 and 870, Patriarch Nikephoros of Constantinople differentiated words from images in terms that Leonardo's polemics echo:

> For often what the mind hasn't grasped while listening to a discourse, the sight seizes without risk of error, has interpreted it more clearly.... [Painting] directly and immediately leads the mind of the viewers to the facts themselves, as if they were present already, and from the first sight

and encounter a clear and perfect knowledge of these is gained.... For often some difficulties and disputes arise from words, and in all likelihood diverse thoughts are brought forth in souls. Many people produce contradictions and disputes both within themselves and with others, not understanding what is said. But belief is gained from visible things, acquired anywhere free from ambiguity.[46]

Byzantine apologists for images saw icons as representations of the truth. Leonardo saw scientific painting as doing the same thing. It is not just Leonardo's defense of painting as the superior art, however, that bears a striking resemblance to Byzantine justifications of images. The Byzantine ekphrastic literature that makes use of metaphors of light, color, and other natural phenomena reverberates in Leonardo's texts, too. Yet the literature that describes Christian ritual is so vast, and its sources in classical formulas so direct, that a close reading of parallel texts would not be able to differentiate among Leonardo's many possible debts.[47] In any event, Leonardo's dependence on these sources is not so literal that a philological approach can adequately document the meaningful continuities. The sustained presence of certain arguments and associated ideas is far more relevant and indicative of the nature of Leonardo's debts to Byzantine theological metaphors.

The prime difficulty is to determine whether Leonardo intended to recall theological metaphors. Or are the intertextual correspondences merely inert patterns embedded like fossils in his texts? Aside from Leonardo's unprecedented characterization of the painter as an almost divine artificer, his writings are not routinely associated with religion.[48] The main reason is Leonardo himself: he rarely mentioned religious topics—when he did, his comments were usually derisive.[49] On the other hand, Leonardo's scientific investigations of optical phenomena found numerous applications in his religious paintings. What are we to make of this disjunctive self-fashioning? How do we account for the *interaction* of science and religion in Leonardo's artistic practice?

In anticipation of the comparisons that follow, it is important to establish that radically different visual traditions developed in Greek and Latin Christianity on the basis of the same Graeco-Roman heritage in literature and science. On the other hand, it would be false to draw firm distinctions between Byzantine and European visual traditions.[50] The important point in the present context of discussion is that artistic resemblances owing to a shared *textual* tradition need not be visual—they

can be *conceptual*. Eleven centuries of intensive cultural interaction between Greek and Latin Christendom—a significant portion of which took place on the Italic Peninsula—produced two cross-fertilized but institutionally segregated visual traditions. Modern disciplinary subdivisions between Byzantine and Renaissance art discourage inquiry into the interactions that actually transpired between them.

What Leonardo's descriptions of praiseworthy painting might owe to Byzantine ideas of aesthetic response has never been considered a topic for investigation. In turning to this subject now, it will be useful first to establish some broad conceptual frames of reference spanning the disciplinary and cultural divide. The upward movement of the soul is a fundamental symbolic expression for the doctrine of salvation throughout Christendom.[51] Since early Christian times, the church used the metaphor of motion to convey its deepest theological message through appeals to the senses, above all the sense of sight. Neither Europeanist nor Byzantinist art historians customarily address the significance of religious representations in these general terms when they speak about church decoration or the literary traditions that accompany it. Yet a cluster of fundamental Christian metaphors focused on light metaphysics and *dynamis,* the implied movement of the image due to the presence of the soul, were communicated to Christian worshipers in the Greek East and Latin West through optical and coloristic effects.[52] The passage of the soul to salvation from its fallen earthly existence was symbolized in the act of procession: the internal passage of the soul metaphorically conceived as a vertical ascent was represented in real space by the movement of worshipers through the church from the west entrance to the altar, reliquary, shrine, or baptismal font at the east end. The ritual procession/purgation that took place in a single building was enacted on a larger scale in urban stational liturgy and in long-distance pilgrimage.[53]

The "living" image of the icon engages the individual devotee on an experiential level analogous to the processional church. Motion understood in this broad sense refers to the phenomenal world of things that come to be and pass away. Leonardo himself wrote about pictorial perspective as a science of motion using this Aristotelian terminology, and he defined painting as philosophy for this reason.[54] The imagery for the movement of the soul developed differently, however, in the Latin-speaking parts of the former Roman Empire than in the Greek-speaking

regions under Byzantine control. The entire interior of the Byzantine church, covered with mosaics like its Islamic counterparts and Roman precedents, was often interpreted in terms of its effect on the beholder. This concern with the interior movement of the senses, initiated by the external play of light and color, is arguably also the most original characteristic of Byzantine ekphrastic literature.[55] This movement is initiated through the contemplation of details. Chorikios of Gaza, describing the Justinian Church of Saint Sergius at Gaza in the sixth century, wrote that "when you enter [the church], you will be staggered by the variety of spectacle. Eager as you are to see everything at once, you will depart not having seen anything properly, since your gaze darts hither and thither in your attempt not to leave aught unobserved: for you will think that in leaving something out you will have missed the best."[56]

In the eleventh century, bracketing the Iconoclastic Controversy at the other end of the era, the scholar-monk Michael Psellus recorded in his *Chronographia* (a history of Byzantine rulers) an extended description of the interior of Saint George of Mangana, every part of which "took the eye, and what is more wonderful, even when you gazed on the loveliest part of all, the small detail would delight you as a fresh discovery."[57] Byzantine writers frequently described the optical effects of church decoration in these terms.[58]

While I do not wish to discount the important differences between texts written five hundred years apart, here my concern is with the ontology implied when movement is described by Chorikios, Psellus, and many other writers as visual delight. This movement is psychological in the sense that it takes place entirely *within* the beholder, just as in the Latin West, but the imagery that catalyzes it was not based on the direct imitation of natural appearances. Literary re-creations of the visual experience of church interiors, although highly conventionalized, are consistent with the nature of Byzantine liturgy to involve all the senses. In the formal setting of worship, devotees touched the holy chrism, tasted the Eucharist, smelled the incense, heard the word of God, sang chants, and saw the icons. The early-twentieth-century Russian Orthodox theologian Pavel Florenskij calls the live performance involving all the senses the Incarnation in liturgical action.[59] With or without the aid of liturgy, icons, ekphrastic descriptions, and other sacred implements indicate how broad the range of ways has always been to stimulate the senses in the service of religious experience.

Modern accounts of Byzantine ekphrastic literature acknowledge that
the frequent use of optical metaphors derived, above all, from Hellenis-
tic literary formulas. They are evidence of a continuing concern with
the lifelikeness of art.[60] John Gage writes about the Byzantine aesthetic
of color in motion, citing the conspicuous display of color in church in-
teriors, where mosaics were deliberately set to create an irregular sur-
face that gives a soft, fluid, shimmering effect, especially when lit by
candlelight and torches during services.[61] The prevailing Byzantine aes-
thetic of color in motion, grounded in the liturgy, gave a fundamentally
new Christian context to inherited literary formulas.[62]

Leonardo's own debt to Byzantine *iconographical* types has been demon-
strated on the basis of Florentine compositional formulas known since
the late thirteenth century.[63] Byzantine pictorial conventions, however,
are far more abstract than anything Leonardo drew or painted. As artic-
ulated by John of Damascus, the lifelikeness of the image must never
cause it to be confused with its divine prototype.[64] In the West, where
no sustained Iconoclastic Controversy shaped such arguments for the
figurative arts, the Aristotelian equation between nature and art pre-
sented the possibility of intentionally deceiving the viewer through the
imitation of appearances. It was, in other words, *correct* for images to
closely imitate the direct apprehension of the world through sight, as it
was not in Byzantium.[65] The formal elements of the Byzantine icon in-
dicate that it is a copy of its archetype. Its style of rendering also re-
minds the viewer never to confuse the image with the original or proto-
type. Naturalistic images of the kind Leonardo crafted would have been
considered incorrect by Byzantine standards for the same reasons—
their formal qualities were meaningless to their audience.[66]

The significant point of similarity between Leonardo's descriptions
of nature in painting and Byzantine *ekphraseis* concerns the role of light,
color, and other sensed data in the spectator's experience of the image.
For the Byzantines, the actual materials—not so much the illusionism
as the actual colors themselves interacting with their environment—
were responsible for moving the viewer. The shimmering effect of light
passing over the surface of mosaics in a darkened church interior lit by
candles is analogous to the effect Leonardo envisioned his depictions of
smoke, dust, transparent water, mists, and other natural phenomena
would have on his audience. In both cases, the direct sensual appeal of

the image was meant to delight, move, and instruct the spectator—the three distinct aims of language according to the rhetorical theory that Greek and Latin Christianity inherited from the ancient Roman world—combined into a single visual event.

The epistemological position that supports this rhetorical reading of images was widely diffused in the East and the West. Both Leonardo and Byzantine apologists for icons claimed that visual images, unlike words, are the works of nature. Arguments about the relative merits of words and images formulated during the Iconoclastic controversies in Byzantium were taken up by medieval writers in discussions of the mechanical arts. According to Hugh of St. Victor, images of God could reveal knowledge of God beyond the power of words because words are arbitrary conventions made by man, whereas wordless manifestations take into account visible qualities: images speak in the language of God (*De Scriptori et Scriptoribus Sacris,* 14).[67] And the language of God, of course, is nature.

Hugh of St. Victor also valued images above words, because most words have only "two or three meanings, but every thing may mean as many other things as it has visible or invisible qualities in common with other things."[68] The outline of an image, or its shape, has the purpose of "stimulating the memory and inciting the emulation of what may be represented" *(De imaginibus).*[69] Leonardo's frequent statements that painting imitates the shapes (figures) that enclose the works of nature stand as a successor to this medieval statement on the manner in which the shapeless receives shape in accordance with our human nature.

Hugh, like Leonardo, argued that the soul can immediately know the intelligible (i.e., God) through an image. Hugh's ideas, which Leonardo may never have known directly, are ultimately indebted to Aristotle's theory that the memory creates "universals" selected out of sense impressions (*Post. Analytics* 99b35–100b). Aristotle's model, transformed by Late Antique writers who praised the divine power of the *phantasia* to imagine things not found in nature, was incorporated by Iconodules like John of Damascus into a theological justification for the use of images made by art, in prayer.[70] In Byzantine justifications of images made by art, the immediacy of the image and the discursive nature of the word were distinguished as two different modes of knowledge. This distinction was also maintained in western Europe, first through Latin texts and later in modern vernacular printed texts. Leonardo lived at the

intersection of this transition to vernacular culture, though it was far from the secular society of today. There is reason to suggest that when he wrote his defense of painting, he was directly informed by the arguments disseminated from Byzantium.

Leonardo integrated two different discussions from rhetorical theory about the external manifestation of movements of the mind, one depicted in the gesture and expression of the represented figures, and the other depicted in the splendor of natural color and other visual phenomena. The *literary* record suggests a series of parallels between Leonardo's defense (and practice) of the lifelikeness of painting and Byzantine ekphrastic writings. Ideas migrated from Scholastic theology to Dante, one of Leonardo's most important known sources, who described light rays within transparent colored substances and reflecting from polished surfaces that dazzle the eye, in terms that anticipate many of Leonardo's images with their extraordinary and unique treatments of light—from the early Madonnas to the Louvre *Virgin with Saint Anne* (Figure 3.6) and the enigmatic *Saint John the Baptist* (see Figure 5.1 in this volume). Like the *Saint John*, the Virgin in the *Virgin of the Rocks* (Figures 3.2 and 3.3) emerges from the darkness and is presented to the viewer as a relic—that is, as a concrete manifestation of the real presence of the divine attributed to the corporeal remains of saints and other sacred persons, or to articles, such as clothing, that came into contact with them.

Portraits of saints—icons—were perceived by, and functioned for, the faithful as artificial relics. A smiling angel pointing to the display in the 1483 version (Figure 3.2) encourages beholders to venerate the Virgin and affirm her presence, simultaneously feigned (in paint) and real (according to Christian doctrine, behind the copy is the living God, its prototype).[71] This gesture is suppressed in the later version (Figure 3.3), perhaps to avoid a theological ambiguity, as Snow Smith suggests, but the connotations are no different.[72] In the *Saint John*, angel and relic merge into a single blissful figure: emanating light, cloaked, paradoxically, by darkness. In both cases, Leonardo presents viewers with a startling coincidence of opposites in two registers: through the formal means of chiaroscuro and figurative gesture.

Leonardo connected the artist's *ingegno*, or powers of imagination, with the "categories of vision," based on Aristotle and later optical theorists, and with the "ornaments of nature," derived from literary theory. The notion of the *fantasia* as a complex of powers that could both collect

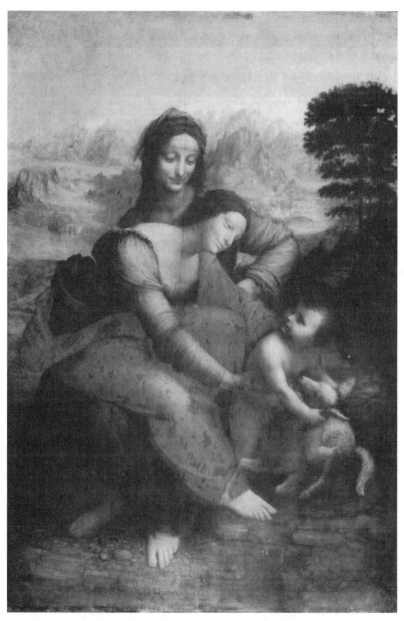

Figure 3.6. Leonardo da Vinci, *The Virgin, Christ Child, and Saint Anne*,
c. 1508–1513. Oil on wood. Louvre, Paris. Copyright Réunion des Musées
Nationaux/Art Resource, N.Y.

images, as a mirrored surface is "impressed" with images, and function like a syllogistic process, considering "now this thing and now that," originates with Aristotle (*De memoria et reminiscentia* 449b). The associations were reinforced by subsequent writers from Boethius to Ibn al-Haytham, one of Leonardo's sources of optical theory, although it is difficult to say whether his manuscripts reflect direct access to these ideas through manuscripts.[73] By making their *ingegni* like the surface of a mirror that contains the similitude of whatever object is placed before it, painters, Leonardo argued, speculate about the causes of nature, that is, the eternal aspect of created things or formed matter. Painters study nature by analyzing the properties of natural appearances, synthesizing from them new images formed in the imagination. It is by combining memory, present experience, and knowledge of nature's eternal causing principles that painters use their *ingegni* to "discourse" about the properties of observed phenomena.

Leonardo conceived of the imagination in mechanistic terms, as a mirror, as did Dante in a passage of the *Convivio* that may have been a direct source of Leonardo's discussion of the "mental discourses" *(discorsi)* in the painter's imagination that enable him to "transmute" his mind into that of nature.[74] Thomas Aquinas and Dante both described the passage of images through the optic nerve as a *discorso* in which the images are constantly transmuted according to the properties of vision. Leonardo conceived of painters as being able to "transmute" themselves into the mind of nature to render its details *(discrezioni)* with scientific truth. The *ingegno* of the painter ought to resemble the similitudes in a mirror, which are "always transmuted by the color of the objects placed opposite it" (MS A, 111v, c. 1492; R. 506). The painter should know how to use his *fantasia* by turning his attention to various objects, considering "now this thing and now that, collecting a store of diverse facts selected and chosen from those of less value." Even at the end of his life, Leonardo wrote in identical terms that the mind of the painter "should be equal in nature to the surface of the mirror," which transmutes itself according to the variations of objects that come before it.[75]

Dante's arguments hinge on the important Scholastic distinction between the transmutable sensitive mind and the immutable intellective mind: one is concerned with particular visible images, and the other with principles, essence. Leonardo makes the same point. We could say,

transposing this distinction into the language of Byzantine theories of the icon, that image and archetype are formally joined. In similar terms, Leonardo frequently extolled the "divine proportionality" of painting, made accessible directly to the sense of sight, though not among nature's visible phenomena, thanks to the painter's scientific knowledge:

> [The painter] makes beauty permanent for many, many years, and it
> is of such excellence that the harmony of its proportionate members
> is kept alive, which nature with all her powers could not conserve. . . .
> For beauty *[bellezza]* consists only in the divine proportionality of
> the members composed together at one time. Such divine harmony in
> the conjunction of members often captivates the viewer. . . . Painting
> composes a harmonic proportionality from different members
> simultaneously, the sweetness of which is judged simultaneously.[76]

The icons made by Byzantine artists may *look* different from Leonardo's religious images, but they share an underlying, widely held assumption that human understanding of the divine is reached through the senses, above all through the most noble sense of sight.[77] By emphasizing the importance of appealing to specifically human modes of cognition, Byzantine apologists for icons deflected the charge of idolatry, which, at the height of the Iconoclastic Controversy, was couched in complex Trinitarian language as a christological dilemma. The solution formulated by Iconodules was that images cannot and do not have presence: their similarity to the prototype is only formal—image and copy are not linked in an essential unity as are Father, Son, and the Holy Ghost.[78] Speaking to this point of view in the eighth century, John of Damascus, Patriarch Nikephoros, Theodore of Studion, and others later on proposed a definition of icons that *denied* the *presence* of the prototype in artificially made images (as opposed to natural ones, like relics, the divine image in us, or Christ as the image of God). The Greek Orthodox Church, following the resolution of the Iconoclastic Controversy in 843, endorsed the use of images in liturgy in line with this point of view: images are necessary in liturgy because they are suited to human ways of knowing through the senses.

Byzantine arguments for the supremacy of image over word and Byzantine descriptions of reflected and transparent color and light are remarkably similar to Leonardo's statements. Ekphrastic descriptions of church

interiors (before and after Iconoclasm) often include elaborate attention to the colored stones and glass. These *ekphraseis* imply paradoxical dimensions to the worshiper's experience of the actual church interior. One of the most extensive and well known of such descriptions is the sixth-century account of Hagia Sophia in Constantinople by Paul the Silentiary, who described the materials out of which the church interior is composed as if he were reporting on an actual landscape. The effects of color and light that interested Paul recall Leonardo's praise for the unsurpassed ability of painting to imitate the details *(discrezioni)* of nature:

> Upon the carved stone wall curious designs glitter everywhere . . . the stones imitate the glories of painting. . . . Yet, who, even in the thundering strains of Homer, shall sing the marble meadows gathered upon the mighty walls and spreading pavement of the lofty church? Mining [tools of] toothed steel have cut these from the green flanks of Carystus and have cleft the speckled Phrygian stone, sometimes rosy mixed with white, sometimes gleaming with purple and silver flowers. There is a wealth of porphyry stone, too, besprinkled with little bright stars that had laden the river-boat on the broad Nile.[79]

Obviously any connection between Leonardo and Paul the Silentiary is indirect—all the same, a continuous history of culturally constructed meanings exists. The arrangement of colored stones functioned for the Byzantine viewer in a similar way as natural phenomena depicted in the artificially constructed image did for Western viewers. In both cases, the sensation of color and light aroused the beholder and contributed directly to individual religious understanding. The rhetorical theory of eloquence is a mediating tradition that helps to explain the continuity between Byzantine descriptions of precious materials and Leonardo's descriptions of how the painter simulates nature: materials and artistic skill both embellished the image.

Another mediating tradition for which textual evidence survives is the genre of treatises on gems and minerals, such as the lapidary composed by Albertus Magnus circa 1250, or the treatises that Leonardo's contemporary Andrea Mantegna could have consulted to achieve his veristic imitations of rare colored marbles, or even the treatise on the colors of gems published by Ludovico Dolce in the mid–sixteenth century. All these texts preserve the formula for describing the colored patterns on stones by comparison with the sun and stars and other landscape elements.[80] The use of precious colored stones on church interiors—and,

by implication, imitations of them in paintings—were not only exercises of artistic skill and imagination, the qualities that modern viewers admire; they were emotional catalysts presented in visual form. For the original viewer of the sacred setting, these subsidiary decorations served a religious purpose; at least the Byzantine ekphrastic literature makes this abundantly clear.[81]

Luminosity was the vehicle of a Christian iconography of light. Texts known in both the Latin West and the Greek East, such as the Pseudo-Dionysian *Celestial Hierarchy* perhaps known directly to Abbot Suger, facilitated cultural exchange and appropriation of language about the formal qualities of images and materials. According to his own testimony, Suger was competing with "the treasures of Constantinople and the ornaments of Hagia Sophia" when he ordered decorations for St. Denis, such as the famous chalice now in the Washington National Gallery.[82] We do not know exactly what the relationship between craftsmen, theologians, and optics actually was in Byzantium, but the material and textual evidence indicates that interchange did exist.[83] In the final analysis of exchanges of information and ideas, it must also be emphasized that metaphysical descriptions of materials and processes are by no means limited to Byzantine writings—they are the product of a culturally diverse heritage. Iberian Islamic appreciations of textiles refer to the optical effects of reflected color, color transparency, mixture, and juxtaposition.[84] In the Latin world, the popular rhetorical figure of *descriptio*, which is the medieval term for *ekphrasis*, was reserved largely for just such paradoxical descriptions of materials and processes.[85]

The painted figures of Byzantine style icons appeared lifelike, in possession of *dynamis*, because they revealed emotions such as grief and love and performed the gestures of speech, largely through the economy of color and light. Recognizable rhetorical types also performed narrative functions by engaging the other figures or the viewer in an internal dialogue.[86] Far from negating the divine power of icons, evidence of artistry provided Byzantine writers with opportunities for inventing new theological metaphors.[87] And vice versa, the expectation of ekphrastic commentary must have invited the conspicuous display of artistry. The form of display, however, was very different from the classicizing conventions of scientific naturalism that Leonardo developed.

Evidence of artistry, valued in terms of its sensate appeal to the beholder across a wide range of styles and even media, has implications

for the religious function of images far beyond the realm of what came to be known—but not before the eighteenth century—as "fine art." The elaborate tableaux at Varallo, mentioned earlier, that re-created the story of Christ's Passion in the Holy Land (with distances between events rendered at actual scale, the guidebooks insisted), the enormous poly-chrome wax effigies in SS. Annunziata, and the terra-cotta tableaux that are still in situ in many Italian churches convey the same close associa-tion between the lifelikeness of devotional images and movement of the soul toward grace via the senses.[88] In Leonardo's day and well beyond, devotional practice and aesthetic response existed side by side, even prac-ticed by the same person differently in different situations during much of the sixteenth century. Across a broad spectrum of religious orders and writers, sensation was the path to achieving a heightened state of religious awareness.

When the patriarch Photios, building on the arguments developed by his predecessor Nikephoros a century earlier, lectured in 867 on the proper use of images to commemorate their restoration in Hagia Sophia, he explained the function of the image in optical terms. Photios argued that images are necessary to religious devotion because the senses, and sight above all others, are our natural human way of learning:

> Just as speech is transmitted by hearing, so a form through sight is imprinted upon the tablets of the soul . . . it is the spectators rather than the hearers who are drawn to emulation. The Virgin is holding the Creator in her arms as an infant. Who is there who would not marvel, more from the sight of it than from the report . . . ? For surely, having somehow through the outpouring and effluence of the optical rays touched and encompassed the object, it too sends the essence of the thing seen on to the mind, letting it be conveyed from there to the memory. . . . Has the mind seen? Has it grasped? Has it visualized? Then it has effortlessly transmitted the forms to the memory.[89]

In his defense of the painter's art, Leonardo wrote about the same phenomenon as Photios in strikingly similar terms, citing theories of vision and describing viewers being drawn to the sight of a holy image more than to words about God: "Who is there who would not marvel, more from the sight of it than from the report . . . ?"[90] Leonardo inher-ited the Western medieval attitude toward light and sight from a variety of scientific and literary sources. His ideas, not constrained by Byzantine theologians, however, broached the issue that Iconoclasts and Iconophiles

alike feared most, namely, that images may be used out of ignorance as idols rather than as gateways to the ineffable godhead.[91] Leonardo advanced the same argument as Photios, namely, that images are more effective than words, but in doing so he advocated, half-seriously, what Photios's argument was intended to circumnavigate—the danger that images are treated as divine presences in and of themselves:

> Do we not see that paintings which represent divine deities are continuously kept covered with their most expensive coverings, and that when they are uncovered, first great ecclesiastical solemnities are held, with various songs accompanied by different instruments? At the moment of unveiling, the great multitude of people who have assembled there immediately throw themselves to the ground, worshiping the painting and praying to the one who is figured in it, in order to acquire the health that they have lost and for their eternal salvation, as if in their minds such a god were alive and present. This does not happen with any other science or works of man. . . . Certainly you will confess that it is this simulacrum, which does what all the writings cannot do—to potently figure the virtue of such a Deity in an effigy.[92]

My aim in juxtaposing the texts of Photios and Leonardo is not to collapse the distinctions between Latin and Greek Christianity but rather to set them into a dialectical relationship with each other. In one sense, Leonardo's preoccupation with presence is the inverse of Photios's denial, in his stress on absence. Yet their respective arguments for the truth value of material aids that appeal to the sense of sight both depend on an Aristotelian physiology of the senses. Considering Greek and Latin Christianity as one heterogeneous cultural formation, rather than two discrete homogeneous ones, enables us to better understand the Christian discourse on images—the tensions, slippages, contradictions, and denials constitute a meaningful semiotic relationship, not independent trajectories or parallel developments.

Leonardo recorded many variations on the theme of vision that are preserved in the first part of the Codex Urbinas.[93] The issues aired during the Iconoclastic controversies were revived during the sixteenth-century reformation of the church. The aesthetics of devotion were secularized over the following centuries. Past scholars have tried to elucidate the mystical strains in Leonardo's paintings on the basis of their own emotional response to the artist's psyche, manifested directly in his visual forms. At the very least, the present study has established on historical

grounds that the combination of motion and emotion is neither natural nor fortuitous—rather, the combination constitutes a cultural signature broad enough to encompass Greek and Latin Christianity. Art historical scholarship is directly in the line of succession to religious ekphrastic literature.[94] The socially constructed nature of subjectivity acquires an entirely new resonance in this historical context.

The simultaneous condensation and displacement of meaning that Roman Jakobson described in the early twentieth century is still the current way to account for sign systems.[95] Theoreticians have since tackled sign systems in many different realms, but the linguistic model (poetic texts, avant-garde texts) remains normative, even for writers such as Roland Barthes, who, early on, experimented with the application of structural theory to nonverbal sign systems such as the "fashion system."[96] Poetic language, avant-garde texts, and dreams are the exceptions that prove the rule in twentieth-century discussions of intersubjective meaning: these types of sign systems displace and redistribute the relation of sign and meaning in such a way that the distinction between signifier and signified is blurred, complex, multivalent, polysemic, open-ended. Such nondenotative use of language emphasizes the artifice or craft of writing over the mimetic relationship between language and external referent. In doing so, it also demonstrates the artificiality and arbitrariness of denotative meaning.

Denotative language posits a mimetic relation between art and the world. In doing so, it both masks and calls attention to the means of its own making. Art history trains viewers to imagine that only a few geniuses (Duchamp, say) played with this issue; but in fact it is the simultaneity of masking and display that maintains the constructedness/naturalness of the formed subject. Leonardo himself was fond of saying that the more true a given depiction of the external world appears to be, the more false it really is.[97] Denotation, in other words, as Leonardo recognized, is a rhetorical strategy like every other form of artifice, no more and no less.[98]

But need there really be two distinct orders of being, representation and the "meaning" of representation? Could "meaning" be something inextricable from the material manifestation of the world? Lacan's rereading of Freudian theory is concerned precisely with this question. Lacan's theoretical considerations about the productivity of signs focus on the

"production" of the subject, and he builds a poststructuralist semiotic account of the *un-unified* self on Freud's discovery that dreams make unconscious signification accessible to language. In dreams, several thoughts can appear condensed into one symbol, or one symbol can be displaced into another symbol (to accommodate dream censorship, according to Freud). According to Lacan's critique, however, meaning disseminates itself in the dream according to the position of the subject and the arrangement of the signifying chain in relation to this position. Because of this, it is never possible to separate the domains of the conscious (conventionally identified with denotation) and the unconscious (conventionally identified with condensation and displacement).[99] According to Lacanian theory, the production of the subject, and therefore the subject's ideological positions, are self-contradictory. Derrida is concerned with the same metacritical aporia in his remarks on writing conceived historically as a remedy for "absence." On the one hand, the structure of the subject, constituted by oppositions between terms, is comprehensible only as a totality of relations. On the other hand, because the subject constantly undergoes transformations and substitutions, the subject's self-understanding is always partial, experienced as it is in "real time." Thus the Lacanian subject is produced, like "meaning" in the poststructuralist sign, continuously in its movement.

The museum is the main stage on which the "language" of absence/ de-absencing—rooted in Christian theories of images as suited to human modes of cognition—was and is deployed in modern life. In this essay, I have tried to suggest that art is the anchor for the modern notion of subjective experience and that this notion includes Byzantine theological metaphors couched as descriptions of nature in both verbal and visual media. In the visual arts, as in dreams, denotation and connotation are inseparable and simultaneously present: art historians have long recognized this in the concept of style, but they haven't often recognized *how* a visual sign constructs individual experience. My rereading of the *Virgin of the Rocks* is meant to suggest that art structures subjectivity as a dynamic process that is neither unified nor simply arbitrary. This semiotic openness, I hope to have suggested, is a quality of material works of art that makes them worthy objects of study for anyone interested in the constructedness of experience. The next question, beyond the scope of this essay, is whether the subjective experience of individuals is really as incommensurable as philosophers from Edmund Burke and Kant to

Wittgenstein and beyond contend—or whether such individual/ism is a modernist myth that justifies viewing history as difference from, rather than immanence within, the present.

Notes

Kirk Ambrose, Janis Bell, Anthony Cutler, Elizabeth Dunn, Samuel Edgerton Jr., Frank Fehrenbach, Luba Freedman, Debra Pincus, Donald Preziosi, Wendy Sheard, Claudia Swan, Kathleen Weilgains Brandt, and Robert Zwijnenberg read preliminary drafts attentively, to the betterment of the final version, for which I remain solely responsible. Citations to Leonardo's manuscripts follow standard forms of abbreviation. Passages in the Treatise on Painting (Codex Urbinas 1270) follow the numeration established by Ludwig (1882–1885): (passage 1 = Treatise on Painting, n. 1). The following abbreviation is used: PG = *Patrologia Graeca* (1857–1866).

1. Schapiro 1953.

2. Although its implications are beyond the scope of the present case study, the relationship of Byzantine theological discussions to contemporary accounts of subjectivity is relevant in a broader contemporary frame of reference; on the relationship of Heideggerian thought to Dionysian or negative theology, see Carlson 1999.

3. Among recent contributions see Carrier 1987a, 1987b; Preziosi 1989, 1993; Moxey 1994, 1995; Holly 1996; Soussloff 1997; Kelly 1995.

4. Scott 1991, 777.

5. Derrida 1988, 6.

6. Derrida 1988, 5–6.

7. Bal, this volume.

8. See White 1987.

9. Clark 1988, 76.

10. Clark 1988, 166.

11. See Preziosi 1989 for an incisive analysis of the formula, artist and/as his work.

12. Steinberg 1973, 297–401.

13. Steinberg 1973, 298.

14. See the excellent study by Sohm (2001).

15. As early as 1903, Herbert Horne proposed, on the basis of sixteenth-century accounts of Leonardo's life by Antonio Billi, the Anonimo Gaddiano, and Vasari, and one circumstantial but highly suggestive archival reference, that the duke of Milan Ludovico Sforza gave Leonardo's first painting as a wedding present on the occasion of his niece Bianca Maria Sforza's marriage to Emperor Maximilian I. It is feasible that in 1493, along with some drawings and Leonardo's associate and collaborator on the commission, Ambrogio de' Predis, the painting now in the Louvre went to Innsbruck, in the Tirol. Archduke Ferdinand, the ruler of Tirol residing at nearby Schloss Ambrass, could have appropriated the painting, just as Ludovico Sforza might have some eighty years earlier, to present it as a gift on the occasion of another dynastic wedding, between the French king Charles IX and Ferdinand's niece Elizabeth in 1570. This hypothetical scenario, unlike many other possibilities proposed since, takes into account the surviving documents, the peculiarities of the physical evidence, and the whereabouts of the painting when it was first noted, by

Cassiano dal Pozzo in 1625, as being in the Royal Collection at Fontainebleau. The other possibility is that the Louvre painting was withheld by the artists, who made a copy to fulfill legal obligations set in 1506, when arbitrators ordered the painting be completed for the Confraternity within two years for a certain price (less than the artists wanted). For a review of other proposals, see Cannell 1984. Cannell takes into account the subsequent discovery of additional documents by Sironi (1981), but his own proposal that the Confraternity wanted "an up-to-date painting, more in tune with their religious convictions," following the hypotheses of Snow Smith (see hereafter), is no less speculative than Horne's solution and less convincing.

16. The image is based on the vision of Saint Bridget of Sweden, one of several Immaculatist texts with visual traditions. Saint Bridget's vision of the Virgin in the wilderness was fused with the mysterious woman of the Apocalypse (Revelations 1:12), shown with a crescent moon at her feet—to which the bright yellow crescent of drapery in Leonardo's 1483 painting no doubt refers. See Levi D'Ancona 1957, 64–65, on Leonardo's second version of the painting. On this iconography, see also Robertson 1958. The *synaxis* (get-together) of the Immaculate Conception was imported from the Eastern Church, as were many of the visual traditions associated with it. The exact viewing conditions for the painting in situ are unknown: the gaps in the historical record include the height of the altar, the appearance of the frame, and whether the painting was always accessible or uncovered only on certain feast days.

17. In his earliest writings on optics, circa 1485–1486, and MS A, circa 1490–1492; on which see Brizio 1954, 81–89. On Leonardo's knowledge of Bacon, see also Strong 1979.

18. Cannell 1984.

19. The dominant opinion today is that Besta refers to the panel later bought by Gavin Hamilton, which now hangs in the London National Gallery; see Cannell 1984, 105.

20. Castiglione, "Vite e gesti delli SS. XI Arcivescovi di Milano predecessori al Santissimo Ambrosio," MS 560, Trivulziana Library, Milan, p. 27; cited in Calderini 1940, 198.

21. Giacomo Filippo Besta, "Origine et meraviglie della città di Milano e delle imprese dei cittadini suoi," MS Trivulziana, 180–83; cited in Calderini 1940, 200–201.

22. Besta, "Origine," 390; cited by Calderini (1940, 202), with further references to publications of the relics in Milan, by Bosca (1695), Lattuada (1738), and others.

23. In this connection, it is possible that Ludovico Sforza Il Moro, who had usurped the Visconti line by assassinating the rightful heir, chose (seized) Leonardo's painting as a wedding present for the Holy Roman Emperor Maximilian I because he did not want to be reminded of his predecessors—or at least he did not share their religious preferences to the same degree. Of course, this is just another speculation, based on a tantalizing scrap of evidence, and cannot be proved or disproved. It is undeniable, on the other hand, that Leonardo's design, executed in two versions, served a religious function as an intermediary between the earthly and divine realms, as well as playing an occasional role as an exceptional gift of state.

24. Besta, "Origine," 391; cited by Calderini (1940, 202–3). The reference to Leonardo's painting is clarified in the next sentence, which describes the elaborate frame known from commission documents. The mention of the 1576 devotion by citizens afflicted with the plague follows immediately in Besta's text.

25. The bibliography on this topic is growing too rapidly to cite here; for a well-informed introduction, see Ringbom 1969, 159–70. Among recent contributions to the manner in which paintings functioned analogously to stational liturgy and pilgrimage, see Botvinick 1992, 1–18.

26. Derrida 1988.

27. Robertson 1958.

28. On the Scholastic tradition, see Cahn 1979.

29. Cahn 1979, 488 n. 8, noting that similar principles were applied to poetry, for example, by Petrarch, in *Invective contra medicium*.

30. Miller 1982.

31. Miller 1982; see further Chastel 1961.

32. For an extended discussion of the painting's possible symbolic references to Saint Francis, see Snow Smith 1983–1984.

33. Gould 1994, 215–17.

34. Ringbom 1969, n. 22, citing Panofsky 1953, n. 277.

35. The most recent analysis of the documents is the study by Pietro Marani, *Letture Vinciana* (2002).

36. Methodius of Olympus, *The Symposium* (1958, 222); cited by Gage (1993, 45).

37. Debra Pincus, personal communication, 1996.

38. Kemp 1989, 94–96.

39. There is an extensive bibliography on creche images, little of which is historical, but see *Il presepio poplare italiano* (1973), illustrating several fifteenth-century examples and tracing the tradition to the early-thirteenth-century life of Saint Francis (8); with further bibliography on Sicily, the Neapolitan urban area, and France, especially Provence. Ancient Greek prototypes of enthroned goddesses associated with nymphs and grottoes are common throughout the same region.

40. See Nova 1995, with further references.

41. Miller 1982, 21.

42. See Steinitz 1970, esp. 257. For a thorough investigation of relationships among Leonardo's widespread artistic interests in landscape settings, see Smith 1985, 183–99.

43. Compare Leonardo's arguments against sculpture in defense of painting on these grounds: Treatise on Painting, nn. 37, 40, 45; see Farago 1992, 264–83.

44. Freedberg 1989.

45. Treatise on Painting, part 1, n. 40; translation cited from Farago 1992, 273.

46. PG 100:380D–84B; translation cited from Barber 1993a, 146–47. See discussion of this same passage by Nelson 2000, 146–53.

47. An excellent example of an ancient argument repeated by numerous Byzantine and Renaissance writers is the topos about the painter's superiority to the sculptor because he can reproduce color and shade, indebted to the third-century sophist Philostratus the Elder's *Imagines*, Proemium 3; cited in Maguire 1974, 127–28.

48. Leonardo made the same claim in a number of passages; in addition to the passages cited in note 73 of this essay, a passage preserved in the Codex Urbinas reads: "The divinity which is the science of painting transmutes the painter's mind into a resemblance of the divine mind." Treatise on Painting, n. 68; translation cited from Leonardo da Vinci 1956, 113 n. 280. Thanks to Luba Freedman for bringing this passage to my attention. On Leonardo's self-characterization as a divine artificer, the classic study is Panofsky 1962; the literary tradition is a long one, as documented in Kris and Kurz 1979.

49. Four notable occasions are found in his polemical defense of painting, pre-served as part 1 of the Treatise on Painting, nn. 7, 8, 25, 33.

50. Certain politically contested locations like the Iberian Peninsula, or geograph-ically peripheral areas like western Asia, produced a hybrid visual culture, and there was both economic interaction and artistic exchange throughout the Mediterra-nean Basin, as the presence of artists working locally in Byzantine styles on the Ital-ian Peninsula and elsewhere in western Europe attests. See the extensive evidence assembled in *Glory to Byzantium*.

51. See the classic essay by Klein (1970, 31–64).

52. A Late Antique ritual was performed by priests for the "ensoulment" of the image, an act of consecration—this infused the object with an invisible pneuma, as descriptions from Porphyry to Proclus attest. See Finney 1994, 73; on the origin of the closely related concept of *praesentia*, see Brown 1981, esp. 86.

53. On stational liturgy, see Baldwin (1987), who distinguishes between popular liturgical processions and the institutionally controlled stational system in which short pilgrimages from one church to another were enacted in imitation of Christ's life; see Carruthers 2000, 99–117. On long-distance pilgrimage, see Sumption 1975; Geary 1978; and Coleman and Elsner 1995, with an excellent introductory bibliogra-phy. On the relationship between the viewer/pilgrim's participation in actual pil-grimages, on the one hand, and their narrative representation of sacred events in art, on the other, see the excellent study by Loerke (1984).

54. Treatise on Painting, part 1, n. 9: "The proof that painting is philosophy is that it treats the motion of bodies in the liveliness of their actions, and philosophy also extends to motion." Translation in Farago 1992, 191.

55. Gage (1993, 57) supports this claim with extensive evidence. Byzantine descrip-tions of buildings are highly conventionalized (see Maguire 1981, 22), but they tell us a great deal about the culturally constructed aspects of the perception of art. Differ-ences between Byzantine *ekphraseis* and their classical precedents are the subject of the new wave of Byzantine studies cited throughout this paper. All of these studies emphasize the Christian context into which classical formulas were recast.

56. Chorikios of Gaza, *Laudatio Marciani* 1.23, in *Choricii Gazaei opera* (1929, 7); translation in Mango 1972, 61.

57. Psellus 1966, 188–90.

58. James (1996, 5–6, 74, 84) emphasizes that color was conceived very differ-ently from our own post-Newtonian, scientific understanding of hues. "Color" re-ferred to light as brilliance, luster, movement, and even encompassed *changing* hue—all of which, according to the literary evidence, imparted to the image its quality of lifelikeness.

59. Pelikan (1990, 119), citing the idea of twentieth-century Russian theologian Pavel Florensky that the theology of the image includes the entire movement of "entrances" from the darkness behind the iconostasis, or altar screen, to the congre-gation. See Florensky 1996. Thanks to Kirk Ambrose for calling this translation to my attention.

60. See the recent review of the scholarship by James and Webb (1991). James (1996, 51–56, 84, 129, 140) emphasizes that the material color of the image, interact-ing with the real space and light in which it is presented, conveyed the qualities of lifelikeness to the Byzantine viewer.

61. Gage 1993, 41.

62. James (1996, 56, 72) also notes correspondences between emission theories of vision (according to which the eye emits light rather than receives it) and the language in which the effects of images on beholders were described.

63. See Lavin 1955, 85–101, esp. 86.

64. John of Damascus, *De imaginibus oratio* 3.16 (PG 94, 1337). The closely related idea that the painting is only a remembrance had been introduced in the sixth century by Pope Gregory the Great; see Belting 1994, 9, 145; further, Ladner (1953, 3–34) emphasizes the theoretical foundation on which further differences between idols and icons were defined by the Iconoclastic debates.

65. James (1996) discusses the Byzantine concept of "correct" representation and color as ultimately originating with Plato's condemnation of illusionism. Leonardo's polemical defense of painting as a science grounded in optics demonstrates analogous individual concerns with the "correctness" of images owing to their correspondence with reality. Barber (1993b) emphasizes that a central issue throughout the Iconoclastic debates was whether the concept of true presence within the Eucharist could provide a paradigm for defining the concept of artificially made images. The Iconophile justification for images (in response to Emperor Constantine V [741–775]) worked against the transparent identification of the image with its prototype (Barber 1993b, 9).

66. I owe this observation to Anthony Cutler.

67. Cited in Berliner 1945, 277.

68. Translation cited in Berliner 1945, 272, from Migne, *Patr. lat.*, 175, col. 20 ff.

69. Translation cited in Berliner 1945, 277.

70. The historical shift from a consideration of mental images to artificial ones is complex; see Farago 1992, 331–32; Summers 1987.

71. The presence of such figures that simultaneously display and are displayed has a long history in religious painting; see Belting 1989, 212. Alberti, in his 1434–1435 treatise *On Painting*, 2.42, 77, appears to have appropriated the idea to encourage viewers to participate in the didactic pictorial narrative, but Alberti's precedent does not adequately explain Leonardo's nonnarrative altarpiece.

72. Snow Smith (1983–1984, 140) argues that the pointing finger of the angel could be read as a visualization of the Dominican Maculist position that the Virgin, like John the Baptist, was released from the stain of original sin while she was in utero.

73. The wording of MS A is sufficiently close to Dante's discussion of sight in *Il Convivio* that it was probably a direct source. CA 184v-c, c. 1515; and Codex Urbinas, 36r-v, from an unknown source (Leonardo da Vinci, 1956: nn. 65, 280, and 175). The passage on MS A, 111v, is part of a series of closely related passages about the way the painter constructs visual images in accordance with vision. These notes include a citation, on 113v, from Dante's *Convivio*, 4.3.3.52–53: "Chi pinge figure / E se non po esser lei, non la po porre" [Whoever painted the figure, it cannot be him, nor can he place it]. First noted by Chastel (1961, 128). Dante's use of optical theory is metaphorical—his real discussion concerns moral qualities. As he explains in the commentary to this poem, the virtuous rational soul is not corrupted by the world, that is, not mutated by its transmutation of effects, because such a soul understands the natural relationship between perceptible qualities and their prior, eternal principles. The painter could not paint a figure if first his *fantasia* did not have the capacity of conceiving the form of it. Otherwise whatever form is conceived in the painter's *fan-*

tasia will be vile or deformed. These discussions of the painter's mental processes are strong evidence that Dante's *Convivio* was an immediate source of Leonardo's ideas about the way in which the painter "transmutes" his mind into that of nature. See also Kemp 1977, esp. 131; on Dante's optics and beauty, see Parronchi 1964, 35.

74. Dante Alighieri, *Il Convivio*, book 2, canzone 10 (ed. Busnelli and Vandelli, 1953–1954: 1.368, citing Dante's sources in Avicenna and Aquinas). Passages as late as CA 184v-c, c. 1515, still recall Dante's text. See further Kemp 1971, 1977.

75. For example, on CA 184v-c, c. 1515, discussed in Farago 1992, 334.

76. Treatise on Painting, part 1, nn. 30 and 32; translation cited from Farago 1992, 243 and 249.

77. Kant's writings on the sublime, which associate painting with the internal activity of aesthetic judgment and sculpture with the (mere) extramental existence of objects, are the direct descendant of this multicultural tradition.

78. The presence of the divinity in the image is a central issue of the Iconoclastic Controversy, although the issues were already formulated by Pope Gregory the Great in the sixth century (see note 64); for related arguments by Iconophiles concerning the lack of presence in icons, see Ladner 1953; Barber 1993b.

79. Paul the Silentiary, description of Hagia Sophia in Constantinople, sixth century, as cited by Mango (1972, 85–86). According to Gage (1993, 39), the literary convention of appreciating marbles for their provenance and their colored veining has its source in the first-century A.D. Roman poetry of Statius. See Macrides and Magdalino 1988, 47–82. The authors emphasize that ekphrastic texts are, beyond description, celebratory by nature, usually delivered in ceremonial circumstances (50).

80. On the textual tradition, see Jones 1987. By focusing on the physical evidence and its *all'antica* context in relation to Aristotelian theories of imagination and artistic invention, Jones tells only half of the story: the interweaving of humanist, antiquarian interests with the religious context in which many painted imitations occur and continue to recur throughout the sixteenth and seventeenth centuries and even later. See also Onians 1980, 8–10, citing extensive evidence that sixth-century Byzantines "saw the colour and figuration of marble as representing other things" (9). For evidence that Byzantine descriptions of buildings (by Manuel Chrysoloras and perhaps others) were known to an early humanist who gave them unprecedented visual form, see Smith 1987, 16–32. The metaphysics of light so important in the East and the West are grounded in the Aristotelian theory that light and color move the imagination, which in turn moves the will or appetite. The other special senses function best, on the basis of a structural analogy to sight, when the information presented to them maintains a mean between extremes. Based on this understanding of the physiology of the eye, Byzantine writers and their medieval Western counterparts such as Abbot Suger repeatedly emphasize the power of light and color to *overpower* the senses. Sensory overload, caused by the beautiful artistry and opulent materials of church decoration, triggers the comprehension of intelligible beauty. As Suger explained in a justifiably famous passage, "When out of my delight in the beauty of the house of God—the loveliness of the many-colored gems has called me away from all external cares. . . . by grace of God I can be transported from this inferior to that higher world in an anagogical manner *(anagogico more)*" (Suger, *De administratione*, xxxiii; translation cited from Panofsky 1946, 62–65). Medievalists have long disputed Abbot Suger's possible debt to Byzantine sources

such as the fifth- or sixth-century theologian known as Pseudo-Dionysius; see Kidson (1987, 1–17), who argues that Suger's lack of specificity suggests he was *not* directly familiar with the Neoplatonist mystic. The same objections could be brought to bear on Leonardo's sources. Yet it is unnecessary to demonstrate that Leonardo and his audience were directly informed by Byzantine metaphysical writings. The central issue in the present context of discussion does not concern the direct transmission of texts.

81. Stressed by Gage (1993). James and Webb (1991) see a dichotomy between the aesthetic and the spiritual and moreover exclude "aesthetic" from their historical categories of culturally constructed responses. The present study is, to the contrary, concerned with the history of the category "aesthetic" that spans the gamut from sensate response to the spiritual and secular contemplation of images. I am arguing that Byzantine concerns with the progression from sense experience to spiritual understanding made an important contribution to Western aesthetic theory.

82. Suger, *Liber de rebus in administratione sua gestis,* in Panofsky 1946, 144–49, describes the colored rock materials of his famous chalice, now in the Washington National Gallery of Art, in terms that immediately recall Byzantine ekphraseis of church interiors by Rhodios, Michael Psellus, and others; for a bibliography of Byzantine writings and further discussion, see James 1996, 113–15, 126, and *in appendice,* 141–42. Translation of Suger's text cited from Frisch 1971, 11.

83. See Maguire 1981, 12; Onians 1980; James 1996, 119, 99–106, on the closely related issue of color iconography.

84. John Gage suggests that Arabic optical treatises followed this literary and visual tradition and not the other way around—that shot silk (and the aesthetic appreciation of its effects) provided optical theorists with new examples to put alongside the traditional ones like the color of feathers on a dove's neck (Gage 1993, 58–63).

85. Medieval and Renaissance descriptions of artistic procedures were often metaphors for various kinds of mental discourse such as poetic invention, even scientific induction. Some of Leonardo's descriptions of painting processes may indeed have been perceived by his original courtly audience as an allegory of the life of the mind; on which see Hazard 1975; Farago 1992, 46–47. Meyer Schapiro has studied a twelfth-century English text that he found to be surprising in its attention to subtle design and the physical work itself. Schapiro did not say whether the text had a figurative dimension. See Schapiro 1977, 11–13. The account was written circa 1175 by Reginald, a monk of Durham, on the translation of the remains of Saint Cuthbert into the new cathedral in 1104.

86. Belting 1994, 351; Brubaker 1989, 19–32.

87. See Gage 1993, 58–63.

88. Thanks to Janis Bell for the example from SS. Annunziata; see also Weil-Garris [Brandt] 1982, 61–79.

89. Mango 1958, 293–94.

90. Photios invokes a different theory of vision from the one Leonardo followed; see Lindberg 1976. The present discussion is not about the transmission of specific scientific sources—obviously Leonardo did not develop his ideas directly on the basis of Photios's homily of 867. More important than the choice between extromission of light rays and intromission is the fact that Photios couched his justification of images in a theory of vision at all. He insisted that the senses played an essential role in gaining an understanding of the divine. Like other Byzantine apologists

for icons, Photios paid special attention to passages of scripture where hearing and seeing are juxtaposed (Pelikan 1990, 107).

91. The arguments put forward on each side are considerably more complex than this brief discussion can suggest. In response to the christological dilemma conveyed by the Trinitarian language in which the debates were initially conducted, Nikephoros proposed a new distinction between the "circumscription" of Christ as a physical reality on earth, existing in time and space, and the "inscription" of Christ as an artificial image; consequently, "In painting there's nothing of presence." Cited from Barber 1993b, 9; see also Barber 1993a, 140–53, esp. 145–46.

92. Translation cited from Farago 1992, 189–91 n. 8.

93. See, for example, Farago 1992, 199–201 n. 15. Photios drew upon discussions of the movement of light and color in optical theory to justify the use of images in religious practice: figurative images serve as a reminder, a mnemonic aid available to human modes of cognition proceeding from sense experience. See Photios, *Myriobiblion* (1960, 149–59). Gage (1993, 44) cites Photios's source in Johannes Stobaeus's *Eclogues,* the first book of which summarized classical ideas on physics including these theories of vision.

94. Carrier 1987b, 20–31.

95. Jakobson 1962–1988.

96. Coward and Ellis 1977.

97. Farago 1992, 257 n. 34.

98. Compare Rorty 1979; see Bal (this volume) for further discussion.

99. See Agamben 1993, 141–51, for a similar argument about Freudian distinctions, situated in the context of medieval Scholasticism.

References

Agamben, Giorgio. 1993. "The Proper and the Improper." In *Stanzas: Word and Phantasm in Western Culture,* trans. Ronald L. Martinez. Theory and History of Literature, vol. 69, 141–51. Minneapolis: University of Minnesota Press.

Baldwin, John. 1987. *The Urban Character of Christian Worship: The Origins, Development, and Meaning of Stational Liturgy.* Rome: Pont. Institutum Studiorum Orientalium.

Barber, Charles. 1993a. "The Body within the Frame: A Use of Word and Image in Iconoclasm." *Word and Image* 9, no. 2 (April–June): 140–53.

———. 1993b. "From Transformation to Desire: Art and Worship after Byzantine Iconoclasm." *Art Bulletin* 75, no. 1 (March): 7–16.

Belting, Hans. 1989. *The Image and Its Public in the Middle Ages: Form and Function of Early Paintings of the Passion.* Trans. M. Bartusis and R. Meyer. New Rochelle, N.Y.: A. D. Caratzas.

———. 1994. *Likeness and Presence: A History of the Image before the Era of Art.* Trans. E. Jephcott. Chicago: University of Chicago Press.

Berliner, Rudolf. 1945. "The Freedom of Medieval Art." *Gazette des Beaux-Arts,* ser. 6, no. 28: 263–88.

Besta, Giacomo Filippo. "Origine et meraviglie della città di Milano e delle imprese dei cittadini suoi." MS Trivulziana, Trivulziana Library, Milan.

Botvinick, Matthew. 1992. "The Painting as Pilgrimage: Traces of a Subtext in the Work of Campin and His Contemporaries." *Art History* 15, no. 1 (March): 1–18.

Brizio, A. M. 1954. "Correlazioni e corrispondenze tra fogli del Codice Atlantico e fogli dell'anatomia B, e dei Codici A e C su l'occhio, la prospettiva, le piramidi radiose e le ombre." *Raccolta Vinciana* 17: 81–89.

Brown, Peter. 1981. *The Cult of Saints: Its Rise and Function in Latin Christianity.* Chicago: University of Chicago Press.

———. 1984. *The Cult of Saints: Its Rise and Function in Latin Christianity.* Chicago: University of Chicago Press.

Brubaker, Leslie. 1989. "Perception and Conception: Art, Theory, and Culture in Ninth-Century Byzantium." *Word and Image* 5, no. 1 (January–March): 19–32.

Cahn, Walter. 1979. *Masterpieces: Chapters on the History of an Idea.* Princeton: Princeton University Press.

Calderini, A. 1940. "Documenti inediti per la storia della Chiesa di S. Francesco Grande in Milano." *Aevum* 14: 197–230.

Cannell, William S. 1984. "Leonardo da Vinci *Virgin of the Rocks:* A Reconsideration of the Documents and a New Interpretation." *Gazette des Beaux-Arts,* ser. 6, no. 47: 99–108.

Carlson, Thomas A. 1999. *Indiscretion: Finitude and the Naming of God.* Chicago: University of Chicago Press.

Carrier, David. 1987a. *Artwriting.* Amherst: University of Massachusetts Press.

———. 1987b. "Ekphrasis and Interpretation: Two Modes of Art History Writing." *British Journal of Aesthetics* 27, no. 1 (winter): 20–31.

Carroll, Lewis. [1871] 1999. *Through the Looking-Glass, and What Alice Found There.* San Diego: Harcourt Brace.

Carruthers, Mary. 2000. "Rhetorical *Ductus,* or Moving through a Composition." In *Acting on the Past: Historical Performance across the Disciplines,* ed. Mark Franko and Annette Richards, 99–117. Hanover, N.H.: Wesleyan University Press.

Castiglione, Bonaventura. "Vite e gesti delli SS. XI Arcivescovi di Milano predecessori al Santissimo Ambrosio." MS 560, Trivulziana Library, Milan.

Caygill, Howard. 1989. *The Art of Judgement.* Cambridge: Basil Blackwell.

Chastel, André. 1961. *The Genius of Leonardo da Vinci.* Trans. Ellen Callmann. New York: Orion Press.

Chorikios of Gaza. 1929. *Laudatio Marciani.* In *Choricii Gazaei opera,* ed. R. Foerster and E. Richsteig. Leipzig: T. B. Teubneri.

Clark, Kenneth. 1988. *Leonardo da Vinci.* New York: Viking.

Coleman, Simon, and John Elsner. 1995. *Pilgrimage: Past and Present in the World Religions.* Cambridge: Harvard University Press.

Cormack, Robin. 1977. *Painting the Soul: Icons, Death Masks, and Shrouds.* London: Reaktion Books.

Coward, Rosalind, and John Ellis. 1977. *Language and Materialism: Developments in Semiology and the Theory of the Subject.* New York: Routledge and Kegan Paul.

Cutler, Anthony. 1995. "The Pathos of Distance: Byzantium in the Gaze of Renaissance Europe and Modern Scholarship." In *Reframing the Renaissance: Visual Culture in Europe and Latin America, 1450–1650,* ed. Claire Farago, 23–46. New Haven: Yale University Press.

Dante Alighieri. 1953–1954. *Il Convivio.* Ed. G. Busnelli and G. Vandelli. 2d ed. 2 vols. Florence: Le Monnier.

Derrida, Jacques. 1988. "Signature Event Context." In *Limited Inc.* Evanston: Northwestern University Press.

Didi-Huberman, Georges. 1995. *Fra Angelico: Dissemblance and Figuration*. Trans. Jane Marie Todd. Chicago: University of Chicago Press.

Farago, Claire. 1992. *Leonardo da Vinci's "Paragone": A Critical Interpretation with a New Edition of the Text in the Codex Urbinas*. Leiden-Köln: E. J. Brill.

———. 2002. "Die Ästhetik der Bewegung in Leonardos Kunsttheorie." In *Leonardo da Vinci*, ed. Frank Fehrenbach. Munich: Wilhelm Fink.

———. 2003. "How Leonardo da Vinci's Editors Organized His *Treatise on Painting* and How Leonardo Would Have Done It Differently." In *The History of the Publication and Non-publication of Perspective Treatises*, ed. Lyle Massey. Center for Advanced Study in the Visual Arts, Washington, D.C. Princeton: Princeton University Press.

———, ed. 1995. *Reframing the Renaissance: Visual Culture in Europe and Latin America, 1450–1650*. New Haven: Yale University Press.

Filipczak, Z. Zaremba. 1977. "New Light on Mona Lisa: Leonardo's Optical Knowledge and His Choice of Lighting." *Art Bulletin* 59, no. 4 (December): 518–23.

Finney, Paul. 1994. *The Invisible God: The Earliest Christians on Art*. Oxford: Oxford University Press.

Florensky, Pavel. 1996. *Iconostasis*. Trans. Donald Sheehan and Olga Andrejev. Crestwood, N.Y.: St. Vladimir's Seminary Press.

Freedberg, David. 1989. *The Power of Images: Studies in the History and Theory of Response*. Chicago: University of Chicago Press.

Frisch, Teresa. 1971. *Gothic Art, 1140–c. 1450: Sources and Documents*. Englewood Cliffs, N.J.: Prentice-Hall.

Gage, John. 1993. *Color and Culture: Practice and Meaning from Antiquity to Abstraction*. Boston: Little Brown.

Geary, Patrick. 1978. *Furta Sacra: Theft of Relics in the Central Middle Ages*. Princeton: Princeton University Press.

The Glory of Byzantium: Art and Culture of the Middle Byzantine Period, A.D. 843–1261. 1997. Ed. Helen C. Evans and William D. Wixom. Exhibition catalog. New York: Metropolitan Museum of Art.

Gould, Cecil. 1994. "The Early History of Leonardo's *Vierge aux Rochers* in the Louvre." *Gazette des Beaux-Arts*, ser. 6, no. 124 (December): 215–22.

Hazard, Mary. 1975. "The Anatomy of 'Liveliness' as a Concept in Renaissance Aesthetics." *Journal of Aesthetics and Art Criticism* 33: 407–18.

Heydenreich, Ludwig. 1954. *Leonardo da Vinci*. 2 vols. New York: Macmillan.

Holly, Michael Ann. 1996. *Past Looking: Historical Imagination and the Rhetoric of the Image*. Ithaca: Cornell University Press.

Il presepio poplare italiano. 1973. Ed. Alessandro Perolini and Fiorella Perolini. Exhibition catalog. Museo Nazionale delle Arti e Tradizioni Poplari, Rome, December 1972–January 1973.

Jakobson, Roman. 1962–1988. *The Poetry of Grammar and the Grammar of Poetry*, vol. 3, *Selected Writings*. Gravenhage: Mouton.

James, Liz. 1996. *Light and Colour in Byzantine Art*. Oxford: Clarendon Press.

James, Liz, and Janet Webb. 1991. "'To Understand Ultimate Things and Enter Secret Places': Ekphrasis and Art in Byzantium." *Art History* 124, no. 2: 1–17.

Jones, Roger. 1987. "Mantegna and Materials." In *I Tatti Studies: Essays in the Renaissance*, vol. 2, ed. R. Bruscagli et al. 71–90. Florence: Giunti Barbera.

Keele, Kenneth. 1959. "The Genesis of Mona Lisa." *Journal of the History of Medicine and Allied Sciences* 14, no. 2 (April): 135–59.

Kelly, Michael. 1995. Review. *Art Bulletin* 77 (September): 690–95.

Kemp, Martin. 1971. "Il 'Concetto dell'anima' in Leonardo's Early Skull Studies." *Journal of the Warburg and Courtauld Institutes* 35: 115–34.

———. 1977. "Leonardo and the Visual Pyramid." *Journal of the Warburg and Courtauld Institutes* 40: 129–49.

———. 1989. *Leonardo da Vinci: The Marvellous Works of Nature and Man.* London: J. M. Dent and Sons.

Kidson, Peter. 1987. "Panofsky, Suger, and St. Denis." *Journal of the Warburg and Courtauld Institutes* 50: 1–17.

Klein, Robert. 1970. "Spirito peregrino." In *La forme et l'intelligible: Écrits sur la Renaissance et l'arte moderne. Articles et essais réunis et presentés par André Chastel.* Paris: Gallimard.

Kris, Ernst, and Otto Kurz. 1979. *Legend, Myth, and Magic in the Image of the Artist: A Historical Experiment.* New Haven: Yale University Press.

Ladner, Gerhart. 1953. "The Concept of the Image in the Greek Fathers and the Byzantine Iconoclastic Controversy." *Dumbarton Oaks Papers* 7: 3–34.

Lavin, Marilyn. 1955. "Giovannino Battista: A Study in Renaissance Religious Symbolism." *Art Bulletin* 37: 85–101.

Leonardo da Vinci. 1882–1885. *Lionardo da Vinci: Das Buch von der malerei.* Quellenschriften für Kunstgeschichte und Kunsttechnik des Mittelalters und der Renaissance, ed. Heinrich Ludwig. Vols. 15–18 (1882–1885), facs. Reprint, Osnebrück: O. Zeller, 1970 (passage 1 = Treatise on Painting, n. 1).

———. 1956. *Treatise on Painting (Codex Urbinas Latinus 1270).* Ed. and trans. A. P. McMahon. 2 vols. Princeton: Princeton University Press.

Levi D'Ancona, Mirella. 1957. *The Iconography of the Immaculate Conception in the Middle Ages and Early Renaissance.* New York: College Art Association in conjunction with *Art Bulletin.*

Lindberg, David. 1976. *Theories of Vision from Al-Kindi to Kepler.* Chicago: University of Chicago Press.

Loerke, William. 1984. "'Real Presence' in Early Christian Art." In *Monasticism and the Arts,* ed. Timothy Verdon with John Dally. Syracuse, N.Y.: Syracuse University Press.

Macrides, R., and P. Magdalino. 1988. "The Architecture of Ekphrasis: Construction and Context of Paul the Silentiary's Poem on Hagia Sophia." *Byzantine and Modern Greek Studies* 12: 47–82.

Maguire, H. 1974. "Truth and Convention in Byzantine Descriptions of Works of Art." *Dumbarton Oaks Papers* 28: 111–41.

———. 1981. *Art and Eloquence in Byzantium.* Princeton: Princeton University Press.

Mango, Cyril. 1958. *The Homilies of Photius, Patriarch of Constantinople.* Cambridge: Harvard University Press.

———. 1972. *The Art of the Byzantine Empire, 312–1453.* Sources and Documents. Englewood Cliffs, N.J.: Prentice-Hall.

Methodius of Olympus. 1958. *The Symposium.* Ed. and trans. H. Musurillo. Westminster, Md.: Newman Press.

Miller, Naomi. 1982. *Heavenly Caves: Reflections on the Garden Grotto.* New York: G. Braziller.

Moxey, Keith. 1994. *The Practice of Theory: Poststructuralism, Cultural Politics, and Art History.* Ithaca: Cornell University Press, 1994.

———. 1995. "Motivating History." *Art Bulletin* 77, no. 4 (September): 392–402.

Nelson, Robert. 2000. "To Say and to See: Vision and *Ekphrasis* in Byzantium." In *Visuality before and beyond the Renaissance*, ed. Robert S. Nelson, 143–68. New York: Cambridge University Press.

Nova, Alessandro. 1995. "'Popular' Art in Renaissance Italy: Early Response to the Holy Mountain at Varallo." In *Reframing the Renaissance: Visual Culture in Europe and Latin America, 1450 to 1650*, ed. Claire Farago, 113–26. New Haven: Yale University Press.

Onians, John. 1980. "Abstraction and Imagination in Later Antiquity." *Art History* 3: 1–23.

Panofsky, Erwin. 1946. *Abbot Suger on the Abbey Church of St. Denis and Its Art Treasures*. Princeton: Princeton University Press.

——. 1953. *Early Netherlandish Painting*. Cambridge: Harvard University Press.

——. 1962. "Artist, Scientist, Genius: Notes on the 'Renaissance-Dämmerung.'" In *The Renaissance: Six Essays*, 121–82. New York: Harper and Row.

Parronchi, Alessandro. 1964. *Studi su la dolce prospettiva*. Milan: A. Martello.

Pelikan, Jaroslav. 1990. *Imago Dei: The Byzantine Apologia for Icons*. Princeton: Princeton University Press.

Petrarch. 1950. *Invective contra medicium*. Ed. Pier Giorgio Ricci. Rome: Storia e letteratura no. 32.

Photios. 1960. *Myriobiblion*. In *Bibliothèque*, vol. 2, ed. and trans. R. Henry.

Preziosi, Donald. 1989. *Rethinking Art History: Meditations on a Coy Science*. New Haven: Yale University Press.

——. 1993. "Seeing Through Art History." In *Knowledges: Historical and Critical Studies in Disciplinarity*, ed. E. Messer-Davidow, D. Shumway, and D. Sylvan, 215–31. Charlottesville: University Press of Virginia.

Psellus, Michael. 1966. *Fourteen Byzantine Rulers: Chronographia*. Trans. E. R. A. Sewter. Baltimore: Penguin Books.

Ringbom, Sixten. 1969. "Devotional Images and Imaginative Devotions: Notes on the Place of Art in Late Medieval Private Piety." *Gazette des Beaux-Arts*, ser. 6, 73: 159–70.

——. 1992. "Devotional Images and Imaginative Devotions: Notes on the Place of Art in Late Medieval Private Piety." *Gazette des Beaux-Arts*, ser. 6, no. 73: 159–70.

Robertson, D. W., Jr. 1958. "*In Foraminibus Petrae*: A Note on Leonardo's *Virgin of the Rocks*." *Renaissance News* 11: 92–95.

Rorty, Richard. 1979. *Philosophy and the Mirror of Nature*. Princeton: Princeton University Press.

Schapiro, Meyer. 1953. "Style." In *Anthropology Today*, ed. A. L. Kroeber, 137–44. Chicago: University of Chicago Press.

——. 1977. "On the Aesthetic Attitude in Romanesque Art." In *Romanesque Art*. New York: Columbia University Press.

Scott, Joan Wallach. 1991. "The Evidence of Experience." *Critical Inquiry* 17, no. 4 (Summer): 773–97.

Sironi, Grazioso. 1981. *Nuovi documenti reguardanti la "Vergine delle Rocce" di Leonardo da Vinci*. Florence: Giunti Barbera.

Smith, Christine. 1987. "Cyriacus of Ancona's Seven Drawings of Hagia Sophia," *Art Bulletin* 69, no. 1 (March): 16–32.

Smith, Webster. 1985. "Observations on the *Mona Lisa* Landscape." *Art Bulletin* 67, no. 2 (June): 183–99.

Snow Smith, Joanne. 1983–1984. "An Iconographic Interpretation of Leonardo's *Virgin of the Rocks* (Louvre)." *Arte Lombarda* 28: 134–42.

Sohm, Philip. 2001. *Style in the Art Theory of Early Modern Italy.* Cambridge: Cambridge University Press.

Soussloff, Catherine. 1997. *The Absolute Artist: The Historiography of a Concept.* Minneapolis: University of Minnesota Press.

Steinberg, Leo. 1973. "Leonardo's *Last Supper.*" *Art Quarterly* 36, no. 4: 297–401.

Steinitz, Kate T. 1970. *Leonardo Architetto Teatrale e Organizzatore di Feste, IX Letture Vinciana, Vinci 15 Aprile 1969.* Florence: Giunti Barbera.

Strong, Donald. 1979. *Leonardo on the Eye: An English Translation and Critical Commentary of Ms. D . . .* New York: Garland Publishing.

Summers, David. 1987. *The Judgment of Sense: Optical Naturalism and the Rise of Aesthetics.* Cambridge: Cambridge University Press.

Sumption, Jonathan. 1975. *Pilgrimage: An Image of Mediaeval Religion.* Totowa, N.J.: Rowmann and Littlefield.

Trinkaus, Charles. 1976. "Protagoras in the Renaissance: An Exploration." In *Philosophy and Humanism: Renaissance Essays in Honor of Paul Oskar Kristeller,* ed. E. P. Mahoney, 190–213. New York: Columbia University Press.

Weil-Garris [Brandt], Kathleen. 1982. " 'Were This Clay But Marble': A Reassessment of Emilian Terra Cotta Group Sculpture." In *Le Arti a Bologna e in Emilia dal XVI al XVII Secolo: Acts of the XXIV International Congress of the History of Art* (1979), ed. A. Emiliani, 61–79. Bologna: CLUEB.

White, Hayden. 1987. *The Content of the Form: Narrative Discourse and Historical Representation.* Baltimore: Johns Hopkins University Press.

CHAPTER FOUR

Touching the Face: The Ethics of Visuality between Levinas and a Rembrandt Self-Portrait

Renée van de Vall

The subject of this essay presented itself during a visit to the exhibition *Rembrandt by Himself* in the Mauritshuis Museum in The Hague.[1] The exhibition showed a large selection of Rembrandt's self-portraits, dating from the beginning of his career in the 1620s to the year of his death in 1669. As Rembrandt grew older, the execution of his portraits became amazingly bold and profound in expression. But there was something peculiar about them, which was brought to my attention by one of my companions who started complaining about his eyesight. There was a fuzziness in the faces, a lack of sharpness, a lack of outline, which he found hard to look at. While we were talking about the way Rembrandt worked his paint, we suddenly noticed how the painting on our left, one of the fuzziest, seemed to have grown out of its frame (Figure 4.1). It was looking at us, looking sternly, or earnestly, more or less measuring us, and although we were not really looking at it, it had become imposing in its presence. It seemed even to have grown in presence *because* we were not really looking at it. And the face wasn't that fuzzy after all, but rather quite mobile—wasn't there the beginning of a smile in the corner of the mouth?

Apparently the painting needed time to grow out of its initial lack of sharpness. Apparently its fuzziness was in another respect its strength. And apparently the development of its strong presence needed—at least at first—a somewhat oblique angle of vision. I want to suggest that these three observations are connected.

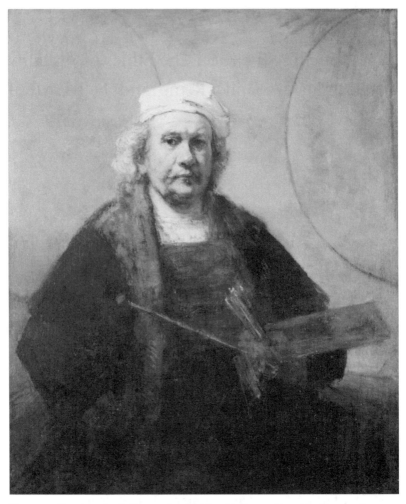

Figure 4.1. Rembrandt, *Self-portrait with Two Circles*, c. 1665–1669. Kenwood House, London. Copyright English Heritage. NMR.

In this essay I would like to argue that the persuasiveness of this self-portrait, and of Rembrandt's later self-portraits and portraits in general, teaches us something about seeing. As James Elkins has written, faces are the most important objects of sight (Elkins 1996, 161). Not only do faces attract our attention more strongly than everything else does, in our visual worlds, but moreover, there are no items that we see with so much alertness, discrimination, and responsiveness. My suggestion would be that Rembrandt's painted faces seem to be so alive because his

way of painting them in many respects articulates our way of seeing faces. I do not, however, claim any art historical validity for my suggestions; that is, I do not contend that Rembrandt intentionally anticipated the kind of visual response that will be sketched hereafter. This is a philosophical essay about the meaning of seeing faces, exploring what may be learned by looking at how Rembrandt painted them. It is not even assumed that there is such a thing as *the* meaning of seeing faces, to be revealed by *the* way Rembrandt painted. We learn to look at faces, just as we learn to look at paintings. Interpreting faces in terms of paintings and, vice versa, paintings in terms of actual faces, I will produce a way of looking at both. In this respect an interpretation has the same performative dimension as will be ascribed later on to the dynamics of the painting.

Yet the pictorial features to which I will point are in no way accidental or fortuitous: they are consistent and recurring elements of Rembrandt's style. The significance that I will ascribe to them is intended to explain why these faces work so strongly *for me*, and hopefully for others, here and now; I do not mean to explain why Rembrandt has chosen to paint in the manner he did. The essay will point to what is known about Rembrandt's historical options and choices, because that information sharpens our awareness of what materially happens in his paintings. But my main aim is to formulate the "mute knowledge" in his work, a knowledge that has as much to do with what the beholder wants to know as with what the artist once wanted to show. Descriptions as will be developed hereafter do not simply state what is there: they construe what they are describing. But even in such a constructive endeavor, one can hope to be true to the work.

A Portrait of Rembrandt by Rembrandt

The painting that so strongly imposed itself upon us was the famous *Self-Portrait with Two Circles* (c. 1665–1669), presently in the collection of Kenwood House, London. Much has been written about the iconographic meaning of the two circles and their implications for Rembrandt's art theory (e.g., Brown et al. 1991, 286). X-ray photographs have shown that Rembrandt initially painted himself in a working posture with the left hand lifted and holding a brush as if actively painting and his right hand holding more brushes and a palette. Of course, as Rembrandt was right-handed, he would have held his brush in his right

hand. But initially he painted his image as he saw it in the mirror, that is, as if he were left-handed. Later on, he changed this posture to a more static one. All the painting equipment was placed in his right hand, the body was turned in a more frontal position, and his left hand was posed at the side. It is supposed that some parts of the painting are unfinished or have been damaged by earlier relinings; the face, however, is considered its most-finished or least-damaged part (284).

And what a face it is! It is almost expressionless, just looking at the beholder with a calm and concentrated gaze. It is not really an active gaze, however: it shows a certain resignation, emphasized by the resting pose of the body. It is likely that if Rembrandt had persisted in his earlier composition, the gaze would have appeared somewhat more intent, if only by the suggestion of movement and purpose implied by the body's active posture. But now the face is there offering itself to be looked at as much as it is looking. Yet in all its stillness, it appears full of hidden movement. There is movement in its expression, calm as that may be: it is as if this face is on the verge of changing, but whether it would turn into sadness or into a smile, it does not yet tell. Both moods are suggested: a touch of sadness hovers in the low, drooping lids of the eyes; the smile is beginning to curl itself in the right corner of the mouth. The left eye is somewhat dull—inward looking? The right eye is more clearly painted, its gaze turned toward the world outside, resigned, but also estimating or appraising.

The movement is first and foremost in the texture of the skin. The skin is a landscape with hills and valleys and full of hidden currents as would be caused by underground streams. The handling of the paint is amazing. Not only is there a rich array of colors: a subtle palette of flesh tones, reds, mud grays, soft greens and blues, and tones ranging from dark cavities to bright glimmers. There is also an enormous variation in the material handling of the paint: thick pasty strokes, dry scraping strokes, blobs, uncovered areas where the underpainting shows through, and even outright scratches. The skin is a structure of colors, of threads drawn of paint, of strokes in varying directions. Inspected at close range, it is a layered and continuously moving surface, and that impression does not vanish when one takes a greater distance. The same goes for its fuzziness. One would expect that the lack of sharpness in its outlines would disappear when one moves further away; but although the coherence increases when one does so, a certain lack of focus remains.

Both the lifelikeness of Rembrandt's portraits and self-portraits and the fuzziness of his contours have been commented on and have even been related to each other. Ernst van de Wetering, in his thorough study of Rembrandt's painting techniques, has shown how deeply Rembrandt's mastery was rooted in contemporary workshop knowledge. By comparing a portrait of a woman by Rembrandt with a portrait by Nicolas Eliasz Pickenoy, Van de Wetering makes clear that, for instance, illusionary effects such as the recording of the reflections from an illuminated part of the face on shadowed parts of its surroundings were shared tricks of the trade. Yet there is a stylistic difference between a Pickenoy portrait and a Rembrandt:

> Where Pickenoy pays close attention to each detail, modeling clearly and sharply (and at first sight more convincingly), Rembrandt uses the brush more loosely and fleetingly, and avoids sharpness in his contours and inner drawing.... Alongside the monumentally molded, frozen forms of Pickenoy, Rembrandt's figure appears to be alive. It is as if she is on the very point of changing her expression or of blinking. (Van de Wetering 1997, 172)

In other words, Rembrandt's looseness of manner allows for the suggestion of an expressive mobility that contributes more to the lifelikeness of the portrait than a precise outlining of facial forms would have done.

According to Van de Wetering, Rembrandt's technique for painting these fuzzy contours was highly peculiar. Unlike Leonardo, who softened his contours by blending the paint of the two adjacent areas wet-in-wet, Rembrandt dragged a brush loaded with stiff paint over the surface to produce a rough contour. Apparently, Rembrandt held the opinion, later formulated by his former pupil Samuel van Hoogstraten, that smooth surfaces would tend to recede, whereas rough surfaces would tend to advance toward the viewer (182–85, 188). Often the underpainting shows through in those passages, just as in the shadowed areas of the face. In fact, Rembrandt's faces in his later period are complex constructions of layers of paint in which it is hard to see how they are painted. Sometimes the impasto of the underpainting is applied very roughly as if done with a thick brush; when a layer of thinner paint is subsequently added, the relief of the brush stroke of the underpainting comes through but shows no connection with the colors and tones we see. An exact definition of form is seldom what is aimed for. Instead we get an "image of rough plasticity"; "the form dissolves time and again in the seemingly

autonomous brushwork" (220). Yet in spite of the roughness and seem-
ing casualness of the execution, these faces possess an atmospheric
quality. Van de Wetering points to the interaction of sharp and blurred
elements in the face and the hair of another self-portrait (the Washing-
ton *Self-Portrait* from 1659). There, elements that are sharply "in focus"
are placed upon passages that are painted with more "cloudiness" and
therefore seem to be "out of focus." The same effect is produced by lumps
and cavities in the paint surface that appear as elements that are "in
focus" compared to the surrounding areas. The result asks for an active
involvement of the beholder with the painted surface. "This interaction
of sharp and blurred elements continuously stimulates the eye to ex-
plore the spatial illusion of the image instead of taking for granted what
it sees as in the work of so many other artists which faithfully 'describes'
the reality of what is suggested" (221). I will argue that the kind of visual
involvement Rembrandt's paintings of faces ask for resembles in many
respects the way in which we usually look at faces in real life. The life-
likeness of these self-portraits lies not only in their resemblance to real,
living, and moving faces; it is also suggested by the mode of visual re-
sponse they evoke.

Before I continue, however, I should answer the question of the sig-
nificance and the function of the self-portrait in Rembrandt's oeuvre. It
is tempting to attribute a psychological meaning to these faces' complex
expressions, and it is just as tempting to deny it. Many commentaries
on Rembrandt's self-portraits have interpreted them as forms of self-
investigation. That Rembrandt painted so many pictures of his own
face—forty in sum, not counting the etchings—has often been explained
by his supposed continuous exploration of his inner self. Van de Weter-
ing argues that these explanations rely on a romantic conception of self,
unknown before the end of the eighteenth century. In fact, the notion
"self-portrait" did not exist in Rembrandt's day. Paintings such as the
one we describe were referred to as "the portrait of Rembrandt painted
by himself" or "his owne picture & done by himself" as in an inventory
of paintings owned by the English king Charles I (Van de Wetering
1999, 17).[2]

Van de Wetering offers an alternative explanation of the unusual num-
ber of self-portraits in Rembrandt's oeuvre, pointing to the preferences
of the seventeenth-century public of "lovers of art." For the art-loving

collector with an admiration for Rembrandt, a portrait of the master that was also done by him was a doubly desirable item. It contained both a portrait of a famous painter and an eminent specimen of his style—Rembrandt was famous for the lifelikeness of his *tronies* and in particular for his technique of painting human skin (32–36). However, this explanation does not necessarily exclude other, more personal and artistic, interests Rembrandt may have fulfilled by painting these self-portraits. They were painted for a market and not for private use. But that being so, they could very well have been vehicles for a painterly investigation into what we nowadays would call expressive subtlety, complexity, and depth. And whereas they cannot have been conceived as self-investigations implying the modern, romantic sense of self, it does not follow that, in painting them, Rembrandt could not have been motivated by a curiosity with regard to his own individual character, temperament, emotions, or artistic identity.[3]

In the following, however, the argument will take an ambiguous stance toward the autobiographical status of the painting. It will interpret the gaze the painting produces as a looking at the face of an *other*, disregarding the possible narcissism implied in self-portraiture. This is a deliberate choice, debatable, but not without reasons. For me, as a present-day spectator, the narcissism of the painting is not at all apparent, unless I would want to reconstruct the meaning of the painting in terms of the artist's intentions or biography. In this painting, there are no indications of narcissistic self-manifestation: no mirrors, no signs of the act of self-representation (they have been there but were dissimulated by the maker). What I see is a portrait of a painter, Rembrandt, that might also have been made by one of his pupils, Carel Fabritius, for instance. Yet the knowledge that it is a self-portrait is not without importance: it strengthens the impression of seeing Rembrandt "himself," with all the projection that this belief implies.[4] The otherness that I encounter is thus even strengthened, instead of weakened, by the fact that the painting has been painted by the person it portrays. It must be admitted, however, that this only goes for the painting taken in isolation. When the painting is seen in the context of an exposition consisting exclusively of self-portraits, another reading imposes itself: the massive repetition of representations of the same face would inform all of them, each painting manifesting the same obsession of the maker with the image of his

self. But by including this context, one would also have to accept the bio-graphical setup of the exposition—so I would prefer to abstract from it.

Seeing the Face of the Other

This elaboration of Rembrandt's style and technique as an evocation of certain aspects of the way we see faces has an ulterior motive. It is to ar-ticulate the richness and varieties of sight, against the reductive notions of seeing that are still predominant, especially in the critique of what is often supposed to be the hegemonic visual regime of modern Western culture. When modernity's privileging of vision is deplored, it is vision as a distancing, objectifying, and controlling sense: Cartesian perspec-tivism, to borrow Martin Jay's well-known notion. In contrast, there is hardly a visual item more suitable for challenging this reductive con-ception of seeing than the human face. No visible thing is less likely to behave like an object or to leave its beholder unaffected. When we see someone's face, we see first of all another *person*, and it is only in the second instance that we observe its visual features. The face of another person can never be reduced to the status of a mere thing. Or if it is so reduced, at least consistently and continuously, something has gone ter-ribly wrong. I write "can" instead of "should," because most of the time we feel indeed incapable of looking at another as if he or she was an ob-ject. When caught in the act of examining the person's features, we tend to look away and evade the other's gaze. The other presents herself or himself first of all as a potential appeal, as a possible claim on our at-tention or a demand for our response. If we do not want any intimacy, we can only avert our eyes. If we would continue staring at the person instead, we would humiliate him or her in a most cruel way.

Some consider this evasion as a sufficient reason to deny vision all moral potential. The eyes necessarily put at a distance and objectify every-thing they see. Emmanuel Levinas obviously thinks so, writing time and again that our encounter with the face of the other must be thought of as a hearing or being spoken to rather than as a form of seeing. His no-tion of "face" appears to function like a metaphor—indicating a feeling of obligation the Other demands "before" all consciousness and percep-tion, rather than a visually apprehensible surface. In this respect, Levinas's moral philosophy is a major example of what Martin Jay has termed "the denigration of vision in twentieth-century French thought" (Jay 1993). Jay shows to what extent French critique of Western metaphysics

since Descartes has been aimed at the ocularcentric bias of this tradition: the tendency, that is, to privilege the sense of sight as its main experiential support and as providing the model for its conceptions of knowledge and rationality. This philosophical predominance of vision has resulted in what is most severely criticized in modern metaphysics (and in Western culture as well). The separation of subject and object, the identification of the subject with a singular and disembodied point of view, the reduction of the world to an array of mentally representable objects, and the search for timeless and encompassing transcendental truths issuing from the subject's rational constitution of its world: these features are all attributed to an undue philosophical emphasis on sight.

With Levinas, the distrust of vision is part of his profound critique of the primacy of ontology above ethics in the metaphysical tradition. Instead of taking our obligation to the other as the prime concern and primordial foundation of all reflection, modern Western philosophy thinks of the subject's relation to others as derived from its relation to things. For Levinas, ontology is intimately connected with vision, as light is connected with power and with a reductive assimilation of the other to the same. "Throughout his work, Levinas associates the historically dominant concepts of ontology—truth, knowledge, reason, reflection, objectivity, and certainty—with a philosophical discourse saturated by the power of light and the violence of a logic of the same" (Levin 1999, 247). Vision, as sensible experience, is endowed with "synoptic and totalizing objectifying virtues" (Levinas 1969, 23); "objectification operates in the gaze in a privileged way" (188). Vision might give an illusion of transcendence, receiving things as if coming from a nothingness, but this nothingness is not the absolute nothingness that would allow for the absolute exteriority of the infinite. Therefore, "vision is not a transcendence. It ascribes a signification by the *relation* it makes possible. It opens nothing that, beyond the same, would be absolutely other, that is to say in itself" (191). The face, in its ethical dimension, is not given to vision: "The face is present in its refusal to be contained. In this sense, it would not be comprehended, that is encompassed. It is neither seen nor touched—for in visual or tactile sensation the identity of the I envelops the alterity of the object, which becomes precisely a content" (194).

Yet, as might be concluded from this latter quotation, Levinas is not completely consistent in his denial of vision. The obligation the other

inspires is revealed in the face-to-face relation; it is the face—that is, something eminently visual—that expresses a transcendence that we cannot grasp. On the one hand, vision is evoked: "this new dimension opens in the sensible appearance of the face" (198); on the other hand, vision is denied: "The vision of the face is no more vision, but listening and word" (quoted in Levin 1999, 273). It could be that Levinas distinguishes between two kinds of vision, between a vision that is literally seeing, and a vision that functions as a metaphor for speaking, for discourse. "If the transcendent cuts through sensibility, if it is openness pre-eminently, if its vision is the vision of very openness of being—it cuts across the vision of forms and can be stated neither in terms of contemplation nor in terms of practice. It is the face; its revelation is speech" (Levinas 1969, 193). However, it is also possible that the second kind of vision, the "vision" that cuts across the literal "vision of forms," is not just a metaphor for discourse. Instead, "discourse" would be a metaphor for a vision that does not contain, does not envelop, the otherness of the face.

This duplicity should be cherished. As David Michael Levin notes, Levinas's use of the notion of the face cannot only be visual in a metaphorical sense. Or if it were, it would be a tragic mistake. Visuality should not be equated with the representational thinking and the objectifying ontology that Levinas's moral philosophy opposes. In fact, our looking away when feeling the gaze of the other tells us quite another tale about vision: its potential for intimacy, involvement, recognition, all of which we withhold when we look away. And on the other hand, it tells us about vision's capacity for disturbance, humiliation, and denial, which goes far beyond the cool distance of objectification.

It is not my aim here to develop an elaboration and critique of Levinas's phenomenology (or nonphenomenology) of the face. I have invoked his philosophy here as a challenge, guiding my further exploration of Rembrandt's self-portrait. Levinas's philosophy reminds one that looking at faces engages the onlooker in a relation that profoundly differs from any other visual encounter. Secondly it points to the urgency of *another* conception of visuality, a conception that might do more justice to the ethicality of our seeing of the face of the other. I do not pretend that what I bring forward measures up to the absoluteness of the obligation this other demands in Levinas's ethics. Yet I think (with Levin) that it is imperative to qualify the impoverished, reductive con-

ception of seeing that is taken for granted, both in ocularcentric and in anti-ocularcentric discourses. And where could one come across better counterexamples than in the visual arts? An artwork may—implicitly, and even unwittingly—constitute a form of visual reflection on, or articulation of, visuality by demanding a particular performance of the beholder. On the other hand, looking for such an articulation, such a performance, may show us the work in a novel way.

Another Way of Seeing

It seems inadequate to counter Levinas's distrust of the visual by invoking painted images, visual representations, objects that we see from a distance and grasp as forms—and in many respects it is.[5] But when I suggested that Rembrandt's self-portraits teach us about our looking at faces, and therefore about other modes of visuality, I did not mean to imply that looking at a painted face is of the same order as looking at a face in real life. When I wrote that the way we look at these paintings resembles the way in which we look at faces in real life, I did not mean that we tend to forget that we are looking at oil paint on canvas. Although they resemble real, living faces, these portraits do not strive for an illusion of transparency by hiding their *facture;* in fact, it is exactly through the way they show their being painted that they gain the kind of immediacy they have. However lifelike, they do not confront us in the same manner as a living human being would. They are indeed images, representations, forms—but also something more. They have a performative dimension precisely because they are not real, living faces. Because of the painterly features that I have mentioned, such as the fuzziness of the outlines, the variegated and layered visible structure of the brush strokes, and the material presence of the paint, they address the eyes of the beholder so as to collapse distance and to demand involvement. A mobile texture solicits a mobile gaze, touching, circling, loosing itself and retracting, going from sharp to blurred and back again, following the directions of the brushwork as if following the face's energies, moods, and thoughts.

The painted texture stages a visual performance that is reminiscent of what we do when we look at a face.[6] For how does one see somebody's face? Seeing a face is looking at it but just as often past it, skimming along its surface, flashing intermittent glances at the eyes, stroking a nearby stretch of its skin, sensing its movement, at one moment focusing on a

detail, vaguely staring past it at the next. One's visual behavior toward the other is a continuously mobile and endlessly variegated involvement—and not in the last instance because that is what the other demands. When we see another's face, we are aware of being seen, and being seen looking, as well; and as we ourselves would feel embarrassed by an unwavering stare, we feel obliged to spare the other the embarrassment. How we look at others is of course thoroughly molded by cultural and social conventions. (Once, when visiting the United States, I noticed that there are even differences between New York City and San Francisco in whether and how people looked at your eyes in public. And every culture has its gendered vocabulary of permitted as against forbidden ways of eyeing.) But the sheer fact that looking at faces is so variously formed only shows that in looking at the other's face, we are never in a subject-object relation *tout court*. There is always something at stake: the possibility of being somehow affected.

Although in immediate encounters with another it is hardly possible to observe his or her face in a steady, dispassionate, and encompassing gaze, this in no way incapacitates us in our awareness of its expression. It is rather the other way around. The fragmentation and mobility of our gaze mirrors the fragmentation and mobility of the face it beholds. Facial expression shows an inexhaustible and ever changing array of nuances, and it is amazing how accurately we can read them without looking someone straight in the eye. This ability increases as our familiarity with the other grows. James Elkins has beautifully described his knowledge of his wife's face, a face that when he first met her was almost a mask. "I can understand many things my wife thinks before she says a word and I can guess at her mood from changes so slight that I imagine no one else could see them. This ability of mine is so subtle and runs so deep, that I can sometimes tell her she's anxious before she has even realized it herself. 'You look sad,' I'll say, and she'll say something like, 'Am I? Oh yes, I suppose I am'" (Elkins 1996, 162).

Yet Elkins wonders that he can only remember fragments of his wife's face when she is away. "[All] I have is this odd, shifting thing that we have to call a memory but that is really the memory of the feeling of seeing, together with momentary remembrances of color and warmth" (163). But if in recollection seeing and feeling merge, that is only because they have never really been apart. In seeing the face of a loved one, we do not dispose of the whole picture. What we have is fragmentary

moments of close sensual involvement, alternated with short overviews of the whole face and with momentary lapses of attention. This is exemplified in the seeming arbitrariness of Rembrandt's brushwork. The eye is drawn into the paint's movements, in an almost tactile encounter with the material structure of the surface, and led through a variegated landscape of strokes in various degrees of thickness, of colors and directions. In its journey, it comes across subtle indications of contrasting energies and moods, which in addition suggest an expression on the verge of changing.

The expressive mobility of the portrait contributes to its lifelikeness because, in their close encounter, faces are never at rest. In the intimacy of seeing each other, it is essential that both faces keep responding to the changes in each, just as they keep responding to the other's words. "Speaking is like making ripples in a pool of water, and a face is like the wall that sends the ripples back.... Faces move in this way even when they are not speaking. If I am looking at my wife and not saying a word—even if I am hardly breathing—I am sending very gentle motions, faint undulations in the pool, and each one comes back to me as quickly as I send it. The two of us are like the two sides of a bowl, and the water between shimmers with an intricate pattern of crossing waves" (167–68).

In such exchanges, moments of blindness or unfocused seeing are just as essential as moments of sharp sight. This explains the importance of Rembrandt's particular handling of outlines, of the fuzziness my friend complained of. "Part of my experience of talking to a friend is not looking at that friend. We spend a fair amount of time failing to see the person we intend to communicate with, and in an obscure way those moments of blindness are necessary to look at a person at all" (208). In contrast to Elkins, however, who seems to consider the unfocused awareness of staring as poor seeing, I would say that imprecise as this awareness may seem, it is just as discriminating, though in another register, as is focused sight. Peripheral seeing is inaccurate with regard to color and form, but alert where it comes to movement and change. And much of our seeing of the other's face is of that unfocused, peripheral kind, as we look past or alongside faces as much as we look at them.

The painting plays with the difference between central and peripheral attention, focused and unfocused vision, and with the passage from one kind of seeing toward the other. By its blurring of facial outlines, it denies the sharp, discriminating kind of sight that is possible only in

what is often called "the useful zone of the visual field" (Aumont 1997, 23), soliciting a kind of absent staring instead. And it emphasizes another part of the visual field, its margins; a part that we usually hardly notice, because as soon as we think of it, our eyes are going that way, and the margins cease to be marginal. In this marginal area, seeing is blurred but sensitive, out of control but alert, nearer to the intimacy of touch than to the clarity and distinctness of thought. A little further, these margins curve inward into a zone of darkness or blindness: one's own body as experienced from the inside, from which vision starts and where it returns, but which can no longer be seen itself, only felt. It is in this dark zone that vision gives over to other senses, especially to the feeling of our body's movements, and to imagination and memory. It is the zone where object and subject finally collapse into each other.

It is not surprising that these other two zones at the edges of vision are not taken to be vision at all. We continuously move our eyes and our bodies, and as soon as anything happens in the periphery of our gaze, our eyes immediately and without our conscious decision react and move in its direction. The fringe turns into center, the blurred becomes the sharply focused, what felt intimate or threatening in its closeness is put into its place. However, the gray and black fringes of the visible remain continuously with us, allowing for hardly perceivable gaps, small areas of hesitancy, margins of inconsistency within the seamless visual world. We are not altogether masters of our visual universes. Whereas central attention might correspond to the distancing, objectifying, and controlling posture of an active, Cartesian subject, peripheral seeing has no access to such command. At the edges of vision, we are at the mercy of the world.

And of the other. Faces, more than any other kind of visual things, *demand* an alternation of central and peripheral seeing. That is what the lifelikeness of Rembrandt's self-portrait shows. And by demanding to give up—momentarily—the effort to focus, they demand a surrender. What actual faces do by being alive and looking at us, Rembrandt's portraits do by their style and technique: staging a form of visual engagement that does not seek to control but receives. And with that, the apparent duplicity in Levinas's indictment of vision may find its justification. As Paul Davies has remarked, Levinas's evocation of the face-to-face encounter has a strong rhetorical effect, precisely because it seems to remind us of actual experiences of seeing faces (Davies 1993, 252–53,

260). Feeling an obligation toward the other cannot be as opposed to seeing this other as Levinas sometimes suggests.

In an essay called "Language and Proximity," Levinas indeed lets vision appear in two guises. On the one hand, vision is paradigmatic for sensibility in its subservience to knowledge; on the other, even in this subservience, vision is still not completely bereft of its capacity for contact and proximity. Vision is only briefly mentioned in an argument concerning sensibility, which, according to Levinas, should not only be understood in cognitive (or ontological) terms. Sensibility is often conceived of as an intentional openness of consciousness upon being that is subservient to the thematization and identification that characterize discursive thought. The structure of all sensibility is thereby modeled on the structure of vision. However, it is questionable whether even vision is properly conceived of in terms of this structure alone. Touch, in any case, should be thought of in two modes: it may be a way of knowing what is touched, but it is primarily *contact*, pure approach and proximity that cannot be reduced to the *experience* of proximity. And "proximity, beyond intentionality, is the relationship with the neighbor in the moral sense of the term" (Levinas 1987, 119). Touch in its ethical transcendence is the caress, or in Levinas's intriguing but enigmatic phrasing: "In reality, the caress of the sensible awakens in a contact and tenderness, that is, proximity, awakens in the touched only starting with the human skin, a face, only with the approach of a neighbor" (118).[7] Although sight is paradigmatic for sensibility in its being directed at consciousness, "even in its subordination to cognition sight maintains contact and proximity. The visible caresses the eye. One sees and one hears as one touches" (118). Proximity, however, should be thought of not as a restful side-by-side but as an obsession felt as haunting one before all consciousness or representation, as a restlessness, an absence.

Davies has tried to explain "Language and Proximity" in terms of an interweaving of the sensible and the ethical. In *Totality and Infinity* there was a clear distinction between the face and sensibility, allowing for a metaphorical *likening* of the disruption of philosophical thematization by the unintelligibility of the face with the resistance to consciousness (the intelligible) by sensibility. This resistance was possible because of the meaning that Levinas gave to sensibility: not only as furnishing givens for cognition, but also as unreflectively lived and thereby enjoyed, as part of the corporeal fullness of "living from" the world.[8] In the happiness

and contentment of savoring life, one is autonomous, retreating into oneself, egoistic. This egoistic individuality is a necessary condition for the ability to resist any form of totalization, including the totalization by philosophical thematization. Yet it is insufficient to account for the appeal of the other.[9] Therefore the face in its ethical dimension is not given to sensibility—neither in its cognitive, nor in its lived, mode. The face as transcendence "cuts across sensibility."

In "Language and Proximity," however, this distinction between the ethical and the sensible is becoming blurred. Sensibility itself is the event that interrupts, and with that, the concept of sensibility is altered. "'Sensibility' thus names not only a relationship subservient to cognition but also a 'proximity,' a 'contact' with a singular passing, a 'contact' with this singular passing of what has always already made the life of consciousness something more than a matter of knowledge. Something more which can perhaps only ever register as something less, as an absence" (Davies 1993, 267). But not only sensibility is contact; language is contact, too. When Levinas writes, "Language, contact, is the obsession of an I 'beset' by the others" (1987, 123), the result is, according to Davies, an "insistence on the ubiquity of the sensible." "In complicating the way in which 'language' and 'alterity' are brought (written) together, 'contact' precludes any literal or metaphorical, any theoretical or pretheoretical circumscribing of sensibility" (Davies 1993, 270). The sensible is no longer excluded from the ethical. And with that gesture, vision too is no longer relegated to the domain of consciousness, where, although amenable to phenomenological description, it remains outside the ethical relation. On the contrary, vision has become part of the paradoxes into which phenomenology is thrown when it attempts a description of the face. As Davies concludes his commentary: *"In seeing, I am implicated. In being implicated, I am faced"* (271).

To Conclude

There might be a sense in which visual art could take over from phenomenology the awkward task of expressing this paradox: it might stage this implication and thereby show us that vision itself is not uniform and contains different modes of sensibility.[10] Although the visual sensibility we have described in itself does not suffice to do justice to the absoluteness of Levinas's conception of the transcendence of the other, it is at least not contrary to it.[11] It might be a possible source to draw on

for the development of a more responsive visual culture and an ethics of the image in which the face of the other will not be exploited in the service of sensation, propaganda, or commerce. The point is that painting and other visual arts not only thematize but also exemplify—and exemplify not only referentially (as in Goodman's concept of exemplification) but also performatively: by making the beholder reenact specific relations of visual involvement. Painting might then function in a way analogous to ethical language, of which Levin remarks (meaning Levinas's own style): "Only an evocative, invocative, exhortatory use of language, a metaphorical and poetizing use of language, a revelatory use of language, a rhetorical form that uses equivocation to speak on and to several different levels of experience at the same time, can function performatively, enacting what it at the same time describes" (Levin 1999, 239).

In the epilogue to his book, Ernst van de Wetering explains why he finds Rembrandt's work so compelling. He points to the way in which the visible brushstroke seems to demand a bodily involvement of the beholder, who latently participates in the movements of the brush. Rembrandt's brushwork shows an extraordinary variation and spontaneity, yet remains always in service of the design of the image. Its freedom is rhythmically orchestrated, its spontaneity directed. The beholder who visually participates in the gestures of the brush feels that the work had to be as it is and could not have been different (Van de Wetering 1997, 279).[12] This aesthetic pleasure, I would say, acquires an ethical dimension when the rhythm of the brush strokes is describing the human face. Painting the face is touching it: molding its features, piercing its surface, caressing its skin. But in touching, one is touched. Looking at the paint is reenacting the quality of the touch, bringing forth what is there, in a bodily activity that is at the same time receptive. Touching the face is surrendering to it. The eye caresses the visible. The visible caresses the eye.

Notes

1. The exhibition ran from 25 September 1999 to 9 January 2000; it was previously at the National Gallery, London, from 9 June to 5 September 1999. I am grateful to Hans Roodenburg and Theo de Boer for their comments on this essay.

2. In the light of these remarks in the catalog, the unabashedly biographical setup of the exhibition and its marketing is at least surprising.

3. H. Perry Chapman argues that the self-portraits were "largely internally motivated" but understands this motivation in seventeenth-century conceptions of the

self—informed, for instance, by the contemporary psychology of bodily fluids determining the human temperament (Chapman 1990).

4. I agree with Mieke Bal that "Rembrandt" is a cultural construction, which does not exclude, however, the possibility and importance of valid historical knowledge about the life of the painter, his ideas, artistic purposes, and working methods. In the light of Bal's refusal to treat "Rembrandt" as anything other than a cultural text, it seems somewhat inconsistent that she analyzes his self-portraits in terms of narcissism. Because one does not see the person portrayed looking at himself, one cannot speak of the narcissism without assuming the personality and motives, conscious or unconscious, of the biographical subject of the painter (in this, narcissism might be different from other psychoanalytical concepts). That is because we, as spectators, do not see a mirror image of ourselves: we see a middle-aged man we recognize as "Rembrandt." In the absence of signs such as mirrors, it would take a complicated act of projective identification to see ourselves in this old man (Bal 1990, 144–48).

5. Not only because of Levinas's distrust of visual form, but also because of his distrust of aesthetic enjoyment, in which he finds "something wicked and egoist and cowardly." See "Reality and Its Shadow" (Levinas 1987, 1–13). The quotation is from p. 12.

6. With the observation that the reminiscence may be no older than the performance that brings it about. Cf. Levin 1999, 279–80, on the performativity of the trace.

7. It is somewhat clearer in the original French: "En réalité, dans le contact, ne se réveille la caresse du sensible et dans le touché—la tendresse c'est-à-dire la proximité—qu'à partir d'un peau humaine, d'un visage, à l'approche du prochain."

8. For an account of the distinctions between Levinas's evaluation of corporeality and Husserl's, Heidegger's, and Merleau-Ponty's, see De Boer 1992, 281–93.

9. Although it is a starting point for ethical awareness: "Gerade weil der Mensch ein genießendes und glückliches Wesen ist, ist er bedroht und verletzbar; diese Verletzbarkeit kann ihm die Augen für das Leid Anderer öffnen" (De Boer 1992, 291).

10. Of course, when one feels implicated in the brushwork of a painting, one does not feel faced as one is by the gaze of a living face. But that is exactly what gives one the opportunity of reflectively experiencing what visual implication might be.

11. Against Levinas's distrust of aesthetic enjoyment, Jacques de Visscher has convincingly argued that art is more than aesthetics alone: it has an expressive dimension that may very well be aligned with what Levinas writes about the expression of the face (De Visscher 1990).

12. Levinas has written beautifully about rhythm, relegating it, however, to the sphere of the aesthetic alone. "Rhythm represents a unique situation where we cannot speak of consent, assumption, initiative or freedom, because the subject is caught up and carried away by it. The subject is part of its own representation. It is so not even despite itself, for in rhythm there is no longer a oneself, but rather a sort of passage from oneself into anonymity. This is the captivation or incantation of poetry and music. It is a mode of being to which applies neither the form of consciousness, since the I is there stripped of its prerogative to assume, its power, nor the form of unconsciousness, since the whole situation and all its articulations are in a dark light, *present*" (Levinas 1987, 4). See also Peters 1997.

References

Aumont, Jacques. 1997. *The Image*. London: British Film Institute.

Bal, Mieke. 1990. *Verf en verderf: Lezen in Rembrandt*. Amsterdam: Prometheus.

Brown, Christopher, Jan Kelch, and Pieter van Thiel. 1991. *Rembrandt: The Master and His Workshop: Paintings*. New Haven: Yale University Press in association with National Gallery Publications.

Chapman, H. Perry. 1990. *Rembrandt's Self-Portraits: A Study in Seventeenth-Century Identity*. Princeton: Princeton University Press.

Davies, Paul. 1993. "The Face and the Caress: Levinas's Ethical Alterations of Sensibility." In *Modernity and the Hegemony of Vision*, ed. David Michael Levin, 252–72. Berkeley and Los Angeles: University of California Press.

de Boer, Theo. 1992. "Feindschaft, Freundschaft, und Leiblichkeit bei Levinas." In *Eros and Eris*, ed. P. J. M. van Tongeren et al. Dordrecht and Boston: Kluwer Academic.

de Visscher, Jacques. 1990. "Levinas: Esthetica, expressie en kunst." In *Levinas over psyche, kunst en moraal*, ed. H. Bleijendaal, J. Goud, and E. van Hove. Baarn: Ambo.

Elkins, James. 1996. *The Object Stares Back: On the Nature of Seeing*. New York: Simon and Schuster.

Jay, Martin. 1993. *Downcast Eyes: The Denigration of Vision in Twentieth-Century French Thought*. Berkeley and Los Angeles: University of California Press.

Levin, David Michael. 1999. *The Philosopher's Gaze: Modernity in the Shadow of Enlightenment*. Berkeley and Los Angeles: University of California Press.

Levinas, Emmanuel. 1961. *Totalité et infini: Essai sur l'extériorité*. Boston: Martinus Nijhoff.

———. 1969. *Totality and Infinity: An Essay on Exteriority*. Trans. A. Lingis. Pittsburgh: Duquesne University Press.

———. 1987. *Collected Philosophical Papers*. Trans. Alphonso Lingis. Boston: Martinus Nijhoff.

Peters, Gary. 1997. "The Rhythm of Alterity: Levinas and Aesthetics." *Radical Philosophy* 82: 9–16.

van de Wetering, Ernst. 1997. *Rembrandt: The Painter at Work*. Amsterdam: Amsterdam University Press.

———. 1999. "De meervoudige functie van Rembrandt's zelfportretten." In *Rembrandt zelf*, ed. Cristopher White and Quentin Buvelot. Den Haag, London, Zwolle: Koninklijk Kabinet van Schilderijen, Mauritshuis; National Gallery Publications, Waanders.

CHAPTER FIVE

Presence and Absence:
On Leonardo da Vinci's *Saint John the Baptist*

Robert Zwijnenberg

A Mystery

There are paintings that fascinate anew every time you look at them, while it is not possible to describe clearly why these paintings are so fascinating or what they mean or signify. To me *Saint John the Baptist,* painted by Leonardo da Vinci (1452–1519) after 1510, is such a painting.

In the extensive Leonardo literature, much attention has been devoted to this painting. In this essay, I will use this art historical scholarship on Leonardo's painting to orient my visual experience to the painting's historical conditions of viewing.[1] It is significant that most art historians who have written about *Saint John the Baptist* are impressed by the strangeness of the figure's presence and its radiating qualities.[2] However, no one has attempted to account for John's remarkable presence and the effect on its beholders; some writers have explicitly refused to do so.[3] My intention in this essay is to try to come to terms with my fascination with this painting, in an effort to expose the painting's mechanism that causes the beholder's fascination. And to do this, I will—by way of an interpretative experiment—juxtapose the painting with a text from Johann Gottfried Herder's (1744–1803) diary.

Thus the purpose of this essay is not to explain or to understand the painting from an art historical or iconographic point of view but to investigate the beholder's response to the painting. To investigate the response of the beholder is in general not considered as part of the art historian's enterprise. Therefore I will not be discussing the lost painting and all the drawings by Leonardo that depict the angel of the Annunci-

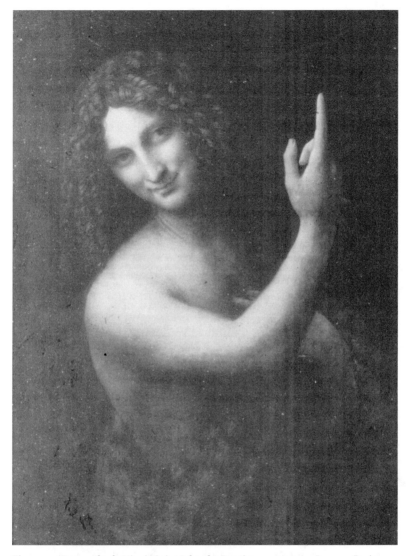

Figure 5.1. Leonardo da Vinci, *Saint John the Baptist*, c. 1508–1515. Louvre, Paris. Copyright Alinari/Art Resource, New York.

ation. This lost painting and those drawings dating from the same period as *Saint John the Baptist* have seemed to art historians to provide clues to the painting's iconographic idiosyncrasies.[4]

My own juxtaposition of text with painting is different from comparing a painting to a textual source. What is at stake when we juxtapose painting and text with each other? The exercise raises metatheoretical

considerations that I will pursue in stages as a process of confrontation between the beholder (myself) and Leonardo's image. The starting point of my discussion is that a painting *in essence* is totally different from a text; why else does one paint? In the final analysis, however, a painting can only come into being as a painting (that is, lose its status as just a visual object) when the visual experience of the beholder is translated into words.[5] This exciting paradox, although others may hear it simply as a cliché, can only be resolved by considering the task of interpreting a painting as a sort of continuous rhetorical process of finding the right words for the beholder's visual and corporeal experience. My observation is related to the rhetorical notion that the "right word" depends on the specific context in which a question (or in this case a painting) is discussed. There is not just *one* correct word to refer to a topic (or a painting), but many apt ones: they appear more or less coincidentally while we consider a given subject. Quintilian warned about a thoughtless use of words that "appear" while we are writing. We must search for the "right word," not rest content with correct words that seem to offer themselves. In this context Quintilian spoke of a choice that has to be made at every turn while we write.[6]

In this essay, I will describe the process of finding the right words as an initial attempt to translate into words my fascination for Leonardo's painting. If this attempt proves successful, it might be the basis for solving metatheoretical questions. This seems to be the right order if we agree that the purpose of describing the experience of a work of art is initially and ultimately to develop a theory of art.

Leonardo's painting depicts a chubby young man who looks at us squinting with a strange smile while he points upward with his right forefinger. In fact, there is nothing else to see, which is why it is so difficult to explain what this painting is signaling or telling us. There is no narrative to provide a context that instantly situates the figure in relation to us by identifying who he is.

Yet it is apparent that Leonardo depicted John the Baptist from a number of traditional iconographic elements, such as the wooden cross, the animal hide (a leopard skin), and the pointing finger.[7] With his left fingers, John presses against his chest on the place of his heart, which may be interpreted as a reference to devotion and religious love, that is, as a reference to the Sacred Heart of Christ.[8] According to the Gospel of

John (19:34), blood and water flowed from the wound in the heart in the crucified Christ. The blood symbolizes the Eucharist, and the water baptism: thus the pierced heart of Christ is a quintessentially concrete symbol of Divine Love.

Nonetheless there are a number of visual elements that problematize the identification of the subject as John the Baptist. For instance, his expression seems to be a mixture not only of amazement, bliss, and compassion but also of irony, even sarcasm, sensuality, and detachment—in other words, expressions that are not readily associated with the Baptist. It is not just his face: his androgynous body problematizes the identity of the depiction even more. The figure's chubby shoulders and arms hardly seem appropriate to a biblical hermit who led an ascetic life somewhere in the Sinai Desert.[9] A comparison with Donatello's sculptures of Saint John (1430–1440) is telling; John's ascetic way of life is evident from Donatello's depictions of his emaciated body.[10]

It has been pointed out that the depiction can also be regarded as Bacchus. In the tradition of Bacchus depiction, the leopard skin and the androgynous body are recurring elements.[11] Moreover, Bacchus is often depicted slightly drunk, which might explain the figure's strange expression. If the portrait is viewed as a conflation of Bacchus and Saint John, the painting might be Leonardo's response to "a fashionable philosophy which was aiming at a pagan-Christian syncretism in art."[12] Furthermore, in the fifteenth and sixteenth centuries, androgynous bodies were a popular subject for painting, and drawing connections between John the Baptist and Bacchus was a recurring theme in literature and art.[13]

This conclusion, that Leonardo conflated John the Baptist and Bacchus in one figure, to produce pagan-Christian syncretism, neutralizes the inconsistencies and ambiguities of the visual image. Such an explanation might satisfy beholders who dislike contradictions and paradoxes, but it does not do justice to my experience of the painting itself. It is more likely that the inconsistencies contribute to the picture's interest and lack of resolution and explain why the painting continues to arouse our visual and intellectual curiosity.[14] The painting is more than just the illustration of a Bible story or a myth.

Paul Barolsky, an art historian with a fear of ambiguities, points out that the ambiguous content of the painting was due to "an ambiguity born of the problematic relation in Leonardo's painting, as in Christian-

ity itself, between the spirit and the flesh, an ambiguity born of Leonardo's audacious and (dare one say it?) flawed attempt to make visible the divine mystery of the spirit in flesh."[15] Although I do not entirely agree with Barolsky's observations, they contain an important clue to the subject of this painting: Barolsky contends that Leonardo depicts the moment of the Incarnation, when the mystery of the divine word becomes flesh in the person of Jesus Christ. After all, John announces and is witness to the Godhead of Christ.

The essential aspect of any mystery, of course, is that it can never be comprehended completely. The purpose of biblical exegesis by theologians and philosophers always was and still is to underline the polysemy of practically every word in the Bible, and to employ (or exploit) this polysemy to deepen our understanding of the divine mysteries, without ever reaching a final point of insight. Otherwise, a mystery like the Incarnation would vaporize into a nice, circumscribable story, totally within the grasp of the human mind. Therefore, is it not rather naive of Barolsky to accuse Leonardo of a flawed attempt to make visible the divine mystery of Incarnation, as if it would ever be possible to make visible a divine mystery? For if such an attempt were successful, it would cease to be a divine mystery!

If we accept the Incarnation as the subject of Leonardo's painting, then we can no longer think of the painting as an illustration or visual translation of the mystery; rather, the painting is the visual location of mystery.[16] Undoubtedly, Leonardo realized, or intuitively grasped, I would like to suggest, that the meanings of a divine mystery are infinite and, in the final analysis, ineffable. In the painting, Leonardo tried to apprehend the mystery pictorially by means of paradoxes and uncertainties. Within the field of possibilities opened up by the visual register, Leonardo has tried out different avenues of approach to the mystery.

From this point of view, the inconsistencies and ambiguities in the painting refer to—or rather, signal—something that cannot be made visible but nevertheless permeates the painting with its presence: the incomprehensible mystery of the Incarnation of the Son of God. To the beholder, this means that the act of looking at the painting may come close to, or equal, an experience of the mystery. Inevitably, the experience is confusing and contradictory: the mystery is not resolved in a clear image. Thus a painter is able to express or evoke something that can never be described properly in words. If my hypothesis is correct,

the aporias of the painting are positive elements rather than failures on Leonardo's part.

However, this line of interpretation, which ought to be elaborated more fully, is in essence negative. When we describe the painting in negative or evasive terms, using words such as "ineffable," "absence," "the unseen," and so on, our language seems to contradict the fact that, as beholders, we *do* see something—there is an image that affects us by its strong visual presence. Is it possible to discuss this positive aspect of the painting qua painting without contradicting the interpretation of it as the locus of the mystery of the divine word becoming flesh?

The Body and the Beholder

The painting shows scarcely more than the upper part of a bare androgynous body.[17] Leonardo devoted much labor to the visual qualities of the skin under different shades of light, and to anatomical details such as the folds in skin of armpit and neck. He also paid a great deal of attention to bodily pose and gesture.[18] The figure consequently has a very sensuous corporal presence. A positive interpretation should take this corporal presence as its starting point.

To view a painting is, in the first place, a sensual experience, and a sensual experience can never be translated entirely into words. There is always a remainder, something in the picture, that escapes translation (though it might be included in a new translation, which will, inevitably, produce new remainders).[19] To interpret a painting is, in the final analysis, a matter of finding the right words and concepts to describe something that, strictly speaking, cannot be—and is *in essence* not meant to be—described. Furthermore, with regard to Leonardo's painting, a part of our sensual experience might be described as a bodily reenactment, a visceral response to the sensuous corporal presence of John. The painting confronts us with a body that we can only fully "understand" through our own corporeality.[20] This return from our visual experience of the painting to our own corporeality, to our own body, is a process without words. That fact alone is not necessarily a problem: viewing a painting is a private matter that we do not need to share with other people to enjoy more fully. If, however, I wish to translate my bodily experience into words, into a text, the challenge of interpreting sensual experiences into words is considerable.

There are different strategies for addressing this problem. As mentioned at the outset, I propose to tackle this problem by means of an experiment: I will employ a text as a support, to find the right words and to reflect on my interpretative approach. Of course, I need a text in which the issue of bodily reenactment and its translation into words is thematized and performed: the text must enlarge my own vocabulary on the issue.

I believe I have found such a text in a diary that Johann Gottfried Herder kept during his voyage to Italy in 1788 and 1789.[21] The correctness of my choice depends on whether Herder's text helps us indeed to grasp effectively, in words, the corporal presence of Leonardo's Saint John. My choice of Herder's text is not only a matter of its immediate contents. I am also compelled by Herder's aesthetic of touch, which plays an important role in the diary fragment.[22]

Herder's Aesthetic of Touch

Herder's philosophical starting point is that reality is accessible to human beings only through sensation, the use of the senses. Without *aisthesis* no self-knowledge and no knowledge of the world are possible.[23] To Herder, the importance of sensation is directly related to the intellectual and philosophical debates of his time, when the senses were vigorously discussed and analyzed.[24] Herder distinguished himself from contemporaries in that he considered the sense of touch as the foundation of the experience of the world and ourselves. Touch is our first and most direct access to the world, in an anthropological sense (a child starts with touching the world to grasp the world around him, to get ahold of the world),[25] as well as in an ontological and epistemological sense: all experience and knowledge of the world around us, and all concepts we use to express that experience, can ultimately be traced back to the primal experience of touch.

Touch is also the sense that leads to self-knowledge. We feel something outside ourselves, and we experience at the same time that we differ from what we touch.[26] Touch makes it possible for me to perceive myself as a sensuous perceiving "I." Touch is thus the sense that leads us into the world, that gives us an understanding of ourselves. Herder epitomized this in the phrase "Ich fühle mich! Ich bin!" [I feel me! I am!].[27] Hence for Herder, the experience of one's own corporeality is the first and only reliable source of our knowledge of the world and ourselves.

Herder described the sense of touch as the slowest and darkest sense. The sense of touch dawdlingly explores an object in complete darkness, hesitant and repetitious, in order to ascertain and to understand what the object is. Touch lacks the transparency, velocity, and simultaneity, as well as the distance and perspectivism, of the sense of sight: in one instant we see and recognize an object at some distance, from a particular point of view. Nevertheless touch gives us the most direct access to, and knowledge of, the world around us. Touch operates meticulously and, according to Herder, renders individual concrete knowledge of an object. Visual perception, sight, is a reduction or abbreviation of touch— sight can lead only to abstract concepts and abstract truth.[28] Still, according to Herder, an authentic intimacy arises between the touching subject and the touched object: the object also touches the one who touches.[29]

Herder's ideas about the primacy of touch help to explain why he considered sculpture the most important art. We must not perceive a sculpture passively; the forms must reveal themselves in an empathic groping. Touch must bring life to the marble.[30] The beauty of a sculpture is not a result of its anatomical correctness—which is superficial and directly perceivable by the eyes—but the result of an inner force, of the soul of the sculpted body, revealed only in this empathic touching of the sculpted human form.[31] According to Herder, the inner beauty of a sculpted human body brings us into close contact with the truth and beauty of God's creation.[32] Thus Herder's aesthetic of touch has strong ethical and even religious undertones.

Herder's description of the sense of touch suggests a manner of looking at the painting of a body: with a groping and emphatic gaze. To view a painting of a body, we have to look as if we are looking at a sculpture, "sich an die Stelle des Gefühls zu setzen; zu sehen, als ob man tastete und griffe" [to put ourselves in the position of our sense of feeling; to see as if we are groping or touching].[33] The beholder of a painting must resist preoccupation with planes and angles of perspectival sight, because that destroys the "schöne Ellypse" [beautiful ellipse] of a body.[34]

The ontological, epistemological, and anthropological primacy of the sense of touch, and the notion that touch can bring us into direct contact with Truth, make it understandable that Herder conflated the different meanings of *tasten* (to touch) and *fühlen* (to feel), as is evident in his

statement "Ich fühle mich, ich bin." For Herder, to touch something (with his body) and to feel something (that is, to experience something emotionally and intellectually in the mind) are correlative acts. This is why he could consider touch as the sense leading us to knowledge both of the world and of ourselves.[35]

Because of his concentration on touch and, as we shall later see, on corporeality and sensuousness, Herder's text may help us to verbally grasp these tactile aspects of Leonardo's painting.[36]

Corporal Presence

Herder's focus on touch readily gives the impression that his philosophy has strong erotic undertones. Herder himself always denied this characteristic of his philosophy, but when we read his description of individual sculptures, we are confronted with great ambivalence in attitude.[37] On the one hand, the un- or nonsensuous character of his writing is sometimes remarkable, considering that he was constantly writing about touch. On the other hand, the reader is often baffled by Herder's sensual and sometimes erotic descriptions, such as the passages in which he expresses, almost in passing, his deep admiration for the beautiful buttocks of sculptures of Venus.[38] This is also the case in the fragment from Herder's diary that describes a sculpture of Hermaphrodite in the Villa Borghese in Rome:

> Another Hermaphrodite is lying on the left side, with eyelids shut lightly. He is lying on his right arm that is under the head, the fingers spread calmly, the elbow in the same position as the head, so that it is in front of the hand. The hair is nicely dressed in a ladylike manner. The left arm on the pillow: the arm softly leaning on the pillow, the fingers spread sensuously; the cloth that he is lying on partly covers this arm below the elbow which makes the hand seemingly come forward. Now he stretches his back softly from left to right side, which reveals the spinal column's uncommonly beautiful line; the left hip juts out prominently, extending itself towards the knee, on which the entire figure is leaning; now the left foot comes back across the right calf, suspended by the foot; only a tiny piece of the cloth is stretching along his calf up to his ankle, and sensuously his toe becomes visible. It is as if the right leg, which is on top of the cloth, extends itself so as to touch the cloth only softly, with the knee slightly bending forward. Calf, leg and foot are stretched softly, and with a toe he provocatively lifts the cloth, which is hanging down from the left foot that is on it. It is an uncommonly sensuous position that really invites one to reach to the back. There one finds a softly protruding,

softly taut female left breast, the budding of which one can still feel, a
very fine budding; a beautiful sensuously curved lower part of the body
with navel and softly taut male genitals. The penis is quite long, supple,
but pointed to the waist rather than to the body; the penis, supply
bending forward, is on the cloth, with only the upper part of the glans
exposed, the testicles taut. Given the beautiful posture, the upper legs
below the hips are equally inviting, as is true of the curving behind the
knee and so on. A beautiful ladylike head and neck, nicely curved; the
hair elegantly dressed; one would like to enjoy and feel the entire curved
back, shoulders, everything.[39]

A remarkable feature of this fragment, besides its erotic allusions, is its
repeated use of the words *wollüstig* (sensuously) and *sanft* (soft). For
Herder, these words refer to both a corporal feeling and a state of mind,
at the same time intensifying each other.[40] The impression of "Wollust,"
of a deep sense of well-being that the sculptured body conveys, is di-
rectly connected with the "sanft" tension of the body. Probably it is not
a coincidence that "sanft" is traditionally a tactile quality; "softness" can
only be perceived by touch.[41] In applying these words, Herder shapes
his bodily reenactment of the sculpture into a text. His first response to
the sculpture is corporeal in nature. His desire is the desire of the sense
of touch: "alles genießen und fühlen" [enjoy and feel everything] and
"Eine ungemein wollüstige Stellung, die recht einladet, nach hinten zu
greifen" [It is an uncommonly sensuous position that really invites one
to reach to the back]. Herder translates the "Wollust" of the sculpture,
and his "Wollust" in touching the sculpture, into a "tiefe Wollust des
Gefühls"[42] [a deep lust (of the sense) of feeling] that is unequaled by the
superficial experience of sight.[43] Thus his tactile desires and satisfaction
coincide with a deep spiritual feeling of happiness.

Furthermore, it is remarkable that in his description, the narrative
context of the sculpted body (the myth of the Hermaphrodite) plays no
role at all. The body is neither presented as part of a story nor described
as being female or male.[44] Herder demonstrates how the sculpted body
comes to life, so to speak, under his groping gaze. Central to his descrip-
tion is the human body *an sich*, that is, the unavoidable presence of a
body and its effect on the beholder.

Thus corporeality and presence are the dominant themes of Herder's
description. Their importance becomes clear when we contemplate a
central theme of Herder's aesthetic of touch, that is, directness or imme-
diacy. Touch is the most direct sense, for without a medium, it brings us

into contact with an object outside our body. Hence the directness of touch is directly connected with corporal presence. For Herder, the most primal experience is the presence of something in the immediacy of touch, because this experience is an unmediated and authentic experience of both the self and the world.

In Herder's diary fragment, the direct experience of touch is evoked in words, and for my purposes it is not important whether Herder really touched the sculpture or not. What is important is that Herder effectively describes the corporal presence of the human body in a work of art with words that evoke the experience of touch, on the theoretical foundation of the concept of "directness" and "presence." Furthermore, Herder demonstrates that the experience of the corporal presence of a work of art comes close to, or equals, our most primal experience of the world—that there is "something" outside our body that we can experience only with our body. In the tactile experience of the human body in a work of art, moreover, bodily touch and spiritual feeling coincide. In the act of touching, there is no opposition between body and mind.

Sculpture and the Limits of Painting

What happens when we return to Leonardo's *Saint John the Baptist*, equipped with Herderian words and ideas?[45] In the first place, from a Herderian point of view, the androgynous character of the painting stands out more distinctly as an essential characteristic of the painting. That is to say that the painting displays a human body that does not distinguish male from female; rather, male and female aspects coexist and become conflated.

Second, from a Herderian perspective, the beholder is likely to be more sensitive to the sensuous and erotic dimensions of the painting. Leonardo's painterly focus on skin refers inevitably to the sense of touch.[46] In the religious iconography of touch, two familiar motifs are erotic touching (the pleasure of the infant Christ touching his genitalia)[47] and painful touching (the pain of the Crucifixion). The image of John touching his breast and pointing to his heart is in keeping with this iconography, in which bodily pain and pleasure are reminiscent of the Fall.[48] Moreover, John performs the baptism of Christ, a ritual in which body and touching are pivotal. Thanks to this focus on touching and the sense of touch in the painting, and by extension, to the pleasurable (erotic)

and painful sensations of touch, the real subject matter of *Saint John the Baptist* appears to be the human body and corporeality.

In this respect, there are three noteworthy passages in Leonardo's manuscripts. In the first part of his *Trattato della Pittura*, the so-called *Paragone*, Leonardo wrote that "sculpture requires certain lights, that is, those from above."[49] In this passage, Leonardo describes a practice dating back to antique prescriptions of the effective lighting of sculptures. John is illuminated from above; thus, he is illuminated as if he were a sculpture.[50]

In another chapter of the *Paragone*, Leonardo wrote: "The prime marvel to appear in painting is that it appears detached from the wall, or some other plane, and that it deceives subtle judges about that thing that is not divided from the surface of the wall. In this [specific] case, when the sculptor makes his works, what appears is as much as there is."[51]

Elsewhere in the *Paragone*, he wrote: "With little effort sculpture shows what painting appears [to show], the miraculous thing of making impalpable things appear palpable, giving relief to flat things, distance to nearby things. In effect, painting is embellished with infinite speculations which sculpture does not employ."[52]

These *Paragone* chapters demonstrate Leonardo's opinions about the sculptor, whose achievements he judged far below the painter's. In the *Paragone*, Leonardo compared the sister arts—painting, sculpture, music, and poetry—in order to establish that painting is the most important and noble art. In his comparisons, sculpture, in particular, is on the receiving end of Leonardo's severe complaints. Repeatedly, he emphasized the low intellectual effort that is needed for sculpture in comparison with the high intellectual level of the painter's activities. For its effects, sculpture can rely on nature, whereas the painter needs "subtle investigation and invention" to create, for instance, pictorial relief.[53]

In the light of Leonardo's often quoted observations from the *Paragone*, his *Saint John* might be considered as a visual explanation of his comparison between sculpture and painting. In this painting, the depiction of a figure on a flat surface miraculously displays sculptural curves and gestures. The painting is an emulation of sculpture in that it demonstrates that it is possible to feign sculptural three-dimensionality on a flat surface. The painting feigns to be a sculpture of a human body.

If we look at Leonardo's painting, it is not difficult to exercise the gaze recommended by Herder: "sich an die Stelle des Gefühls zu setzen;

zu sehen, als ob man tastete und griffe" [to put ourselves in the position of our sense of feeling; to see as if we are groping or touching].[54] The beholder's inclination to grope the surface with her or his eyes is intensified by the tactile qualities of the leopard skin, John's flesh, his curly hair, and the sensuous curves of his body; all of these painted features invite the viewer to touch the painting.

We can elaborate this if we contemplate the Herderian concepts of directness and presence, in relation to the sense of touch. An interpretation that is confined to the what, how, and why of the story of the painting—to historical documentation—has no place for the presence of the painting. Yet it is precisely the presence of the depiction that is the most remarkable feature of Leonardo's *Saint John*. Leonardo heightened the painting's remarkable presence by depicting John against a dark background. The light-emanating quality of John's body, his attitude, expression, and gestures contribute to his confrontational and inescapable presence. We are visually overwhelmed simply and solely by the figure's presence. It is undeniable that we see a human being, but it is not clear at first sight whether it is a man or a woman, or who it is. But are these important things to know? Such considerations lead us away from the painting qua painting; that is to say, they distract us from the significance of the directness and presence of the image.

Leonardo reinforced the effect by making the experience of touch the theme of the painting in the experience of the beholder. From a Herderian point of view, we may argue that Leonardo's painting pushes the extent of the painting's abilities to evoke the primal experience of touch. If my interpretation is correct, considering that the manner in which this painting emulates sculpture is the subject of the painting from Leonardo's perspective, the painting is about the limits of the art of painting. In that case, the true subject of the painting is the art of painting. We can corroborate this hypothesis by reference to the *Paragone* passages cited earlier.

Bodily Reenactment

In the *Paragone* fragments, Leonardo presents a poignant definition of painting. A painting is characterized *in primo* by the coincidence of opposites: depth and flatness. The (material) flatness of the panel is connected to its (painted) depth. Because of this coincidence of opposites, Leonardo argues, a painting differs completely from other things made

by men: what we see is a flat surface with depth. This special quality is also lacking in natural things.[55] This quality of painting is, moreover, strongly accentuated by the use of linear perspective from the fifteenth century onward.[56]

For Leonardo, one of the most important tasks of the painter is to create an opposition between flatness and depth, that is, pictorial relief: "il quale rilevo è la importantia e l'anima della pittura" [this relief is of importance to, and the soul of, painting].[57] In *Saint John the Baptist* Leonardo achieves this coincidence not by means of linear perspective but by constructing a sharp contrast between the dark ground and the luminous figure. Such juxtaposition of dark and light is an important aspect of Leonardo's innovative chiaroscuro. In the context of this painting, however, this juxtaposition of opposites might have a more meaningful connotation than just a painter's technique.

As we already observed, *Saint John the Baptist* is the representation of a mystery—the image refers to something that fills the painting but is not directly present visually in the image, that is, the divine. That is to say, a mystery is represented as the tension between visible and invisible. The painter, who only has material means to make something visible, is yet inclined to represent the invisible, the unrepresentable, or something that is materially absent. In Leonardo's painting, the opposition between light (the body) and dark (the background) alludes to the tension between visible and invisible, the true heart of Christian mystery.

The power of the painter to make visible or present what is in reality invisible or absent is a recurring theme in early Renaissance treatises on art that predate Leonardo. For example, according to Cennino Cennini in *Il libro dell'arte* (c. 1400), the painter's duty is "to find things not seen, to seek them beneath the shadow of the natural, and to fix them with the hand, showing that which is not, as if it were *(quello che non è sia)*."[58] Such ideas shape important art theoretical treatises such as Alberti's *De Pictura* from 1435 ("Painting . . . make[s] the absent present" [chap. 25]), and the work of sixteenth-century authors such as Benedetto Varchi ("la pittura fa parere quello che non è" [painting feigns that which is not]), Baldassare Castiglione, and Francisco de Hollanda. In general, the power of the painter to make the invisible visible is understood as an indication of the painter's artistic license.

In *Saint John the Baptist,* Leonardo radicalizes the meaning of this power. The reflection on the art of painting that takes place in this paint-

ing revolves around depth, visibility, directness, and presence in opposition to flatness, invisibility, indirectness, and absence as essential, non-mimetic characteristics of painting.

In *Saint John the Baptist*, Leonardo focused on the most crucial feature of painting: the three-dimensional presence of something on a flat surface that instantly leaps to the eye of the beholder. Leonardo achieved this effect with breathtaking force by depicting a human body, by which presence and directness are conveyed to the beholder on the most elementary level of his or her experience, as an experience of touch, evoked by bodily reenactment. The painting thematizes the tension between visible and invisible as necessary poles of our sense experience that painting unites.

The beholder has recourse only to words that indirectly express the direct experience of corporeality evoked by the painting. With the help of Herder's aesthetic concepts and his description of a work of art, I have tried to verbalize what is at the outset wordless, corporal experience.

Painting as the Locus of Contradictions

We are now better equipped to comprehend the fascination that Leonardo's *Saint John the Baptist* evokes, without beating an interpretative return, or rather retreat, to historical or iconographic information about what narrative is depicted. The fascination of the beholder of Leonardo's painting is roused in the first place by a bodily presence in the painting that is inescapably forced upon the fortuitous beholder. At the same time, we perceive that the depicted person who evokes this presence is represented in a negative way; the mystery remains mysterious. To rephrase what I just said from a Herderian point of view: the corporal "Wollust" that John forces upon the beholder is reexperienced by the beholder's groping gaze, and the beholder recognizes that John's spiritual "Wollust" has a divine origin beyond human understanding.

To reduce my foregoing discussion to a single, somewhat exalted, sentence: the painting of St. John represents the unrepresentable (a mystery) not by its who- or what-ness (because that is not possible) but in a presence that can only be described by its that-ness (presence and directness), as a crucial feature of painting. In other words, Leonardo's efforts to express in paint the mystery of the Incarnation coincide with his efforts to understand the art of painting. Or is it preferable to conclude that any effort of a painter to represent a mystery entails reflec-

tion on the status and extreme limits of the art of painting? If so, then a painting is, in essence, a place where presence and absence conflate: every painting *is* a *locus* of contradictions. In Leonardo's painting, the game of presence and absence is the origin of contradictions and ambiguities that, above all, are visible in the body of the figure and in the opposition between flatness and depth. It appears that Leonardo knew how to play this game breathtakingly, for the fascination of Leonardo's *Saint John the Baptist* is due to the tangible contradictions that the painting communicates to the beholder without words.

Notes

1. For an interpretation of *Saint John the Baptist* from an art historical and theoretical point of view, see Zwijnenberg (in press). On its historical reception, cf. the interpretation by Lavin (1981, 193–210).

2. For instance, Kemp (1981, 341): "The *St John* conveys a remarkable impression of emotional involvement." Clark (1967, 153–56) considered Saint John as Leonardo's double: "the spirit which stands at his shoulder and propounds unanswerable riddles."

3. Cf. Kemp (1981, 341): "The 'psychological' interpretation is, to my mind, a supreme irrelevance when it comes to understanding in historical terms why the image of the saint crystallized in the form it did."

4. See Pedretti 1982, 140–70; 1991. See also Clark 1967, 153–56. As will become clear in this essay, Pedretti's and Clark's conclusions do not in any way refute my interpretation of *Saint John.*

5. Cf. Marin 1999, 29–31.

6. Cf. Quintilian, *Insitutio Oratoria* 10.3.5. Cf. also Zwijnenberg 1999, 83–111, in which Leonardo's method of writing and drawing is described in terms of this rhetorical process of finding the right word.

7. John the Baptist announces the coming of Christ as redeemer, and he baptizes him. See Matthew 3:1–17.

8. See Stevens 1997. It is not until the latter half of the seventeenth century that the Sacred Heart begins to emerge as a specific object of popular devotion with a liturgy of its own.

9. From the Bible it is not clear when John retreated into seclusion. He lived as a hermit until about A.D. 27. He began preaching in public when he was thirty, and he died at the age of thirty-three, seven months before Christ's crucifixion. See Kraft 1981, 10. Von Metzsch (1989, 45) suggests that a six-year period of seclusion was usual before a preacher became active in public life.

10. For illustrations, see Von Metzsch 1989, 56.

11. Cf. *The Oxford Companion to Classical Literature* (1937, 147–48): "[Bacchus] is frequently represented as a youth of rather effeminate expression, with luxuriant hair, reposing with grapes or a wine-cup in hand, or holding the *thyrsus,* a rod encircled with wines or ivy."

12. Pedretti 1982, 168.

13. Orchard 1992, 69.

14. See Stoichita (1997, 162): "Are interpretative polysemy and ambiguity not the products of an innate failure of the discipline referred to as 'art history' or is it the painting itself that lends itself to hypothetical and inadequate interpretations?"

15. Barolsky 1989, 15.

16. I owe my thoughts on mysteries and painting and on painting and mystery to the more extensive elaboration of this theme in Didi-Huberman 1995.

17. See Kemp 1981, 341, discussing "the crude overpainting by someone who wished to rescue the fading outlines of Leonardo's figure from the ever-darkening depths of the panel."

18. Because of his extensive anatomical studies and dissections, Leonardo had a considerable knowledge of the anatomy and the movements of the human body; see Zwijnenberg 1999, 147–74.

19. Leonardo was well aware of this phenomenon. See Farago 1992, *Paragone*, chap. 15.

20. Podro 1998, 87–93.

21. Herder 1988.

22. For an extensive treatment of Herder's aesthetics, see Norton 1991.

23. Adler 1990, 63.

24. Morgan 1977. For Herder's response to his contemporaries, see Norton 1991, 11–60.

25. See Herder 1987, 996.

26. According to Herder, to touch (or feel) an object is at the same time to touch (or to feel) touch itself; see Adler 1990, 110.

27. Herder 1994, 236. To Herder, "Ich" (I) is subject and object of "Empfindung" (inner feeling); cf. Braungart 1995, 66.

28. Herder 1994, 250–53.

29. Adler 1990, 103. Recently, American president Bill Clinton explained eloquently that to be touched and to touch do not always coincide.

30. See also Herder's reference to the Pygmalion myth in Herder 1994, 243.

31. Herder 1987, 986, 1022–23.

32. Herder 1994, 296–98.

33. Herder 1987, 115.

34. Herder 1987, 116.

35. Of course, this conflation deserves more explanation than is possible to give in this essay.

36. I am aware of the considerable differences in intellectual and cultural context between Leonardo and Herder. However, my comparison between Leonardo and Herder seems justified because my interpretative experiment is not about the relation between Leonardo and Herder but about words and concepts of sensuousness, sensuality, and corporeality.

37. Herder 1987, 1012.

38. Herder 1987, 1017, 132; see also Herder 1988, 632–43.

39. "Andrer Hermaphrodit liegt auf der linken Seite, das Auge sanft geschlossen. Er liegt auf dem rechten Arm, der unter dem Haupt ist, die Finger gehn ruhig auseinander, der Ellbogen dem Haupt gleich, so daß der Kopf vor der Hand ruht. Das Haar jungfräulich hübsch gearbeitet. Der linke Arm auf dem Kissen: sie stützt sich auf ihn etwas, die Finger wollüstig auseinander, das Gewand, das unter ihm liegt, deckt etwas von diesem Arm unter dem Ellbogen, daß die Hand wie hervorkommt.

Nun zieht sich der Rücken sanft von der linken zur rechten Seite, daß das Rückgrat in ungemein schöner Linie läuft; die linke Hüfte liegt also stark vor u. läuft bis zum Knie, auf welches die Figur sich stützt; nun kommt der linke Fuß über die rechte Wade zurück, daß er in der Luft schwebt; nur etwas vom Gewande läuft unter seiner Wade herab, bis an den Knöchel, u. der Zeh wird wollüstig sichtbar. Das rechte Bein, das auf der Decke liegt, dehnt sich gleichsam, sie sanft zu berühren, das Knie etwas vorwärts. Wade, Bein u. Fuß sind sanft angespannt, u. mit dem Zeh hebt er spannend die Decke, die vom linken aufgelegten Fuß herunterläuft. Eine ungemein wollüstige Stellung, die recht einladet, nach hinten zu greifen. Da findet man denn eine sanft aufliegende, sanft angespannte weibliche linke Brust, deren Knöspchen man noch fühlen kann, ein sehr feines Knöspchen; ein schöner wollüstig gebogner Unterleib mit Nabel u. sanft angespanntem männlichem Gliede. Es ist ziemlich lang, elastisch, hebt sich aber nicht bis zum Leibe, sondern bis zur Mitte; elastisch gebogen ruht's auf der Decke, die Eichel nur oben etwas entblößt, den Testikel ange- zogen. Die Oberbeine unter den Hüften laden in der schönen Stellung ebenfalls ein, so die Biegung hinter dem Knie u. so fort. Ein schöner jungfräulicher Kopf u. Hals, schön gebeugt; die Haare zierlich gearbeitet, man möchte den ganzen gebog- nen Rücken, Schultern, alles genießen u. fühlen" (Herder 1988, 602–3).

40. See Grimm, *Wörterbücher,* s.v. *wollust* and *sanft.* According to Grimm, both words have a wide range of connotations. I quote two definitions from Grimm that I believe come close to Herder's understanding of the words, which were in use in Herder's time. *Sanft:* "von zuständen und verhältnissen, die ihrer entwicklung und beschaffenheit nach in der natur ihres trägers selbst begründet oder mit ihr eng verbunden sind, hinsichtlich ihrer rückwirkung auf körperliche befinden, aber auch auf das innerliche leben" (1779) [*Soft:* "of objects and situations, the development and character of which are intrinsic to them, or closely tied to them, with regard to their retroactive effect on bodily being, but also on inner life"]. *Wollust:* "zur kenn- zeichnung des gefühls innerer freude, befriedigung und erquickung, wie es sich na- mentlich mit geistiger tätigkeit oder dem bewusztsein sittlich guten handelns ver- bindet" (1393) [Lust (in a nonpejorative sense): "as characterization of feeling of inner joy, fulfillment, and comfort as it is linked up especially with spiritual activity or conscious, morally good conduct"]. Grimm emphasizes that underlying all differ- ent connotations is the use of *Wollust* "als bezeichnung des triebhaften und in präg- nant erotischer anwendung" (1384) [indication of instinctive urge having a decid- edly erotic connotation].

41. According to Aristotle, "softness" is one of the objects of touch; see *De Anima* 2.6 418a13 en 2.10.

42. Herder 1987, 132.

43. I believe it can be argued that Herder in this way dissolves his (what I called earlier) ambiguous attitude toward sculpture, both erotic and ethical-intellectual and even religious in nature.

44. In the myth, Hermaphrodites is a young man until his fatal encounter with the amorous nymph Salmacis, who fuses their bodies into one, that is, into a body both female and male. In German as in Latin, the gender of Hermaphrodites is masculine.

45. As will become clear, I selected facts and findings that wonderfully sustain my argument and interpretation based on Herderian concepts. It is my contention that there are no historical data that contradict my interpretation.

46. According to Aristotle, the skin is the medium, and not the organ, of touch, as for instance the eye is the organ of sight. In the Renaissance, Aristotle's notions of the senses were well known, probably also to Leonardo.
47. Steinberg 1983.
48. Gilman 1993, 200.
49. Farago 1992, *Paragone*, chap. 38.
50. This light from above can also be considered as a reference to John 1:6–7, writing about John the Baptist: "There was a man sent from God, whose name *was* John" who came "to bear witness of the Light."
51. Farago 1992, *Paragone*, chap. 45.
52. Farago 1992, *Paragone*, chap. 38 (continued).
53. Farago 1992, *Paragone*, chap. 45.
54. Herder 1987, 115.
55. Polanyi 1994, 155.
56. For an extensive treatment of linear perspective in Renaissance painting, see Kemp 1990, 9–98.
57. Ludwig 1882, no. 124; see also nos. 123, 136.
58. Cennini 1932, 1.

References

Adler, Hans. 1990. *Die Prägnanz des Dunklen.* Hamburg: Felix Meiner Verlag.
Barolsky, Paul. 1989. "The Mysterious Meaning of Leonardo's *Saint John the Baptist.*" *Source: Notes in the History of Art* 8, no. 3.
Braungart, Georg. 1995. *Leibhafter Sinn.* Tübingen: Max Niemeyer Verlag.
Cennini, Cennino. 1932. *Il libro dell'arte.* Ed. D. V. Thompson. New Haven: Yale University Press.
Clark, Kenneth. 1967. *Leonardo da Vinci.* Harmondsworth: Penguin.
Didi-Huberman, Georges. 1995. *Fra Angelico: Dissemblance and Figuration.* Trans. Jane Marie Todd. Chicago: University of Chicago Press.
Farago, C. J. 1992. *Leonardo da Vinci's "Paragone": A Critical Interpretation with a New Edition of the Text in the Codex Urbinas.* Leiden: Brill.
Gilman, Sander. 1993. "Touch, Sexuality, and Disease." In *Medicine and the Five Senses,* ed. W. F. Bynum and R. Porter. Cambridge: Cambridge University Press.
Herder, Johann Gottfried. 1987. *Herder und die Anthropologie der Aufklärung.* Ed. Wolfgang Pross. *Werke,* vol. 2. München/Wien: Carl Hanser Verlag.
———. 1988. *Italienische Reise: Briefe und Tagebuchaufzeichnungen, 1788–1789.* Ed. and with commentary and an afterword by Albert Meier and Heide Hollmer. München: Verlag C. H. Beck.
———. 1994. *Schriften zu Philosophie, Literatur, Kunst, und Altertum, 1774–1787.* Ed. Jürgen Brummack and Martin Bollacher. *Werke,* vol. 4. Frankfurt am Main: Deutsche Klassiker Verlag.
Kemp, Martin. 1981. *Leonardo da Vinci.* London: Dent.
———. 1990. *The Science of Art.* New Haven: Yale University Press.
Kraft, H. 1981. *Die Entstehung des Christentums.* Darmstadt: Wissenschaftliche Buchgesellschaft.

Lavin, M. A. 1981. "The Joy of the Bridegroom's Friend: Smiling Faces in Fra Filippo, Raphael, and Leonardo." In *Art, the Ape of Nature: Studies in Honor of H. W. Janson,* ed. Moshe Barasch and Lucy Freeman Sandler, 193–210. New York: Abrahms.

Ludwig, H. 1882. *Lionardo da Vinci: Das Buch von der Malerei nach dem Codex Vaticanus (Urbinas) 1270.* 3 vols. Quellenschriften für Kunstgeschichte und Kunsttechnik des Mittelalters und der Renaissance. Wien: Wilhelm Braumüller.

Marin, Louis. 1999. *Sublime Poussin.* Trans. C. Porter. Stanford: Stanford University Press.

Morgan, Michael J. 1977. *Molyneux's Question: Vision, Touch, and the Philosophy of Perception.* Cambridge: Cambridge University Press.

Norton, Robert E. 1991. *Herder's Aesthetics and the European Enlightenment.* Ithaca: Cornell University Press.

Orchard, Karin. 1992. *Annäherungen der Geschlechter: Androgynie in der Kunst der Cinquecento.* Münster/Hamburg: Litt.

The Oxford Companion to Classical Literature. 1937. Comp. and ed. Sir Paul Harvey. Oxford: Oxford University Press.

Pedretti, Carlo. 1982. *Leonardo: A Study in Chronology and Style.* Reprint edition. New York: Johnson Reprint Corporation.

———. 1991. "The Angel in the Flesh." *Achademia Leonardi Vinci* 4: 24–48.

Podro, Michael. 1998. *Depiction.* New Haven: Yale University Press.

Polanyi, C. M. 1994. "Was ist ein Bild?" In *Was ist ein Bild?* ed. Gottfried Boehm. München: Wilhelm Fink.

Steinberg, Leo. 1983. *The Sexuality of Christ in Renaissance Art and in Modern Oblivion.* New York: Pantheon Books.

Stevens, Scott Manning. 1997. "Sacred Heart and Secular Brain." In *The Body in Parts,* ed. D. Hillman and C. Mazzio, 263–84. New York: Routledge.

Stoichita, Victor I. 1997. *The Self-Aware Image.* Cambridge: Cambridge University Press.

Von Metzsch, Friedrich-August. 1989. *Johannes der Täufer—Seine Geschichte und seine Darstellung in der Kunst.* München: Callwey.

Zwijnenberg, Robert. 1999. *The Writings and Drawings of Leonardo da Vinci: Order and Chaos in Early Modern Thought.* Trans. C. A. van Eck. Cambridge: Cambridge University Press.

———. In press. "*John the Baptist* and the Essence of Painting." In *The Cambridge Companion to Leonardo da Vinci,* ed. Claire Farago. Cambridge: Cambridge University Press.

CHAPTER SIX

Rococo as the Dissipation of Boredom

F. R. Ankersmit

I was a sickly child: with an almost perverse dedication I went through the whole long list of sicknesses to which children are apt to fall prey, while repeating several items on that list over and over again as if to make sure that I had not forgotten or inadvertently skipped them. This regular confinement to bed tended to put me out of touch with things, which led my parents to allow me to travel more or less with my bed through the whole house, which in turn often brought me to their bedroom. Now, in spite of being ill so frequently, I was a quite active child. So I remember lying in my parents' bedroom painfully aware that meanwhile, my friends were swimming or playing in the snow. This painful awareness of being excluded from my school friends' games stimulated in me an intense feeling of boredom. Boredom, as has been pointed out, is the feeling that brings one closest to the nature of things. In boredom the interactions between ourselves and the world are temporarily suspended, and this suspension invites reality to manifest its true nature, untainted and undistorted by our interests and preoccupations.[1]

Overwhelmed by boredom, I often felt a peculiar fascination for the flower patterns on the curtains in my parents' bedroom. And I am convinced of an intimate connection between those feelings of boredom, on the one hand, and fascination, on the other. The intimacy of this connection is at first sight paradoxical, since boredom seems to exclude us from reality and all that goes on in it, whereas fascination (derived from the Latin *fasces*, meaning a bundle or truss) clearly suggests the tying together of subject and object. So, initially, boredom and fascina-

tion seem to travel in diametrically opposite directions. The paradox disappears, however, as soon as we recognize fascination as the tantalizing promise of a fusion between the subject and the object in the *absence* of the intensely desired fulfillment of this promise. Obviously, in fascination, the desire of such a fusion can be so inordinately strong precisely because its promises have not yet been fulfilled. And this must provoke, again, an awareness of the unattainability of the object and, thus, of boredom. We are never more sensitive to *both* the desire to fuse with reality (i.e., the origin of fascination) *and* of the final unattainability of that reality (i.e., of what causes *boredom*) than when fusion seems so much at hand, so imminent, and so much a natural thing to expect. Think, for example, of what Narcissus must have experienced when looking, with so much fascination, at his own image in the fountain: what could still separate the subject from the object when the object is the subject's own reflection? But ultimate closeness also proved to be ultimate unattainability. Hence the melancholic expression of boredom on Narcissus's face in Caravaggio's painting, so perceptively analyzed by Mieke Bal in her recent book.[2]

I recently came to understand the nature of my fascination. My belated revelation came as I read the following passage by Scruton on the aesthetics of music:

> Consider the leaf-mouldings in Gothic architecture. There is no doubt that these are of great aesthetic significance: by the use of these mouldings the Gothic architect was able to transform stone into something as full of light and movement as a tree in summer. But the resulting building conveys no thought about leaves. . . . The same is true of the stylized flowers in a dress or a piece of wallpaper. There is all the difference in the world between the pattern of wallpaper and a picture of the thing used in the pattern: even if they look exactly the same. The wallpaper is not asking us to think of the flowers contained in it. Put a frame around one of the flowers, however, and a signature beneath it, and at once it jumps at you, not as a pattern, but as a flower, asking to be understood as such. (Scruton 1997, 121)

Scruton is saying here, I believe, something profound about the essential experience of decoration. We can do, Scruton argues, two things with vegetal ornament: see the stylized leaves or flowers as representations of the real thing, or see them as pure wallpaper patterns, regardless of what the design represents or refers to. In the former case, we situate

ourselves, as spectators, somewhere in the trajectory between a real flower (the represented) and its depiction (or representation); in the latter, the flowers are drained of their representational content and now start to interact freely with each other. Shapes begin to interweave with each other and acquire new meanings—meanings that may be derived as much from the shapes of the flowers depicted themselves as from the negative spaces between them; that is, from the background of the design or by any aspect of the wallpaper that may catch our interest. New meaning may even crystallize around imperfections in the wallpaper or the curtain, such as a stain or a tear, as long as these incidental qualities interact with the design itself.

And this is not a matter of seeing one thing where we used to see another thing, as in the case of seeing a duck where we used to see a rabbit, or the Rorschach pattern that seems to change from a face into a sailing ship or vice versa. In such cases, we project a new pattern onto what the eye perceives. Here, however, the imagination frees itself from all previous patterns: we no longer ask ourselves what the design *looks like*. Imagination is left to itself, in a free play such as the one Kant attributed to imagination when there is no concept to guide the cooperation between the imagination and the understanding. As Crowther put it when discussing Kant, in these cases, the imagination has an unusual freedom to function as "an originator of arbitrary forms of possible intuitions" (Crowther 1991, 56).

Put differently, normally we recognize the things we see (as flowers, as human beings, etc.); we take the things we see apart, first, into the *kind of thing* that they are and, second, into the *properties* that are specific to *this* individual specimen and differentiate it from other specimens of the same kind. The secret of the duck-rabbit drawing and of the Rorschach test is that they can resolve into two, or even several, familiar patterns. But in the case of the near fusion of subject and object in the wallpaper design, we have been discussing familiar patterns that are *developed* in this fusion and not *applied*.

This, I suggest, is the closest that we can come to pure experience, to a complete openness to what the senses present to us: for now neither the real world nor our perception of it is forced any longer within pre-existing patterns. Admittedly, a psychological explanation may be given of how this most peculiar state of affairs came into being. Perhaps psychological laws can clarify why we may sometimes have these moments

of a quasi-Heideggerian receptivity to the world's *aletheia*. And this seems to reduce the conviction of openness to mere illusion. But this conclusion would be invalid. The conclusion would follow only if we embrace two further premises, namely: (1) that there is only *one* way to see reality and only *one* pattern to discover in it; and (2) that the laws of cognitive psychology determine and fix this pattern. On the basis of these two premises, it could be shown that we have clearly mistaken openness for psychological determination. But these two premises ought to be rejected as the codification of the psychologist's fallacy that the world is how we perceive it because of our psychological makeup.

In sum, the way of seeing that Scruton has in mind invites a complete free play of the imagination. Compared to how we ordinarily perceive reality, this way of seeing is, however, strangely paradoxical. On the one hand, it has liberated us from all patterns and structures that require us to see reality in one way rather than in another. This is why reality may now manifest to us its quasi-noumenal qualities. On the other hand, a complete subjectivity of perception must now also be diagnosed, since nothing in what is seen still guides, instructs, or determines the free play of our imagination. And this condition of subjectivity seems to remove us, again, further from the perceived object than even the most structured perception of it. For we will agree with Kant that the workings of such cognitive structures do not in the least exclude the possibility of knowledge of objective reality. So from a cognitive perspective, we always founder when we seem to have come closest to our goal. Freedom of the imagination may bring us closest to reality and to a direct experience of it, but that freedom also takes away all that might put a fix on, or give a firm hold of, the object. The greatest objectivity thus gives way to the greatest subjectivity, and vice versa.[3] And in the process of becoming aware of this distressing dialectic, we are removed further from the object the closer we come to it. We will turn away in *boredom:* for what else could our reaction be, since reality hides most on the verge of revealing itself? This is the deep truth taught to us by the story of Narcissus—as recounted a moment ago—who so movingly sublimated his boredom in his metamorphosis into a flower.

This, then, is how freedom of the imagination and the paradoxes of experience are interrelated. In Kantian terminology, the sublime (in which the paradoxes of experience manifest themselves) does not provoke in us an awareness of our freedom and of moral destination. The reverse

happens: freedom results from our experience of the sublime indiffer-
ence of reality to the categories and structures that we both so eagerly
and so uselessly project on it.

Ornament

I have been speaking of ornament and of how ornament may dissolve
the structures and conventions that determine our perception of the
world. I hope that my autobiographical introduction has sufficiently
suggested, in this manner, that ornament is a far more interesting cate-
gory than contemporary common wisdom is prepared to concede.

"Ornament is crime," as we nowadays tend to say with Adolf Loos—
for ornament conceals essence, and doing so is a crime against art's goal
to reveal essence. To be sure, Loos was quite well aware of the seductions
of ornament and of the power that ornament consequently has over us.
In his famous denunciation of ornament, Loos was prepared to admit
that even the most "primitive" people, such as the Papuans, cover every-
thing—their own bodies, their boats and rudders—with decorative tat-
toos (Loos 1982, 78). Loos believed that the passion for decoration is as
typically human a property as sexual desire. And precisely this recogni-
tion may make us wonder to what extent we should see Loos's attack on
decoration as originating from the same deep-seated impulses as the
Papuans' desire for ornament. Put provocatively, is Loos's rejection of
ornament not a eulogy on the "ornament of the absence of ornament"
rather than the attack on ornament that it pretends to be? He certainly
seems to have had a pronounced *aesthetic* preference for objects from
which ornament was most conspicuously absent. As Rykwert put it: "His
passion for smooth and costly objects was an unconscious desire that
he rationalized later on, as I will show" (Rykwert 1983, 109). Loos was
not an aesthetic Calvinist who rejected ornament with pain in his heart
because its attractions might divert our attention from the essence of
things. Loos could love beautiful things no less than the "primitive"
Papuans (or ourselves)—but he could love them only on the condition
of their being *un*decorated. He simply loved the decoration of being
undecorated.

Nevertheless, his aesthetic preference for the undecorated object
blinded Loos to the secrets of ornament and of decoration. In order to
come to an understanding of these secrets, let us consider a late-
seventeenth-century engraving by Bérain (Figure 6.1).[4] The engraving

Figure 6.1. A late-seventeenth-century engraving by Bérain presents an elegant arrangement of grotesques.

presents us with an elegant arrangement of grotesques. The grotesque, as is important to recall in this context, presents us with something that we will not find in the real world, although it is not at odds with the logic of nature itself.[5] The grotesque may be partly human, partly animal, or plantlike (see Figure 6.2);[6] the logic of organic growth does not forbid the existence of such hybrid creatures—it would forbid the kind of fictive visual structure we see represented in an Escher engraving.[7] Contingently, the world does not contain grotesque creatures any more than Escher's spaces could be built in it. The grotesque exemplifies the

Figure 6.2. Example of the plantlike grotesque.

Kantian free play of the imagination that I mentioned a moment ago. On the one hand, the grotesque deliberately places us in phenomenal reality: it carefully obeys all the laws of perspective and of illusion characteristic of phenomenal reality as it presents itself to us through the senses. On the other hand, the grotesque depicts things that do not really exist and are the product of the free play of imagination. In this way, the grotesque is a visualization of the Humean distinction between empirical laws and logic: it respects logic while being at odds with what empirically is the case in our world.

But if we now return to Bérain's engraving, we will perceive here an interesting complication of what was just said about the grotesque. Even a momentary glance at the engraving will make clear that it is composed of two parts or elements. Bauer distinguishes between these two elements as follows:

> In the grotesque's center we find a small tempietto of Amor—both the engraving's theme and its pictorial condensation. But already in its graphic articulation the tempietto distinguishes itself from the surrounding ornament of grotesques thanks to its heavy, shadowy and pictorial forms. It is, so to speak, truly an object proper for depiction. That is wholly different with the surrounding ornament of grotesques. For this is not situated in a three-dimensional space, as is the case with the tempietto, even though naturalist motives, such as putti and animals, have been strewn all through it. For this ornament organizes the two-dimensional space of the page. (Bauer 1962, 4, 5; translation mine)

Hence the center of the engraving—the tempietto—is intended by the engraver to be seen by us as the depiction or the representation of a

real, though imaginary, tempietto that *could,* actually, be built in a real three-dimensional world as represented here. The case is obviously different concerning the richly elaborated framework. Though reality effects abound here as well—consider the shadows and the perspectivalism of the lower edge—it is clear that the ornamental frame does not depict a three-dimensional world. It is what it is—an engraving—and this fictive representation does not give the illusion of being anything else. We are firmly situated in the two-dimensional space of the image itself and nowhere else, just as we are in the case of Escher's engravings. As Bauer succinctly summarizes the epistemological status of the grotesque ornamentation: "Its logic is that of depiction, of representation, the logic of free forms which are, as such, objects themselves and not represented objects" (Bauer 1962, 5; translation mine).

The convention of a picture representing a three-dimensional world within a picture frame is familiar enough. And it is widely recognized that picture frames belong to the semantics of the picture itself. In a famous essay, Meyer Schapiro has convincingly argued that picture frames are far more than the irrelevant ornament that they may initially seem to be: frames actually, and even essentially, contribute to the meaning making that takes place in paintings and drawings (Schapiro 1969, 224, 225). The picture frame is a nonmimetic component of the painting that instructs us on how to understand its mimetic components. The picture frame does this by clearly demarcating the painting from the three-dimensional space inhabited by the spectator. The picture frame thus requires us to see the picture differently from the way we perceive our surroundings: the former sensitizes us to the illusionist suggestions in the painting, urging us to see something as three-dimensional in that which possesses two dimensions only. In this way, according to Schapiro, the picture frame makes us see depth as a distinction between foreground and background—and by forcing us to do this, the frame does substantially contribute to the meaning of the painting itself.

But in the Bérain engraving there is something odd about the relationship between the picture frame and what is enframed by it. In the first place, the engraving gives us both the picture itself (i.e., a representation of the tempietto) and the picture frame (i.e., the framework of grotesques around the tempietto). Hence it is as if painting were to depict its own picture frame. Two-dimensionality and (the illusion of) three-dimensionality are both present in the engraving. And this makes

the structure supporting the tempietto of special epistemological inter-est. To see this, we should note that the structure, in its turn, rests with four feet on the surfaces of two tables that are part of the ornamental frame. It is noteworthy that the outer left and right feet of the structure should logically with regard to actual circumstances have been placed *behind* the two inner feet, yet they are deliberately depicted as if they were actually on either side (if the structure were real, it would in-evitably fall either toward, or away from, us).[8] This Escher-like effect—the structure in Bérain's engraving could not exist in actual three-dimensional space—marks the transition from the picture's center to the ornamental framework. The structure might thus be described as representing the transition from the two-dimensional space of the ornamental framework on the one hand to the (illusion of) the three-dimensionality of the pic-ture's center on the other. And as such, the transitional motif is crucial to the engraving as a whole: the engraving would be illogical if it failed to recognize the difference between two- and three-dimensional space. The engraving does actually represent this transition. Of course, Bérain could have taken care that the picture in the center would never come into contact with the ornamental framework—we could imagine the tran-sition from two to three dimensions taking place silently and impercep-tibly somewhere in the empty space surrounding the picture center. But since the picture in the center actually blends *into* the framework, in-evitably, the transition must be represented somehow, somewhere.

Suppose we decide to remove the engraving from the book or the portfolio where we found it, and hang it on the wall. We would then frame it—and to prevent a conflict between the ornamental order of the engraving and that of the actual picture frame, we choose a smooth, undecorated picture frame. But the picture frame would, in agreement with Schapiro's argument, be just as necessary as in the case of less-unusual pictures or paintings. The engraving represents something— the transition from two to three dimensions (or vice versa, depending on whether one starts with the center or with the ornamental frame)— that is not part of the three-dimensional world in which we live. (This is true as well for the [illusion of] three-dimensionality inside the pic-ture frame.) In short, the engraving is a representation of dimensional change: *dimensional change* is its subject in much the same way that a portrait has its sitter as its object. And the engraving therefore requires a frame to allow us to move from the viewer's "normal" reality, which,

self-evidently, is free from dimensional change, to the reality of the engraving, where dimensions change. Put differently, the frame marks the difference between "dimensional change actually taking place," on the one hand, and a "depiction of dimensional change," on the other: within the frame we have dimensional change *itself,* whereas the engraving as a whole (i.e., center plus frame) is a *depiction* of dimensional change. It is the articulation of this philosophically deep difference between the two levels—between object level and metalevel—that is effected by the picture frame.

So far, so good. But now suppose that the ornamental framework within the engraving itself were to be replaced by (the depiction of) just such a smooth and undecorated picture frame. (I shall not consider the question of what then would have to happen to the Escher-like confusion of dimensions taking place where center and frame are actually in contact with each other in the profoundly ambiguous space below the tempietto.) In the real world, the result would be awkward enough, if not destructive of the entire subject of the engraving. Now the engraving would represent a tempietto only, and no longer the transition from two to three dimensions and vice versa that is so provocative in the engraving as it exists. It follows, then, that to represent this change in dimensionality, we really cannot do without the *ornamental* framework of the engraving (replacing it by an undecorated framework would spoil the whole point of the engraving). This is an important new insight. Insofar as this change in dimensionality is an aspect of *all* (figurative) representations of reality, and insofar as *all* figurative paintings represent this change, apart from all the other things that they depict, not only will *each* picture require a picture frame (as Schapiro argued), but more specifically, each picture requires a *decorated* picture frame. Undoubtedly this is why there is something almost inevitable about decorated picture frames. Smooth picture frames are justifiable only when the picture tends to withdraw within its own center and, so to speak, to shun its own borders—as is most typically the case with portraits.

In sum, Bérain's representation of dimensional change represents what is intrinsic to all figurative painting and drawing. The engraving can only effect this "actual" dimensional change on the condition of formal resemblances between the order of spaces depicted by the picture in the center and the purely fictive spatial order depicted by the components

of the ornamental framework. Without formal continuity, the engraving's framework would function like an "ordinary" picture frame: as such, it would certainly *effect* the transition from ordinary space to the space of the picture or painting, but it could then no longer be said to *represent* this transition. And so it is with all pictorial representations of reality. In the case of "ordinary" paintings and pictures, the level of Bérain's ornamental framework is tacitly subsumed, so to speak, in the picture's actual picture frame. In conclusion, I have argued that Bérain's engraving is a depiction of (the epistemological order of) ornamental picture frames. The effects that we experience depend on depicted variations of the kinds of things in the "real" world, as well as on the formal similarities between these things as they "really" are and the ornaments that are depicted on the picture frames.

Rocaille as Representable Reality

At the beginning of this essay, I mentioned my fascination with patterns in the flowered curtains of my parents' bedroom. Whether there is any causal link I do not know, but I developed a love of rococo decoration early on. When I was younger, I even received some instruction in rococo decoration from an expert wood-carver. Even today I habitually sketch rococo motives whenever I am idle or bored. I still consider rocaille to be the quintessential kind of decoration, unsurpassed in elegance and formal logic of its forms by any other decorative style. This conviction, however, is responsible for my profound hatred of Jugendstil, which I perceive to be a stupid, vulgar, and repulsive caricature of rococo's aristocratic elegance. Both styles of ornament draw their primary inspiration mainly from vegetal forms—but what a difference! Compare, for example, the weak, wilted, and elongated flowers of Jugendstil to the vigorous and compact forms of rococo ornament. The subtle balance between imitation and the free play with vegetal forms of rococo is wholly lost in Jugendstil. But insofar as ornament differs from "real" things—and this is a requirement for all good ornament—the difference testifies to the artist's freedom of imagination. I am not arguing that the Jugendstil artist is simply a bad draftsperson. Style is what permits the artist to violate reality in an imaginative and pleasing manner while simultaneously representing it. For style may make a representation more interesting than the represented, and an imagined real-

Figure 6.3. Example of a rococo arabesque designed to look like a flower.

ity more suggestive than reality itself. And this is where, in my opinion, Jugendstil sadly fails: whereas we may prefer a rococo arabesque to a real flower, real flowers are infinitely better than their insipid Jugendstil counterparts (see Figure 6.3).[9]

In what is arguably still the best book on rocaille, Bauer explains the evolution of rococo style most strikingly by Figure 6.4,[10] an engraving taken from Juste Aurèle Meissonnier's *Livre d'ornemens et dessines* (1734).[11]

Figure 6.4. An engraving from Juste Aurèle Meissonnier's *Livre d'ornemens et dessines*, 1734.

The publication of this book is generally seen as one of the most important milestones in the history of rococo ornament. If we compare this engraving with the one by Bérain (Figure 6.1), the most conspicuous difference between them is, according to Bauer, the relationship between the picture center and ornament. Both are clearly and unambiguously separated in Bérain's engraving, and I have argued that this distinction is essential to the semantics of the image. But in the Meissonnier engraving, ornamental forms have penetrated right into the picture center; they are emancipated from the status of being merely decoration and have become *themselves* potential objects of depiction. Quite instructive, in this respect, is the ornamental line running from the top center to the bottom right of the engraving. At the top and the bottom, the rococo ornament around this line has become part of the picture frame. Incidentally, the frame itself is about the least decorative frame that one can think of: for the greater part of the engraving, it is merely a simple straight (!) line. The difference from Bérain's most elaborate grotesque ornament could not possibly be more dramatic. But no less important, as this straight line twists and curls over the page, it becomes part of *both* the line demarcating the plane of the engraving itself *and* the architecture depicted in the engraving. The levels of representation are deliberately conflated here.

Sometimes the status of the ornament in the Meissonnier engraving is plainly ambiguous. Obviously, the staircase on the left and the portico on the right depict some very weird imaginary architecture—but what about the two C curves on the top right? It is impossible to say whether these are part of the fictive architecture or mere ornament. Ordinarily, we distinguish the medium of representation (painting, engraving, etc.) from what is represented (a real landscape, architectural structure, etc.). Think, for example, of Michelangelo's Sistine ceiling. All that is of (philosophical) interest in the pictorial representation of reality can be expressed in terms of this distinction. But in the case of Meissonnier's engraving, the formal properties of the representation deserve to be taken into account. The engraving is not simply a representation of an (imaginary) work of architecture (as is the case with "normal" pictures). Here we are required to discern *two* levels in the representation: first, the picture as representation of a represented reality (a trait that it shares with all pictures); and second, the plane surface of the engraving, which provocatively and paradoxically is acknowledged within the representation itself. The engraving clearly speaks about its own status as representation, although it seems to speak only of an (imaginary) represented.

To correctly appreciate the sheer nerve of this invention (to use the appropriate rhetorical term here), we can note that even the greatest practitioner of rococo, the Dutch graphic artist Maurits Escher (1898–1972), never used this device.[12] Escher's play with the representation of space always takes place *within* the frames of his pictures—he never involves the frames themselves in his play with spatial representation. His play always resolutely stops at the picture frame, within which he always safely contains his dizzying paradoxes, as if to avoid the danger that these paradoxes might infect the real world. Meissonnier—and before him Watteau—had no such fears.[13] The explanation is probably that Escher meant his engravings to invite extrapolation of his spatial experiments beyond what is shown in the engraving itself, rather than to be objectified by a picture frame.[14] The viewer is never invited to participate in the space suggested by the engraving, never to move outside it, in order to obtain a vantage point from which this space might be objectified, discussed, or analyzed. Put differently, Escher's engravings exemplify a certain spatial paradox, but the artist avoids introducing the paradox or suggesting how it can become an object of thought. They

are not self-reflexive representations. However, as I shall show in a moment, the rococo artist's play with space is. The depicted space encloses itself within itself, and the artist puts an imaginary fence around his image in this way.

To switch to a different idiom, Escher's play with space is totalitarian, whereas his rococo predecessors created for themselves a private world of their own, within which they could move with complete liberty. Escher's play is serious, whereas that of the rococo artist is truly play and nothing but play.[15]

Bauer summarizes Meissonnier's amazing achievement with the following words:

> For Watteau, a picture still is a representation of a representable reality. Meissonnier, La Joue, and Mondon went beyond this. For now all of reality has become ornament, or, to be more precise, the grotesque now became worthy of being represented. This is only possible on the condition that the representation no longer pretends to be the representation of a representable reality. This is not primarily a question of the object. For until the beginning of the eighteenth century the classical gods and Arcadia were taken as realities. It is, rather, a question of the conception of art. In the eighteenth century, the mannerist circle in which art refers to art and becomes an object to itself is closed again. (Bauer 1962, 38; translation mine)

Ornament has invaded representable reality, but in doing so, it has changed the nature of both reality and itself. Ornament transformed itself from being *mere* decoration into a reality as real as real trees and real palace architecture, and as a result of this ornamental hubris, decorative forms came to be just as much potential objects of representation as the normal objects of perception. Obviously, reality was not unaffected. Reality itself was now forced to adapt to the strange forms of rococo ornament. Hence also the perplexing mixture of small-scale ornament with the larger proportions of natural objects or architectural structures, so that the spectator does not know whether he or she has to do with a monumental macroworld or with microscopic miniatures. Bauer suggestively speaks here of the "mikromegalische" ambiguity of rococo art (Bauer 1962, 20, 21).[16]

Nevertheless, when representable nature has to negotiate with ornament, nature is compensated for its loss by acquiring a license that was previously reserved exclusively for the artificial. Forms in objective na-

ture become possible and perfectly acceptable subjects for representation that were hitherto possible only in the artificial world of ornament. One could now have the best of both worlds—forms presented to us by nature and the formal playfulness of sheer ornament.

It is impossible to say, therefore, which of the two, ornament or reality, is the victor or the vanquished in the process. Probably it is best to say that rococo presents us with a synthesis of the logic peculiar to ornament and with the logic that belongs to representable nature in such a manner that what was prevented by one is now made possible and acceptable by the other. In this way, a *new* imaginary world is possible—a world in which pure elegance is achieved through the transcendence of absurdity. The nostalgic elegance of Watteau's paintings expresses profound logic in seemingly idle play with space.

The Meaning of Rococo

Until now one important aspect of rococo decoration has been left unaccounted for. One sometimes speaks of the "grammar of decoration," a phrase that suggests that decoration and ornament consist of fixed conventional constants that artists and architects can vary.[17] The Doric, Ionic, and Corinthian columns are obvious examples of such constants. One may think of the convention of acanthus leaves, of the stylized lotus leaf of Egyptian decoration; also of ovolo-moldings or the arabesque. Most often, ornamental motifs do have their origins in certain organic and vegetal forms: Goethe even argued that this is a necessary condition for all successful ornament.[18] A century later, the same understanding guided Alois Riegl's impressive catalog of decorative forms: "All art, and that includes decorative art as well, is inextricably tied to nature. All art forms are based on models in nature. This is true not only when they actually resemble their prototypes but even when they have been drastically altered by the human beings who created them, either for practical purpose or for simple pleasure" (Riegl 1993, 14).

But these elementary organic forms can further be systematized. Attempts to do so were undertaken already by artists such as Dürer and Hogarth. Dürer did so by reducing ornamental forms to three elementary geometric figures—the line, the circle, and the S curve. He did the same for letters of the alphabet, thus adding an unexpected extra dimension to the notion of "the grammar of ornament": just as letters are the most elementary components of language as the vehicle of meaning, so

ornamental meaning has its "alphabet" in these three simple geometric forms. Hogarth followed another approach, one more suitable to the philosophical taste of his age, by systematizing ornaments in agreement with the feelings they provoke in the spectator (Graevenitz 1994, chap. 2).

But in whatever way Dürer's way of cataloging might be elaborated, it is clear that the rococo added a new first and last item. "Die Rocaille ist das letzte originäre abendländische Ornament" (Bauer 1962, 49)— such is Bauer's claim—rococo is the last truly original addition to the West's repertoire of ornamental forms. And as I hope to show, rococo arguably is its most subtle and sophisticated acquisition, as well.

What is at stake here is the following. The primary characteristic of all rococo ornament is the C curve, as it is usually called. The architecture depicted in Meissonnier's engravings shows an abundance of C curves, as do the ornaments that connect the picture to the frame. The rococo C curve is often identified with the scallop shell that made its first appearance in sixteenth-century decorations. But the C curve differs from the scallop shell in its provocative asymmetry: one end of the rococo C curve, where the C curve curls up into itself, is always smaller than the other. In order to negotiate this difference, one end of the C curve is always slightly different from the other. If we compare the rococo C curve with its origins in baroque ornament, we find that this asymmetry is most pronounced. Symmetry is the highest law of the baroque, above all the style of Louis XIV ornament:[19] recall that Mme de Maintenon sighed in resignation that "in the end, we shall all have to die symmetrically." Symmetry is the formal counterpart to hierarchical social order during the age of Louis XIV, exemplified in Saint Simon's Versailles.

But rococo asymmetry is far from being mere arbitrariness. On the contrary, though we might be completely incapable of explaining why, we nevertheless feel that ordinarily these C curves are perfectly "right" in one way or another and that they simply are the way that they ought to be. Why the lines, circles, and ellipses of Dürer and the symmetrical motifs of others satisfy us is not difficult to ascertain: in most cases, geometry provides sufficient change. But with the C curve, the impression of perfection is born from a curious combination: considerable freedom in determining the curve of the C curve, on the one hand, and, on the other hand, absolute surety about whether it has been drawn "right" or "wrong." Freedom transcends the application of rules here.

These curves are far from arbitrary and even seem to exemplify certain rules—though I am unable to define the nature of these rules (perhaps an inventive mathematician could help).[20] One is tempted to ask: Can the secret of the rococo curve explain the nature of free, moral action? Does the C curve demand that we ponder an aesthetically inspired ethics? Could the C curve's inversion of rule and aesthetic freedom be interpreted as a visual analogue of freedom beyond rules?

There is one more feature of the rococo C curve worth observing. I mentioned that the two ends of the C curve have different proportions. This difference in size suggests the illusion of depth, as if one end of the C curve (the larger one) is closer to us than the other (the smaller one). Hence the rococo C curve is far more suggestive of depth and of three-dimensionality than the line, the circle, or the S curve of previous ornamental grammars (I shall return to this point in a moment). The illusion of depth is accompanied by suggestions of movement and mobility—whether we look at a rococo ornament, a rococo interior, or the rococo decoration of an altar, we always have the impression that its components have been caught at one instant in their movement and that they will continue moving in the very next instant. It is difficult to explain how this suggestion of movement is actually achieved, but anyone who has ever visited a Bavarian rococo church, such as the Vierzehnheiligen or the Wieskirche (surely the most beautiful of them all), will understand what I have in mind. If we recall, then, that all movement takes place in time, we will recognize that the rococo C curve, unlike any other previous grammar of ornament, can truly be said to represent the four-dimensional world of length, width, depth, and time in which we actually live. If Newtonian science inspired the Enlightenment's confidence to conquer space and time, rococo ornament is the artistic expression of this confidence.

This becomes clear if we apply one more categorization of ornament to the rococo C curve. I cite Wersin:

In agreement with the two most fundamental impulses of ornament, the manifold of ornamental forms can be ordered within two main groups: the ornament suggestive of a rhythmic repetition of the same act—without beginning or end—and the form of ornament suggestive of a closed ornamental organism whose coherence is dynamic in origin. . . . To the last category also belong the simplest autonomous ornaments . . . that dominate rococo art. (Wersin 1940, 15; translation mine)

Hence there is the kind of "rhythmic" ornament that could go on with-out end or beginning, suggesting infinity (recall the geometric style of early Greek amphorae) and the "organic" ornament that tends to en-close itself within itself. At first sight, the former kind seems to be the more audacious of the two: where the latter suggests a closed world, the former appears to give us an open one. But this intuition is wrong, as we might already expect from the fact that the former kind of ornament is older and less sophisticated than the latter. The problem becomes clear as we recognize that rhythmic ornament obediently fits within a spatial order prior to the ornament, whereas organic ornament actually forms space itself. Typically in rococo ornament, the composition and the form of the objects within the cartouche are adapted to the slope of the rococo frame (Figure 6.5).[21] The frame arranges these elements within the cartouche. In the case of the extremities of the C curve, the two end in a line, as if they were the tendrils of a previous ornamentation that could continue indefinitely, were they not pulled together by the C curve and curled up in themselves. Infinity is, so to speak, represented as a tendril, reduced to what can be surveyed by human beings in a single glance. In this manner, the C curve is suggestive of a victory over space and infinity.

This shorthand infinity of the C curve, then, gives us the "meaning" of rococo ornament. Rococo ornament's first step had been the auspi-cious leap from the merely ornamental framework into the realm of representation. Rococo ornament invades reality by ornament: the ob-jects of representation adapt themselves to ornament. Ornament su-persedes itself, so to speak, by becoming part of reality—so that, histor-ically, ornament paradoxically disappeared at the very moment that ornament became everything. In this way, rococo ornament is both the most sophisticated stage of ornament and the death of ornament. Loos and his contemporary followers are, from this perspective, not the ene-mies of ornament that they seemed and wished to be: they should rather be seen as the true heirs to (the logic) of rococo ornament. Loos's proposed design for the offices of the Chicago Tribune in 1923 is a strik-ing example of the logical progression I have in mind: rococo orna-ment turned into an architectural structure; that is, Loos gave the entire building the shape of one huge Doric column.[22] The realized design shows Loos as having been, in fact, a twentieth-century Meissonnier.

Figure 6.5. An example of how objects within the cartouche are adapted to the slope of the rococo frame.

But with a second step, rococo ornament also took possession of space itself, domesticated it, and made it inhabitable for the people of a new era in the history of the West. The Enlightenment's optimism, especially its conviction that the sciences would make us victors over the natural world, is heralded and expressed by rococo ornament. And this is where its meaning and interest lie.

Conclusion

I began this essay by recalling how the flower design in my parents' bedroom provoked in me an intense feeling of boredom and of how the feeling of being excluded from the world of my playmates was curiously repeated and reinforced by my experience of this type of ornament. Ornament has the power to estrange us from reality and to effect boredom. But only now do I recognize what was at stake: I see only now that this early childhood experience produced my (later) fascination with rococo ornament. Not only does rococo ornament achieve an illusion of space that no other ornament succeeds in producing in us, but it actually carries the spectator into real space, thus effecting the actual experience of the real world. This is, as we have seen, what happened in the Meissonnier engravings: here ornament left the flatness of the picture plane and invaded corporal space itself. Bavarian rococo churches owe their justly deserved fame to the same splendid kind of ornament. Here space becomes tangible, at our fingertips; and this tangibility promises the celebration of other real pleasures. In this sense, the rococo ornament is a (homeopathic) cure from the boredom and the feelings of estrangement from reality that other kinds of ornament may inspire. One who has felt oppressed by ornament can liberate oneself from this oppression—and, more importantly, from what it symbolizes and expresses—by losing oneself in the spatial play of rococo. Moods may express and articulate the most fundamental characteristics of how we relate to the world. This may also suggest that moods, like boredom or feelings of estrangement, need to be considered seriously from a historical and cultural perspective.

Notes

1. The feeling of boredom has its paradigmatic manifestation in what has come to be known as the "demon of noontide." In southern countries objects tend to

coincide with their shadows at noontide, and this may provoke in us an awareness of the objective nature of reality that is inaccessible to us when things and their shadows intermingle. See Kuhn 1976.

2. "To use Figlio's terms, Caravaggio did not repress the melancholic mourning of absence through acts of mapping" (Bal 1999, 239).

3. This insight has its antecedents in the Dionysian conclusions that Nietzsche inferred from his reading of Schopenhauer.

4. Bauer 1962, fig. 1.

5. The grotesque in art and literature can be defined as "the unresolved clash of incompatibles in work and response" (Thomson 1972, 27). But Vitruvius offered already the following characteristic of the grotesque, which is most appropriate in the present context: "For our contemporary artists decorate the walls with monstrous forms rather than producing clear images of the familiar world. Instead of columns they paint fluted stems with oddly shaped leaves and volutes, and instead of pediments arabesques; the same with candelabra and painted edifices, on the pediments of which grow dainty flowers unrolling out of robes and topped, without rhyme or reason, by little figures. The little stems, finally, support half-figures crowned by human or animal heads. Such things, however, never existed, do not now exist, and shall never come into being. . . . For how can the stem of a flower support a roof, or a candelabrum bear pedimental sculpture? How can a tender shoot carry a human figure, and how can bastard forms composed of flowers and human bodies grow out of roots and tendrils?" (Kayser 1963, 20). For the Renaissance, especially for Pirro Ligorio's authoritative conception of the grotesque, see Summers 1981, 496, 497.

6. Goethe n.d., 1.

7. Which has the interesting implication that what is logically impossible can, nevertheless, be depicted.

8. This feature of the engraving is not mentioned by Bauer.

9. Pevsner 1956, fig. 110.

10. Bauer 1962, fig. 45.

11. For Meissonnier, see Fuhring 1994.

12. Escher's play with spatial dimensions has its antecedents in Giambattista Piranesi's *Carceri*. And Escher's deep admiration for this prototypically rococo artist is well attested. See, for example, Locher 1975, 24.

13. See, for example, Banks 1977, fig. 102. Where Meissonnier makes ornament into part of represented reality, the tree above the couple of lovers is presented here as ornament. Hence we may observe here the same ambiguity between ornament and represented reality, though Watteau exploits this ambiguity differently from Meissonnier.

14. Escher 1975, 40–44.

15. Needless to say, I am thinking here of Huizinga's conception of play as developed in his *Homo Ludens:* "Het spel schept, tijdelijk en plaatselijk, een eigen, uitzonderlijke, omheinde wereld binnen de gewone, waarin de spelers zich naar eigen dwingende wet bewegen, totdat die wet zelf hen verlost" [Within the ordinary world, play creates a unique, enclosed, local, and temporary world of its own in which the movements of players are dictated by separate laws—until these very laws set the players free again] (Huizinga 1950, 5).

16. Bauer 1962, 20, 21. For a complete enumeration of the four most important properties that Bauer attributes to rocaille, see p. 46.
17. The phrase was already used by Jones (1856).
18. As is explained in Waenerberg 1992.
19. Illustrative here is the Bérain engraving, even though careful investigation will bring to light certain imperfections in its symmetry.
20. It might be interesting to hear a mathematician speak about the C curve.
21. Wersin 1940, 15.
22. Rykwert 1983, 108.

References

Bal, M. 1999. *Quoting Caravaggio: Contemporary Art, Preposterous History.* Chicago: University of Chicago Press.
Banks, O. T. 1977. *Watteau and the North.* New York: Garland.
Bauer, H. 1962. *Rocaille: Zur Herkunft und zum Wesen eines Ornament-Motivs.* Berlin: Walter de Gruyter.
Crowther, P. 1991. *The Kantian Sublime: From Morality to Art.* Oxford: Oxford University Press.
Escher, M. C. 1975. "Oneindigheidsbenaderingen." In *De werelden van Escher,* ed. J. L. Locher, 40–44. Amsterdam: Meulenhoff.
Fuhring, P. J. 1994. *Un génie du Rococo: Juste Aurèle Meissonnier (1695–1750). Orfèvre, dessinateur, architexte.* Paris: Gallimard.
Goethe, J. W. von. N.d. *Reinecke Fuchs: Zeichnungen von Wilhelm Kaulbach.* Stuttgart: Cotta.
Graevenitz, G. von. 1994. *Das Ornament de Blicks, über die Grundlagen des neuzeitlichen Sehens: Die Poetik der Arabeske und Goethes "West-östlichen Divan."* Stuttgart: Metzler Verlag.
Huizinga, J. 1950. *Verzamelde Werken 5.* Haarlem: Tjeenk Willink.
Jones, O. 1856. *The Grammar of Ornament.* London: Quaritch.
Kayser, W. 1963. *The Grotesque in Art and Literature.* Bloomington: Indiana University Press.
Kuhn, R. 1976. *The Demon of Noontide: Ennui in Western Literature.* Princeton: Princeton University Press.
Locher, J. L., ed. 1975. *De werelden van Escher.* Amsterdam: Meulenhoff.
Loos, A. 1982. *Trotzdem.* Vienna: Georg Prachner Verlag.
Pevsner, N. 1956. *Rococo Art from Bavaria.* London: Lund Humphries.
Riegl, A. 1993. *Problems of Style: Foundations for a History of Ornament.* Princeton: Princeton University Press.
Rykwert, J. 1983. *Ornament ist kein Verbrechen: Architektur als Kunst.* Cologne: Dumont Buchverlag.
Schapiro, M. 1969. "On Some Problems in the Semiotics of Visual Art: Field and Vehicle in Image-Signs." *Semiotica 1.*
Scruton, R. 1997. *The Aesthetics of Music.* Oxford: Oxford University Press.
Summers, D. 1981. *Michelangelo and the Language of Art.* Princeton: Princeton University Press.
Thomson, P. 1972. *The Grotesque.* London: Methuen.

Waenerberg, A. 1992. *Urpflanze und Ornament: Pflanzemorphologische Anregungen in der Kunstttheorie und Kunst von Goethe bis zum Jugendstil.* Helsinki: Societas Scientiarum.

Wersin, W. von. 1940. *Das elementare Ornament und seine Gesetzlichkeit: Eine Morphologie des Ornaments.* Ravensburg: Otto Maier Verlag.

CHAPTER SEVEN

Mourning and Method

Michael Ann Holly

In the sight of an old pair of shoes there is something profoundly melancholy.

—Flaubert

My principal preoccupation as an art historian (actually as a historiog-rapher, which means that I am a scholar of the intellectual history of the history of art) has always been a philosophical one: why do we write about works of visual art in the first place? Why do subjects *(us)* need to talk about objects? What kind of a dialogue, even game, is taking place? In my book of 1996, *Past Looking: Historical Imagination and the Rhetoric of the Image,*[1] I tried to make a case for the variety of ways that works of art both literally and metaphorically prefigure their subsequent histori-cal and interpretive understandings. It had long been a commonplace of poststructuralist thinking that all the energy for interpretation em-anates from the subjective side of the equation, and I wanted to restore a certain agency to the objects themselves.

In the following essay, however, I want to address the character of the field between: the magnetism that perpetually binds subjects and objects, an exchange enacted under the pall of mourning. I am haunted by a couple of memorable, melancholic sentences in the history of art by two fellow art historians, long dead, with whom I have spent consid-erable scholarly time communing. First of all, Erwin Panofsky, writing in 1955: "The humanities are not faced by the task of arresting what

would otherwise slip away, but enlivening what would otherwise remain dead."[2] And then, more than a century before, Jacob Burckhardt, writing in 1844: "I feel at times as though I were already standing in the evening light, as though nothing much were to come of me...I think that a man of my age can rarely have experienced such a vivid sense of the insignificance and frailty of human things...I'm a fool, am I not?"[3]

In his letters, Burckhardt is always the melancholic observer on the other side of history, the outsider looking in, the spectator who admires but can never inhabit the sunny vistas from which he is separated in time. "This," he exclaims, "is where I stand on the shore of the world—stretching out my arms towards the *fons et origo* of all things, and that is why history to me is sheer poetry."[4] He saw the "'culture of *old* Europe'... as a ruin," and he despaired that historical events, especially contemporary ones, had any meaning at all.[5] The crucial paradox of history writing, as Burckhardt knew a century and a half ago, is that it validates death in the present while preserving the life of the past. My question arises from that conundrum: how might melancholy, regarded as a trope, help art historians to come to terms with what I see as the elegiac nature of our disciplinary transactions with the past?

I begin with Burckhardt's and Panofsky's lamentations to set the tone for considering a certain paradigm of Renaissance art historical scholarship in terms of the theme of melancholy—not the iconography of the humor (fairly standard), but rather its translation into a historiographic point of view. A political or intellectual history that is rooted in written documents is difficult enough to execute; a narrative written out of a loyalty to visual objects is very often an assignment in exasperation. The very materiality of objects that have survived the ravages of time to exist in the present frequently confounds the cultural historian who retroactively sets out to turn them back into past ideas, social constructs, documents of personality, whatever. Works of art metonymically, like links on a chain, express the lost presence.[6] Images are so often what we "depend on in order to take note of what has passed away."[7] The contemplative paralysis that arises from the recognition of an inability to make contemporary words connect with historical images—that is, to write a definitive history of art—was for Burckhardt, as it was over half a century later for Walter Benjamin, that prescient theologian of melancholy, an essential trait of the mournful sensibility.[8]

On its sunny surface, the practice of connoisseurship in Renaissance studies would seem to be about as far from sharing such shadowy sentiments as one could go, but I would prefer to regard it in this context as just a different kind of historical performance provoked by a sense of loss. Burckhardt and Bernard Berenson, by this reckoning, might be two sides of the same coin.[9] The connoisseur locates certain motifs in which the hand of the artist is relaxed and therefore most revealing of self, such as the insignificant details revealed in drapery folds, thumbs, and earlobes. From there it is a rather short step to identifying artists and authenticating masterpieces. The mental tools required for such an undertaking, however, are daunting. Not only must the connoisseur be possessed of a prodigious visual memory, but he or she must also have the culturally acquired confidence and inborn sensitivity to assess quality.

I am far less interested in the psychobiography of either Burckhardt or Berenson, however, than I am in the pressing desire to connect with the past by way of an authentic aesthetic experience, a desire (although unnamed) that seems to be as obvious in Berenson's labors of attribution as it is in Burckhardt's "ruined" project. Both sought that moment of contact that is forever foreclosed; the material site where history and the immediacy of aesthetic appreciation become one. The tactile values Berenson admired in Quattrocento painting become an allegory in this psychic scenario for his yearning to reach across time and touch the hand of the master painter (something akin to Benjamin's fabled "act of friendship toward the dead"). Locating provenance and authenticating historical presences may indeed be standard protocol for careful connoisseurship, but the melancholic disposition that choreographs such a commitment also merits recognition.

The performance of art history as a disciplinary practice so often depends on the lure of the unknown. A good art historical tale can be as provocative as a mystery story. Something has gotten lost, someone has gone missing, a visual clue remains unseen. From connoisseurs to iconographers to social historians, the quest for clarity within the shadowy realms of origins, meanings, and contexts has long been of compulsive importance.[10] But when all is said and done, when all the loose ends of the story are tied up, something inevitably appears to be left over. Who has not felt it? What might we call it? The compelling visuality of the work of art resists appropriation by either the cleverness of historical explanations or the eloquence of descriptive language. *Something re-*

mains; something gets left over. Consequently, I want to argue, the discipline is constitutionally fated to suffer from a quiet melancholic malaise. The distance between present and past, the gap between words and images, can never be closed. In Freud's phrase, it is melancholy, or unresolved mourning, that keeps the wound open.[11]

The yearning for the past that poets and painters often evince is also latent in the longings of scholars who have devoted their intellectual lives to history writing, to invoking that which came before but is no longer. The poignancy is especially acute with historians of art. In the sight of old objects that continue to exist materially in the present, but whose once noisy and busy existence has long since been silenced, there is something profoundly melancholy. Such a state of mind is, of course, easier to *feel* than define. Many psychoanalysts, from Freud to object relations theorists in the legacy of Melanie Klein, have explored this quiet, brooding aspect of the psychic life.[12] Several, in fact, have even linked it to the uncanny phenomenological experience of being enveloped by a work of art, what Christopher Bollas has called falling under the "shadow of the object, ... the sense of being reminded of something never cognitively apprehended but existentially known."[13]

Of course I am far from the first to emphasize what has been regarded by many as our quintessential postmodern predicament. The "rhetoric of mourning" that has engendered and connected so many late-twentieth-century studies in the humanities is one devoted to the incomplete and the missing: fragments, allegories, ruins, retreats from definitive meanings. Yet the practice of art history provides an oxymoronic twist on this by now common characterization. The very materiality of objects with which we deal presents historians of art with an interpretive paradox absent in other historical inquiries, for works of art are both lost and found, both present and past, at the same time. As Martin Heidegger once put it, "World-withdrawal and world-decay can never be undone. The works are no longer the same as they once were. It is they themselves, to be sure, that we encounter there, but they themselves are gone by."[14] Attending to this rhetoric of loss in critical writings about art could certainly take us in many directions.

The quest for lost origins, for example, has lain at the heart of the history of art ever since the discipline itself originated. On this ground alone, the typical art historical enterprise seems predestined to be a melancholic one. It is not just a matter of trying to retrieve forgotten historical

meanings or neglected artists. Seeking to situate provenance, identify individual intentions, relocate physical settings, decipher underdrawings, and emplot works of art back into their cultural and ideological contexts are all prosaic indications of a compulsion to recover a *certain something* long since forgotten or abandoned. The concept of "melancholy writing," of which Julia Kristeva speaks so evocatively in *Black Sun,* is especially apposite for reflecting on this *underside* of the art historical enterprise.[15] "The Thing, the unnameably, irretrievably withheld," as Max Pensky puts it, "establishes the impossibility and necessity of melancholy writing by its absolute absence."[16] What are the implications of this buried rhetoric of privation for the sundry practices of art history, both new and old? What is the connection between this deeply philosophical recognition of loss—functioning almost as the latent unconscious of the discipline—and the manifest, even rather prosaic, projects of historical recovery so paramount in art historical discourse? Finding, as Freud reminded us in *Beyond the Pleasure Principle,* is often just the prelude to losing yet again.[17] An example, actually the comparison of two historiographic events—two ostensibly dissimilar exercises in the history of art—is in order.

One fine spring day nearly two years ago, many distinguished scholars of early Netherlandish art from both Europe and the United States gathered at the Philadelphia Museum of Art to contemplate two nearly identical paintings of the mystic Saint Francis, both reputed to be painted by Jan van Eyck in the 1430s, one now residing in Turin, the other in Philadelphia, and there brought together for the first time in an exhibition (Figures 7.1 and 7.2). The task of the hour was voiced in the accompanying catalog: "That both works belong to van Eyck's circle is indisputable, but are they both by the master's hand? Or is one—and which one—a slightly later copy of the other, which would then constitute a single authentic work? Or do both derive from a lost original?" This enigma was not a new one. Ever since the late nineteenth century—the great age of historical science—the two pictures had been compared in earnest, establishing the issue of "the precedence of one or the other and their mutual (or independent) relation to Jan van Eyck, his workshop, and followers—as one of the thorniest conundrums in the study of early Netherlandish art,"[18] as a quick survey of the major scholars of twentieth-

century Netherlandish studies can attest. (Max Dvořák, for example, considered both paintings to be copies of a lost original; Erwin Panofsky [openly modeling his methods at detecting "disguised symbolism" on those of Sherlock Holmes] dismissed both as "heresy" to the van Eyck canon and regarded them only as conglomerations of Eyckian motifs probably painted by Petrus Christus; Millard Meiss agreed with Panofsky that they certainly could not have been executed by van Eyck; Julius Held found the Turin painting superior and therefore perhaps the original masterpiece; and Charles Cuttler considered both to be replicas of a lost work by the master.)[19] Although no deciding vote was taken after the daylong symposium in Philadelphia, the tentative consensus of the connoisseurs seemed to be that the smaller Philadelphia painting possessed most of the earmarks of an authentic and original work.

In declaring at the start which one the experts seem to have preferred, I hope I am not robbing you of the thrill of joining the investigation, like telling you "whodunit" before you have a chance to read the mystery novel. What interests me here, however, is not the resolution to the story (in fact there actually isn't one) but the disciplinary protocols that are deployed in the well-funded international effort at discovering origins. Archival research, iconographic comparisons, stylistic analysis, microscopy, infrared reflectography, dendrochronological analysis, even the geological history of the garden of LaVerna in which the mystical vision supposedly took place (which proved that it was "geologically unlikely" that these were Alpine rocks [it's only paint, after all!])[20]—all became potential instruments of discovery. Confidence in the methodological potential of art historical science was triumphantly on display. And even though my grander intent here is eventually to turn this particular episode in Philadelphia into one of two parables about disciplinary suffering and melancholic revelation, I cannot help but take delight in the art historical ingenuity of this particular quest.

The historical tale, as much as can be reconstructed, is an intriguing one. Anselme Adornes, a mid-fifteenth-century member of the Genoese merchant family active in the economy and politics of the Burgundian court, journeyed at least twice to the Holy Lands, perhaps on diplomatic missions for Charles the Bold. Although the portrayal of Francis was rare in northern art, the saint was considered to be the caretaker of Christ's tomb at the Holy Sepulcher in Jerusalem, upon which Anselme

Figure 7.1. Jan van Eyck, *Saint Francis Receiving the Stigmata*, 1430s. Oil on vellum on panel, 4⅞ x 5¾ inches. Philadelphia Museum of Art, the John C. Johnson collection.

was modeling his own memorial chapel in Bruges. His will of 1470 leaves his two daughters (somewhat ambiguously—"St. Francis in portraiture from the hand of Master van Ecyk") two pictures of the nature-worshiping saint by the artist.[21] Since one is considerably smaller than the other, some have speculated that the large Turin one was an original, and the delicate Philadelphia painting was a revered copy, small and portable enough to be carried by Anselme on his pilgrimages, or even perhaps commissioned later for the second daughter. Until they (if indeed these are the two named in the testament) resurfaced in the nineteenth century, their locales and ownership were unknown. Because the sources are lacking in chronological proof, the works have been subjected to analysis by a number of instruments in the formidable art historical arsenal.

Many and diverse are the "facts" that are mustered in defense of one or the other claimant: dendrochronological analysis, for example, reveals that the Philadelphia version, painted in oils on parchment and attached

Figure 7.2. Jan van Eyck, *Saint Francis Receiving the Stigmata*, 1430s. Oil on panel, 11½ x 13⅛ inches. Galleria Sabauda, Turin.

to a wooden panel, was cut from the same tree as two other authenti-cated portraits by van Eyck. Although there are some subtle differences, the two Saint Francis paintings are practically identical. The brushwork, for example, is strikingly similar: whether in modeling the rims of the eyes or in depicting "wrinkles on the brow or stubble on the chin."[22] If there are discrepancies, they are explained by the Philadelphia paint-ing's diminutive size.

It is, however, in the anomalies—as though they were clues left be-hind at a crime scene—where the real art historical suspense begins. And as in a mystery story, the nature of Saint Francis's wounds—how he suffered them and when—becomes critical. In many paintings of the humble saint, the stigmata in his side, hands, and feet (mimicking those that Christ suffered on the cross) are visibly present, as are the agents of their appearance, the piercing rays of light descending from the seraphic vision. The concealment of these standard iconographic details, as in his side, then, becomes highly symptomatic.

Figure 7.3. Infrared reflectogram of the feet of the Turin Saint Francis.

And then there's the real clincher. The autopsy of the body in Turin—in art historical science it is known as infrared reflectography—has revealed a secret of mystery-solving proportions (Figure 7.3). The feet of Saint Francis were first underdrawn with some kind of footwear covering them—socks or close-fitting pointed shoes, with rims at the ankles. In recognizing this iconographic error, or perhaps in changing his mind about what moment in the story to depict, van Eyck corrected the telling secret detail in the overpainting while also adjusting the position of the right foot to make it more anatomically acceptable. Yet the question then arises as to how both Joseph Rischel, the senior curator who organized this wonderful and perplexing exhibition, and many of the other art historical detectives could go on from there to suggest that the Philadelphia painting—which reveals no sandals in the preparatory drawing—might be thought to come "first." Should it not be the other way around? The intrigue continues, but we will leave it there in order to attempt some critical distance on my principal theme: the role of the missing

and absent in the deep structure of art historical discourse. This partic-
ular van Eyck mystery I am incapable of, and uninterested in, solving.

*I guess what I'm asking is this: are these the only kind of questions that
art historians should be asking: Whodunnit? Or whatisit? Is there nothing
else we can say? Is the point of art history to nail the case shut; to pin
down artists, original works, iconography? Maybe. But I'm sympathetic to
other more critical or philosophical kinds of questioning, and I'll give you
an example.*

Naturally, any reference to the enigma of painted shoes is bound, in
certain critical circles, to invoke the specter of Jacques Derrida and his
dense but ludic essay in *The Truth in Painting* on the debate between
Martin Heidegger and Meyer Schapiro over van Gogh's haunting paint-
ings of workers' boots done in the 1880s (Figure 7.4).[23] The quarrel be-
tween the philosopher (Heidegger) and the art historian (Schapiro) over
the ownership of these old shoes (they are, after all, only paint) poses "a
delirious dramaturgy" and an excuse for Derrida to play with two of his
favorite themes: the inadequacy of words to come to terms with images,
and the inability of aesthetic discourse to keep concerns extrinsic to the
work of art separate from those that are intrinsic. "Let us posit as an ax-
iom," Derrida first of all asserts, "that the desire for attribution is a de-
sire for appropriation."[24] As well known as this art historical drama is, I
want to recount it briefly in order to stage an occasion for reviewing the
comparable performance in Philadelphia—using the portrayal of shoes
as the hinge that connects the two episodes.

In 1935, during the rise of national socialism, Heidegger (he of prob-
lematic sympathies) wrote an essay entitled "The Origin of the Work of
Art."[25] It was a critique, in part, of Kant's third critique, and the Enlight-
enment thinker's concept of the aesthetic. For both philosophers, a
work of art has the capacity to achieve something larger than the sum
of its individual parts. Yet Heidegger, in emphasizing the strangeness
and thickness of art, regarded a meaningful work less as an object (and
thereby subject to stable conceptual aesthetic categories) than an event
in the world.[26] The crux of his phenomenology rested on the work's
extraordinary address to its viewers and their ability to put it "to work,"
transforming mere material into meaningful form ("earth" becoming
"world," a place of unveiling, unconcealing, lighting up). Take the primor-
dial example of van Gogh's painting of shoes, where, Heidegger claims,
"truth sets itself to work."[27] The reverie provoked by the shoes yields to

Figure 7.4. Vincent van Gogh, *A Pair of Shoes,* 1886. Oil on canvas, 37.5 x 45.5 cm. Amsterdam, Van Gogh Museum (Vincent van Gogh Foundation).

him their essential being-in-the-worldness, the equipmentality of common equipment, *and here I will quote one of the most famous passages in contemporary critical theory:*

> A pair of peasant shoes and nothing more. And yet—From the dark opening of the worn insides of the shoes the toilsome tread of the worker stares forth. In the stiffly rugged heaviness of the shoes there is the accumulated tenacity of her slow trudge through the far-spreading and ever-uniform furrows of the field swept by a raw wind. On the leather lie the dampness and richness of the soil. Under the soles slides the loneliness of the field-path as evening falls. . . . This equipment is pervaded by uncomplaining anxiety as to the certainty of bread, the wordless joy of having once more withstood want, the trembling before the impending childbed and shivering at the surrounding menace of death. This equipment belongs to the *earth,* and it is protected in the *world* of the peasant woman. From out of this protected belonging the equipment itself rises to its resting-within-itself.[28]

Of course there is nothing in this evocative description that reveals that Heidegger is talking about a painting of shoes, and not the shoes

themselves. Nothing, that is, except for his subsequent stepping outside of the lyricism of his reverie and remarking, "But perhaps it is only in the picture that we notice all this about the shoes."[29] The work of art, in other words, does not have its origin in the "real thing"; quite the reverse. The material thing in the world has its origin—*only comes into its own*—in its visual representation. Talking about an image from the vantage point of art history, it follows, is anathema to the phenomenologist: "Art-historical study makes the works the objects of a science.... in all this busy activity do we encounter the work itself?"[30] (certainly a question we might legitimately ask of the van Eyck crew). For Heidegger, something will inevitably go missing in the painting's art historical reception, and it is not only the peasant woman herself.

For the scholar Meyer Schapiro, however, what went astray in Heidegger's prose was not just art historical knowledge, although the philosopher's iconographic ignorance did pose a problem. Had Heidegger sought out the literary sources, including van Gogh's letters, he would quickly have recognized that the shoes were those of van Gogh—a kind of psychological self-portrait of the creative individual himself—and thus have been appropriately arrested in his search for all sorts of venomous *volkisch* affirmations, such as those about the soil, the peasant life, the dignity of drudgery, et cetera. Instead the national socialist Heidegger substituted nationalist "projection" for "a close and true attention to the work of art."[31] Asked to contribute an essay to a 1968 commemorative volume for the German Jewish refugee and fellow Columbia University professor Kurt Goldstein, Schapiro chose to confront the insidious political and social context of Heidegger's supposedly ahistorical meditations through the discourse of art historical correctness: "The essential fact [is that] for van Gogh the shoes were a piece of his own life.... This concept of the metaphysical power of art remains here a theoretical idea. The example on which [Heidegger] elaborates with strong conviction does not support that idea."[32]

For Jacques Derrida, who actually "staged" a mythical correspondence between Heidegger and Schapiro at Columbia in October 1977, Schapiro's recourse to professional rhetoric was itself symptomatic: "One is surprised that an expert should use all this dogmatic and precritical language. It all looks as though the hammering of the notions of self-evidence, clarity, and property was meant to resound very loudly to prevent us from hearing that nothing here is clear, or self-evident, or

proper to anything or anyone whatsoever."[33] Asking repeatedly if any-
one can actually prove that there is indeed a pair of shoes represented in
the picture, Derrida proffers the verdict (as if anything could be final in
deconstruction) that neither thinker is innocent: "One claim," he says, is
"more naive, more excessive . . . than the other. . . . One attribution exceeds
the other. . . . Where do they . . . get their certainty?"[34] In asserting a "spe-
cialist's" authority over a domain (art history) "whose frontiers he
thought were determinable," Schapiro neglected to see beyond those
boundaries, to the realm where Heidegger had dared to venture and re-
turn art historically ignorant but not so devoid of insight: *to the philo-
sophical world provoked by the thought of the painting.*[35] "Is it enough for
Heidegger to be wrong to make Schapiro right?" Derrida provocatively
asks.[36] The interlacing of the two meditations on shoes has only under-
scored a metaphorics of loss endemic to all attempts at reconstruction:
"In both directions, making come back, making go away, making come
back again, inside, outside, down there, here, *fort, da.*"[37] The rhythm is
breathless, the questions unceasing:

> Whose are the shoes? (257). What is one doing when one attributes a
> painting? (266). Who is going to believe that this episode is merely a
> theoretical or philosophical dispute for the interpretation of a work?
> (272). Is it a matter of rendering justice to Heidegger, of restituting what
> is his due, his truth? (301). What is reference in a painting? (322). Are we
> reading? Are we looking? (326). [Is the point] to make ghosts come back?
> Or on the contrary to stop them from coming back? (339).[38]

Clearly, something momentous "*happens,* something *takes place* when
shoes are abandoned."[39]

So now I've placed two pairs of shoes on the table, a serious breach
not only of my grandmother's rules of etiquette but of those of tradi-
tional art history, as well: those missing in van Eyck's Saint Francis and
those of van Gogh's anonymous ghost, separated from each other by
nearly half a millennium. And what should I do with them? What do
they have to do with each other, two pairs of shoes serving as the ful-
crum of my own memorializing aesthetics? Why, as Flaubert poignantly
asked, does the sight of a pair of old shoes provoke such melancholy?
The questions proliferate; I can't seem to evade the rhetoric of Derrida
("They've put a picture . . . and two texts under my nose. . . . But I still
don't know where to start from, whether I must speak or write . . . nor,

above all, in what tone, following what code, with a view to what scene").[40] I proceed only with the sense that their connection—this serendipitous motif of the shoes—lies not just in the stark contrast of critical approaches between traditional and revisionist art histories, but rather in the *melancholic undertow* that these two episodes share: the *similarity* that connects, rather than the confrontations that divide. Both art historical tales are somehow similarly caught up in a swirling vortex of irrevocable loss, of unrecoverability—acknowledged or not.

I'm not claiming that writings on art, of whatever persuasion, are obsessed with what gets left out, or even that they are especially attuned to their own submerged rhetoric of loss. Granted, the methodological procedures in our two exemplary shoe parables are very different. The Philadelphia/Turin explorations burrow in, literally penetrate through the thickness of paint to uncover layer after layer of significance. And in the end, the detectives are left with fragments of paint, scraps of scarlet borders, shady underdrawings, no firm solution to their puzzles about authorship. Nevertheless these investigations have provided the occasion to mount a sparkling exhibition of a small collection of van Eyck gems. The Heidegger/Schapiro debates, on the other hand, as recounted by Derrida, skim along the surface of interpretation, refusing to rest, fabricating comparisons, dissolving connections in a kind of stream-of-consciousness recitation about the impossibility of real discovery. And in the end we are left with no objects at all—no van Eycks, no van Goghs—but plenty of authors-as-subjects, subjects enmeshed in a congeries of ideological contexts. My point, however, is that the distinction between these two axes of exploration, one proceeding from surface to depth, one sliding over the surface, is perhaps not there at all when it comes to the deep and common rhetorical structure that underlies each.[41] In both cases, I would argue that the compulsion of the narrative derives its interpretive animation from the real threat of loss. (Remember Heidegger's apt question: "In all this busy activity do we encounter the work itself?") With each passing word, the image recedes. The experience of the aesthetic (is there such a thing?) diminishes.

The provocative predicament that art history finds itself in today—from simultaneously performing dendrochronological analysis to flirting with deconstruction—might be regarded as the effect of a collective disciplinary desire to locate a meaningful route around our incapacity

to articulate why works of art are meaningful on their own terms, something that, despite all his faults, Heidegger strove to do. Despite deconstruction's dismantling of the classic yearning in Western metaphysics after some self-authenticating presence,[42] even Derrida, to some extent, has been seduced by aesthetic desire: "Even if [a work of art] isn't exhausted by the analysis of its meaning, by its thematics and semantics," he claims, "it is there in addition to all that it means. And this excess obviously provokes discourse *ad infinitum.*"[43] Indeed, what Derrida draws attention to in his rehearsal of the Heidegger/Schapiro debates is the likelihood that the birth of art history tolled the death knell for aesthetics, and the deconstructionist himself is not insensitive to the sentiment that his own ramblings depend on the repetition of that dying.

The invocation of the aesthetic, of course, conjures up another haunting, that of Kant, whose specter hovers not only over the philosophical musings of Derrida and Heidegger but also over the art historical projects of Schapiro and the Philadelphia gang. Permit me to walk down that rocky path for just a moment. If we consider the intellectual history of our field of study, we would have to acknowledge that the active, but ultimately futile, search for the elusive originates in the aftermath of Kant's *Critique of Judgement* of 1790. Kant himself, of course, was not a seeker into the penumbral. If anything, his "Analytic of the Beautiful" and "Analytic of the Sublime" together represent the supreme effort to bring principles of Enlightenment logic and reason to bear on the nature of human interaction with works of art.[44] Paring away essentials, stripping down to minimal criteria, he worked at making manifest both the sequence and the significance of a pure and universal aesthetic experience. Kantian aesthetics are predicated on a refusal to succumb to the inexpressible, a reluctance to acknowledge the expulsion of a perceiving subject from the world of objects. But in this conviction, it seems to me, his *Critique of Judgement* can simultaneously be read as an elegant and sustained "apology" for that which cannot be articulated, namely, the experience of the sublime in nature, the unspeakably beautiful in art.[45]

Kant's "four moments of taste" were all negatively defined, which is to say that they are all positively based on principles of appreciation that must be phenomenologically bracketed off from other areas of experience. According to the order of his formal conditions, we find that aesthetic judgment, to be categorized as such, must be devoid of all interest, devoid of any concepts that might subsume it, devoid of any pur-

pose or end outside itself, and devoid of disagreement if it is to solicit universal acceptance.[46] Since "beauty is really a claim about the *subject* rather than the object,"[47] one could even paradoxically assert that his scheme is devoid of objects themselves. It almost goes without saying that any considerations of context are dispatched without ceremony. Ironically, then, art historians by definition must be those viewers who are least sensitive to the attractions of art. The feeling of pleasure that a beautiful object can provoke "can occur only when our contemplation of an object is free of any antecedent interest."[48] So here, of course—if we are attentive scholars of art's history—we suffer the most primal loss of all, the pure experience of beauty.

Secondly, this commandment of disinterestedness, which weaves its way throughout *The Critique of Judgement,* seems designed to provoke a kind of personal aesthetic melancholy. If one finds an object "beautiful," Kant would insist that he or she is judging it solely under the aegis of its aesthetic presence in the present. An invocation of any sort of memory would taint the purity of the reaction. Referring the beautiful "form" of an object of art back either to its real embodiment in nature, for example, or to its significance in the life of the observer, or even to another work of art, would be a step backward in both time and discriminating judgment. In fact, all of his "four moments" resolutely resist reference to anything that has come before *the* moment when the shadow of the object falls across the consciousness of the viewer. This injunction to cast off anything that does not partake in the immediacy of the perception cannot help but have consequences for the subject who has presumably exercised his or her other critical faculties, in other contexts, before this moment of pure disinterested contemplation. One of these consequences, I would argue, would have to be a melancholic one: what has been excluded, namely, the memories and sensations of the individual—especially one with scholarly intent—returns to unsettle. To call something "art" is to ignore not only its past but our own as well.

By extension, then, both of these Kantian claims about the subject require a profound degree of abstinence and abandonment on his or her part. The first "professional" mandate makes the viewer choose between poetic engagement and historical understanding, phenomenological apprehension and intellectual commitment, and the second demands that he or she forswear a lifetime of personal memories and experience.

Of course, this may be characterizing the ideal Kantian subject rather crudely, but the psychic toll exacted in these prescriptions seems to me to have had lasting effects on just what transpires in aesthetic discourses about art. In the interest of either finding something out (authorship, for example) or proving that indeed nothing can be found out at all (such as "meaning"), the discipline of art history, new or traditional, necessarily papers over an undercurrent of renunciation.

In some way I guess I would argue that each of the twentieth-century art historical "shoe" projects, thanks in part to Kant, derives its interpretive urgency from a sense of missing or missed origins, both literal and figural: about what cannot be uttered, what cannot be found, what cannot be thought. It is this submerged sensitivity toward the lost and forgotten that gives these diverse writings their melancholic edge, acknowledged or not. My justification for talking about Derrida in the context of van Eyck, even Kant in the context of infrared reflectography, is not as absurd as it first might seem. On the one hand, I am convinced that their shifting interdependencies can challenge, or at the least provoke us to defend, the secure epistemological foundations on which we scurry about fulfilling our professional engagement with restoration and recovery. On the other, the constitutional inability of the discipline to possess objective meanings, to make contemporary words say something definitive about historical images—however much its practitioners might genuinely try—is what I imagine to be the source of its institutional melancholy.[49]

So, then, by way of conclusion, three or four thoughts about the nature of mourning and method in art historical investigations. I take it as axiomatic that history writing is a psychic activity, that both its traditional and revisionist tales are always narratives of desire, doomed searches after lost origins. The urge to recover meaning, context, precedents, whatever, presses upon the scholar, but so too does the recognition of the futility of the search, thus converting her or him into a melancholic subject who nonetheless often possesses an ethical commitment to the past. Quite a quandary. Given that the works of art with which we deal professionally can themselves be metaphoric expressions of a lost presence, art historians, in their attempts to make words match images, are doubly fated to experience loss, twice removed from originary meanings. Like a souvenir, an object of art is regarded as standing in place of a past event to which it was once metonymically related.[50] Paradoxically, it is

writing that gets in the way: "That which cannot return, that which cannot again become present. . . . The image indeed returns, but it emerges from a past whose pastness, adhering to it like some dark shadow, accompanies it into the present. . . . Loss is the precondition of interpretation. But much writing represses that truth, and the will of much interpretation is a will to forget loss."[51] The past is precisely that which is beyond resurrection, possibly even recognition.

Let me venture a final pictorial parable by returning to our two monks, especially since Brother Leo, off to the side, shares the slothful, contemplative demeanor of Dürer's well-known portrait of Melancholia (Figure 7.5). Panofsky, who regarded this figure as a spiritual self-portrait of Dürer himself, says of her: "Winged, yet cowering on the ground— wreathed, yet beclouded by shadows—equipped with the tools of art and science, yet brooding in idleness, she gives the impression of a creative being reduced to despair by an awareness of insurmountable barriers which separate her from a higher realm of thought."[52]

Prompted by Dürer's visual allegory, I wonder if Freud's distinction between mourning and melancholy, which I have almost avoided until now, might not be relevant here after all. In mourning, Freud claims, loss is conscious; in melancholy (what he characterized as "unresolved mourning"), loss is unconscious because the sufferer introjects the emptiness as his or her own. "The distinguishing mental features of melancholia," according to Freud, "are a profoundly painful dejection, abrogation of interest in the outside world, loss of the capacity to love, inhibition of all activity, and a lowering of the self-regarding feelings."[53] The melancholic, in his words, keeps the wounds open.[54]

Back to our van Eyck. Even though Saint Francis is the possessor of the wounds, he conveys a more salutary emblem of healing and empowerment than Brother Leo, who is mired in either sleep or paralytic sadness. Francis is the one with the visions, the one who, in the denial of suffering, finds consolation. Surely there's a moral here. As Walter Benjamin both hoped and anticipated, a historian's labor is never devoid of redemptive possibilities: "An appreciation of the transience of things, and the concern to rescue them for eternity," can also yield its own scholarly consolations; "pensiveness," Benjamin moralized, "is characteristic above all of the mournful."[55] The only way to "recover" the meanings of objects that always already exist, even in part, is through language, for "the humanities," as Erwin Panofsky, whom I quoted at

Figure 7.5. Albrecht Dürer, *Melencolia I*, 1514. Engraving, 9½ x 7⁵⁄₁₆ inches. Photograph copyright 1994 Sterling and Francine Clark Institute. Used by permission.

the beginning, said, "are not faced by the task of arresting what would otherwise slip away, but enlivening what would otherwise remain dead."

I am tempted to argue in general that the discipline of art history is eternally fated to be a melancholic one, primarily because the objects it appropriates as its own always and forever keep the wound open (the cut between present and past, word and image)—resistant to interpre-

tation, these works of art nonetheless insistently provoke it. Writing never cures, but healing comes in degrees. Positivistic art history, of the sort manifested in the Philadelphia allegory, may be based on *loss,* but it has also *lost* the capacity for pain; traditional art historical practice, such as that of connoisseurship, has come to terms too easily with its psychic *tears.* That's why I tend to prefer the other, more critical sort. As both Heidegger and Derrida recognized, the aesthetic capacity of a work of art to wound, to pierce, has been *anesthetized* by the pursuit of origins, the confidence in endings. Why shouldn't we want to suffer the sting of loss? Isn't that where the most profound philosophical questioning comes from? So where does that leave me—a historian of the field of art history—in relation to the changing face of art history in both the museum world and academic practice? Only with my own allegorical conviction, born of a commitment to the innovations of recent challenges toward both the art historical canon and its tried-and-true methodologies. If the customary routes to understanding offer little more than the comfort and familiarity of fossilized procedures, then, to my mind, fresh incisions must be made.

Notes

This essay first appeared, in a slightly changed version, in *Art Bulletin* (December 2002): 660–69.

1. Holly 1996.
2. Panofsky 1955, 24.
3. 10 June 1844, in Dru 1955.
4. 19 June 1842, in Dru 1955.
5. See White 1974, 234.
6. See Stewart 1993.
7. Stamelman 1990, 7.
8. Benjamin [1916] 1925.
9. The literature on Berenson and connoisseurship is vast. A few historiographic texts that should be cited here are Freedberg 1989; Brown 1979; Wollheim 1973; Schapiro 1994.
10. See the classic essay on the subject by Ginzburg (1980).
11. Freud 1957, vol. 14, 239–58.
12. Klein 1987.
13. Bollas 1987, 16.
14. Heidegger 1971, 41.
15. Kristeva 1989, 6.
16. Pensky 1993, 5.
17. Freud, the well-known tale of *fort/da,* found in *Beyond the Pleasure Principle* (1920) (Freud 1957, vol. 18, 3–64).

18. Watkins 1997, 5, 13.

19. Ibid. See the annotated bibliography by Katherine Crawford Luber in Watkins 1997.

20. Ibid., 91.

21. Ibid., 7; "I give to each of my dear daughters, to be theirs, to wit, Marguerite, Carthusian, and Louise, Sint-Truiden, a picture wherein Saint Francis in portraiture from the hand of Master van Eyck, and make the condition that in the shutters of the same little pictures be made my likeness, and that of my wife, as well as can be made" (4) (note confusion between singular and plural).

22. Ibid., 39.

23. Derrida 1987.

24. Ibid., 260.

25. Heidegger 1971.

26. Bruns 1994, 374.

27. Heidegger 1971, 36.

28. Ibid., 33–34.

29. Ibid., 34. For a provocative discussion of this whole episode, see Walker 1980.

30. Heidegger 1971, 40.

31. Schapiro 1968, 206.

32. Ibid., 206, 208.

33. Derrida 1987, 313.

34. Ibid., 318, 261.

35. Ibid., 353.

36. Ibid., 359.

37. Ibid., 357.

38. Most of this list of questions is provided by Payne (1992, 91).

39. Derrida 1987, 265.

40. Ibid., 262–63.

41. Barthes (1977, 147) once characterized these two axes of interpretation so as to favor the metaphor of interpretive skimming: "In the multiplicity of writing, everything is to be *disentangled*, nothing *deciphered;* the structure can be followed, run (like the thread of a stocking) at every point and at every level, but there is nothing beneath: the space of writing is to be ranged over, not pierced."

42. Norris, 1990, 19.

43. Derrida, in Brunette and Wills 1994, 17.

44. Kant 1952.

45. The sublime can only be found in nature, but that is not to say that it does not serve as "something like a cornerstone for the claim to aesthetic judgement in the beautiful" (Ferguson 1992, 30).

46. Sec. 15, "Analytic of the Beautiful," in Kant 1952, 71.

47. Kemal 1997, 31.

48. Guyer 1997, xvii. As Kemal points out, an "object cannot be considered both beautiful and a work of fine art. If we recognized it as a work of art, we would apply a concept to identify the end and so make an aesthetic judgement impossible." Yet "Kant can speak coherently of objects as both beautiful *and* art" (Kemal 1986, 36–37).

49. To cite Pensky (1993, 22) again: "Melancholia is a discourse about the necessity and impossibility of the discovery and possession of 'objective' meaning by the subjective investigator."

50. See Stewart 1993.
51. Stamelman 1990, 7, 9, 31.
52. Panofsky 1971, 168.
53. As quoted in Schor 1996, 2, from Freud 1963, 165.
54. Freud 1963.
55. Benjamin [1916] 1925, 223, 139–40.

References

Barthes, Roland. 1977. "The Death of the Author." In *Image, Music, Text*, ed. and trans. Stephen Heath, 142–48. New York: Hill and Wang.
Benjamin, Walter. [1916] 1925. *The Origin of German Tragic Drama*. Trans. John Osborne. London.
Bollas, Christopher. 1987. *The Shadow of the Object: Psychoanalysis of the Unthought Known*. New York: Columbia University Press.
Brown, David Alan. 1979. *Berenson and the Connoisseurship of Italian Painting: A Handbook to the Exhibition*. National Gallery of Art.
Brunette, Peter, and David Wills, eds. 1994. "The Spatial Arts: An Interview with Jacques Derrida." In *Deconstruction and the Visual Arts: Art, Media, Architecture*. New York: Cambridge University Press.
Bruns, Gerald. 1994. "Martin Heidegger." *The Johns Hopkins Guide to Literary Theory and Criticism*. Baltimore: Johns Hopkins University Press.
Derrida, Jacques. 1987. *The Truth in Painting*. Trans. Geoff Bennington and Ian McLeod. Chicago: University of Chicago Press. Originally published in 1978 as *La vérité en peinture* (Paris: Flammarion).
Dru, Alexander, ed. and trans. 1955. *The Letters of Jacob Burckhardt*. New York: Pantheon Books.
Ferguson, Frances. 1992. *Solitude and the Sublime: Romanticism and the Aesthetics of Individuation*. New York: Routledge.
Freedberg, S. J. 1989. "Berenson, Connoisseurship, and the History of Art." *New Criterion* 7 (February).
Freud, Sigmund. 1957. "Mourning and Melancholia." In *The Standard Edition of the Complete Psychological Works of Sigmund Freud*, ed. and trans. James Strachey. London: Hogarth Press.
———. 1963. "Mourning and Melancholia." In *General Psychological Theory: Papers on Metapsychology*. New York.
Ginzburg, Carlo. 1980. "Morelli, Freud, and Sherlock Holmes: Clues and Scientific Method." *History Workshop* 9: 5–36.
Guyer, Paul. 1997. *Kant and the Claims of Taste*. 2d ed. New York: Cambridge University Press.
Heidegger, Martin. 1971. "The Origin of the Work of Art." In *Poetry, Language, Thought*, trans. Albert Hofstadter. New York: Harper and Row. Originally published in 1950 as "Der Ursprung des Kunstwerkes," in *Holzwege* (Frankfurt-am-Main: Vittorio Klosterman).
Holly, Michael Ann. 1996. *Past Looking*. Ithaca: Cornell University Press.
Kant, I. 1952. *The Critique of Judgement*. Trans. James Creed Meredith. Oxford: Clarendon Press.

Kemal, Salim. 1986. *Kant and Fine Art: An Essay on Kant and the Philosophy of Fine Art and Culture.* Oxford: Clarendon Press.

———. 1997. *Kant's Aesthetic Theory: An Introduction.* 2d ed. New York: St. Martin's Press.

Klein, Melanie. 1987. "Mourning and Its Relation to Manic-Depressive States." In *The Selected Melanie Klein,* ed. Juliet Mitchell, 147–74. New York: Free Press.

Kristeva, Julia. 1989. *Black Sun: Depression and Melancholia.* Trans. Leon Roudiez. New York: Columbia University Press.

Norris, Christopher. 1990. *Deconstruction: Theory and Practice.* Rev. ed. New York: Routledge.

Panofsky, Erwin. 1955. "The History of Art as a Humanistic Discipline." In *Meaning in the Visual Arts,* 4–25. Garden City, N.Y.: Doubleday.

———. 1971. *The Life and Art of Albrecht Dürer.* 4th ed. Princeton: Princeton University Press.

Payne, Michael. 1992. "Derrida, Heidegger, and Van Gogh's 'Old Shoes.'" *Textual Practice* 6 (spring): 87–100.

Pensky, Max. 1993. *Melancholy Dialectics: Walter Benjamin and the Play of Mourning.* Amherst: University of Massachusetts Press.

Schapiro, Meyer. 1968. "The Still Life as a Personal Object: A Note on Heidegger and van Gogh." In *The Reach of Mind: Essays in Memory of Kurt Goldstein,* ed. Marianne L. Simmel, 203–29. New York: Springer.

———. 1994. "Mr. Berenson's Values." In *Theory and Philosophy of Art: Style, Artist, and Society: Selected Papers,* 200–226. New York: George Braziller.

Schor, Naomi. 1996. *One Hundred Years of Melancholy: The Zaharoff Lecture for 1996.* Oxford: Clarendon Press.

Stamelman, Richard. 1990. *Lost beyond Telling: Representations of Death and Absence in Modern French Poetry.* Ithaca: Cornell University Press.

Stewart, Susan. 1993. *On Longing: Narratives of the Miniature, the Gigantic, the Souvenir, the Collection.* Durham: Duke University Press.

Walker, John A. 1980. "Art History versus Philosophy: The Enigma of the 'Old Shoes.'" *Block* 2: 14–23.

Watkins, Jane, ed. 1997. *Jan van Eyck: Two Paintings of Saint Francis Receiving the Stigmata.* Philadelphia: Philadelphia Museum of Art catalog.

White, Hayden. 1974. *Metahistory: The Historical Imagination in Nineteenth-Century Europe.* Baltimore: Johns Hopkins University Press.

Wollheim, Richard. 1973. "Giovanni Morelli and the Origins of Scientific Connoisseurship." In *On Art and the Mind: Essays and Lectures.* London: Allen Lane.

CHAPTER EIGHT

A Guide to Interpretation: Art Historical Hermeneutics

Oskar Bätschmann

Translated by Ton Brouwers

Clarifications

Art historical hermeneutics concerns itself with the well-founded interpretation of visual artworks.

Thus I have defined three aspects: (1) Art historical hermeneutics deals with the same object as art history, while it also contributes to changes in the definition of its object. (2) Interpretation is based on the application of a well-founded method that substantiates conclusions through critical argument. (3) Art historical hermeneutics, as an object-specific theory and method of interpretation, differs from general or philosophical hermeneutics: while the latter studies understanding and interpretation historically and systematically, art historical hermeneutics is geared toward understanding and interpreting specific objects. As such, it is related to philosophical hermeneutics in a critical way, its close relatives being other object-specific disciplines that are aimed at interpretation, such as literary hermeneutics or literary theory.[1]

Art historical hermeneutics comprises the theory of interpreting visual artworks, the development of methods of interpretation and their validity, and the praxis of interpretation.

A scholarly discipline that seeks to move beyond merely addressing studio practices and unexplained theories of copying and imitation cannot do without well-founded, verifiable procedures, which always remain open to scrutiny. Methodological reflection alone is not sufficient,

because methods are based on assumptions, object definitions, and scholarly objectives, which likewise require ongoing scrutiny. This is the focus of the theory of interpretation. Theories and methods cannot be developed, however, without taking into account the praxis of interpretation. This praxis does not simply supply the specific materials of reflection, nor does it merely entail the application of methods on the basis of theory. Rather, it involves the ongoing scrutiny of both theory and method. This concise "guide to interpretation" cannot address all the relevant issues. Based on a discussion of a specific example, its primary aim is to establish a critical link between method and praxis.

In the act of interpretation, we consider works of art as themselves.

The foregoing sentence is the most intricate one of this contribution. To consider a work as itself does not mean that we look at it in isolation, as in the earlier tradition of "work-immanent" interpretation. What I mean instead is that by interpreting a work of art, we do not view it as evidence of something else. It is important in this respect to distinguish between various scholarly concerns. It is possible, for instance, to consider a work of art primarily as a document of the artist's biography, intellectual history, or particular social conditions. In these cases we rely on the artwork—as well as on other documents—to address concerns associated with its more immediate or broader context. When Erwin Panofsky, in his iconology, considers artworks as symptoms of the general principles on which they are based and which can be deduced from the *habitus* (or the major political, religious, or philosophical tenets), he supplies a historical explanation, which in turn is construed on the basis of abduction and deduction.

An artwork's historical explanation is as important for the logical basis of interpretation as for the reconstruction of the work's historical and social context. However, interpretation is geared toward *not* enclosing the artwork in what we can explain. This is why interpretation focuses on what renders a work visible in terms of its materials, color, depiction, composition, content, or, put differently, in terms of the multiple relationships between the various aspects of form and content. Interpretation starts from the hypothesis of the open and revealing (productive) work of art and should provide a basis for this hypothesis by exploring the essential difference between, on the one hand, thought, *habitus,* and social conditions and, on the other hand, the work made of

stone, wood, or colors. Therefore, when I suggest that in the act of interpretation one considers the work as itself, I do not mean to propose the exclusion of contextual or historical explanation. The two concerns must be linked up with each other in the act of interpretation, and this precisely requires that they are identified as such, as separate concerns, rather than that they dissolve into each other. Even though concerns associated with an artwork's context or historical explanation provide answers to other questions than those associated with a work's interpretation, a work's interpretation requires such answers for generating interpretive ideas and establishing their logical basis. This need also underscores the fact that we do not consider a work as itself when we naively resort to our immediate experience of the work. Evidently, the ignorant gaze is as blind as the innocent eye.

Art historical interpretations are articulated in language; an interpretation is the linguistic product of the interpreting subject.

Interpretations are articulated in spoken or written language, but visual artworks are drawn, chiseled, cast, painted, built, or construed. Even though certain works may figure signatures and inscriptions, the alphabet does not count as a basic means of expression in visual art. We are nevertheless inclined to obscure the various means of expression used in visual art with a range of language-related metaphors: we speak of "reading" the image as if it were a text; we encounter expressions such as *architecture parlante* and *peinture parlante;* we refer to the "message" (Aussage) of an image as if it were the linguistic articulation of a specific situation; and we claim that an image does not "speak" to us when we feel unaffected by it, when it leaves us indifferent. Moreover, in a religious context, "speaking" images figured prominently, as in the case of the pax that said "Pacem meam do vobis" to believers, or the image of the Salvator Mundi that communicated the words "antonellus messaneus me pinxit" to the collector.

In relying on the metaphor of images that "speak" to us, a metaphor that in fact dates back to antiquity, we express our wish to decipher and hear the work's *kerygma,* the message it holds for us; or put more straightforwardly, we express our wish to experience its "call." This kind of metaphoric language, however, may confuse our speaking and writing about visual art. An artwork's interpretation is a scholarly product that is expressed in another medium than the work itself, is generated by

subjects other than the original maker of the work (except in cases of artistic self-interpretation), and assumes a certain historical distance from the original maker and the person who commissioned it, as well as from the function of the work (except in interpretations of contemporary art). A work of art is accessible to our gaze and experience through its physical presence.

Approaches

The understanding of an artwork is conditional on the interruption of the work's casual perception and everyday usage and begins in the acknowledgment of the work's incomprehensibility.

Our casual or perfunctory perception is limited to the acknowledgment that something is there, or that it exists as an unchanging object. This is how we generally perceive a monument or building. If, for instance, we are in Rome on the Corso Vittorio Emanuele and ask a passerby the way to a particular pizzeria, this person may well mention the Marco Minghetti monument or the Palazzo della Cancelleria as points of orientation, and most likely, we consider them accordingly, especially if we are hungry. In everyday life, art historians tend to relate to artworks in the same way as everyone else.[2] We interrupt our perfunctory gaze when we pause in front of a painting or building, and we ask ourselves who made it, or who commissioned it, what subject it expresses, what use was made of the building, and so forth. Perhaps we gather snippets of information from a museum guide or an art handbook, after which we absentmindedly go on looking for some new object to please our eyes.

It also happens, though, that we are looking at a work and that we experience its "call," or that we are struck by its mystery or incomprehensibility. It may be either such a call or our incomprehension—our *Unverständnis*—that prompts us to engage in the act of interpretation. We can describe the interpretation of a visual artwork in general terms as the act by which we seek to do away with our incomprehension. We should make a distinction between a work's call, which is geared toward understanding (Verstehen), and other calls for our attention that seek to influence our conduct, as, for example, a poster that tries to lure us into buying a certain brand of beer. I also believe we have to make a distinction between the understanding of works of visual art and under-

standing derived from reading a text. Klaus Weimar has suggested that understanding on the basis of reading, which involves a continuous dynamic of anticipating new sentences and returning to previous sentences, depends on a "mental reflex": the understanding that follows from reading cannot be willingly suppressed, or otherwise one simply stops reading.[3] In contrast, one can look at a visual artwork without engaging in the act of understanding.

Understanding and interpretation only become possible and necessary after the work has lost its original function.

As long as a work has a strictly defined practical, political, cultic, or representative function that determines its use, we do not refer to our dealings with it as "understanding" or "interpretation." In such a case, any form of incomprehension can simply be removed by demonstrating or learning the work's use. But understanding and interpretation can only be realized in situations where a distance between work and function has been established. In thirteenth- and fourteenth-century liturgy, for instance, a pax was used in the ritual of the kiss of peace. Its proper application by believers triggered emotions such as adoration or admiration, but not activities such as understanding or interpretation. These activities only become possible and necessary after the pax's cultic function has been superseded by its artistic value.

The same holds true for other functions of buildings or objects of crafts and design. A chair by Mario Botta in the Museum of Modern Art, for example, is cut off from its normal use by the exhibit platform and by the sign that prohibits one to sit on it. When for various historical or institutional reasons an object has lost its original function, several questions come to the fore: How was it made? Which ideas, rules, or models did the artist or maker rely on? What was the relationship between the form and the earlier function?[4] In other words, we are confronted with the interesting problem of the interrelationship of interpretation and artistic production. The two are not necessarily subjected to the various functions mentioned earlier. Artistic production requires knowledge of the rules associated with the making of an object that has a specific function, but the rules of its making do not correspond to the rules of its function or use. In our interpretive effort, then, we are as much in need of knowledge of the particular rules and models associated with a work's production as we are of knowledge of its functions.

Interpretation begins in articulating our incomprehension (Unverständnis) as a series of questions.

We may begin to articulate our incomprehension by looking at a particular artwork, by describing it, or by reading about it. Generally, it is worthwhile to spend quite some time looking at a work of art and comparing it to others before turning to the relevant literature. This is not to suggest the importance of feigning ignorance, but the importance of training oneself to look carefully—of educating oneself in visual experience. Moreover, by looking at an image, we may discover a better angle for formulating the proper questions than by reading the relevant literature. The answers encountered in the literature are frequently so sophisticated that they altogether keep us from articulating our incomprehension in "silly" questions. If, however, for some reason it does not suit us well to start off with questions, we should begin with a description. Simply naming the persons or the facts that can be identified in the image, or taking in its colors and lines, may already encourage us to watch more carefully. This results in a basic grasp of the image—one that may be used for developing a concrete set of questions. By interrogating our initial understanding of the artwork, we objectify it, whereas the ensuing detachment generates opportunities for correcting our initial responses to the work. This is also a useful practice for developing the detachment we need from the understanding of others as found in the literature. Rather than drawing our description into the text of our interpretation, though, we should throw it away. After all, nothing is duller or more inappropriate than merely linking up description and interpretation. Interpretation should proceed not on the basis of a fixed model but according to the questions that were generated on the basis of the work to be interpreted. It is perfectly fine to develop an argument with the help of brief descriptive statements, for this implies that one adds a language of one's own to the work. We may avoid merely presenting a schematic description by writing down our questions. The articulation of one's incomprehension is not just an exercise for beginners. To paraphrase a sentence from Klaus Weimar: the talent and competence of art historians will grow in accordance with their ability to interrogate their own or some given basic understanding of a work of art in an objectified manner.

I would like to discuss and demonstrate this process on the basis of one specific painting. I believe it is more productive to discuss a single case in detail than to provide general advice. Although I selected a classic case, I do not want to leave the impression that this "guide to interpretation" is only useful for paintings from between 1500 and 1800. Sustained reflection on the interpretive process should enable one to develop the problems addressed in more detail or to apply the same principles to visual artworks from other times. Making minor methodical adjustments should be fairly easy in most cases, yet the application of this guide to other artistic genres (architecture, sculpture, arts and crafts, design) will require more substantial adjustments.

The information I supply about the image corresponds to what one commonly finds in a catalog entry: Nicolas Poussin, *Landscape with Pyramus and Thisbe*, 1651, oil on canvas, 192.5 x 273.5 cm, Frankfurt am Main, Städelsches Kunstinstitut (Figure 8.1).[5] The questions that enter our minds when we are looking at this painting may include the following: What are the depicted figures doing? Which landscape is depicted? What do the figures in the foreground have to do with the thunderstorm? Why does the painter show a struggle with a lion in the middle of the painting? Why are there two lightning flashes in the sky? What is the name of the city to the right of the painting's middle? How is the thunderstorm depicted? Why is the sky in the background to the left brightening? Why does the water in the middle of the image show a surface that is smooth as glass while everywhere else the effect of the strong wind is clearly visible? Why was the painter not consistent in this respect? With this list of questions, we have already generated more incomprehension about this painting than anyone has ever managed to produce before us.

The process of interpretation can be visualized as an indefinite surface.

In what follows, I illuminate the various stages of the interpretation process, but I do not provide a map that prescribes each of the individual steps and their consequences. The complex process involved I divide into analysis, creative abduction, and validation. Although I discuss the various relevant problems in a specific order, this is not to suggest that they can or should be addressed and solved in this order only. To underscore the complexity of the interpretation process, I include a

Figure 8.1. Nicolas Poussin, *Landscape with Pyramus and Thisbe*, 1651. Oil on canvas, 192.5 x 273.5 cm. Städelsches Kunstinstitut, Frankfurt am Main.

representation of an indefinite surface (Figure 8.2). This particular visualization suggests that the process of interpretation may start with any activity, go on in various directions, while its earlier stages may be reconsidered at any point. It is even crucial, I would submit, to return to the completed stages of the interpretation process repeatedly, or, in other words, to proceed in a recursive manner.

Analysis

The materials for the preliminary answers to our questions and for the development of further questions are generated through analysis, that is, by close examination and classification of works and elements thereof.

Proper analysis cannot be executed without studying the scholarly literature. Of course, we gather relevant information from bibliographies and journals, but we begin with reading the most recent literature on our topic. In this way, we do not first have to grapple with outdated views, which in most cases only have significance from a historical angle. For methodical reasons, since one cannot process everything at the same time, we focus our research on individual elements. Drawing up

Figure 8.2. The indefinite surface as a representation of the interpretation process.

lists with information on the iconographic type, the genre, or the style of the work reflects the view that one can determine a work's characteristic features only on the basis of distinctive comparison. Analysis functions primarily as a preparatory effort for creative abduction, which is why our analytic effort should aim for the articulation of further questions. I have selected a case that allows us to demonstrate as many steps of the interpretation process as possible. It has to be taken for granted that in each individual case the challenges and opportunities of analysis depend on the materials that can be located.

The commentary of artists about their work, if available, is taken into consideration.

With respect to *Landscape with Pyramus and Thisbe*, there is a detailed description by Poussin in a letter of 1651 to his colleague Jacques Stella in Paris:

> I have tried to represent a thunderstorm on earth. To the best of my knowledge and abilities I imitated the effects of an impetuous wind and an atmosphere that is permeated by darkness, rain, sheet lightning, and flashes of lightning that come down in various locations and cause chaos all around. All depicted figures have a role to play in accordance with the weather: some escape through clouds of dust toward the direction of the wind, which pushes them further still, but others stride against the wind, barely advancing, and cover their eyes with their hands. On one side a shepherd, hurrying away and leaving his flock behind, catches sight of a lion that has just knocked down a few ox-drivers and is busy attacking others. While several drivers are defending themselves, others stir up

their oxen and try to get away. Amidst this tumult the dust is rising in great swirls. At some distance a dog is barking, its hairs standing on end, but it does not dare to come closer. In the foreground of the image one sees Pyramus lying dead on the ground and near him Thisbe, who is devastated by sorrow.[6]

The commentary of artists on their work can enlighten us about the nature of artistic work, about the genesis of a particular work, or about its intentions or theme; it may tell us how artists viewed, evaluated, or interpreted their own work. Yet we should always try to ascertain what a specific artistic comment means and how, exactly, it relates to the work.

Poussin's description was written down after the painting was completed. His words address the artistic problem of faithful imitation, the true-to-nature rendering of a thunderstorm in particular. Furthermore, the description contains the names of the victims of misfortune in the foreground; it provides us with both the artistic and thematic intention. The detailed listing of the various effects of the thunderstorm invites us to look at the image once again: perhaps we can now discover among the thunderstorm's manifold effects the dust swirl at the nearby lakeshore in the painting's middle and between the houses along the lakeshore to the right. By mentioning the barking dog, Poussin identifies an element that we did not yet see or, for that matter, hear. Nothing is said in the description about the combination of the thunderstorm and love's misfortune. The remarks about the artistic problem and how it can be overcome reinforce the mystery of the quiet lake. We must ask why Poussin does not say anything about the combination of the thunderstorm and love's misfortune, and why he does not justify the fact that the lake is unaffected by the strong wind. It is not difficult to come up with swift answers and say that Poussin's letter underscores the intention of all-out imitation and therefore the rendering of the lake must reflect the observation of a fact of nature, while he added the lovers as a fitting motif for the thunderstorm landscape. Such answers, however, fall short, not so much because they are easy but because they shut off further analysis and reflection. We should keep in mind, of course, that there is a difference between painting and writing, image and text, artistic work and artistic self-interpretation.[7]

First, iconographic analysis elucidates whether an image refers to a specific text, and if so, which text; and second, it determines the relationship of the

image to the text as well as to similar kinds of representations of the same subject.

On the basis of a particular visual representation, it is impossible to reconstruct the text to which it refers: all we can do is *assign* a text to it. This requires (1) the establishment of a list of representations that are characterized by minimal similarities among the depicted figures and sufficient similarity among the acts, facts, and attributes depicted; and (2) the identification of the text to which the list is related by means of an inscription, the mentioning of proper names, or specific documents from the artist (or the person who commissioned the work). This kind of iconographic research has meanwhile covered most canonical artworks and resulted in extensive knowledge, which can be found in handbooks, lexicons, monographs, and case studies.

If the iconographic problem of the work at hand has not yet been solved, though, we are faced with a challenging task. How can we know whether the work refers to a particular text? How can we assign a text to this work? If we are lucky, we may trace an image that mentions a text, or at least the names of the figures in the painting, by putting together an iconographic list. This allows us to link up this *list* with a text. It remains an unsolved question, however, whether or not the work at hand refers to this particular text. Therefore we have to study both text and image for their unambiguously corresponding features or rely on some document from the artist that verifies his thematic intention.

In the case of *Landscape with Pyramus and Thisbe*, Poussin's letter provides an answer to our first question. The determination of the text is made easier by literary or iconographic lexicons, which direct us to the *Metamorphoses*, written by the Roman poet Ovid. In book 4, verses 43–166, we find the story of Pyramus and Thisbe of Babylon. The story tells us not only about the misfortune of the two lovers, who on the night of their escape meet with death after a series of chance accidents and wrong decisions, but also about the transformation of the mulberry fruit, the color of which changes from white to black by the blood of Pyramus. The *Metamorphoses* first introduced this Babylonian love tragedy in Europe.

Did Poussin base his work on Ovid, or did he merely follow a visual model? To answer this question, we have to take into consideration our iconographic list and explore the text and the image for their corre-

sponding features. The outcome is that in illustrations, drawings, and paintings of this particular subject that were made before Poussin, each time the final moment of the tragedy is represented, the one in which Thisbe stabs herself with a sword in the presence of Pyramus's dead body. Moreover, we discover, many representations mock the couple's fate as a case of love's folly, while there is only one nightly landscape with this motif, by Niklaus Manuel Deutsch from 1513 or 1514 (Figure 8.3), and but a single illustration of Thisbe's escape from the lioness. The tragic moment selected by Poussin, the one in which Thisbe recognizes her dying lover, is not found in other visual representations, but it is found in Ovid, who describes the tragic turn of events in great detail (verses 128–49). The poet, however, does not say anything about a thunderstorm, nor does he evoke the scene of the struggle with the lioness or that of fleeing shepherds and their flocks. On his part, the painter ignores the mulberry motif and the description of the location.

Poussin's departure from the pictorial tradition and the choice of another scene we interpret as indications of his having read Ovid. But we do not know why the painter with respect to location and time deviated from the text, nor why he introduced scenes in his composition that are absent in the text. An iconographic analysis may solve these problems, which we may articulate as new questions: (1) Are there any explanations for Poussin's departure from both the pictorial tradition and Ovid's text? (2) Are there any texts by other authors on this same subject? (3) Are there any other connections between image and text involved that we did not notice because our attention was solely geared toward the identification of the depicted scenes and objects? (4) Is it possible to explain Poussin's deviations by considering either the person who commissioned the work or the specific location for which the painting was made?

An analysis of the work's genre, in connection with an examination of its style and mode (its stylistic level), determines the image's general historical level; a distinctive comparison with other works from the same artist determines the particular place of the image in the artist's oeuvre.

Previously, one sought to compensate for the one-sidedness of iconographic analysis by combining it with stylistic analysis. I believe, however, that a combined analysis of a work's style, mode, and genre is preferable. If iconographic analysis of motifs provides too small a basis for

Figure 8.3. Niklaus Manuel Deutsch, *Pyramus and Thisbe,* 1513–1514. Distemper on canvas, 151.5 x 161 cm. Öffentliche Kunstsammlung, Basel.

interpretation, a classification of relevant pictorial genres already widens it. A systematic inventory of the depicted scenes or objects found in individual artworks allows us to identify genres such as history, allegory, portrait, landscape, still life, and so on. Style refers both to the sum total of the general formal characteristics of a representation and to the individual patterns of its representational form. Similarly, the mode or style level (for instance, the general tone) refers to the general rules of expression and to the individual repertoire of expression. The rules of genre, of the various aspects associated with form and content, are determined historically and geographically. By investigating these various rules, we study the historical level of the pictorial representation within a limited scope. Evidently, in our analysis of a specific work, we also draw on contemporary theories of genre, style, and mode.

This kind of analysis requires great effort. We may rely on the countless diachronic and synchronic studies of genre and style and on the few

studies about the general tone. For those who consider this investment too high for a single image, I should point out that strictly speaking, it is impossible to interpret a single work. Without a reconstruction of the historical levels of representation, we cannot establish the place of a particular image in the history of art, nor can we say anything about the relationship between invention and imitation or formal pattern and originality, or about the particular nature of meaning and representation. This is why we cannot yet engage in a reconstruction of the historical level. Instead we should try to determine the relationship between the general rules and the individual artistic patterns of representation.

In the case of Poussin's image, we will first consider the tradition of Roman landscape painting. By studying its patterns of composition and mimetic representation, we may discover that we have to do with an *ideal* (that is, a composed) landscape, rather than a topographic depiction. Furthermore, we find out that this particular type of composed landscape, comprising historical or mythological scenes and ancient buildings, was called a *heroic* landscape. Poussin's image also belongs to the specific genre of so-called thunderstorm landscapes, which gives us reason to extend our distinctive comparison to include thunderstorm images from painters that go back as far as Giorgione and also from painters outside the Roman circle such as, for instance, Rubens. Thus we are able to establish that Poussin in *Landscape with Pyramus and Thisbe*—in contrast to other thunderstorm representations, including his first thunderstorm image, the *Storm* of 1651—"disrupts" the symmetrical composition by the diagonal movement of the thunderstorm, the direction of both light and wind, and the sprinkled color splotches. The gloominess of the colors, the *contre jour,* and the paleness of the large lightning flash create an atmosphere of disaster that accompanies the ominous disruption of the ideal order.

By studying the relevant genre theory, we discover that Leonardo da Vinci left instructions on how to represent a thunderstorm. Poussin's illustration of the copy of Leonardo's treatise was commissioned by Cassiano dal Pozzo, the same person who ordered the painting of Pyramus and Thisbe. The first edition of Leonardo's *Trattato della pittura* came out in 1651. Poussin used one of the images in his illustrations for the book also in his Thisbe painting.[8] When we look at the first edition, we notice that Leonardo's instructions are found under the heading "Come si deve figurar' una 'fortuna'" [How one should represent a thunder-

storm]. "Fortuna," however, does not only mean storm and thunder but also means luck, chance, destiny, and misfortune. This particular knowledge may give rise to the idea that thunderstorm and love's misfortune come together in "fortuna" in a double sense. Poussin, then, may have interpreted Leonardo's theoretical suggestion in practical terms, extending it to achieve this ambiguity. If we consider this to be the case, we will be even more bothered by the striking gap in Poussin's true-to-nature rendering in the Thisbe painting, namely, the lake with the glasslike surface in the middle of turmoil, as this precisely contradicts the first sentence of Leonardo's instruction. Significantly, the *Storm*, Poussin's other thunderstorm landscape from 1651, does not contain such mimetic disparity, while at the same time it refrains from developing a double meaning and agrees very well with an instruction from Leonardo found in another copy.

When we consider a genre that is directly linked up with particular texts, our analysis should include—in addition to genre theory and the relevant pictorial tradition—the history of the work's cultural reception.

In our iconographic analysis, we were content with studying the artwork's motif and tracing the text to which its image refers. This, however, is not enough in this particular case. After all, Ovid's *Metamorphoses* has had a broad influence, not only in the visual culture of the West but also in its literary and musical culture.

If we extend our investigations to the genre of the mythological image, we will come across Guercino's *Venus and Adonis* from 1647 (Figure 8.4). The similarity between Poussin's representation of Pyramus and Thisbe and Guercino's representation of Venus, who finds her dead lover Adonis, gives one the impression that Poussin developed his new representation of the couple on the basis of Guercino's image. The question is, what do we do with this possibility? A comparison of iconographic forms or developments is interesting here, since it broadens our view of artistic invention beyond the boundaries of our specific research project. Poussin's choice to depict love's misfortune in a lofty manner makes it impossible for us to consider the fate of Pyramus and Thisbe as a case of love's folly. This in turn suggests to us the view that what is at stake here is a fate to which even the love of the gods was subordinate.

This matter will keep floating in the air, however, if not argued better, and to do so, we should consider the relevance of the history of literary

Figure 8.4. Guercino, *Venus and Adonis,* 1647. Destroyed; formerly Staatliche Kunstsammlungen, Dresden.

influence, if only by consulting literary lexicons or surveys of individual motifs.[9] This will supply us with information about the spread of Ovid's *Metamorphoses* in the sixteenth and seventeenth centuries and about the ways in which the subject of Pyramus and Thisbe was used in tragic, comic, and moralist reworkings. Around 1595, Shakespeare, for one, wrote a tragedy on the basis of a variation *(Romeo and Juliet),* as well as a jocular play *(A Midsummer Night's Dream).* During the same period, in Spain, Cervantes and Góngora parodied this subject matter, while in France, between 1625 and 1671, a tragedy on this subject by Théophile de Viau was a great success. Moreover, various authors of contemporary moralist commentaries on Ovid tried to establish the mistakes and guilt of the two lovers and their parents.

One needs a detective's instinct, the ability to piece together information, and help from others to know where information derived from the literature should be replaced by one's own careful reading of the relevant materials. For example, it is more likely that Poussin knew the French

tragedy than the Spanish reworkings or the performances of English theater companies. Moreover, our genre analysis and the preference of the gods on whom to bestow their love do not point in the direction of a parodic view, and our iconographic analysis resulted in the rejection of the model of love's folly. It appears more productive, then, to start with a reading of Théophile de Viau's tragedy than with the comedies. Rather than by relying on help and instructions, our chances are best guarded by doing a careful reading of the actual materials. Only then will we discover that de Viau's tragedy also contains the sequence of thunderstorm and love's misfortune. Of course, we will familiarize ourselves with the wider context of de Viau's tragedy so as to confirm that this particular combination is found only in his play, which establishes the likelihood that Poussin, who exposes Pyramus and Thisbe to a thunderstorm, based himself on this particular tragedy. It speaks for itself that we should explore other motifs as well. For example, there is another uncommon motif in de Viau's tragedy whereby a scheme involving a prince explains the cause of love's misfortune, thus linking up the lovers' unfavorable *fortuna* with contemporary political actualities.[10]

The visual and literary references of an image follow from iconographic analysis, genre analyses, and study of the scholarly literature.

The study of the scholarly literature is mentioned once again for obvious reasons: it may contain findings we would not have thought of on our own. Anthony Blunt, for instance, identified the striking building to the left in the back, behind the lake, as a Bacchus temple after a design by Andrea Palladio (Figure 8.5).[11] It is the only identified building in the painting. As always, we will have to ask ourselves whether this reference should be understood in terms of its formal (stylistic) value or also in terms of its meaning.

The notion of visual and literary references replaces the commonly used notion of "sources," and this requires a brief explanation. The traditional notion of sources suggests that a new work is based on given models, much the same way a brook is fed by its sources. Accordingly, the relationship between a new work of art and earlier works is called "influence." This way of conceptualizing the relationship between a new work and earlier works, based as it is on a single image or concept, prevents us from investigating their proper interaction. Generally, such interaction can only be studied when the genesis of the visual image is

Figure 8.5. Andrea Palladio, Bacchus temple. Woodcut. In *Quattro libri dell'architettura* (Venice, 1570), 86.

sufficiently documented by sketches, designs, and preliminary studies. Where these materials are available, one can frequently observe that artists select and insert existing motifs only during a later stage of their work on a particular painting. Thus the new work does not so much emerge as the outcome of a passive "confluence" but functions as an active center in which particular visual or literary motifs are evoked in a constructive manner. Regarding works that came into being after artistic invention became viewed as a positive value, this seems a more appropriate way of conceptualizing this issue, except in cases where motifs are simply repeated.

How does one move from a work's various analyses to identifying its visual or literary references? There are two ways: by exploring similarities and correspondences, and by exploring the possibility whether the artist in the case could have been familiar with other particular works. Despite some similarities between Poussin's painting and a painting such as *Pyramus and Thisbe* by Niklaus Manuel Deutsch from 1513 or 1514 (Figure 8.3), it is out of the question that Poussin used it as a reference. We know that Deutsch's painting has been in Basel since at least 1586;

we know that Poussin never traveled to that city; and we know that there were no engravings of this painting. Although the illustrations in editions of Ovid and the engravings and etchings by Lucas van Leyden and Antonio Tempesta are possibly relevant here, they can be ruled out as visual references because we are unable to establish any formal correspondences. How, then, should we analyze the references in Poussin's painting? We may consider them as elements that determine the invention, but also as elements that establish particular connections between form and content and as such potentially acquire the function of semantic units in the image.

To provide a historical explanation of the visual and literary references, as well as an explanation of the function of the image, the person who commissioned the work is taken into consideration.

An explanation is an answer to the question: why is this the case? It consists of a logical derivation of the *explanandum* (that which is to be explained) from the *explanans* (that which explains something). In historical explanations, the rules of a historical connection and the motives for a specific connection together make up the *explanans*. Whether it is possible to provide an explanation that is associated with the commission of the work or the motives of the person who commissioned it depends on the available information about such motives and about the relationship between the artist and the person who commissioned the work, as well as on the function of the work. In our case, the most important Roman friend and collector of Poussin, Cassiano dal Pozzo, is the person who commissioned the work. Information is available about his early life, his collection of drawings of antiquities, and his interest in Leonardo and mythology, but little precise information is known about his many and frequent contacts with scientists. So far, we do not know of a document in which Poussin is given the assignment to make a painting called *Landscape with Pyramus and Thisbe*. It is imaginable that the commission involved the painting of a second thunderstorm landscape, one in competition with Leonardo's instructions but without the everyday scene of the fallen oxen. Because of the exceptional size of the image and because of the connection with Leonardo, we have to consider the idea of Cassiano dal Pozzo merely being the buyer of a finished painting an unlikely one. We have reason to assume, then, that the work was

specifically made for the collector. This is, of course, a conjecture, but it is one that we may turn into a fact if we can lay our hands on the relevant documents.

Artistic invention can be described by analyzing the relevant artistic statements, the visual and literary references, the patterns and rules of the genre, the genesis of the work, and, if applicable, its function.

The description of a painting's invention may be a product of the analytic method as presented in this section of the "guide," but like iconographic analysis or genre analysis, it may also be a separate objective of scholarly work. Determining an artwork's invention is a major step in the interpretation process, because it allows us to recognize what artists reveal in their work in a new way and what procedures they rely on. Invention involves the choice of certain references, the rejection or adoption of genre rules and patterns, the combination of motifs or composition schemes, the spatial arrangement of figures and objects (buildings, objects of nature), and the arrangement of colors and shapes. The analysis of an artwork's genesis allows us to identify the stages in which the work came into being. Obviously, invention and its significance as part of the artistic effort change over time. Art theory includes various models about the significance and dimension of the invention process. What we borrow from art theory is the general framework for the articulation of individual artistic invention efforts.

Creative Abduction: Conjectures of Meaning

Conjectures (well-founded speculations) about the possible meaning of the image are articulated by means of creative abduction, that is, by establishing relationships between the image's various objects and elements.

It proved impossible to put the foregoing sentence in more simple terms. This may arise from the fact that the discipline of art history—despite its constant deployment of assumptions and abductions—basically lacks an analytic framework for its conjectural procedures. It is this absence that might give one the impression of being seduced to enter a domain that lies outside of art history. We are familiar with abductions, and with at least one type very familiar, because the practice of art history largely consists of formulating hypotheses about a specific fact that

is considered to be the outcome of other facts. Classic examples are hypotheses about common models (which today are no longer known), individualization on the basis of stylistic analysis (Morelli's procedure), Panofsky's iconology, and the historiography of art. To be sure, there is no science—and this includes the scholarship produced in the humanities—that operates without abduction.

The most common type of abduction should be employed in a conscious way, but the possibilities of another type ought to be explored as well. This second type of creative abduction starts from a number of facts and is aimed at the formulation of a hypothesis about their interrelationship (a coherent rule, a coherent meaning). An example of this second type of creative abduction is the heliocentric theory of Copernicus.[12] Conjectures about the meaning of a work also belong to this second category. Once we notice art history's conjectural approach, we should no longer have any reason to be afraid of developing ideas into conjectures about a work's meaning. It is not possible to accuse anyone of subjectivity or overinterpretation because it is essential to formulate and subsequently verify one or more hypotheses about a work's meaning (just as Copernicus's theory had to be tested). What matters, therefore, is not the fear of too much subjectivity but the insight that without subjects there is no science and that hence subjectivity should be qualified rather than denied. After all, what is left for us to do when we, overly anxious about possible objections, no longer dare to rely on our intellect, intuition, and imagination when it comes to substantiating our hypotheses?

The hypothesis of coherency among facts is a text, that is, a linguistic interconnection.

Hereafter I discuss a simple example of such a linguistic interconnection for three reasons: to show that creative abduction may involve a simple process; to demonstrate that our hypothesis may well contradict the words of the painter without also contradicting the image; and to suggest that we may gather new ideas by reading critically. I quote from a text that the scholar Giovan Pietro Bellori, an acquaintance of Poussin and his first biographer, published in 1672:

> With open arms Thisbe throws herself upon the body of her beloved Pyramus and in utter despair she also descends into death, while the

earth and the sky and everything else spew up fear and disaster. A storm wind is building, shaking and snapping the trees. From the clouds one hears the roar of thunder, and the flash of lightning cuts off the largest branch of a trunk. Amidst the dark cloud cover a terrible lightning flash illuminates a castle, and across a mountain pass a few houses light up. Not far off the wind brings in impetuous rain, shepherds and their flocks flee and look for shelter, while one on his horse does his utmost to drive his cattle toward the castle in an attempt to escape from the thunderstorm and find a dry place. In a horrific scene a lion, which emerged from the woods, tears apart a horse that with its rider fell to the ground, while the rider's companion hits the wild animal with a cudgel; it is this lion that has caused the deaths of the misfortunate lovers.[13]

Bellori's text is a conjecture about the meaning of the work for two reasons: he establishes a narrative coherence between the lion as cause and love's misfortune as effect, and he describes the horrible phenomena of nature as expressions of that tragic event. Poussin's text, however, as the *sequence* of the sentences suggests, appears to establish another coherency: the case of love's misfortune that is mentioned at the end seems to complete the effects of the thunderstorm. If we disregard our set of questions for a moment and carefully look at the painting once again, we may determine whether the image offers clues for either one of the two proposed coherencies. We may notice, for instance, that the shape and direction of the large flash of lightning correspond quite well with the lowered silhouette and direction of the body of Thisbe. This observation, however, can be accounted for by the coherencies that are assumed in both hypotheses. Since the other problems we analyzed remain unaddressed, we might decide to develop one of the hypotheses, if not both, into a direction suggested by these problems. For now, I let this matter rest and turn to another conjecture.

A further conjecture may follow from the establishment of a link between the artistic invention process and the unsolved problems.

Without ignoring the fact that it is we who construe this particular link between invention and unsolved problems, it depends on the quality of our examination whether we find reason to accept or reject it. There is no other way to arrive at ideas about a specific coherency than through analytical effort, the development of questions, and the recurrent going back to the image. Nor is it possible to predict if or when the spark is produced.

One idea worth exploring might be the following: there is perhaps a connection between our *nightmare,* the smooth surface of the lake, and the single identifiable building on its shore, the Bacchus temple. How can we develop this idea into a hypothesis? We should investigate mythology and painting for connections between Bacchus and glasslike lakes. This means that once again we undertake a search for literature and images. In the literature on mythology, we will discover the existence of the Bacchus or Dionysus mirror, which the Neoplatonists of antiquity thought displayed the entire world in all its multiple dimensions and everything that has ever occurred; as such, they believed, it explained why souls got lost in the turmoil and the tempting chaos of matter.[14] It is obvious that we can only use this for developing our conjecture because the painting represents a mirrorlike lake and *also* a Bacchus temple: it does so in such a way that the mirror effect in the middle of the turmoil of the elements *cannot* be understood as a natural phenomenon (as, for instance, in the landscape image *The Rest*).

Several ways of further pursuing this issue present themselves. For example, the two lightning flashes could be seen as another reference to Bacchus and his father, Jupiter: the mother of Bacchus died in the castle of Thebes when Jupiter had to be with her as if she were his wife, namely, during the thunderstorm, even though Jupiter did not take the large flash but the smaller, second flash. When we consider a contemporary illustration that shows the death of Semele and the birth of Bacchus (Figure 8.6), we may draw the castle—hit by the smaller lightning flash in Poussin's image—into our hypothesis. Only now do we identify in another of Poussin's paintings a Bacchus mirror as well, and only now, after rereading Ovid, do we realize that the first time we altogether failed to see any connection between Bacchus and the story of love's misfortune, largely because we were preoccupied with taking stock of the various elements in the image. We may conclude that the story of Pyramus and Thisbe interlocks with the story of Bacchus, specifically his birth, his behavior, and his powerful influence (books 3 and 4).

Is there a way to link this information with love's misfortune? Not without a further hypothesis. Contrary to tradition, the painting depicts the tragic turn from fortune to misfortune in which Thisbe recognizes her dying lover. Bacchus is the master of both tragedy and satire, of both orgiastic pleasure and the fall from fortune into misfortune. We should add that the lightning sky reflects not only the fall from clarity

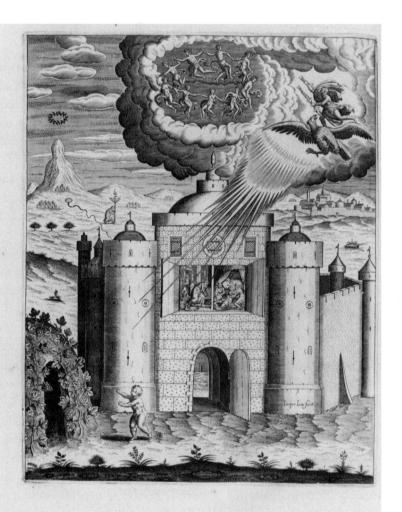

Figure 8.6. *The Death of Semele and the Birth of Bacchus.* Etching. In Blaise de Vigenère, ed., *Les images de philostrate* (Paris, 1629), 108.

to darkness (a metamorphosis that is similar to that of the fruits of the mulberry) but also the reverse change.

In this way we have ended up with a conjectural meaning of the painting—one that is based on many facts, but not all facts, and for this reason alone, we must suspect that other abductions are equally possible. The pleasure about the text we have generated on our own is substantial for the following reason in particular: it is impossible to imagine how someone else could come up with another text. We perhaps gladly ignore that some elements, such as the lion's attack or the *fortuna* in both senses (as thunderstorm and fortune/misfortune), have not yet been included into our interpretation. Furthermore, although we discovered that Théophile de Viau's tragedy provides the important motif of the connection of thunderstorm and love's misfortune, the question about the political cause of misfortune, posed by the tragedy, is not yet answered. Much to our advantage, though, another scholar proposed to view some of these elements as effects of *fortuna,* specifically in the thunderstorm, the animal attacks, and the adverse wind Thisbe has to face. A statement by the painter from 1648, saying that he wanted to represent the effects of the blind and mad *fortuna,* provides support for this view.[15] The confrontation of our conjecture with this scholar's conjecture helps us to make a first step in the objectification process in which we have to ask ourselves whether the two conjectures exclude or complement each other—whether we must reject our conjecture, adopt the other one, or develop a third one.

Each conjecture implies hypotheses about the method of representation and is completed by reflection on these hypotheses.

This statement means that a conjecture should be developed in such a way that it may be checked in part by looking at the work. Poussin's conjecture suggests the complete visibility of thunderstorm, effects, and misfortune; Bellori hears things that are invisible in what is visible, namely, the roar of the thunder. Poussin mentions the barking dog. The two conjectures about *fortuna* and the Jupiter-Bacchus relationship suggest that the visible order, via specific signs, leads to the (paradoxical) presence of the invisible and that the two lists of the visible and invisible are connected on the basis of their interaction. It is our hypothesis, then, that Poussin's image links up the visible and the invisible, as may be schematically represented as follows:

I	II	III	IV
nature	interaction	myth	moral standards
thunderstorm	cause	Jupiter	
chaos	peripeteia	Bacchus	fortuna
misfortune	effect	Pyramus and Thisbe	

I shall add no further comments. One can see immediately that this diagram comprises all conjectures, with the exception of the one by Bellori, and that it applies to the nature of representation.

Validation: Sealing the Argument

Validation, that is, the sealing of the meaning through argument, completes the interpretation so that it may be considered as correct.

An interpretation is complete and correct when in methodical terms it is properly developed and sealed by argument. There may be several correct interpretations of a work, none of which is a refutation of another. The incorrectness of an interpretation can only be demonstrated by the identification of methodical error. When the argumentative sealing of the work's meaning is absent, that is, when the interpretation process is not properly completed, the conjecture does not go beyond being merely an opinion. Validation is not geared toward articulating the work's meaning as "objective" meaning, nor does it seek to trace an authority that can confirm the conclusion.

Where possible, the established meaning is examined in terms of whether the artist could support it.

If the artist is still alive, we confront him with our interpretation and ask him whether he feels some element in it to be misguided. We should not ask the artist whether the meaning corresponds to his intention, so as to avoid the risk that he knows more about the relationship between intention and artistic work, or that he read Wittgenstein more closely than we did and that he replies, saying: How should I know, for I too have but the image at my disposal?[16] If the artist is no longer alive and we established the meaning through analysis and creative abduction, it is hard to carry out this examination because we have already taken

into account the artist's statements and biography and there is no other way of reconstructing the artist's point of view. This examination can only consist of explicitly comparing meaning and biography, or artistic statements and the artist's oeuvre, so as to trace discrepancies rather than confirmations.

A comparative consideration of relevant works should prove whether the established method of representation is historically and individually possible at all, meaning that it agrees with specific rules.

The materials for this examination have already been developed to some extent as part of the genre analysis, where a preliminary explanation for the particular rules of artistic creation was provided as well. At this point we attempt to determine not the historical rules of genre or the individual artist's rules of artistic work but the historical and individual rules of representation: what can images from seventeenth-century Rome reveal about Poussin, and how do we furnish them as evidence? This task is anything but easy: the determination of the rules of representation would require a systematic and historical analysis of the specific visual tradition involved. In our case, we should restrict our effort to establishing whether we can find with the same painter (or among his contemporaries or those he used as an example) similar connections between the visible and the invisible, a similar reaching out to what cannot be represented, such as sounds and noises, and an analogous game of showing and hiding. By carefully analyzing Poussin's second self-portrait of 1650, we have made a good start in sealing the argument about the meaning we established for *Landscape with Pyramus and Thisbe.*

A work's function and meaning are examined for their compatibility or incompatibility.

The function of a work can be determined by considering its commission, its first location, and its use. The relationship between form, function, and content is subject to examination.[17] In the case of Poussin's image, the aesthetic function (art as function of the work) is sufficiently warranted by the general historical rule, by the inclusion of the painting in the collection of a scholar, and by the fact that it was most likely commissioned. What, however, is the proper function of art? In his description, Bellori mentioned the emotional effect; Poussin described his

art of complete imitation; and our interpretation established a link be-
tween imitation, the sign of the hidden gods, and the visualization of
how *fortuna* operates. The question whether this is compatible with the
historical function of art we solve with reference to the biography of the
artist, his statements, the biography of the person who commissioned
the work, the exploration of art theory (notably theories of reception
and their spread), and the exploration of the actual usage of art. I give
only two clues: the literature on art has frequently expressed the view
that art aims to *delectare, docere,* and *movere* (to give pleasure, instruct,
and move). It might be worthwhile to examine whether the artist of the
work and the person who commissioned it shared this view.

The second clue I derive from a remark by Poussin. In 1648 he wrote
that his planned images about the mad power of *fortuna* were meant to
remind people of wisdom and virtue and to encourage them to be stead-
fast.[18] This is a reference to the cognitive, emotional, and moralist func-
tion: the realization, shattering, and stoic hardening of character. We have
reason to suspect, then, that in our case, function and meaning are joined
together. A contradiction between function and meaning would dis-
qualify the function as argument, but if we can provide support for the
established meaning through other arguments, it is not contradicted by
the function. With respect to function, we should ask if we can account
for the fact that, at that particular time in history, the painter enriched
the function with the images he created or with those that the person
who commissioned the work wanted him to create. To deliver a histor-
ical explanation is to derive a single case from general rules of conduct
and from individual motives. Therefore we have to look for reasons in
the historical and social environment of which the artist was part, in the
historical context, and in the artist's response to his world. An explana-
tion might be the following: the political unrest caused by the opposi-
tion in France and the people's uprisings in Europe after 1648 were ex-
tremely worrisome to Poussin. In response to the chaotic world of his
day and age, he took recourse in a stoic attitude. This is a possible expla-
nation of the function of the image, not an explanation of its meaning.

*By providing support for my approach and by the argumentative sealing of
the meaning, I establish the preconditions for others to add further support
for my interpretation or to reject it on the basis of well-founded reasons.*

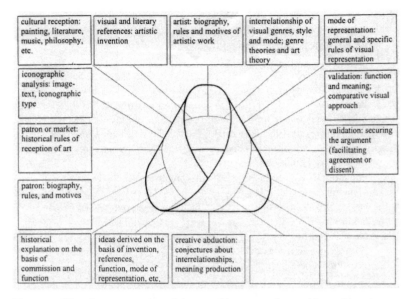

cultural reception: painting, literature, music, philosophy, etc.	visual and literary references: artistic invention	artist: biography, rules and motives of artistic work	interrelationship of visual genres, style and mode; genre theories and art theory	mode of representation: general and specific rules of visual representation
iconographic analysis: image-text, iconographic type				validation: function and meaning; comparative visual approach
patron or market: historical rules of reception of art				validation: securing the argument (facilitating agreement or dissent)
patron: biography, rules, and motives				
historical explanation on the basis of commission and function	ideas derived on the basis of invention, references, function, mode of representation, etc.	creative abduction: conjectures about interrelationships, meaning production		

Figure 8.7. Visual representation of the act of interpretation and its various steps.

By offering our founded method and sealing our conclusion in argument, we become members of a discursive community. I would like to consider this a basic requirement of scholarly academic work. We have to present our methods and results in such a way that our readers do not become objects of persuasion but participants in a shared intellectual discursive endeavor. What matters is that we continue it, either by approval or rebuttal. When we find approval and thus see our interpretation endorsed through intersubjective agreement, we do not see this as proof of a definitive explication. Nor do we forget the historicity of our interests and discourses.

The figurative representation of interpretation, the indefinite surface, can be used to check the completeness of our interpretation.

I conclude with this small mnemonic device (Figure 8.7). In contrast to the first representation of this figure (Figure 8.2), the fields have been inscribed. Some are left empty, though, and this suggests that in our interpretive effort, we are never operating in a closed system, but rather in one whose coherency is always open to further development. If and how we will change this figure depends on whether we reject it or can agree with it. In both cases, we need good reasons.

Notes

1. Szondi 1988; Jauss 1997; Weimar 1993.
2. Benjamin [1936] 1974, 361–508, esp. 503–5.
3. Weimar 1993, sec. 285–97.
4. Ricoeur 1975, 179–215.
5. Blunt 1966, 177, 126. For more on the painting, see my *Nicolas Poussin: Landschaft mit Pyramus und Thisbe* (Frankfurt am Main, 1987; 2d ed., 1995); *Nicolas Poussin, Claude Lorrain,* exhibition catalog, Städel, Frankfurt am Main, 1988; *Nicolas Poussin, 1594–1665,* exhibition catalog, Paris 1994, no. 203, pp. 453–56.
6. Poussin [1911] 1968, 188, 424.
7. For more on the problem of self-interpretation, see the exemplary analysis by Thürlemann (1986).
8. Leonardo da Vinci 1651, chaps. 64, 14; Bialostocki 1954, 131–36; Marin 1981, 61–84.
9. Schmitt–von Mühlenfels 1972.
10. De Viau 1967.
11. Blunt 1967, vol. 1, p. 235; Palladio 1570, 4:85–87.
12. Eco and Sebeok 1985.
13. Bellori [1672] 1976, 455.
14. Vinge 1967, 123–95. In the seventeenth century, knowledge was based on Plotin and Macrobius; for more on the spread of their views, see Panofsky 1960.
15. Verdi 1982, 680–85; cf. Brandt 1989, 234–58; McTighe 1989, 333–61.
16. Wittgenstein 1969, 447.
17. Belting 2000; Kemp 1992.
18. Poussin [1911] 1968, 384.

References

Alpers, Svetlana. 1982. *The Art of Describing: Dutch Art in the Seventeenth Century.* Chicago: University of Chicago Press.

Bätschmann, Oskar. 2001. *Einführung in die kunstgeschichtliche Hermeneutik: Die Auslegung von Bildern.* 5th ed. Darmstadt: Wissenschaftliches Buchgeschellschaft.

Baxandall, Michael. 1985. *Patterns of Intention: On the Historical Explanation of Pictures.* New Haven: Yale University Press.

Bellori, G. P. [1672] 1976. *Le vite de'Pittori, Scultori e Architetti moderni.* Ed. E. Borea. Turin: Giulio Einaudi.

Belting, Hans. 2000. *Das Bild und sein Publikum im Mittelalter: Form und Funktion früher Bildtafeln der Passion.* 3d ed. Berlin: Mann.

Belting, Hans, and D. Eichenberger. 1983. *Jan van Eyck als Erzähler: Frühe Tafelbilder im Umkreis der New Yorker Doppeltafel.* Worms: Werner'sche Verlagsgeschellschaft.

Benjamin, Walter. [1936] 1974. "Das Kunstwerk im Zeitalter seiner technischen Reproduzierbarkeit." In *Gesammelte Schriften,* vol. 1, pt. 2. Frankfurt am Main: Suhrkamp.

Bialostocki, Jean. 1954. "Une ideé de Léonard réalisée par Poussin." *La Revue des Arts* 4.

Blunt, A. 1966. *The Paintings of Nicolas Poussin: A Critical Catalogue.* London: Phaidon.
———. 1967. *Nicolas Poussin.* New York: Phaidon.

Boehm, Gottfried, and H. Pfotenhauer, eds. 1995. *Beschreibungskunst—Kunstbeschreibung: Ekphrasis von der Antike bis zur Gegenwart.* Munich: Fink.

Brandt, R. 1989. "Pictor philosophus: Nicola Poussins *Gewitterlandschaft mit Pyramus und Thisbe.*" *Städel Jahrbuch* 12: 234–58.

Bryson, Norman. 1981. *Word and Image: French Painting of the Ancien Régime.* Cambridge: Cambridge University Press.

Bryson, Norman, M. A. Holly, and K. Moxey, eds. 1991. *Visual Theory: Painting and Interpretation.* New York: HarperCollins.

De Viau, Th. 1967. *Les amours tragiques de Pyrame et Thisbé: Tragédie.* Critical edition by G. Saba. Naples: Nizet.

Eco, Umberto, and Th. A. Sebeok, eds. 1985. *Der Zirkel oder im Zeichen der Drei.* Munich: Dupin, Holmes, Pierce.

Imdahl, Max. 1996. *Giotto—Arenafresken: Ikonographie, Ikonologie, Ikonik.* Theorie und Geschichte der Literatur und der schönen Künste, vol. 60. 3d ed. Munich: Fink.

Jauss, H. R. 1997. *Ästhetische Erfahrung und literarische Hermeneutik 1.* 2d ed. Munich: Fink.

Kaemmerling, Ekkehard, ed. 1994. *Ikonographie und Ikonologie: Theorien, Entwicklung, Probleme.* Bildende Kunst als Zeichensystem, vol. 1. 6th ed. Cologne: Dumont Buchverlag.

Kemp, W., ed. 1992. *Der Betrachter ist im Bild: Kunstwissenschaft und Rezeptionsästhetik.* New ed. Berlin: Dietrich Reimer.

Lang, B., ed. 1979. *The Concept of Style.* Chicago: University of Chicago Press.

Leonardo da Vinci. 1651. *Trattato della pittura nuovamente dato in luce.* Paris.

Marin, Louis. 1981. "La description du tableau et le sublime en peinture: A propos d'un paysage de Poussin et de son sujet." *Communications* 34: 61–84.

McTighe, S. 1989. "Nicolas Poussin's Representation of Storms and *Libertinage* in the Mid–Seventeenth Century." *Word and Image* 5: 333–61.

Mitchell, W. J. T. 1986. *Iconology: Image, Text, Ideology.* Chicago: University of Chicago Press.

———, ed. 1974. *The Language of Images.* Chicago: University of Chicago Press.

Otto, G., and M. Otto. 1987. *Auslegen: Ästhetische Erziehung als Praxis des Auslegens in Bildern und des Auslegens von Bildern.* 2 vols. Seelze: Akademie Verlag.

Palladio, A. 1570. *I quattro libri dell'archittetura.* Venice.

Panofsky, Erwin. 1955. *Meaning in the Visual Arts.* Garden City, N.Y.: Doubleday.

———. 1960. *A Mythological Painting by Poussin in the Nationalmuseum Stockholm.* Stockholm: Nationalmusei Skriftserie No. 5.

———. 1992. *Aufsätze zu Grundfragen der Kunstwissenschaft.* Ed. H. Oberer and E. Verheyen. 4th ed. Berlin: Hesseling.

Poussin, Nicolas. [1911] 1968. *Correspondance.* Ed. Ch. Joanny. Paris: De Nobele.

Preziosi, Donald. 1979. *Architecture, Language, and Meaning: The Origin of the Built World and Its Semiotic Organization.* Approaches to Semiotics, vol. 49. The Hague: Mouton.

Ricoeur, Paul. 1965. *De l'interprétation: Essai sur Freud.* Paris: Editions de Seuil.

———. 1975. "Sa tâche de l'herméneutique: La fonction herméneutique de la distanciation." In *Exegises: Problèmes de méthode et exercices de lecture,* ed. F. Bovon and C. Rouiller, 179–215. Neuchâtel and Paris: Delachaux and Niestle.

Roskill, M. 1989. *The Interpretation of Pictures.* Amherst: University of Massachusetts Press.

Schapiro, Meyer. 1973. *Words and Pictures: On the Literal and the Symbolic in the Illustration of a Text.* Approaches to Semiotics, vol. 11. The Hague and Paris: Mouton.

Schmitt–von Mühlenfels, F. 1972. *Pyramus und Thisbe: Rezeptionstypen eines Ovidischen Stoffes in Literatur, Kunst und Musik.* Heidelberg: Carl Winter.

Szondi, Peter. 1988. *Einführung in die literarische Hermeneutik.* Ed. J. Bollack and H. Stierlin. 3d ed. Frankfurt am Main: Suhrkamp.

Thürlemann, F. 1986. *Kandinsky über Kandinsky: Der Künstler als Interpret eigener Werke.* Berlin: Bertelli.

Verdi, R. 1982. "Poussin and the *Tricks of Fortune.*" *Burlington Magazine* 124: 680–85.

Vinge, L. 1967. *The Narcissus Theme in European Literature up to the Early 19th Century.* Lund: Gleerups.

Weimar, Klaus. 1993. *Enzyklopädie der Literaturwissenschaft.* 2d ed. Tübingen: Francke.

Wittgenstein, Ludwig. 1969. "Philosophische Untersuchungen." In *Schriften,* vol. 1. Frankfurt am Main: Suhrkamp.

Zaunschirm, Th. 1995. *Leitbilder: Denkmodelle der Kunsthistoriker.* 2d ed. Klagenfurt: Ritter.

CHAPTER NINE

Seeing Soane Seeing You

Donald Preziosi

Never was there, before, such a conglomerate of vast ideas in little. Domes, arches, pendentives, columned labyrinths, cunning contrivances, and magic effects, up views, down views, and thorough views, bewildering narrow passages, seductive corners, silent recesses, and little lobbies like humane mantraps; such are the features which perplexingly address the visitor, and leave his countenance with an equivocal expression between wondering admiration and smiling forbearance.

—George Wightwick (1853)

This labyrinth stuffed full of fragments is the most tasteless arrangement that can be seen; it has the same kind of perplexing and oppressive effect on the spectator as if the whole large stock of an old-clothes-dealer had been squeezed into a doll's house.

—Adolf Michaelis (1882)

While it may be difficult to capture in words the complexities and nuances of architectonic artifice of an ordinary kind, those that characterize Sir John Soane's Museum in London (1812–1837),[1] the object of the two conflicting observations in the epigraphs and the subject of this essay, present virtually insurmountable difficulties, and not only because of the restricted space available here. The few illustrations in the following text, then, must serve as synopses of the most salient portions of the following narrative; more complete discussions of the present subject may be found elsewhere.[2]

Soane's Museum has received unprecedented attention in recent years from many architects and art historians due in large part to its seeming

resonance with certain postmodernist or poststructuralist design tendencies (wherein Soane [1753–1837] is often framed as a proto-poststructuralist).[3] What follows is an attempt to articulate some of the original aims and intended effects of this extraordinary institution in the light of its relationships to early modern museology and art history, relationships largely unexamined in the contemporary discourse on both the institution and its creator.[4]

Seeing Soane

Let us begin by walking through it. Our walk-through will be in aid of addressing the question: What exactly were you expected to see (or indeed to have become) in the bizarre labyrinth of a place known as Sir John Soane's Museum, a place that seems to bespeak a *horror vacui* of monumental and encyclopedic proportions and seems obsessed with death and commemoration: a haunted house, teeming with ghosts? What was legible in what was visible here? And in what ways can we speak of this extraordinary fabrication as a "museum"?

What you see at first is a rather unremarkable building on the northern side of the large square called Lincoln's Inn Fields:[5] a four-story light brown brick facade set back behind an iron fence (numbers 12, 13, and 14), virtually indistinguishable from the others on the street. There are in London many thousands like these three contiguous row houses that today make up Sir John Soane's Museum. The main distinguishing feature here is the white stone facade of number 13, built out several feet from the face of the brick wall, comprising a glassed-in loggia spanning two full stories. This is extended up into the central portion of the third story.

There is white stone trim delineating each of the stories, extending both horizontally and vertically from the projecting stone facade. Simple classicizing decoration can be seen on the facade and roofline: there are strips of meanders carved into the stone, and small *akroteria* surmounting the third story and the fourth-story roof balustrade. Between the three windows on the first and second stories, there are twin Gothic pedestals in the form of column capitals affixed as brackets to the facade. Two stone caryatids, recalling those of the Erechtheion on the Athenian Akropolis, stand on either end of the top of the second-story stone facade. Parts of the side windows of this stone loggia are of colored glass.

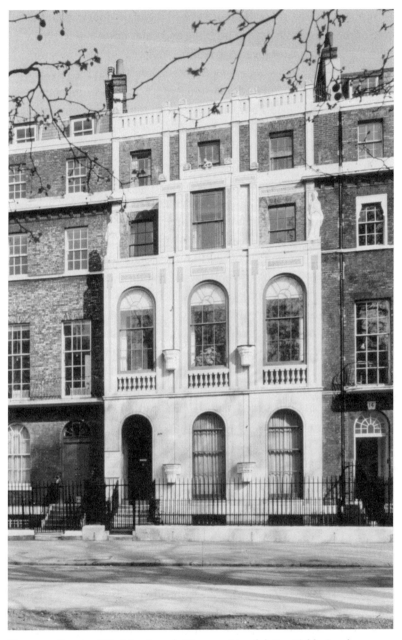

Figure 9.1. Facade of Sir John Soane's Museum, Lincoln's Inn Fields, London.

You walk up the short flight of steps to the main doorway on the left side of the central part of the building and enter into a modest hallway, which, beyond a cantilevered spiraling stairwell, opens out suddenly into one of the most astonishing domestic interiors in the city, resembling at first glance a three-dimensional mock-up of a trompel'oeil wall painting of the Fourth Pompeian style, with buildings resembling fantastic stage sets, airy garden pavilions the size of palaces, and spaces of logic-defying, Escher-like complexity.[6]

The interior is truly kaleidoscopic, replete with light wells, skylights in both clear and brilliantly colored panes of glass: a maze of rooms interspersed with open-air courts of varying size and surprising position. Some spaces have low ceilings; others are two stories or more in height. Parts of some floors are of glass block, admitting light into the lower basement rooms. Changes of level and scale occur unexpectedly, and there seem to be several different ways of getting from any one room to any other.

You also become aware that there are scores of mirrors everywhere. They are flat and convex, large and small, and are fixed to walls, on concave or square indented ceilings, in pendentives, and in countless recessed panels that collect, focus, and pass on direct and indirect light, enriching and juxtaposing colors and multiplying the spaces of each room in such a way as to collect the contents of adjacent rooms into the space you're in. Ceilings are divided into recessed and projected panels—many carved, others plain, and all richly colored. The room colors that predominate are Tuscan red and antique yellow (giallo antico), and some walls are painted to imitate marble and porphyry. Some of the wood trim is painted a greenish color suggestive of weathered bronze.

Everywhere you look there are statues, busts, bas-reliefs, paintings, stone and clay vases, medallions, architectural motifs, full-size fragments of buildings, as well as models of both ancient and modern buildings made of wood, stone, plaster, and cork, standing on tables, wall brackets, balustrades, shelves, and even embedded in ceilings. To virtually every surface of every room is affixed some object or part object, some fragment of a thing. And each is often visible several times over, and from different angles, in the many mirrors and mirrored panels on walls, ceilings, windowsills, and the tops of bookcases; indeed, it's hard at first glance to tell what is mirrored and what is not. The scale of things often changes dramatically from one object to the next: a piece of

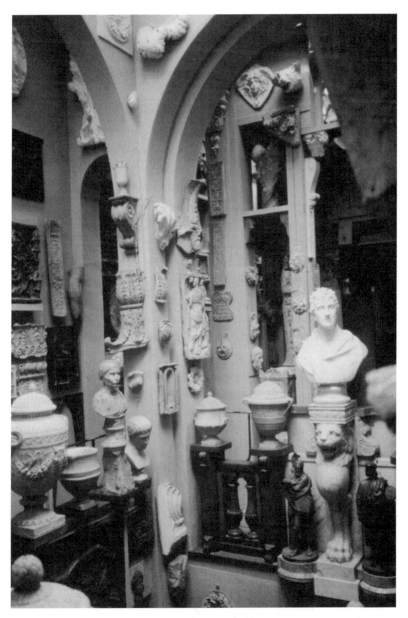

Figure 9.2. Interior of the Dome, Sir John Soane's Museum.

a fifteenth-century roof abutting a miniature figure of a Greek goddess; an architectural model forming the plinth of a life-size statue.

One room, whose walls are covered solely by paintings (the Picture Room, in the northeast corner of the building), contains three walls (north, east, and south) made up of hinged leaves of superimposed panels, with paintings hung on all surfaces. The hinged leaves make it possible to hang several times the number of pictures than might be accommodated by a room of this size with normal walls.[7]

The south panels in fact make up the wall itself: they may be opened up to reveal a two-story light well beyond, revealing the basement-story Monk's Parlour below. Out across that two-story space, and surmounting a model of the facade of the Bank of England, of which Soane himself was the architect, is a semidraped female statue, a white plaster nymph by Sir Richard Westmacott, seen against a window originally made up of brilliantly colored panes of glass (as were most of the building's windows).

You might indeed want to make some academic art historical sense of the place by assigning a particular area, tableau, or decorative schema to a single style (classicist, romanticist, Egyptianizing, neo-Gothic, etc.), responding to sets of obvious questions that pop up as you walk by: Why is this image of Britannia in a basement recess adjacent to one in which there are those wooden models of Soane's tomb? What is a second-century Roman altar doing near two Twenty-second Dynasty Egyptian stelae made a millennium earlier? And so forth.

The place was no small scandal to more than one nineteenth-century continental (and usually German) art historian or connoisseur of the predictably historicist or Hegelian bent.[8] You sense that any such pursuit in this case would be one that somehow sets off on the wrong foot and misses something basic about the place: not merely Soane's (rarely acknowledged but very great) wit but rather something else, and something rather more critical, guaranteed to strip the gears of your common or garden-variety art historical Hegelianism, or to dampen many of your postmodernist enthusiasms.[9]

The place was in fact a rather remarkable critical instrument, one closely attuned to the museological atmosphere of the first third of the nineteenth century in its carefully calibrated commentary on the galloping historicist gloom that was taking place elsewhere at the time, notably in

the British Museum nearby in Bloomsbury.[10] Soane's Museum has what by hindsight seem some powerful and startling things to say about history and art, and about ourselves as subjects of artifice and history. The legibility of this has been a long time coming, given the universal dissemination and success of a museological modernism that now itself might seem on the wane.[11] But let us leave this for the moment and look at the plan (Figures 9.3 and 9.4).

At what seems the approximate center of the building—on the north-south axis of number 13, and adjacent to the east-west axis of the structure—is a small, open-air court (18), which contained at its center a large-scale pasticcio, a composite pylon made up of ancient and modern (and non-Western) architectural pieces, erected in 1819.[12] It was surrounded by fragments of a Roman frieze whose forms echoed those of the branches of an ash tree found in the woods of Sussex, which were hung nearby. The court is visible on all four sides through glazed windows on the first floor—from the dining room on the south, the breakfast parlor on the west, Soane's study and dressing room on the east, and, on the north, from a passageway forming part of the southern section of a colonnade running east to west (10).

This latter, about twenty feet in length, consists of ten low Corinthian columns carrying a room above (the Upper Drafting, or Student's, Office), which is detached from the ambient walls, allowing light into side aisles on the north and south. Following this to the west, you come upon a brightly lit area known as the Dome (11). This is a three-story space capped by a conical skylight, with smaller, colored glass skylights on three sides. The brightest interior part of the building, it seems for various reasons to be a climactic or focal point of the museum. The room carried by the Colonnade—steps lead up to it at the east end, and you will find there a drafting room (34) whose walls were hung with classical bas-reliefs—has a small window at its west end, which looks down into the Dome.

The first-floor balustrade of the Dome is mostly surmounted by stone funerary urns (whether they are authentically antique is not readily discernible) and several busts. On its east side stands the bust of John Soane himself. Opposite him and across the space to the west is a cast of the *Apollo Belvedere,* made from the original in the Museo Pio Clementino in Rome.[13] Apollo, originally bright white, since darkly varnished, and

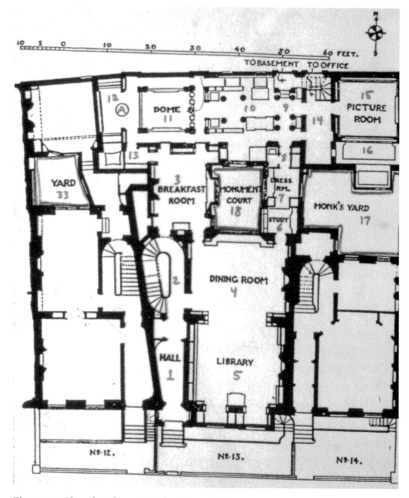

Figure 9.3. Plan, first floor, Sir John Soane's Museum, 1837.

John (still white after all these years) face each other across the space that is open down into the basement story. The small window of the drafting room above the Colonnade looks down over Soane's shoulder. Standing in that window is a bust of the painter Sir Thomas Lawrence, whose portrait of Soane stands in the first-floor dining room.

On the wall surfaces and pendentives of the Dome are masses of architectural and sculptural fragments, heads, medallions, and vases on brackets. Looking down, you will see, in the area known as the Sepul-

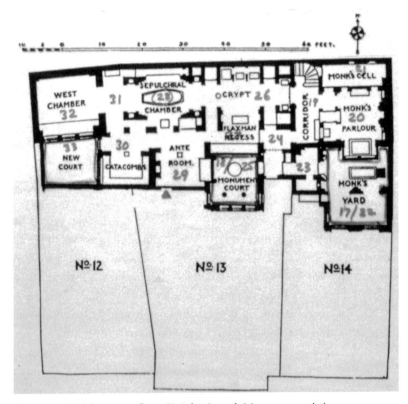

Figure 9.4. Plan, basement floor, Sir John Soane's Museum, as existing.

chral Chamber (28), a large Egyptian sarcophagus, made for the pharaoh Seti I circa 1300 B.C.E., excavated at Thebes by the famous archaeologist, adventurer, and entrepreneur Giovanni Belzoni.[14] Faded to virtual invisibility inside is the full-size image of the goddess Nut, whose outstretched arms would have protected the mummy of the deceased Seti. Only faint traces remain of the extensive hieroglyphic inscription, some of which was incised and filled with colored paste, much decayed since the sarcophagus was installed here in 1824. The installation of this item occasioned a three-night lamplight celebration with colored lanterns, costumes, music, and scores of notables from Coleridge to Turner jostling each other in the gloom for a glimpse of glyph and a piece of cake.[15]

You can enter that lower floor by returning through the Colonnade (what Soane at times called the "museum" of his museum) and descending a staircase to the left (north), where you find a gloomy sepulchral

underworld, a crypt of many chambers and recesses strewn with epitaphs, memorials, ancient and medieval ruins and relics, and several tombs and tomb models apart from the Egyptian sarcophagus.

Parts of this basement receive shafts of light through the (post-Soane) glass block floors in the Colonnade's south aisle and south end of the corridor to the west of the Picture Room. There was a chamber to the east of the sarcophagus beneath the Colonnade known as the Egyptian Crypt, which originally was unlit and made of massive stone blocks on walls and ceilings; it was remodeled and its back eastern wall cut through in 1891. The tomb of "Padre Giovanni" can be seen in the Monk's Yard (17) on the east of the building, through a south window in the Monk's Parlour (20, under the first-floor Picture Room). It is surrounded by ruined fragments of an anonymous (and imaginary) medieval building (actually a fifteenth-century piece of old Westminster, staged as a medieval ruin). The Monk's Cell is to the north, beyond the Parlour.

The Yard and its tomb are also visible from above and to the west, from a small set of rooms to the southeast of the first-floor Colonnade. The one to the south (6) was Soane's tiny and ingeniously outfitted Study (after his wife's death in 1815, Soane took to referring to this room as "his Monk's Cell," a title he later applied to the room beyond the Monk's Parlour in the basement). The room to the north (7) was Soane's Dressing Room. If you look upward, you will see lead busts of Palladio and Inigo Jones surmounting the lintels of these two first-floor rooms, each reflected in a mirror placed on the surface below the other as you pass through the room. Above these opposed and "conversing" busts, you will also see the small lantern skylight in the Dressing Room (originally placed in the small Lobby room to the north). This is a model of the one designed by Soane for the dome of the "Temple" Hall within the Freemason's Hall in 1828 to 1830, a building whose twentieth-century successor stands in Great Queen Street several hundred meters to the west of the museum, on a site connected with Masonic gatherings since the early eighteenth century.[16]

Standing between the Monk's Yard below to the east and the Monument Court below to the west, these two rooms form a bridgelike passage linking the Colonnade area (itself connecting the Dome on the west with the Picture Room on the east) with the Dining Room and Library (4, 5) to the south. The latter two rooms open into each other, being separated only by short projecting piers.

Completing our walk-through brings us to the Library, whose south end constitutes the building's front facade.

Seeing Soane Seeing

What kind of museum or collection is this? Let's begin by noting two things that do *not* happen here.

1. Moving from the Colonnade to the Dome (or the Dome to anywhere else) does not seem to bring you from the ancient to the medieval, from the classic to the romantic, from the Egyptian to the Greek, from groups of works of one artist to those of another—or indeed along any clear diachronic trajectory mapped onto sequences of space such as would be familiar later on, in more explicitly historicist institutions, such as the British Museum in its present form. You can look everywhere in most every room or passageway, and you will not find items arranged in any apparent chronological or genealogical order: this is not a monument to the ideologies of romantic nationalism. To walk through Soane's Museum is *not* to travel through time or dynastic succession (as one did in the Louvre), with each room corresponding to a period (a century or political epoch) or an artistic tradition or school.[17]

2. The items in any delimited space—a room, a recess, or an alcove—are rarely homogeneous on strictly stylistic, chronological, cultural, or functional grounds. They do not necessarily constitute tableaux of fragments or relics drawn from a particular historical environment, such as the reign of a given monarch. Indeed, the Parlour of Padre Giovanni seems almost a parody of such period tableaux common in some museums of the time. In other words, the "medieval" character of the basement rooms devoted to the mythical Father John is not a function of an aggregation of genuine medieval artifacts but in fact a pastiche of old or old-looking things staged in a gloomy, faux-medieval manner.

The building's organization is thus not apparently "historical" in any familiar museological or art historical sense. Objects seem rather to be placed where they might fit together on a wall or ceiling, on a pendentive or over a bookcase, on the basis of associations that seem to make some kind of aesthetic sense, perhaps of shape, color, or material. But exactly what kind of sense would any such aesthetic relationships make? Are we confronted with morphological, stylistic, or thematic compatibility or complementarity? Complementary referential subject matter? On many such grounds, it is difficult to account for the placement of

the hundreds of sculptures, architectural fragments, paintings, models, medallions, reliefs, and other items visible from almost any point (which moreover are frequently multiplied and transformed in the many mirrors everywhere).

Nor is it at all immediately apparent what the presence of a particular object might be intended to symbolize or represent—or if indeed the very notion of representation in its familiar contemporary senses would be at all pertinent or apt here. Semiotically and epistemologically speaking, just what significative value may be assigned to all these originals, models, and copies; these objects and part objects? How are we to construe them in a meaningful manner? What, if anything, are they supposed to mean? And for whom (apart from Soane) would they be meaningful?

Let's look more closely at the material scenography and architectonic order(s) of the place itself—the stage on which whatever seems to be played out is afforded and/or constrained. In the process, we may arrive at a better position to appreciate whether the museum can be construed as a stage in the common sense of the term, as a platform on which things take place, or whether the stagecraft itself has a full speaking role of protagonist in the cast of characters.

The isometric diagram (Figure 9.5) presents a simplified sketch of the sequence of spaces, on the two levels making up the museum as such, and apart from the more private quarters on the second floor of number 13, or the rooms devoted to other purposes in numbers 12 and 14.

You become aware right away that certain spaces are *physically* traversable, whereas a few are only accessible *visually,* through the windows of those spaces that are accessible. (Three stories or parts of stories are in fact accessible, from the basement to the first floor to the "mezzanine" constituting the Upper Drafting Office above the Colonnade on the first floor. I'll refer to these—the basement, first floor, and Drafting [or Student] Office levels—in shorthand as levels A, B, and C.

The spaces only visually accessible include, on level A, the Monument Court (18) and the Monk's Yard (17), along with the Recess (16), which may be seen from the Picture Room (15) above to the north, once the hinged wall panels are opened, or through a window in the corridor (14) to the west. The Recess of level B is, on level A, the south third of the Monk's Parlour (20), which is traversable.

The Sepulchral Chamber (28) of the Dome (11) is visually but not kinesthetically accessible on B; you can walk into it only on A. On A, the

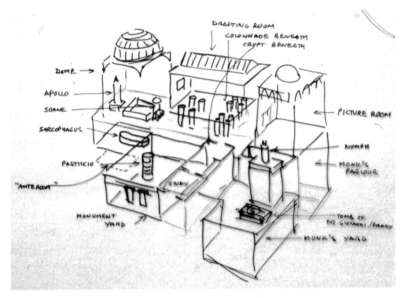

Figure 9.5. Isometric diagram of main parts of Soane's Museum.

Monk's Cell (21) is visible from the Monk's Parlour, and the Monk's
Yard and Monument Court are visible, respectively, only from the Par-
lour and spaces 23 and 24 on A (below Soane's Study [6] on B). But on
the west side of the building, there is an area—the New Court (or Yard)
(33)—that is not at all physically accessible from the museum proper,
being only visually accessible, and then only on level A, from the West
Chamber (32) beyond the Sepulchral Chamber/Dome area. This Court
lies to the south of a room that is physically and functionally part of the
number 12, level A portion of Soane's properties in this final state of the
building; in fact that room was once part of Soane's original working
office when he first occupied number 12.

It may be seen, then, that there are several kinds of spaces in the
museum:

1. Those physically accessible on A (19, 20, 23, 24, 26–32).
2. Those only visually accessible on A (21, 22, 25, 33; and [16], [11] of B).
3. Those physically accessible on B (1–15).
4. Those only visually accessible on B (16, 17, 18).
5. Those physically accessible on A but only visually accessible on B
 (two-level spaces) (28 [11], 20 [16]).
6. In addition, a distinction may be made between multilevel spaces that
 are exterior to the museum's physical areas and only functionally part

of it visually—22, 25, 33—and multilevel spaces that are interior to the museum, visually part of it on two levels, such as 16, 28 (11), and kinesthetically functional on one level.

One space (21; the Monk's Cell, on A) is entirely interior, functionally a part of the ensemble, but only accessible visually.

One whole level (space 34, or C; the Drafting Office level) is physically accessible via the stairwell off 14 on B. It is also *visually* connected to the Dome and Sepulchral Chamber areas (11 on B; 28 on A) by means of the window in its west wall.

It becomes apparent, then, that there is a simple and marked distinction or hierarchy among the spaces that make up the museum, looked at merely (and for the moment) in terms of their physical accessibility to the visitor or user of the institution. This distinction might be referred to as making up an opposition between *physical* and *virtual* spaces.

To reiterate, Soane's Museum is differentially accessible, in three ways:

1. Some spaces are fully accessible, physically or kinesthetically, to the visitor: you can walk into and/or through them.
2. Others are only virtually accessible to the visitor: they can only be seen and not touched or physically entered.
3. Yet some spaces are virtually accessible from one level in the building (B and C) and physically accessible from another (A and B).

We are dealing, then, with a highly complex spatial domain: an architectonic organization that stages, affords, and constrains whatever is meant to be experienced here, in several dimensions or formats. This is done, moreover, in a manner that is materially extremely rich and varied—indeed, rather kaleidoscopic. The domain of the museum consists of a series of juxtaposed and interleaved spaces, some physical and some virtual, along with some that, in the visual purview of the visitor, are compounded of both, where visually the visitor is confronted with virtual (physically inaccessible) and physically accessible regions simultaneously. Moreover, the virtual spaces take on a vitrinelike quality of their own, as a kind of museum-within-a-museum: some interior (Monk's Cell), others exterior (Monk's Yard, Monument Court, New Court).

In other words, there are many places where one can stand in the museum and see, superimposed *and* juxtaposed at the same time, physical *and* virtual places: like a stage set made up on the principles of Fourth Pompeian Style architectural painting (illustrations of which may in

fact be found in several places in the museum), interleaving diverse, accessible, inaccessible, and impossible or improbable spaces on the same stage, as it were, or from a single perspectival point. A veritable Los Angeles in a cabinet.

But that's not all.

Recall the plethora of mirrors of all shapes, sizes, and degrees of convexity scattered throughout the spaces of the museum. Here too is another dimension of the virtual spatial order of the place, for in addition to areas that are only virtually accessible visually (such as the various courts or yards, or two-story spaces such as the Dome/Sepulchral Chamber, or the Recess/Monk's Parlour), spaces are extended, multiplied, and altered by the many mirrors of different kinds in many rooms (but interestingly, mainly on level B; apart from the large mirror on the north wall of the basement Monk's Parlour, there appear to have been few if any mirrors on A or C).

The simple result of this is to render yet more complex the spatial character of a number of rooms otherwise fully accessible physically. In other words, a number of first-floor rooms have a double or multiple visual dimension: some walls, wall areas, or recesses open up and reflect other areas, and in fact in a couple of spaces (most notably the Dining Room [4]) there are mirrored surfaces close to the windows opening on to the virtual space of (in this case) the Monument Court, bringing its reflection back into these physical spaces. The skylight in the Dressing Room (7) also has mirrored edges and sides, providing extraordinary upside-down reflections of the room and ceiling ornaments, along with slices of views of the adjacent exterior courts. There are, in short, very few areas of level B in which there is *no* virtual space of one kind or another.

But not only are other spaces reflected within a given room, thereby becoming the (often miniaturized, often not) virtual components within a physically accessible room; what is also transformed is the perspectival angle or point of view of the other spaces that are revealed in the mirror(s). For the visitor standing in a given room, then, not only can she or he see multiple spaces—both within the present room and outside—reflected in the mirrors, but those reflected spaces exist in multiple perspectival positions.

Thus from any given standpoint one sees the geometric order of the room one is physically in, and the geometric order of a space only

accessible virtually. But within the latter may be several kinds of virtual space, of which at least two may be distinguished:

1. that which is visible but not physically accessible, and juxtaposed to the space one is in, where you see in effect the one superimposed on the other; and
2. that which is visible in one or more *mirrors* in the space you're in, which, depending on a mirror's position and angle, transforms the geometric order of the reflected space(s) to an order that requires (projects) a perspectival point different from that represented by the viewer's present position in space. In other words, there coexist views within a single physical space that have divergent vanishing points. There are, then, a number of anamorphic transformations within this dimension of the museum's virtual space.

I have referred to these spatial distinctions as simply physical (kinesthetic accessibility) and virtual (visual accessibility). The latter may now be divided between what may be called perspectival spaces (virtual spaces accessible only visually, but conforming to the perspectival order one is physically positioned in) and anamorphic spaces (virtual spaces that are visually accessible by means of mirrors but transform the perspectival geometry of a reflected space in single or multiple ways). The architectonic and visual effect, then, is astonishingly complex, with many different perspectival points, geometric orders, and topological dimensions of accessibility, all palpable from a given singular position in any one of many rooms in the museum's domain. We are dealing with a most extraordinary spatial domain. But to repeat our original question, what exactly is all this in aid of?

We see what appears to be a multiply refractive and dynamic theatric experience being staged: that is, a performative domain with what might well have been multiple possibilities for construal. Places of several different kinds and in several different dimensions are both juxtaposed and superimposed, reflected singly, multiply, and in different angles, and anamorphically transformed in relation to a given viewer's point of view. Moreover, the most startling and powerful effects obtain (architecture, after all, being a four- rather than a three-dimensional art) when one moves through the place. Views expand and contract, reflections of rooms (and rooms beyond rooms) go off at multiple and often divergent angles, and spaces open up both kinesthetically and visually, on one level or two, as one passes through a series of rooms. Not to speak of what hap-

pens to the objects that any given room contains: many are accessible to sight from multiple angles to begin with. In addition, in its original state, the museum's light was vibrantly and richly colored, as most of the skylights and many windows were of old and reused stained glass and modern (nineteenth-century) colored panes.

The stagecraft suggests not only that some kind of narrative is unfolding in space but that the stage itself is unfolding in a series of cascading metamorphoses: an architectonic dramaturgy. A labyrinthine, kaleidoscopic, spatiotemporal domain, one that moreover demands of the visitor a degree or level of attentiveness beyond what we commonly take, today, to be the ordinary run of museological experiences of reading discrete objects, whether they may be seen in a narratological light or not.[18] These visual and spatial complexities were commented on and appreciated by not a few visitors to the museum during Soane's day and afterward.[19]

Concluding and Beginning Again

I would like to suggest, in conclusion, that we may begin to appreciate the significance of Soane's stagecraft and his museum's dramaturgy by recalling something that has become largely invisible today in the modern discourse on museology and art history: that the rise of the modern museum as an instrument of individual and social transformation during the Enlightenment was a specifically Masonic idea. It is not simply the case that practically every founder and director of the new museums in Europe and America in the late eighteenth century and the early nineteenth was a Freemason; in addition, it may be suggested that the idea of shaping spatial experience as a key agent in the shaping of character was central to the Enlightenment mission of Freemasonry from the beginning. The civic museum institutions founded in the late eighteenth century and the early nineteenth in Europe and America were a Masonic realization of a new form of fraternization not dependent on political, religious, or kinship alliances, and tied to the social revolutions on both sides of the Atlantic—that is, citizenship. As with the most influential institution, the Louvre Museum (explicitly organized for the political task of creating republican citizens out of former monarchical subjects), they provided subjects with the means for recognizing and realizing themselves as citizens of communities and nations.

Soane's Museum is in fact unique today because in its actual physical preservation, it has retained a palpable flavor of the articulation of the Masonic program that Soane shared with contemporaries such as Alexandre Lenoir, founder of the Museum of French Monuments in the former Convent of the Lesser Augustines,[20] the original Ashmolean, the first public museum in Europe and founded by one of the first known British Masons, Bernard Ashmole,[21] and, in part, the British Museum during its Montague House period, the antecedent of the present classicist confection of 1847 to 1851. In Berlin, Karl Friedrich Schinkel's Altes Museum exemplified similar organizational principles.[22] Of all these Masonic foundations, only Soane's retains the character that all these others (where they still exist) have lost. The earliest American museum, Peale's Museum in Philadelphia, occupying the upper floor of the newly inaugurated American government building, no longer exists.[23] Soane's collection of Masonic books also included those of Lenoir, and he was well acquainted with Ledoux's 1804 volume *L'architecture considerée sous la rapport de l'art, les moeurs, et de la législation.*[24]

Free or speculative Masonry, which was set in opposition to practical masonry as theory to practice, was founded on a desire to reconstitute in modern times simulacra of the ancient Temple of Solomon, said to have been designed by the Palestinian (Philistine) architect Hiram of the old coastal city of Tyre for the Jews of the inland kingdom of Israel— a building that, in its every, tiniest detail, was believed to encapsulate all knowledge.

It may well be asked how this might have been materially manifested in Soane's Museum. The museum, as far as the archival records examined to date indicate, was not used as a Masonic lodge or temple. Yet there is a passage through these complex spaces that uncannily replicates the stages illustrated in the Masonic "tracing-board" presentations of the three stages or degrees of initiation—that is, the three stages of enlightenment the individual is exhorted to follow.[25]

Where this route may have been is given by a single remaining clue— the name Soane gave to a small space in the basement on the south side of A (29), namely, the Anteroom, indicated with an arrow in Figure 9.4. Today this is a room a visitor would pass by on the way to the public restrooms, but in Soane's day it could be entered directly from outside the building. This constituted the other or lower ground floor level access into the building. If you were to begin your visit to the museum in

this anteroom or vestibular space, you would then proceed into and through the dark and sepulchral basement, with its reminders of death and mortality, the (no longer extant cul-de-sac of) the Egyptian tomb ahead of you, and into the realm of the medieval Padre Giovanni—his Parlour, Cell, and Tomb Yard to the east.

This would then lead you to the stairwell to level B, the first floor, with its classical decoration, and you would pass through the Corinthian order colonnade toward the back of the bust of Soane confronting the Apollo Belvedere across the open space. From behind, as you approach the back of Soane's bust, Soane and Apollo are superimposed, Soane's head in fact hiding the (now fig-leafed) god's genitalia. The position of Soane's bust on the Dome's balustrade was the place where the fragments of the collection fell into their proper perspective, and where, standing with Soane, the veritable genius loci or spirit of the place, you would see laid out vertically before you the progression from the sarcophagus in the basement to Apollo to the brilliant light of the Dome skylight above. This vertical tableau corresponds, in Masonic lore, to a passage from the death of the old self to rebirth and enlightenment. The sarcophagus on these tracing boards symbolically holds the dead body of the artist or architect before rebirth and enlightenment.[26]

You have, in other words, a series of progressions mapped out throughout the museum's spaces—from death to life to enlightenment; from lower to higher; from dark to light; from multiple colors to their resolution as brilliant white light; from a realm where there is no reflection (basement level A) to one where everything is multiply reflected and refracted (the mirrored spaces of the first-floor level B). Soane stands at the pivotal point of all of this and moreover ostensifies his role as a Master Mason devoted to community outreach, charity, and education by (if you stand across the Dome by Apollo) appearing to carry on his shoulders the future generation of student apprentices who study and work in their office above and behind his bust. In Masonic tracing boards, the Master Mason is frequently depicted as carrying a child on his shoulders.[27]

Soane—who as a Master Mason (and as grand superintendent of works within the upper echelons of British Freemasonry) was obliged to dedicate his life to communal or public service, and created this as a kind of secular Masonic institution—here provided his visitors with a set of techniques, derived from Masonic practice, for creatively and

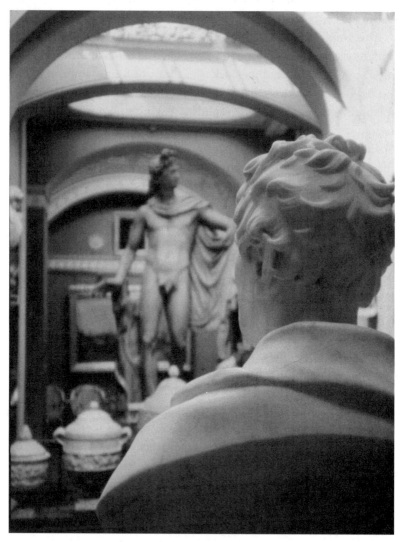

Figure 9.6. Soane and Apollo.

concretely imagining a humane modern world, a world that reintegrated the lost social and artistic ideals being rent asunder by the early industrial revolution, that is, by capitalism. It did not portray or illustrate a history of art or architecture, and in this respect, Soane's Museum was a critical rather than representational artifact. At the same time, Soane ostensified, revealing by his pose and position, the taking up of a point of view—literally a telling perspective—that provided keys to the narrative sense and compositional order and syntax of the fragments in the museum.[28] In seeing Soane seeing, the visitor could learn to envision a new world out of the detritus of the old.

Soane's Museum was thus neither a historical museum nor a private collection in their more familiar recent senses. The museum was among other things an instrument of social change and transformation. To visit it was to enter not a warehouse but a kaleidoscopic machinery designed to proactively engage the imagination. It was a collection in the root meaning of the term: an assemblage of objects given to be read together, in which the process of reading—the visitor's active use of the spaces over time—was dynamically and metamorphically productive of sense.

Whatever art historical values we may attribute to the objects we see today in Soane's Museum, they did not, in Soane's time, have primarily autonomous meanings that were fixed or final; they were, to use a linguistic or semiotic analogy, more phonemic than morphemic, being indirectly or differentially meaningful rather than directly significative. Their significance lay in their potential to be recombined and recollected by the visitor to form directly meaningful units—what Soane himself referred to as the "union of all the arts."[29] They are thus not strictly objects at all in the common (modern art historical or museological) sense of the term, and still less are they historical in any historicist sense.

John Soane's Museum ostensified a mode of perception understood as proactive and constructive, rather than passive and consumptive. Emblematic of Soane's practice as an architect and designer, the museum existed to enlighten and to project a vision of a humane modern environment in response to the massively disruptive forces of early-nineteenth-century industrialization. That world came to be apotheosized a decade and a half after Soane's death in the Great Exhibition of the Arts and Manufactures of All Nations, at the Crystal Palace of 1851.[30] The latter's many progeny—and not Soane's more radical Masonic Enlightenment visions—constitute the museological and art historical institutions and

their associated professional practices so familiar to us now as to seem natural or inevitable.[31]

Notes

1. Soane donated his museum to the state with the stipulation that it remain in perpetuity as it was at his death (1837).

2. A good history of Soane's Museum, and the definitive guide to the building and collection, is that of the late former director of the institution, John Summerson (1991); Millenson 1987, an updated version of Feinberg 1979, provides a useful introduction to some of the issues surrounding the evolution of the building. The best critical introduction not only to Soane's relationship to the neoclassical tradition in art and architecture in Britain but also to the relationship of early museology to the evolving discourse of aesthetics and art history is Ernst 1993; see also Elsner 1994; Watkin 1996; and Du Prey 1977. On museums and the origin of aesthetics, see Bann 1984 and Deotte 1993. See Soane 1830, 1832, and 1835 for a complete description of the museum shortly before Soane's death in 1837; and Soane 1929 contains his lectures on architecture at the Royal Academy between 1809 and 1836. An excellent recent biography is that of Gillian Darley (1999). The present essay builds on one of my Slade Lectures at Oxford in winter 2001 (Preziosi 2003, chap. 5).

3. Discussed by Ernst (1993, 486), in commenting on Soane's own 1812 manuscript (unpublished at the time), "Crude Hints towards a History of My House in Lincoln's Inn Fields," imagining his museum as a future ruin—a text whose allegorical implications recall issues investigated by Walter Benjamin in his study of the German mourning play or *Trauerspiel* (Benjamin 1977).

4. The principal exception to this, and still the most perceptive study of Soane's relationships specifically to early museology, aesthetics, and art history, is Ernst (1993). Excellent discussions of the museum's architecture may be found in Summerson 1952, 1978, 1991; Summerson, Watkin, and Mellinghoff 1983; Bolton 1924; Stroud 1984, 1996; Teyssot 1978.

5. Unless otherwise noted, all illustrations are by the author.

6. Ramage and Ramage 1991, 121–49.

7. Summerson 1991, 22–30. Perhaps the most famous paintings in the room are William Hogarth's two series, *A Rake's Progress* (1732–1733) and *An Election* (1754), the former purchased by Mrs. Soane at Christie's in 1802.

8. A good example being Michaelis 1882.

9. See Ernst 1993, 486.

10. On the origins and history of which see Shelly 1911; Crook 1972; Caygill 1981; Miller 1973; on the Louvre, see McClellan 1994.

11. On which see Crimp 1993; Preziosi and Farago 2003; Preziosi 1996, 1998.

12. Summerson 1991, 17; Millenson 1987, 103–4. The increasingly precarious pasticcio, which included a "Hindu" capital among Greek and Roman pieces, was dismantled in 1896.

13. Summerson 1991, 48. The cast was made for Lord Burlington and stood in his villa at Chiswick until given to the architect John White, who in turn gave it to Soane, who installed it in the Dome in 1811.

14. Belzoni 1820; Summerson 1991, 41–43; Millenson 1987, 88, 101–2.

15. Summerson 1991, 41. Soane's arrangement of the basement crypt was influenced by Belzoni's "Egyptian Exhibit" at Piccadilly Hall in 1821, according to Millenson (1987, 101). See also Watkin 1995, n. 7. That exhibition included a replica of the Seti sarcophagus, the original being in the possession of the British Museum's trustees as that institution was contemplating its purchase. Soane bought it once the British Museum rejected it because of cost.

16. Summerson 1991, 19. In 1813 Soane was appointed grand superintendent of works at the United Fraternity of Freemasons. On Soane's relationship to Freemasonry, see Watkin 1995; Darley 1999, 222–23; Taylor 1983, 194–202. On the United Grand Lodge building, see Stubbs and Hauch 1983. On Freemasonry in England more generally, see MacNulty 1991; Curl 1993; Dyer 1986; Jacob 1991; Lemay 1987; Weisberger 1993. On relationships between Enlightenment architecture and Freemasonry, see Rykwert 1980; Vidler 1987.

17. See Bann 1984, 1989.

18. The classic study of such episodic chains is that of Duncan and Wallach (1978).

19. Millenson (1987, 106–18) cites a number of published observations, including some appearing in the contemporary *Penny Magazine*, on which see also Elsner 1994, 160.

20. Lenoir 1800–1821, 1814; Watkin 1995, 404; Watkin 1996; see also Vidler 1987, 167–73, on Lenoir's Museum of French Monuments.

21. Discussed by Simcock (1983, 77). See also Josten 1966.

22. A useful introduction to the literature on Schinkel's museum may be found in Crimp 1993, 292–302; see also Jacob 1991 for a general background on continental Freemasonry, including Germany and the Low Countries.

23. The best critical introduction to early museums in the United States and their Masonic connections is Sacco 1998, chap. 4. The Masonic skeleton of American revolutionary institutions is quite clear, albeit today largely forgotten.

24. Ledoux 1804; Lenoir 1814. See also Watkin 1995, 402.

25. MacNulty 1991, 15–32.

26. A useful discussion of tracing-board symbolism may be found in MacNulty 1991.

27. MacNulty 1991, 28–33.

28. On the narratological nature of collecting, see Bal 1994, 97–115.

29. Soane 1827; on which see Summerson 1982.

30. Preziosi 1999, 2003.

31. Preziosi 1998, 507–25; 1996, 281–91; Preziosi and Farago 2003, introduction.

References

Bal, Mieke. 1994. "Telling Objects: A Narrative Perspective on Collecting." In *The Cultures of Collecting*, ed. John Elsner and Roger Cardinal, 97–115. London: Reaktion Books.

Bann, Stephen. 1984. *The Clothing of Clio: A Study of the Representation of History in Nineteenth-Century Britain and France*. Cambridge: Cambridge University Press.

———. 1989. "The Sense of the Past: Image, Text, and Object in the Formation of Historical Consciousness in Nineteenth-Century Britain." In *The New Historicism*, ed. H. Vesser. New York: Routledge.

Belzoni, Giovanni. 1820. *Narrative of the Operations and Recent Discoveries within the Pyramids, Temples, Tombs, and Excavations in Egypt and Nubia.* London: J. Murray.

Benjamin, Walter. 1977. *The Origin of German Tragic Drama.* London: Verso.

Bolton, Arthur T. 1924. *The Works of Sir John Soane, F.R.S., F.S.A., R.A. (1753–1837).* London: Sir John Soane's Museum.

Caygill, Marjorie. 1981. *The Story of the British Museum.* London: British Museum Publications.

Crimp, Douglas. 1993. *On the Museum's Ruins.* Cambridge: MIT Press.

Crook, J. Mordaunt. 1972. *The British Museum: A Case-Study in Architectural Politics.* London: Allen Lane.

Curl, James Stevens. 1993. *The Art and Architecture of Freemasonry.* Woodstock, N.Y.: Overlook Press.

Darley, Gillian. 1999. *John Soane: An Accidental Romantic.* New Haven: Yale University Press.

Deotte, Jean-Louis. 1993. *Le Musée: L'origine de l'esthétique.* Paris: Harmattan.

Duncan, Carol, and Alan Wallach. 1978. "The Museum of Modern Art as Late Capitalist Ritual: An Iconographical Analysis." *Marxist Perspectives* (winter): 28–51.

Du Prey, Pierre de la Ruffiniere. 1982. *John Soane: The Making of an Architect.* Chicago: University of Chicago Press.

Dyer, Colin. 1986. *Symbolism in Craft Freemasonry.* London: Ian Allen.

Elsner, John. 1994. "A Collector's Model of Desire: The House and Museum of Sir John Soane." In *The Cultures of Collecting,* ed. John Elsner and Roger Cardinal, 155–76. London: Reaktion Books.

Ernst, Wolfgang. 1993. "Frames at Work: Museological Imagination and Historical Discourse in Neoclassical Britain." *Art Bulletin* 75, no. 3 (September): 481–98.

Feinberg, Susan. 1979. "Sir John Soane's Museum: An Analysis of the Architect's House-Museum in Lincoln's Inn Fields, London." Ph.D. diss., University of Michigan, Ann Arbor.

Jacob, Margaret. 1991. *Living the Enlightenment: Freemasonry and Politics in Eighteenth-Century Europe.* Oxford: Oxford University Press.

Josten, C. H. 1966. *Elias Ashmole (1617–1692): His Autobiographical and Historical Notes, His Correspondence, and Other Contemporary Sources Relating to His Life and Work.* 5 vols. Oxford: Clarendon Press.

Ledoux, Claud Nicholas. 1804. *L'architecture considérée sous la rapport de l'art, des moeurs, et da la legislation.* Paris: H. L. Perronneau.

Lemay, J. A. Leo, ed. 1987. *Deism, Masonry, and the Enlightenment: Essays Honoring Alfred Owen Aldridge.* London and Toronto: Associated University Presses.

Lenoir, Alexandre. 1800–1821. *Musée des Monuments Français.* 8 vols. Paris: Imprimerie de Guilleminet.

———. 1814. *La franche-maçonnerie rendre à sa véritable origines, ou, L'antiquité de la franche-maçonnerie.* Paris: Fournier.

MacNulty, W. Kirk. 1991. *Freemasonry: A Journey through Ritual and Symbol.* London: Thames and Hudson.

McClellan, Andrew. 1994. *Inventing the Louvre: Art, Politics, and the Origins of the Modern Museum in Eighteenth-Century Paris.* Cambridge: Cambridge University Press.

Michaelis, Adolf. 1882. *Ancient Marbles of Great Britain*. Trans. C. A. M. Fennell. 2 vols. Cambridge: Cambridge University Press.

Millenson, Susan Feinberg. 1987. *Sir John Soane's Museum*. Ann Arbor: UMI Research Press.

Miller, Edward. 1973. *That Noble Cabinet: A History of the British Museum*. London: Deutsch.

Preziosi, Donald. 1996. "Museums/Collecting." In *Critical Terms for Art History*, ed. Robert Nelson and Richard Shiff, 281–91. Chicago: University of Chicago Press.

———. 1999. "The Crystalline Veil and the Phallomorphic Imaginary." *The Optics of Walter Benjamin*, a special issue of *De-, Dis-, Ex-* 3: 120–36.

———. 2003. *Brain of the Earth's Body: Art, Museums, and the Phantasms of Modernity*. Minneapolis: University of Minnesota Press.

———, ed. 1998. *The Art of Art History*. Oxford: Oxford University Press.

Preziosi, Donald, and Claire Farago, eds. 2003. *Grasping the World: The Idea of the Museum*. London: Ashgate Press.

Ramage, Andrew, and Nancy Ramage. 1991. *Roman Art: Romulus to Constantine*. Englewood Cliffs: Prentice Hall.

Rykwert, Joseph. 1980. *The First Moderns: The Architects of the Eighteenth Century*. Cambridge: MIT Press.

Sacco, Ellen Fernandez. 1998. "Spectacular Masculinities: The Museums of Peale, Baker, and Bowen in the Early Republic." Ph.D. diss., UCLA.

Shelly, Henry. 1911. *The British Museum: Its History and Treasures*. Boston: L. C. Page.

Simcock, A. V. 1983. "A Dodo in the Ark." In *Robert T. Gunther and the Old Ashmolean*, ed. A. V. Simcock. Oxford: Museum of the History of Science.

Soane, John. 1812. *Crude Hints towards a History of My House in L.I. Fields*. London: Sir John Soane's Museum.

———. 1827. *The Union of Architecture, Sculpture, and Painting: Exemplified by a Series of Illustrations, with Descriptive Accounts of the House and Galleries of John Soane*. London: John Britton.

———. 1929. *Lectures on Architecture: Delivered to the Students of the Royal Academy from 1809 to 1836 in Two Courses of Six Lectures Each*. Ed. Arthur T. Bolton. London: Sir John Soane's Museum.

———. 1830, 1832, 1835. *Description of the House and Museum on the North Side of Lincoln's Inn Fields, the Residence of John Soane*. 1st, 2d, 3d eds. London: Sir John Soane's Museum.

Stroud, Dorothy. 1984, 1996. *Sir John Soane, Architect*. 1st, 2d eds. Boston: Faber and Faber.

Stubbs, Sir James, and T. O. Hauch. 1983. *Freemasons' Hall: The Home and Heritage of the Craft*. London: United Grand Lodge of England.

Summerson, John. 1952. *Sir John Soane, 1753–1837*. London: Art and Technics.

———. 1982. "The Union of the Arts." *Lotus International* 35: 2.

———. 1991. *A New Description of Sir John Soane's Museum*. 7th rev. ed. London: Trustees of Sir John Soane's Museum.

Summerson, John, David Watkin, and G. Tilman Mellinghoff. 1983. *John Soane*. London: Academy Editions Monograph.

Taylor, John. 1983. "Sir John Soane: Architect and Freemason." *Ars Quatuor Coronatorum* 95: 194–202.

Teyssot, George. 1978. "John Soane and the Birth of Style." *Oppositions: A Journal for Ideas and Criticism in Architecture* 14: 67–75.

Vidler, Anthony. 1987. *The Writing of the Walls.* Princeton: Princeton University Press.

Watkin, David. 1995. "Freemasonry and John Soane." *Journal of the Society of Architectural Historians* 54, no. 4 (December): 402–16.

————. 1996. *Sir John Soane: Enlightenment Thought and the Royal Academy Lectures.* Cambridge: Cambridge University Press.

Weisberger, R. William. 1993. *Speculative Freemasonry and the Enlightenment: A Study of the Craft in London, Paris, Prague, and Vienna.* East European Monographs, no. 367. New York: Columbia University Press.

Contributors

F. R. Ankersmit is professor of intellectual history and historical theory at Groningen. He has published widely on historical theory, political philosophy, and aesthetics; his most recent publications include *Aesthetic Politics: Political Philosophy beyond Fact and Value; Historical Representation;* and *Political Representation.*

Mieke Bal is a well-known cultural critic and theorist, professor of theory of literature at the University of Amsterdam, and A. D. White Professor-at-Large at Cornell University. Among her many books are *Louise Bourgeois' "Spider": The Architecture of Art-Writing; Looking In: The Art of Viewing;* and *Quoting Caravaggio: Contemporary Art, Preposterous History.* Her areas of interest include literary theory, semiotics, visual art, cultural studies, feminist theory, the seventeenth century, and contemporary literature.

Oskar Bätschmann is professor of the history of art at the University in Bern, Switzerland. He is a member of the Swiss Academy of Humanities and Social Sciences, deputy at the Union Académique Internationale, member of the Trustee of the Swiss Institute for Art Research, member of the Trustee of the Swiss National Science Foundation, secretary of the International Committee of History of Art (CIHA), member of Comité scientifique de l'Institut nationale d'Histoire de l'Art, Paris, and member of Advisory Board Bibliotheca Hertziana, Rome. His publications include *Nicolas Poussin; Dialectics of Painting; Hans Holbein* (with

coauthor Pascal Griener); and *The Artist in the Modern World: The Conflict between Market and Self-Expression.*

Georges Didi-Huberman is a philosopher and historian of art. He teaches at L'École des Hautes Études en Sciences Sociales, Paris. He has been the curator of many exhibitions, including *L'empreinte* at Centre Georges Pompidou (Paris, 1997) and *Fables du lieu* at the Studio national des Arts contemporains (Tourcoing, 2001). Among his more than twenty books on the history and theory of images are *L'homme qui marchait dans la couleur; Génie du non-lieu: Air, poussière, empreinte, hantise;* and *L'image survivante: Histoire de l'art et temps des fantômes selon Aby Warburg.*

Claire Farago is professor of art history and theory at the University of Colorado at Boulder. She has published widely on Leonardo da Vinci, art theory, and the historiography of art, and her recent publications include *Reframing the Renaissance, Transforming Images: Locating New Mexican Santos in-between Worlds* (coauthored with Donna Pierce), and *Grasping the World: The Idea of the Museum,* coedited with Donald Preziosi.

Michael Ann Holly is director of research and academic programs at the Clark Art Institute in Williamstown, Massachusetts. She has written and edited several books and many essays on the historiography of art and contemporary movements toward visual culture, and she is writing a book on melancholia and art history writing. She is the recipient of several awards, such as the Guggenheim and an NEH fellowship, and she is a cofounder of the Visual and Cultural Studies Program at the University of Rochester.

Donald Preziosi is professor of art history at the University of California, Los Angeles, and research associate in art history and visual culture at Oxford University. He developed and directs the art history critical theory program and the museum studies program at UCLA. Among his books are *Brain of the Earth's Body: Art, Museums, and the Phantasms of Modernity* (Minnesota, 2003); *Rethinking Art History: Meditation on a Coy Science; The Art of Art History: A Critical Anthology; Aegean Art and Architecture* (with Louise Hitchcock); and *Grasping the World: The Idea of the Museum* (with Claire Farago).

Renée van de Vall works in the Faculty of Arts and Culture of the University of Maastricht, The Netherlands. She has published a book on the painting of Barnett Newman and the philosophy of the sublime, as well as several articles on the aesthetics of Jean-François Lyotard and Maurice Merleau-Ponty and on modern visual art. She is editing the volume *Spectatorship: On Artistic, Scientific, and Technological Mediation.*

Robert Zwijnenberg is professor of art history in relation to the development of science and technology in the Faculty of Arts and Culture of the University of Maastricht, The Netherlands. He recently published *The Writings and Drawings of Leonardo da Vinci: Order and Chaos in Early Modern Thought* and contributed an article to the forthcoming *Cambridge Companion to Leonardo da Vinci.*